P9-CNI-981

Understanding Art

ABOUT THE PROGRAM

Understanding Art takes a chronological approach to art, focusing on art works from ancient to contemporary times. The text blends art history with cultural and social traditions, emphasizing the role of art in everyday life. The images and content present art as historical evidence of the creative process.

ABOUT THE COVER ILLUSTRATION

Queen Nefertari Presenting Her Offerings. 19th Dynasty. Egyptian wall painting, Tomb of Nefertari, Valley of the Queens, West Thebes, Egypt. Giraudon/Art Resource, New York.

Chinese Horseman. **Chinese.** Later Han Dynasty. Bronze, from Lei-t'a, China. Giraudon/Art Resource, New York.

Mexican Bird Motif. Culhuacan. Flat stamp. *Design Motifs of Ancient Mexico,* Dover Publications, New York.

The wall painting of Queen Nefertari is an example of the unique Egyptian art style and also provides a glimpse into the traditions and practices of an ancient lifestyle. The Chinese tomb figure and the medallion from a Mesoamerican relief carving represent more art of advanced civilizations that existed hundreds of years ago.

Understanding Art

Gene Mittler, Ph.D.
Professor Emeritus
Texas Tech University

Rosalind Ragans, Ph.D.
Associate Professor Emerita
Georgia Southern University

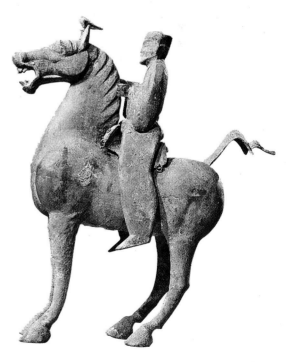

Glencoe McGraw-Hill

New York, New York Columbus, Ohio Woodland Hills, California Peoria, Illinois

ABOUT THE AUTHORS

Gene Mittler

Gene Mittler is one of the authors of Glencoe's middle school/junior high art series, *Introducing Art, Exploring Art,* and *Understanding Art.* He is also author of *Art in Focus,* a chronological approach to art for Glencoe's senior high program, and *Creating and Understanding Drawings.* He has taught at both the elementary and secondary levels and at Indiana University. He received an M.F.A. in sculpture from Bowling Green State University and a Ph.D. in art education from the Ohio State University. He has authored grants and published numerous articles in professional journals and has lectured in the United States and abroad. Dr. Mittler is currently Professor Emeritus at Texas Tech University.

Rosalind Ragans

Rosalind Ragans is one of the authors of Glencoe's middle school/junior high art series, *Introducing Art, Exploring Art,* and *Understanding Art.* She served as senior author on the elementary program *Art Connections* for the SRA division of McGraw-Hill, and wrote the multi-level, comprehensive *ArtTalk* text for Glencoe's senior high program. She received a B.F.A. at Hunter College, CUNY, New York, and earned a M.Ed. in Elementary Education at Georgia Southern College and Ph.D. in Art Education at the University of Georgia. Dr. Ragans has taught art in grades K–12, and has earned several honors including National Art Educator of the Year for 1992. She is currently Associate Professor of Art Education Emerita at Georgia Southern University.

ABOUT ARTSOURCE®

 The materials provided in the Performing Arts Handbook are excerpted from *Artsource®: The Music Center Study Guide to the Performing Arts,* a project of the Music Center Education Division. The Music Center of Los Angeles County, the largest performing arts center in the western United States, established the Music Center Education Division in 1979 to provide opportunities for lifelong learning in the arts, and especially to bring the performing and visual arts into the classroom. The Education Division believes the arts enhance the quality of life for all people, but are crucial to the development of every child.

Glencoe/McGraw-Hill

A Division of The McGraw·Hill Companies

Copyright © 1999, 1992 by Glencoe/McGraw-Hill. All rights reserved. Except as permitted under the United States Copyright Act, no part of this publication may be reproduced or distributed in any form or by any means, or stored in a database or retrieval system, without prior written permission of the publisher.

Send all inquiries to:
Glencoe/McGraw-Hill
21600 Oxnard Street
Woodland Hills, CA 91367

ISBN 0-02-662359-5 (Student Text)
ISBN 0-02-662361-7 (Teacher's Wraparound Edition)

Printed in the United States of America.

4 5 6 7 8 9 004/043 03 02 01 00

EDITORIAL CONSULTANTS

Claire B. Clements, Ph.D.
Specialist, Special Needs
Associate Professor and Community Education
 Director at the Program on Human Development
 and Disability
The University of Georgia
Athens, Georgia

Robert D. Clements, Ph.D.
Specialist, Special Needs
Professor Emeritus of Art
The University of Georgia
Athens, Georgia

Cris Guenter, Ed.D.
Specialist, Portfolio and Assessment
Professor, Fine Arts/Curriculum and Instruction
California State University, Chico
Chico, California

Nancy C. Miller
Booker T. Washington High School for the
 Performing and Visual Arts
Dallas, Texas

Faye Scannell, M.A.
Specialist, Technology
Bellevue Public Schools
Bellevue, Washington

Dede Tisone-Bartels, M.A.
Specialist, Curriculum Connections
Crittenden Middle School
Mountain View, California

Jean Morman Unsworth
Art Consultant to Chicago
Archdiocese Schools
Chicago, Illinois

CONTRIBUTORS/REVIEWERS

Jill Ciccone-Corey
Art Teacher
Monmouth Regional High School
Tenton Falls, New Jersey

Pat Gullett
Art Teacher
Morton East Intermediate School
Highland Park, Illinois

Jennifer Lawler
Art Consultant
Lenexa, Kansas

Pam Layman
Art Teacher
Bardstown Middle School
Bardstown, Kentucky

Diane Mark-Walker
Art Consultant
Los Angeles, California

Barbara Perez
Art Teacher
St. Athanasius School
Evanston, Illinois

Jan Stephens, M.A.
Art Specialist
Birmingham Museum of Art Liaison
Jefferson County Board of Education
Birmingham, Alabama

Johanna Stout
Art Teacher
New Caney High School
New Caney, Texas

PERFORMING ARTS HANDBOOK CONTRIBUTORS

Joan Boyett
Executive Director
Music Center Education Division
The Music Center of Los Angeles County

Melinda Williams
Concept Originator and Project Director

Susan Cambigue-Tracey
Project Coordinator

Arts Discipline Writers:
 Dance—Susan Cambigue-Tracey
 Music—Rosemarie Cook-Glover
 Theatre—Barbara Leonard

STUDIO LESSON CONSULTANTS

Acknowledgements: The authors wish to express their gratitude to the following art coordinators and specialists who participated in the field test of the studio lessons.

Donna Banning, El Modena High School, Orange, CA; Thomas Beacham, Telfair County High School, McRae, GA; Lydia Bee, Junction Middle School, Palo Cedro, CA; Kellene Champlain, Fulton County Schools, Fulton, GA; Jane Dixon, Highlands Junior High School, Jacksonville, FL; Karen Roach Ford, Tecumseh Middle School, Lafayette, IN; Nadine Gordon, Scarsdale High School, Scarsdale, NY; Margie Ellen Greer, Ridgeway Junior/Senior High School, Memphis, TN; Barbara Grimm, Taylor Road Middle School, Alpharetta, GA; Wanda Hanna, South Florence High School, Florence, SC; Ken Hatcher, Douglas Anderson School of the Arts, Jacksonville, FL; Annette Jones, Fletcher Junior High School, Jacksonville Beach, FL; Audrey Komroy, Akron Central School, Akron, NY; Frances Kovacheff, Charles N. Scott Middle School, Hammond, IN; Geri Leigh, Stanton College Preparatory School, Jacksonville, FL; Nellie Lynch, Duval County Schools, Jacksonville, FL; Mary McDermott, Valleywood School, Kentwood, MI; Sandra Moore, John Sevier Middle School, Kingsport, TN; Bunyon Morris, Marvin Pittman Laboratory School, Statesboro, GA; Barbara Perez, St. Athanasius School, Evanston, IL; Virginia Marshall Ramsey, Mabry Middle School, Marietta, GA; Joanne Rempell, Bradwell Institute High School, Hinesville, GA; Lahwana Reynolds, Glen Hills High School, Augusta, GA; Jane Rhoades, Georgia Southern College, Statesboro, GA; Julia Russell, Memphis City Schools, Memphis, TN; Faye Scannell, Medina Elementary, Bothell, WA; Barbara Shaw, Cobb County Schools, Cobb County, GA; Linda Smith, Millen Middle School, Millen, GA; Carolyn Sollman, Eminence School, Eminence, IN; Catherine Stalk, North Augusta High School, North Augusta, SC; Nancy Walker, Colonial Junior High, Creative & Performing Arts School, Memphis, TN; Betty Womack, William James Middle School, Statesboro, GA; Shirley Yokley, Tennessee Department of Education, Nashville, TN

Table of Contents Illustration:
Lisa Pomerantz/Deborah Wolfe, Ltd.

CONTENTS

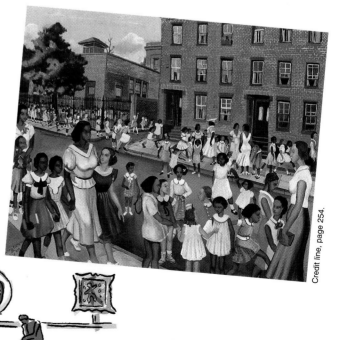

Credit line, page 254.

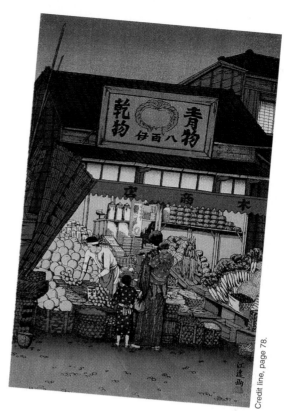

Credit line, page 78.

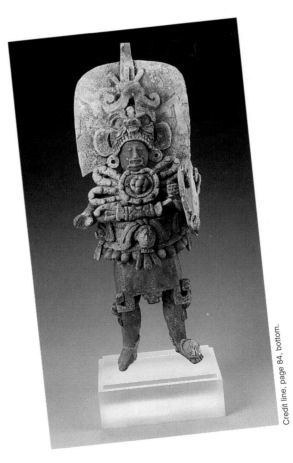

Credit line, page 84, bottom.

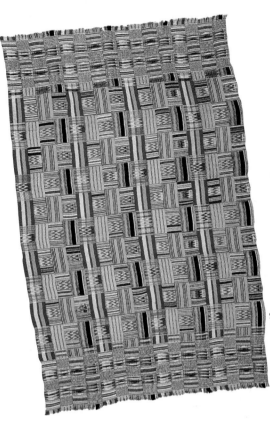

Credit line, page 142.

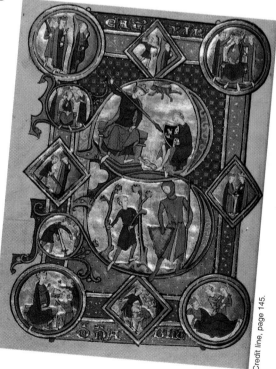

Credit line, page 145.

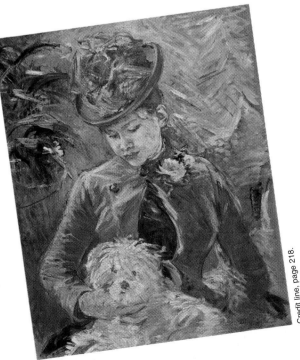

Credit line, page 206.

Credit line, page 218.

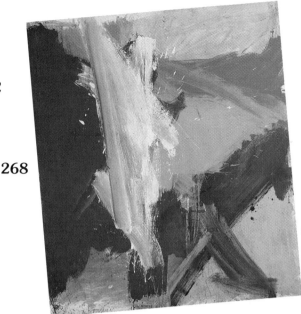

Credit line, page 34.

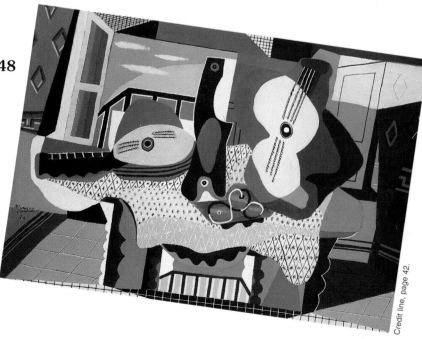

Credit line, page 42.

LISTING OF STUDIO LESSONS BY MEDIA/TECHNIQUE

Understanding Art

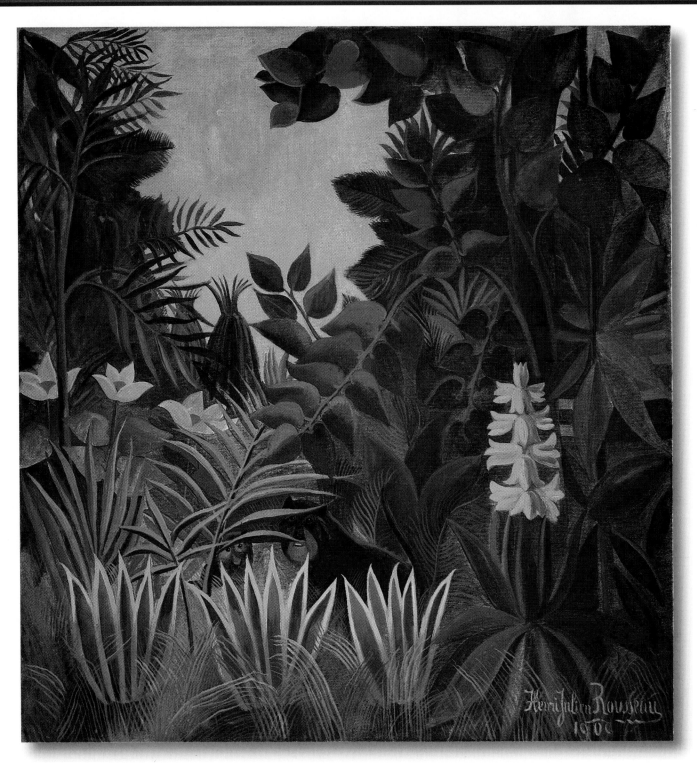

▲ Henri Rousseau has skillfully used the language of art to create a colorful, intriguing painting. Can you name the colors he used? Can you point to curved and straight lines? Does he use both large and small shapes?

Henri Rousseau. *The Equatorial Jungle.* 1909. Oil on canvas. 1.406 x 1.295 m (55¼ x 51″). The National Gallery of Art, Washington, D.C. Chester Dale Collection.

The Language of Art

To learn how a watch works, you might take it apart and study the pieces. While the parts are spread out before you, however, the watch cannot run. Only when the parts are in place will the familiar ticking tell you that the watch is working.

Like watches, works of art are made up of parts. When an artist skillfully puts the pieces of an art work together, it succeeds as art. You can see how the parts work together to make a unified whole. In this chapter you will learn about these parts and how they can be organized, as in the painting at the left, to make a pleasing whole.

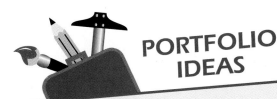

PORTFOLIO IDEAS

Keep your art work in a portfolio. A **portfolio** is *a carefully selected collection of art work kept by students and professional artists.* Make sure each entry includes:

- Your name and the date you completed the art work.
- A summary or self-reflection of the assignment.
- Any additional information requested by your teacher.

Throughout the book, watch for other "Portfolio Ideas." Professional artists do similar types of exercises for their own portfolios.

OBJECTIVES

After completing this chapter, you will be able to:
- Define and recognize the elements of art.
- Make an abstract design, experimenting with the elements of art.
- Identify the principles of art.
- Use the elements of art and principles of art in a studio experience.

WORDS YOU WILL LEARN

balance
color
emphasis
form
harmony
line
movement
non-objective art
proportion
rhythm
shape
space
texture
unity
variety

The Elements of Art

Art is a powerful language. Through it, artists communicate thoughts, ideas, and feelings. Like most languages, the language of art has its own special vocabulary. Unlike other vocabularies, however, the vocabulary of art is not made up of words. Rather, it is made up of visual elements. The visual elements include color, line, shape, form, space, and texture.

COLOR

Have you ever noticed it is harder to see colors when the light is dim? Color relies on light. In fact, **color** is *what the eyes see when light is reflected off an object*.

Color has three properties, or traits. These are:

- **Hue**. Hue is the name of a color, such as red, blue, or yellow. Hues are arranged in a circular format on a color wheel. Red, yellow, and blue are the primary hues. They are equally spaced on the color wheel. (See Figure 1–1.) Look at the picture in Figure 1–2. How many different hues, or colors, can you find in this work? Which ones can you name?
- **Value**. Value is the lightness or darkness of a hue. The value of a hue can be changed by adding white or black. Can you point out different values of any one color in the picture in Figure 1–2?

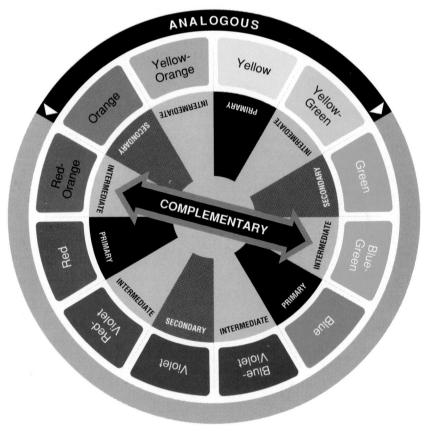

▶ **Figure 1–1 Color Wheel.**

- **Intensity**. Intensity is the brightness or dullness of a hue. Pure hues are high-intensity colors. Dull hues are low-intensity colors. Which objects in Figure 1–2 would you describe as high in intensity? Which would you describe as low in intensity?

Colors can be combined to produce many interesting and striking results. Artists make use of different types of color schemes to create different effects. Following are some of the color schemes that trained artists use:

- **Monochromatic** (mahn-uh-kroh-**mat**-ik) **color scheme**. This scheme uses different values of a single hue. For example, dark green, medium green, and light green make a monochromatic scheme.

- **Analogous** (uh-**nal**-uh-gus) **color scheme**. This scheme uses colors that are side by side on the color wheel and share a hue. Look at the color wheel in Figure 1–1. What colors share the hue red?

- **Warm or cool color scheme**. Warm color schemes — with red, yellow, and orange colors — remind us of the sun and warmth. Artists use blue, green, and violet — cool color schemes — to make us think of cool items such as ice or grass.

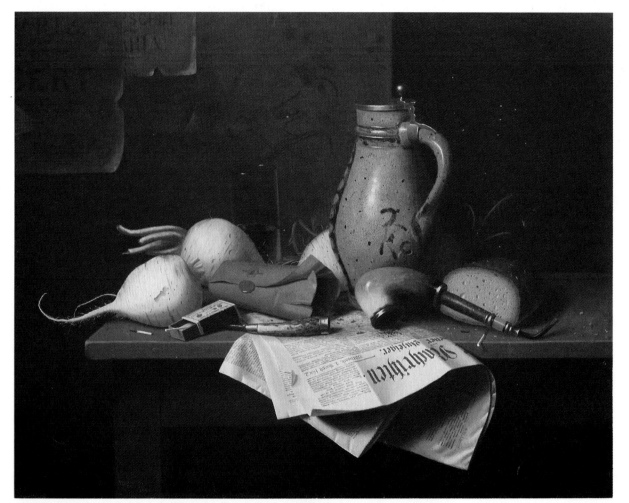

▲ **Figure 1–2** Can you point to places where the value changes are gradual? How do these gradual changes of value help to suggest round, three-dimensional form? Can you find places where the value changes are sudden?

William Michael Harnett. *Munich Still Life*. 1882. Oil on canvas. 62.5 x 76.8 cm (24⅝ x 30¼"). Dallas Museum of Art, Dallas, Texas.

LINE

An element of art that can be used to send different messages to viewers is a line. **Line** is defined as *the path of a moving point through space*. You can draw lines on paper or scratch a line in wet clay with a tool. Lines can be seen in your environment, such as the web of a spider or the railing on a stair.

There are five main kinds of lines:

- Horizontal lines, which run parallel to the ground, appear to be at rest.

- Vertical lines — lines that run up and down — seem to show dignity, formality, and strength.
- Diagonal, or slanting, lines signal action and excitement.
- Zigzag lines, which are made from combined diagonal lines, can create a feeling of confusion or suggest action.
- Curved lines express movement in a graceful, flowing way.

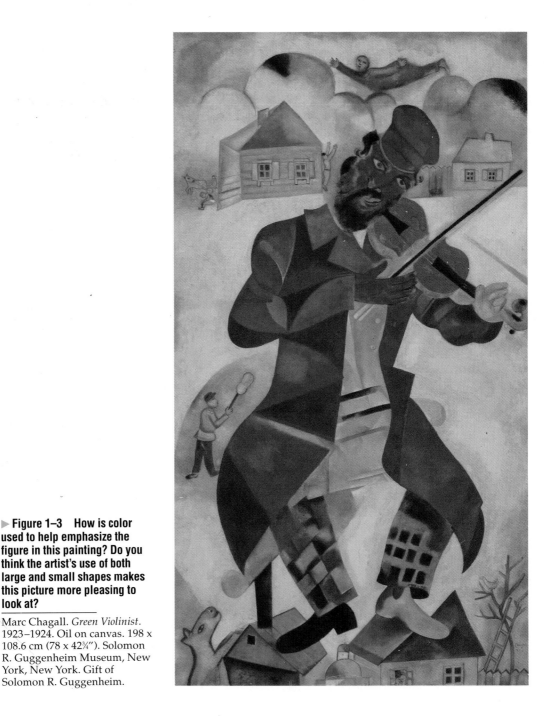

▶ **Figure 1–3** How is color used to help emphasize the figure in this painting? Do you think the artist's use of both large and small shapes makes this picture more pleasing to look at?

Marc Chagall. *Green Violinist.* 1923–1924. Oil on canvas. 198 x 108.6 cm (78 x 42¾"). Solomon R. Guggenheim Museum, New York, New York. Gift of Solomon R. Guggenheim.

Look again at Figure 1–2 on page **3**. How many different lines can you find? In what directions do these lines go?

In art, line quality and line variation influence the viewer's reaction to a work of art. Line quality is the unique character of the line. It can be affected by the tool or medium used to produce the mark or by the particular motion of the artist's hand. Line variation describes the thickness or thinness, lightness or darkness of a line.

SHAPE AND FORM

Every object—a cloud, a house, a pebble—has a shape. **Shape** is *an element of art that refers to an area clearly set off by one or more of the other elements of art*. Shapes are limited to two dimensions—length and width.

All shapes belong to one of two classes:

- **Geometric** (jee-uh-**meh**-trik). Geometric shapes look as though they were made with a ruler or drawing tool. The square, the circle, the triangle, the rectangle, and the oval are the five basic geometric shapes. Look at the painting in Figure 1–3. Can you find any geometric shapes?
- **Organic**. Also called free-form, organic shapes are not regular or even. Their outlines may be curved or angular, or they may be a combination of both, to make free-form shapes. Organic shapes, such as clouds and pebbles, are usually found in nature. Can you find any organic shapes in Figure 1–3?

Like shapes, forms have length and width. Forms also have a third dimension, depth. **Form** is *an element of art that refers to an object with three dimensions*. With the forms found in works of art, such as sculpture and architecture, you can actually experience the three dimensions by walking around or into the works.

SPACE

All objects take up space. **Space** is *an element of art that refers to the distance between, around, above, below, and within things*. Which objects in Figure 1–3 appear closest to you? Which seem to be farther back in space?

In both two- and three-dimensional works of art, the shapes or forms are called the positive area. The empty spaces between the shapes are called negative spaces. The relationship between the positive and negative space will affect how the art work is interpreted.

TEXTURE

Run your fingers over the top of your desk or work table. You are feeling the surface's texture. **Texture** is *an element of art that refers to the way things feel, or look as though they might feel, if touched*.

Imagine you could touch the objects in the picture in Figure 1–2 on page **3**. Which of them do you think would feel smooth? Do any look rough or uneven?

✔CHECK YOUR UNDERSTANDING

1. What are the three properties of color?
2. What message do vertical lines send to a viewer? What message do diagonal lines send?
3. What is the difference between shape and form?
4. What is the difference between the positive area and the negative area in a work of art?
5. Define *texture*.

Using the Elements of Art

Sometimes artists create **non-objective art**. These are *works in which no objects or subjects can be readily identified*. Figure 1–4 is such a work. This one is by Grace Hartigan. She has combined several elements of art in this work to create unusual effects.

WHAT YOU WILL LEARN

This is the first of many studio lessons. In these lessons you will use your creative skills and experiment with different media. You will create many works of art that may be displayed.

For this first studio experiment, you will create a non-objective design using all the elements of art. You will use pencil, felt-tip markers, colored pencils, and crayons. (See Figure 1–5.)

WHAT YOU WILL NEED

- Pencil and ruler
- Sheet of white drawing paper, 18 x 24 inches (46 x 61 cm)
- Colored markers, colored pencils, and crayons

WHAT YOU WILL DO

1. Using one continuous pencil line, make a design that fills the sheet of drawing paper. Allow your pencil to drift off the edge of the paper and return. Try to create a design that has both large and small shapes.
2. Using the ruler, divide your paper into eight equal rectangles. Each should measure 6 x 9 inches (15 x 23 cm). Number the eight boxed areas lightly in pencil. You may order the numbers any way you like (Figure 1–6).

▲ **Figure 1–4** Hartigan has painted a non-objective work that shows several elements of art combined to make a pleasing whole. What elements can you identify in this painting?

Grace Hartigan. *The Faraway Places*. 1974. Oil on canvas. 228.6 x 166.4 cm (90 x 65½"). McNay Art Museum, San Antonio, Texas. Purchase made possible by a grant from the National Endowment for the Arts with matching funds, Marion Koogler.

3. Using primary *hues* of crayons, color the shapes in Area 1. (See the color wheel on page **2**.)
4. Using light and dark *values* of colored pencils, color in the shapes in Area 2. Using bright and dull *intensities* of colored pencils, color in the shapes in Area 3.
5. Using the pencil, go over the *lines* in Area 4. Make some of the lines straight and others curved. Try pressing down on the pencil for some of the lines. This will give a thicker, darker result.

6. Using pencil, crayons, colored pencils, or markers, create three different *textures* in Area 5.

7. Using the markers, draw outlines around *shapes* in Area 6. Fill in some of the shapes with the markers. Leave the others white.

8. Use pencil to add a new shape that overlaps the existing shapes in Area 7 to show *space*. Add to this feeling of space by using colored pencil to color this shape in a bright hue. Color the other shapes in dull hues.

9. Using the pencil, shade the shapes in Area 8 little by little. Try to make these shapes look like rounded, three-dimensional *forms*. (For information on shading, see Technique Tip **6**, *Handbook* page **278**.)

10. Display your design. See if other members of your class can identify the different art elements found in each area.

▲ Figure 1–5 Student work. Non-objective design.

EXAMINING YOUR WORK

● **Describe** Tell which element each area of your design highlights. Identify the media you used to create the different areas.

● **Judge** State whether your design clearly highlights each element of art. Tell which section of your design you think is the most successful. Explain your answer.

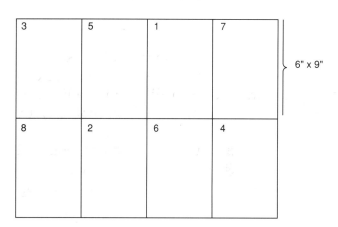

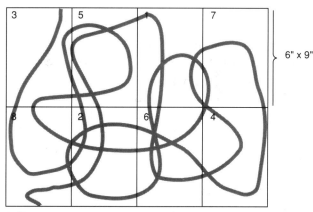

▲ Figure 1–6 Drawing the elements of art.

Try This! ## COMPUTER OPTION

▪ Use a medium Brush tool. Draw a continuous line that drifts off the edges of the screen and fills the page. Draw an open box around your line design, 8 x 10 inches (20 x 25 cm). Use the Grids and Rulers option to guide you. Select the Straight Line tool and hold down the Shift Key. Click and drag straight lines to divide the large box into eight small sections 2½ x 5 inches (6.4 x 12.7 cm). Follow directions in the Studio Lesson. Choose colors and Drawing tools on the computer to create texture and value.

The Principles of Art

If you want to use a language, knowing the vocabulary is not enough. You must also know how the words go together. You must know the rules of grammar for that language.

The same is true of art. Instead of rules of grammar, the language of art has art principles. These principles, or guidelines, govern how artists organize the visual elements to create a work of art.

The principles of art include balance, variety, harmony, emphasis, proportion, movement, and rhythm.

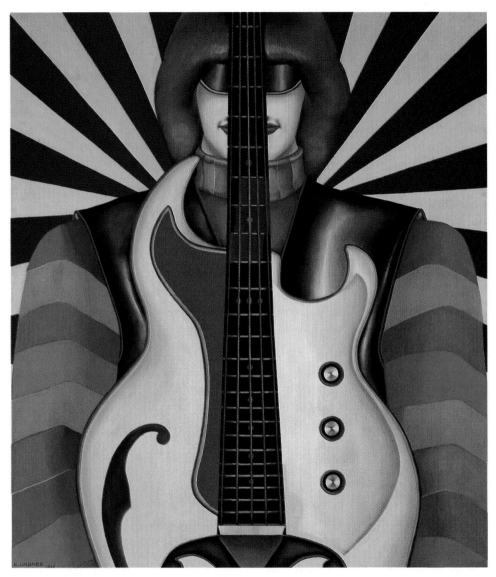

▶ **Figure 1–7 This picture combines familiar images from our modern rock culture. Do you think the artist has succeeded in organizing the elements of art to create a visually pleasing whole?**

Richard Lindner. *Rock-Rock.* 1966. Oil on canvas. 177.8 x 152.4 cm (70 x 60"). Dallas Museum of Art, Dallas, Texas. Gift of Mr. & Mrs. James H. Clark.

BALANCE

If you have ever carried a stack of dishes or books, you know the importance of balance. In art, balance is also important. **Balance** is *a principle of art concerned with arranging elements so no one part of a work overpowers, or seems heavier than, any other part*. In art, balance is seen or felt by the viewer.

In works of art, three kinds of balance are possible. They are formal balance, informal balance, and radial balance. In works of art with formal, or symmetrical (suh-**meh**-trih-kuhl), balance the two halves are mirror images. In works with informal, or asymmetrical (ay-suh-**meh**-trih-kuhl), balance two unlike elements seem to carry equal weight. For example, a small shape painted bright red will balance several larger items painted in duller reds.

Radial balance occurs when elements or objects in an art work are positioned around a central point. Study the art works in Figures 1–7, 1–8, and 1–9. Which uses formal balance? Which uses informal balance? Which uses radial balance?

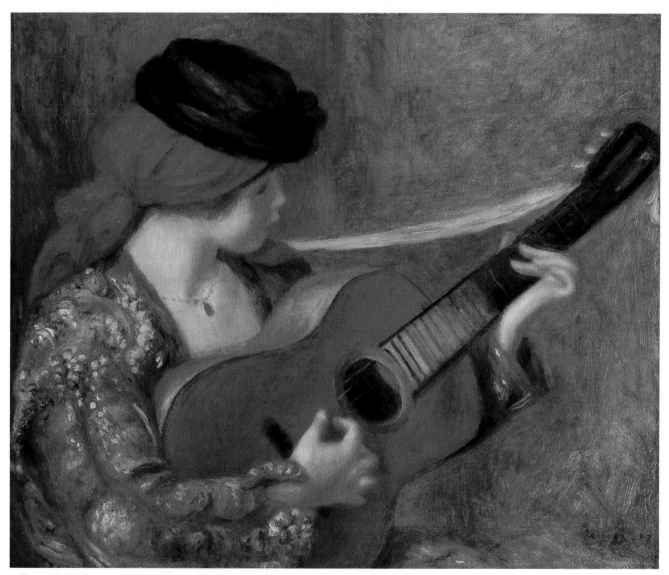

▲ Figure 1–8 Compare this painting with the one in Figure 1–7. How are they similar? Do the different elements in these paintings help suggest a certain kind of music? Would the mood of this painting change if the artist used the same colors as those in Figure 1–7?

Auguste Renoir. *Young Spanish Woman with a Guitar.* 1898. Canvas. 55.6 x 65.2 cm (21⅞ x 25⅝"). National Gallery of Art, Washington, D.C. Ailsa Mellon Bruce Collection.

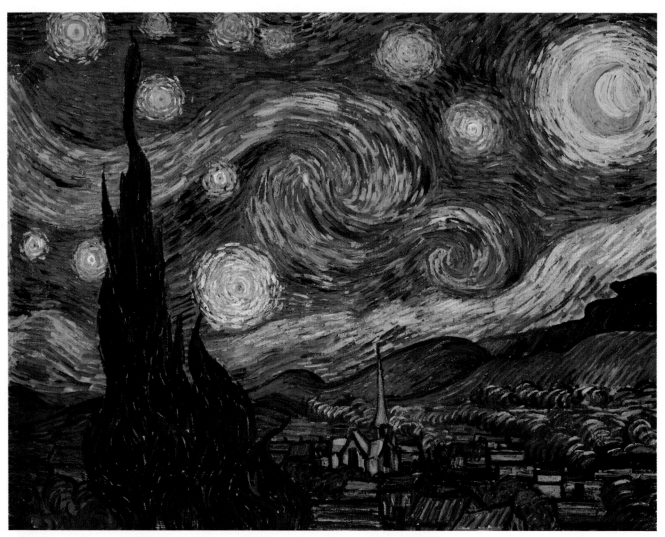

▲ **Figure 1–9** How many different art elements did Vincent van Gogh use in this painting? What has he done to create the illusion of movement? What images in this painting do not appear to move?

Vincent van Gogh. *The Starry Night.* 1889. Oil on canvas. 73.7 x 92.1 cm (29 x 36¼"). Collection, The Museum of Modern Art, New York, New York. Acquired through the Lillie P. Bliss bequest.

VARIETY

The same routine day after day can become dull. The same color or shape repeated over and over in an art work can become equally dull. To avoid dullness, artists use the principle of variety in their works. **Variety** is *a principle of art concerned with combining one or more elements to create interest by adding slight changes*. By giving a work variety, the artist heightens the visual appeal of the work.

Look again at the picture in Figure 1–7. How does the artist's use of color add variety to the work? Which other elements are used to add variety?

HARMONY

If too little variety can become boring, too much variety can create chaos. Artists avoid chaos in their works by using the principle of harmony. **Harmony** is *a principle of art concerned with blending elements to create a more calm, restful appearance*.

Of the two paintings in Figures 1–7 and 1–8, which has greater harmony? Which elements does the artist use to introduce harmony to the work?

EMPHASIS

To attract a viewer's attention to important parts of a work, artists use the principle of emphasis. **Emphasis** is *making an element in a work stand out.* Emphasis can be created by contrast or by extreme changes in an element.

Look once more at Figure 1–8. What has been done to emphasize the face of the young woman?

PROPORTION

Have you ever tasted a food that was so salty you couldn't eat it? The problem was one of proportion. **Proportion** is *the principle of art concerned with the relationship of one part to another and to the whole.*

The principle of proportion is not limited to size. Elements such as color can be used in differing proportions to create emphasis. It is used this way in Figure 1–7. Which color is used in greatest proportion?

MOVEMENT

You may not have realized it, but when you look at a work of art your eye moves from part to part. Artists use the principle of movement to lead the viewer's eyes throughout the work. **Movement** is *the principle of art used to create the look and feeling of action and to guide a viewer's eye throughout the work of art.*

Study yet again the paintings in Figures 1–7, 1–8, and 1–9. How have the artists used line and shape to move your eyes throughout the works?

RHYTHM

Often artists seek to make their works seem active. When they do, they call upon the principle of rhythm. **Rhythm** is *the principle of art concerned with repeating an element to make a work seem active or to suggest vibration.* Sometimes to create rhythm, an artist will repeat not just elements but also the same exact objects over and over. When this is done, a pattern is formed.

Compare the works in Figures 1–7, 1–8, and 1–9. Which uses the principle of rhythm? What element is repeated?

UNITY IN ART

When you look at works of art, it may be difficult to determine where one part ends and the other begins. Instead, the piece of art works together as a whole. It has unity. **Unity** is *the arrangement of elements and principles with media to create a feeling of completeness or wholeness.* You will sense this unity as you look at works of art in which artists use the elements and principles with skill, imagination, and sensitivity.

✔ CHECK YOUR UNDERSTANDING

1. What are principles of art?
2. Name three kinds of balance. Describe each kind.
3. What principles do artists use to prevent works from being static?
4. How can emphasis be created in a work of art?
5. Define *movement*.

Using the Principles of Art

Artists use the language of art in different and often highly imaginative ways. Figure 1–10 gives us painter Charles Demuth's (duh-**mooth**) view of a fire engine racing through a rain-swept city at night.

Notice that the artist has not attempted to create a true-to-life picture. There are no clear images of trucks, wet streets, or darkened buildings. Rather, Demuth has captured the *idea* of those images. Look closely and you can almost hear the screaming of Engine Company 5's siren. You can almost see the red truck's lights flashing.

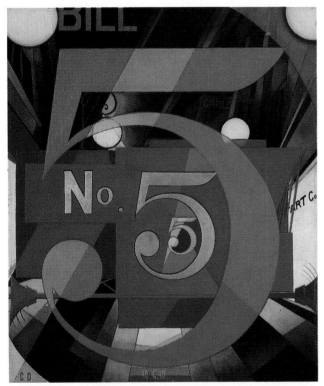

▲ **Figure 1–10** How is the principle of proportion demonstrated in this work? Explain how repetition is used to suggest movement and rhythm. Do you think this painting demonstrates unity?

Charles Henry Demuth. *I Saw the Figure 5 in Gold.* 1928. Oil on composition board. 91.4 x 75.6 cm (36 x 29¾"). The Metropolitan Museum of Art, New York, New York. The Alfred Stieglitz Collection.

WHAT YOU WILL LEARN

You will create the "idea of your name." You will do this through a design made up of the letters of your name or nickname. All the principles of art will be used in your design. You will use watercolor paint and tempera paint in your work. (See Figure 1–11.)

WHAT YOU WILL NEED

- Sheets of scrap paper
- Pencil, ruler, and eraser
- Sheet of white drawing paper, 18 x 24 inches (46 x 61 cm)
- Watercolor paint and several brushes
- Tempera paint and mixing tray

WHAT YOU WILL DO

1. On scrap paper, practice making block letters of different sizes and shapes. Focus only on the letters in your name or nickname.
2. Working lightly in pencil, create a design with the letters on the sheet of drawing paper. Arrange for some of the letters to overlap and some to go off the page. Fill the entire sheet of paper.
3. Using the ruler, divide your paper into eight equal rectangles. Each should measure 6 x 9 inches (15 x 23 cm). Number the eight boxed areas lightly in pencil in any order you like.
4. Using the pencil and eraser, draw in or erase lines to rearrange the shapes in Area 1 so they have formal *balance*. Fill in some of the shapes with pencil.
5. Using a *variety* of hues of tempera, paint the shapes in Area 2.
6. Using no more than three hues, paint the shapes in Area 3. Repeat one of these colors over and over to add *harmony*.

7. Identify the most interesting shape in Area 4. Using the brightest hue, paint this area to give *emphasis* to this shape. Paint other shapes with dull hues.

8. Using the pencil and eraser, rearrange the shapes in Area 5 to create *rhythm*. Use watercolors to paint the shapes.

9. Using watercolors, paint the shapes in Area 6. Increase the *proportion* of one of the colors you use. Notice how doing this *emphasizes* that color.

10. Using the pencil and eraser, rearrange the shapes in Area 7 to create a sense of *movement* in any direction. Use watercolors to paint the shapes. Pick colors that will add to the feeling of movement.

11. Rearrange similar shapes in Area 8 to create a pattern. Pick one color of tempera to paint the shapes in Area 8. Paint the nearest shapes. Paint the other shapes, adding white to lighten the value of the hue. (For information on mixing paint to change value, see Technique Tip **12**, *Handbook* page **280**.) In this way the shapes will appear to create rhythm.

12. Display your design and identify the different principles of art found in each area.

balance	variety	rhythm	proportion
emphasis	harmony	movement	unity

▲ Figure 1–11 Grid showing principles of art in Figure 1–12.

EXAMINING YOUR WORK

- **Describe** Tell where the different letters of your name or nickname are found in your design. Identify the art media you used to create the different areas.
- **Analyze** Name the principle of art highlighted in each area of your design.
- **Judge** Tell whether your design clearly highlights each principle of art. Tell which section of your design you think is the most successful. Explain your answer.

SAFETY TIP

Remember to check paints for safety labels. The labels *AP* (for Approved Product) and *CP* (for Certified Product) mean the paint does not contain harmful amounts of poisonous substances. An *HL* label (for Health Label), on the other hand, warns that the paint contains poisonous ingredients and is dangerous to use.

▲ Figure 1–12 Student work. Design using the principles of art.

Try This! **STUDIO OPTION**

■ On a sheet of white paper, create a second design. This work should be based on your initials. Focus on the part of your first design that you found most interesting. Complete your work using techniques from the Studio Lesson.

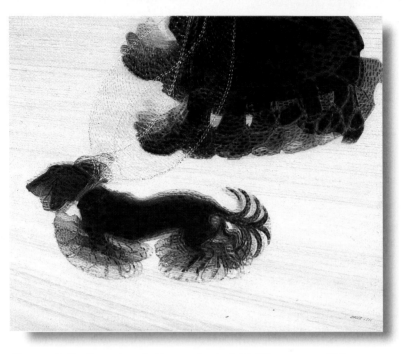

Giacomo Balla. *Dynamism of a Dog on a Leash.* 1912. Oil on canvas. 89.8 x 109.9 cm (35⅜ x 43¼"). Albright Knox Art Gallery, Buffalo, New York. Bequest of A. Conger Goodyear and Gift of George F. Goodyear. 1964.

How Does the Eye Perceive Movement?

Our eyes and brain work together to help us make sense of what we see. Human eyes provide an amazingly detailed, three-dimensional view of the world. How do the eyes accomplish this work?

Everything we see depends on rays of light. Light rays pass into the eye through the cornea. A thin layer of cells called the retina picks up these rays of light, detecting the image created by the light. Some of the light-sensitive cells of the retina detect shapes and shades of light but not color. Other cells are sensitive to details, colors, and movement.

The eye then sends a pattern of signals to the brain. The brain decodes the signals and makes sense of the shapes, colors, and movements transmitted through the rays of light. Thus it is the brain that really interprets colors, shape and form, and movement. Sometimes what we see can play tricks on the brain, as with Giacomo Balla's painting shown here. Balla tried to create the illusion of movement using brush strokes that imitate the process of animation. In this technique, a series of images is repeated quickly, one right after another. The eye and brain blend the images together to give the impression that the image is moving.

MAKING THE CONNECTION

✔ In Giacomo Balla's *Dynamism of a Dog on a Leash*, what technique has the artist used to imitate actual movement?

✔ Find some examples of multiple-exposure photographs. How is Balla's painting similar to the photographs?

✔ Find other examples of art that simulate, or imitate, movement. Explain the technique the artist has used and why you think the technique was or was not successful.

INTERNET ACTIVITY

Visit Glencoe's Fine Arts Web Site for students at:

http://www.glencoe.com/sec/art/students

BUILDING VOCABULARY

Number a sheet of paper from 1 to 15. After each number, write the term from the box that best matches each description below.

balance
color
emphasis
form
harmony
line
movement
non-objective art

proportion
rhythm
shape
space
texture
unity
variety

1. What the eyes see when light is reflected off an object.
2. Path of a moving point through space.
3. The way things feel, or look as though they might feel, if touched.
4. An area clearly set off by one or more of the other elements of art.
5. An object with three dimensions.
6. Arranging elements so no one part of a work overpowers, or seems heavier than, any other part.
7. Combining one or more elements to create interest by adding slight changes.
8. Blending elements to create a more calm, restful appearance.
9. Making an element in a work stand out.
10. The repeating of an element to make a work seem active or to suggest vibration.
11. The relationship of one part to another and to the whole.
12. The arrangement of elements and principles with media to create a feeling of completeness or wholeness.
13. The principle of art used to create the look and feeling of action and to guide a viewer's eye throughout the work.
14. Art works in which no objects or subjects can be readily identified.
15. The distance between, around, above, below, and within things.

REVIEWING ART FACTS

Number a sheet of paper from 16 to 20. Answer each question in a complete sentence.

16. What are the elements of art?
17. Which of the three properties of color refers to a color's name and place on a color wheel?
18. What are the two different kinds of shapes?
19. What is non-objective art?
20. What is symmetrical balance? What is asymmetrical balance?

THINKING ABOUT ART

On a sheet of paper, answer each question in a sentence or two.

1. **Extend.** What kind of lines would you use in creating a picture of an action-packed horse race? What kind of lines would you use in creating a calm, peaceful picture of a lake and trees? Explain your answers.
2. **Compare and contrast.** What do the elements of shape and form have in common? In what ways are the two different?

MAKING ART CONNECTIONS

1. **Science.** Make a list of the elements of art. Choose an object from nature that shows examples of these elements. Beside each art element listed, write a one- or two-word description of the natural object you chose.

2. **Language Arts.** Think about a career in art. Read a book with interviews of people working in the art field, *Careers for Artistic Types,* by Andrew Kaplan. Make a poster that shows some of the art careers you read about.

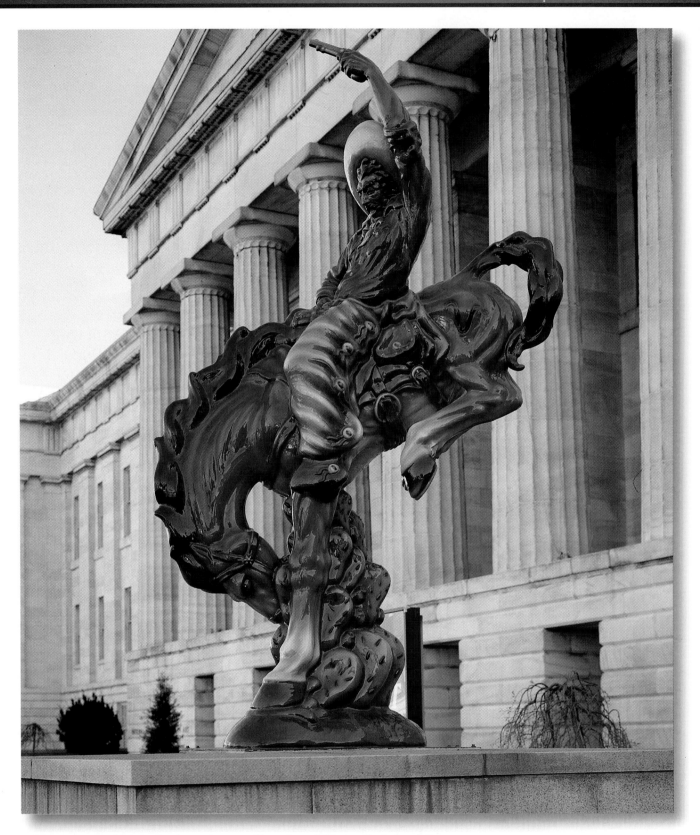

▲ **What art media did the artist choose to create this sculpture? What method of sculpting was used?**

Luis Jiménez. *Vaquero.* Modeled 1980/ cast 1990. Acrylic urethane, fiberglass, steel armature. 505.5 x 289.6 x 170.2 cm (199 x 114 x 67"). National Museum of American Art, Smithsonian Institution, Washington, D.C. Gift of Judith and Wilbur L. Ross, Jr., Anne and Ronald Abramson, Thelma and Melvin Lenkin. Art Resource, New York. ©1980 Luis Jiménez.

The Media of Art

You may think of an artist as someone who paints. While it is true that many artists are painters, paint is just one material artists use. Some artists prefer to work with the tools and materials of printmaking. Others prefer to work with the tools and materials of architecture. Still others would rather work with the tools used to create the sculpture at the left.

In this chapter you will learn about the many different materials of the artist's profession.

PORTFOLIO IDEAS

Often, you will begin an art work in a sketchbook. A **sketchbook** is *a pad of drawing paper on which artists sketch, write notes, and refine ideas for their work.* Think about a work of art you know and like. In your sketchbook describe the art work using the elements and principles of art.

What media was used to create it? What do you like about the art work? Date this entry. Refer to this written entry in the future and use it as a source of inspiration for one of your art works.

OBJECTIVES

After completing this chapter, you will be able to:
- Identify drawing, painting, and printmaking media.
- Discover the ways electronic media and computers can be used to create art works.
- Explain the basic methods of print-making and sculpting.
- Explain the basic uses of architecture and crafts.
- Create art work using different art media.

WORDS YOU WILL LEARN

architecture
binder
crafts
edition
freestanding sculpture
medium of art
mixed media
menus
pigment
pixels
printmaking
relief sculpture
solvent

Drawing, Painting, Printmaking, and Computer Art

One of the most important decisions for an artist is which medium to use. A **medium of art** is *a material used to create a work of art.* Paint is one medium. Pencil and crayon, which you have used, are two others. The computer has also become an important medium for artists. When we speak of more than one medium at a time, we use the plural *media.*

When artists use several different media, such as pen and ink and watercolor, they create a mixed media work of art. **Mixed media** means *the use of more than one medium in a work of art.*

In this lesson you will learn about the media used in drawing, painting, printmaking, and computer art.

DRAWING

Pen, pencil, charcoal, and chalk are some of the media used to draw. The picture in Figure 2–1 was made using another medium, pastels. This is a soft, chalky medium. Notice how delicately the artist has used this medium to capture her subject.

The Purpose of Drawing

Artists use drawing for different purposes. One is to create finished works of art. Another use is to help plan projects. Artists often make studies, or sketches, for their works. Look at the drawing in Figure 2–2. This was done by French artist Paul Cézanne (say-**zahn**) as a study for the painting in Figure 2–3.

PAINTING

Like other artists, painters use a wide variety of media. Before a painter begins a work, he or she chooses a type of paint and an appropriate surface on which to work. Canvas, paper, or fabric are three surface materials that painters use.

Regardless of the type of paint, all paint has three basic parts:

- **Pigment** (**pig**-muhnt) is *a finely ground, colored powder that gives every paint its color.*
- **Binder** is *a liquid that holds together the grains of pigment.* The binder is what makes the pigment stick to a surface.
- **Solvent** is *a material used to thin a paint's binder.* The thickness or thinness of a paint depends on the amount of solvent used.

▲ Figure 2–1 Works created with pastels sometimes seem like paintings. What does this work have in common with a painting? How is it different?

Mary Cassatt. *Sleepy Baby.* c. 1910. Pastel on paper. 64.7 x 52.0 cm (25½ x 20½"). Dallas Museum of Art, Dallas, Texas. Munger Fund.

▲ **Figure 2–2** **Cézanne used pencil and watercolors for his study of a card player. Did he use all the detail captured in this sketch for his painted version?**

Paul Cézanne. *The Card Player.* 1892. Pencil and watercolor. 53.4 x 36.4 cm (20¼ x 14⁹⁄₁₆"). Museum of Art, Rhode Island School of Design, Providence, Rhode Island. Gift of Mrs. Murray S. Danforth.

Turpentine is the solvent in oil paints. Water is the solvent in watercolors. Solvents are also used to clean brushes.

Painting Media

Every medium of painting has its own un-mistakable look. Some of the most commonly used media are the following:

- **Oil paint.** Oil paint takes its name from its binder, linseed oil. Turpentine is its solvent. Because oil paint dries slowly, the artist is able to blend colors right on the canvas. The painting in Figure 2–3 was done with oils.

- **Tempera** (**tem**-puh-ruh). Some of the earliest paintings on record were made with tempera. A mixture of pigment, egg yolk, and water, tempera is very hard to use. The school tempera you use is a different type. It is also called poster paint.

- **Watercolor.** Watercolor is named for its solvent. Its binder, gum arabic, is a gummy plant matter. Watercolor gives paintings a light, misty quality. In Figure 2–4, notice how the sun rays seem to "melt" into the sky and water.

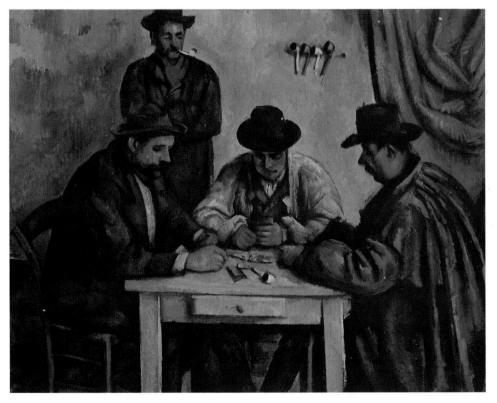

◀ **Figure 2–3** **Did the medium make a difference in how Cézanne painted the figures in his oil painting? Compare the man in the sketch with the one in the final version.**

Paul Cézanne. *The Card Players.* Oil on canvas. 65.4 x 81.9 cm (25¾ x 32¼"). The Metropolitan Museum of Art, New York, New York. Bequest of Stephen C. Clark.

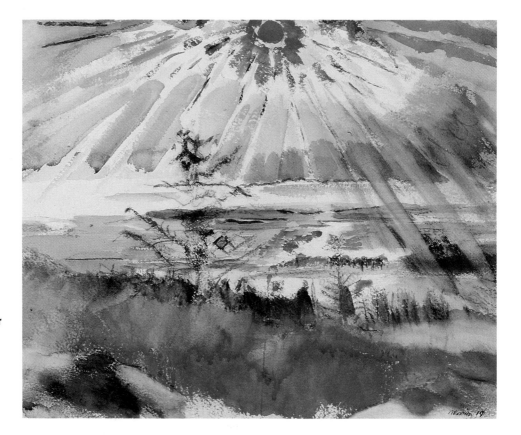

▶ **Figure 2–4** Study the painting on the right. Can you find spots in the picture where the artist seems to have used a lot of solvent? Do you remember what the solvent for watercolor is?

John Marin. *Sunset, Casco Bay.* 1936. Watercolor on paper. Wichita Art Museum, Wichita, Kansas. Ronald P. Murdock Collection.

- **Acrylic** (uh-**kril**-ik). A quick-drying water-based paint, acrylic is a very popular medium among painters today. Acrylics are synthetic, or manufactured, paints that were introduced in the 1950s. Because its solvent is water, acrylic is easy to use. It offers the artist a wide range of pure, bold colors. Notice the lively splashes of color in the work in Figure 2–5.

COMPUTER ART

Artists use the computer like any other medium to create images. Art work produced on the computer can look computer-made or it can imitate other media. Computer art is still judged by the same criteria as other fine art, by the ability to communicate an idea effectively.

Painting and Drawing Programs

Two types of art applications for a computer are Paint or Draw programs. Some programs combine the advantages of both.

- **Paint programs** simulate other creative art media such as watercolors, oils, or chalks.

Working in a Paint program is like sketching with a pencil or painting with a brush. With a Paint program you can create custom shapes and textures and edit *individual squares on the computer screen,* called **pixels.**

- **Draw programs** are based on mathematical formulas. Graphics and text are object-oriented. Working in a Draw program is similar to cutting out shapes and making a collage. You can use a Draw program to create smooth, crisp graphics and quickly select and move objects.

PRINTMAKING BASICS

Another form of art is called **printmaking.** This is *a technique in which an inked image from a prepared surface is transferred onto another surface,* such as paper or fabric.

There are three basic steps in printmaking. First, the printmaker creates a printing plate by altering a surface to create an image. Next, ink is applied to the plate. Finally, the printmaker transfers the ink to the paper or cloth by pressing the plate against the surface to be printed and then pulling the paper or cloth off the plate.

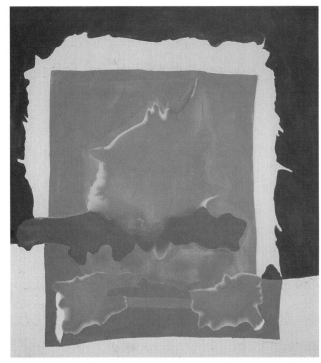

▲ **Figure 2–5** What is the name used to identify art works like this one? Since the artist was clearly not interested in painting realistic subjects, what was she interested in showing?

Helen Frankenthaler. *Interior Landscape.* 1964. Acrylic on canvas. 266.4 x 235.3 cm (104⅞ x 92⅝″). San Francisco Museum of Modern Art, San Francisco, California. Gift of The Women's Board.

These steps may be repeated many times for a given plate. *A series of identical prints made from a single plate* is called an **edition.**

Printmaking Methods

Printmakers may choose from one of four main methods to create a print.

- **Relief printing.** In relief printing, the image to be printed is raised from a background. A medium used often in relief printing is wood.
- **Intaglio** (in-**tal**-yoh). Intaglio may be thought of as the reverse of relief printing. In this method, the image to be printed is scratched or etched into a surface. (See Figure 2–6.) The plates for intaglio prints are often made of metal.
- **Lithography** (lith-**ahg**-ruh-fee). To make a lithograph, the artist draws the image to be printed on a limestone, zinc, or aluminum slab with a special greasy crayon. Lithography lets the artist blend, little by little, light and dark values of a hue.
- **Screen printing.** To make a screen print, the artist transfers the design through various processes on a silk screen. The areas not to be printed are blocked off so that a kind of stencil remains. Screen prints that are handmade by an artist are also known as serigraphs (**ser**-uh-grafs).

✔ CHECK YOUR UNDERSTANDING

1. Define *medium of art.*
2. Name three media used in drawing.
3. Name three media used in painting.
4. How is computer art judged?
5. Describe two printmaking methods.

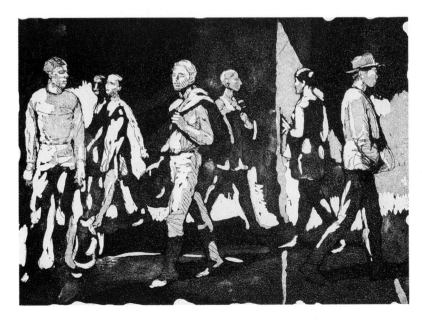

◀ **Figure 2–6** How are the figures emphasized in this intaglio print? Do all the figures seem to be moving? Explain how the principles of harmony and variety are demonstrated.

Isabel Bishop. *Men and Girls Walking.* 1969. Aquatint on paper. 21.3 x 29.2 cm (8⅜ x 11½″). National Museum of Women in the Arts, Washington, D.C. Gift of Mr. and Mrs. Edward P. Levy.

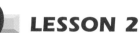 **LESSON 2**

Creating Mixed-Media Art

Study the mixed-media work of art in Figure 2–7. Notice how the artist has united visual and verbal symbols. The letters are woven into the design so that their shapes are as important as their meanings. They are not written in neat rows that are easy to read, but are integrated into the surface of the work.

Some of the visual symbols are directly related to the words, while other symbols just fit the design. Some visual symbols have been drawn and painted by the artist, or have been printed with rubber stamps. Others are made with decals, lace, and stamps. Notice that some of the letters are written and printed by the artist. Stick-on letters or those cut from magazines and glued on are also used.

WHAT YOU WILL LEARN

You will create a mixed-media design uniting visual and verbal symbols in the manner of Aubin. Weave the letters into the design so that their shapes are as important as their meanings. Use the principle of rhythm to create a sense of visual movement in the work. Use harmony of shape, color, and texture to unify your work.

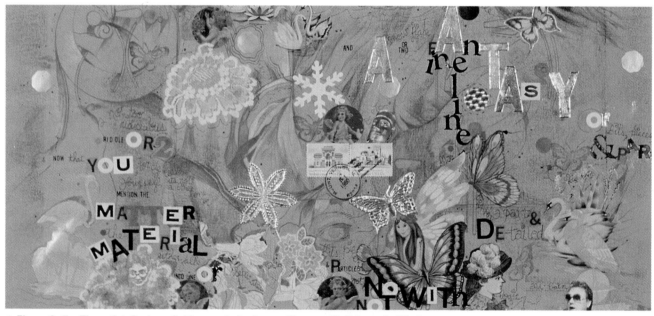

▲ **Figure 2–7** The artist, Barbara Aubin, created a dream-like mood in this work. What other sources of inspiration do artists use in getting ideas for their art?

Barbara Aubin. *I Dreamed I Saw a Pink Flamingo in the Salle de Bain.* 1981. Mixed media on paper. (Detail.) 45.7 x 61 cm (18 x 24").

WHAT YOU WILL NEED

- Pencil and sketch paper
- Found materials
- Magazines, scissors, and white glue
- Envelope
- Construction paper or lightweight poster board, 12 x 18 inches (30 x 46 cm), in a color of your choice
- Watercolor markers, thick and thin-tipped
- Crayons, colored pencils, and watercolor paints

WHAT YOU WILL DO

1. Select some lines from a favorite poem, song, story, or saying. The words may be your own or something you have read. Write the words on your sketch paper.
2. Make sketches of objects and scenes to go with your words.
3. Look through magazines and cut out interesting shapes, letters, or printed words for your work. Collect found materials that fit your ideas. Keep all the small cutouts in an envelope. Select a color for your background.
4. Notice how Aubin has used the letters as design elements. They are not written in neat rows that are easy to read, but are woven into the composition as shapes. Make some rough sketches to plan your design on your sketch paper. Repeat shapes to create movement that makes the viewer's eyes move through the work. Plan for harmony by using monochromatic or analogous colors as well as related shapes and textures. Select your best idea, and sketch it lightly on your construction paper or poster board.

EXAMINING YOUR WORK

- **Describe** Identify the media you used. Read the phrase you chose, and explain why you chose it. Describe the visual images you chose to go with the words.
- **Analyze** What shapes did you repeat to create rhythmic movement? How did you use color, shape, and texture to create harmony?
- **Judge** Did you create a unified design? Are the verbal symbols and visual images equally important? If not, how could the unity of the work be improved?

5. Place the found objects and cutouts on your design. Do not glue them down. Take time to arrange and rearrange your words and images until you are satisfied. Then glue them down.
6. Use a variety of media to draw and paint the remaining images and words. For example, use paints to fill large spaces, and use fine-line markers to draw thin lines.
7. Place your work on display with that of your classmates. Look for works in which the words and pictures are unified.

Try This! COMPUTER OPTION

■ Choose the Text tool and large Font to write favorite words or phrases. Use Selection tool or Transformation tools to move and Flip or Rotate letters. Use clip art files or scanned images to make a collage. Follow the Studio Lesson directions to organize the elements. Save and title your work.

Sculpture, Architecture, and Crafts Media

Drawings, paintings, and prints created as two-dimensional works often appear to have roundness and depth. Some works of art have *real* roundness and depth. These works, which have height, width, and depth, are known as three-dimensional works.

In this lesson you will learn about three areas of art—sculpture, architecture, and crafts—in which three-dimensional works are created. You will learn about the media used in making such works.

SCULPTURE

Sculpture is art that is made to stand out in space. All sculpture is of one of two types, freestanding or relief. Also called sculpture "in the round," **freestanding sculpture** is *sculpture surrounded on all sides by space*. It is meant to be seen from all sides. The work in Figure 2–8 is an example of freestanding sculpture.

Relief sculpture, on the other hand, is *sculpture only partly enclosed by space*. It is flat along the back and is meant to be viewed only from the front. The work in Figure 2–9 is an example of relief sculpture.

Sculpting Methods

Sculptors use four basic methods or techniques in their work. These are:

- **Carving**. Carving is cutting or chipping a shape from a mass. Often stone and other hard materials are used in carving. The sculpture in Figure 2–8 was carved from a block of marble.

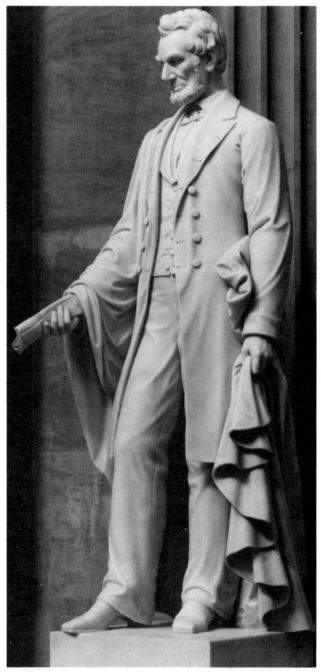

▲ **Figure 2–8** Do you think a work like this is meant to be viewed from a fixed position or from all sides? When talking about this work, would you refer to its shape or its form?

Vinnie Ream Hoxie. *Abraham Lincoln*. 1870. Marble. 210.8 cm (6'11") high. United States Capitol Art Collection.

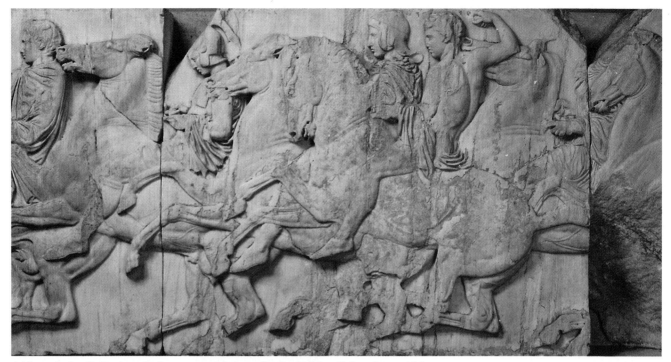

▲ **Figure 2–9** Notice how the horses seem to be galloping in this relief sculpture. This frieze circles the top of a famous Greek temple known as the Parthenon.

Horsemen Riding at a Gallop. Parthenon. British Museum.

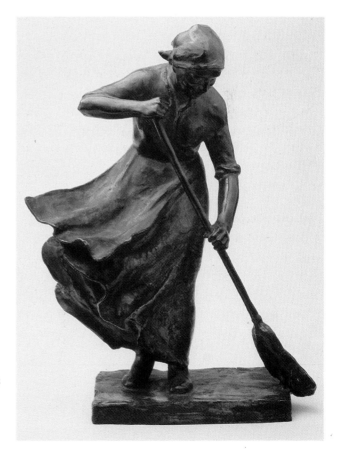

● **Casting.** In casting, a melted-down metal or other liquid substance is poured into a mold to harden. Bronze is a material often used in casting. (See Figure 2–10.)

● **Modeling.** In modeling, a soft or workable material is built up and shaped. Clay is the material used most often in this sculpting method.

● **Assembling.** Assembling is gathering and joining different kinds of materials. Wood, wire, glue, and nails are a few of the materials used in assembling. The sculpture in Figure 17–14 on page **267** is an example of assembling.

▶ **Figure 2–10** How did the sculptor show movement in this figure? Would you have needed the title to tell you the wind was blowing?

Abastenia St. Leger Eberle. *The Windy Doorstep.* 1910. Bronze. 34.5 x 24.4 x 16 cm (13⅝ x 9⅝ x 6⅜"). Worcester Art Museum, Worcester, Massachusetts.

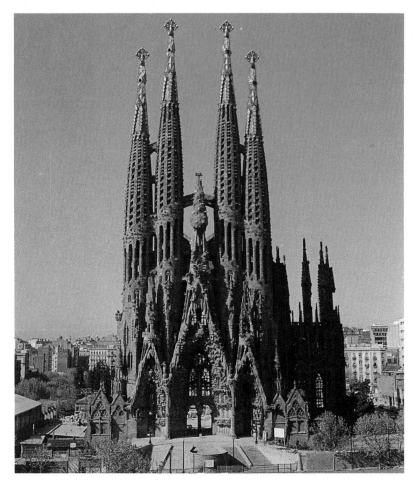

▶ **Figure 2–11** This is a unique example of architecture. Notice how the architect repeated the pointed arch shape in the towers, emphasizing the height of the structure.

Antonio Gaudi. *Church of the Sacred Family.* Barcelona, Spain.

ARCHITECTURE

All art is made to be seen. Some art is made to be used as well as seen. Works of art known as architecture fit into this second category. **Architecture** is *the planning and creating of buildings.* The success of a work of architecture is measured partly by how well it does the job it was meant to do and partly by its appearance.

The Uses of Architecture

Since earliest times, a chief form of architecture has been the creation of dwelling places. This has by no means been the only type, however. Two other examples have been the artistic creation of the following kinds of buildings:

- **Structures for prayer.** The building of temples, churches, and other houses of worship dates to the dawn of history. The unusual house of prayer shown in Figure

2–11 was begun in the late 1800s. It is still under construction. Notice how this unique building seems almost to be reaching toward the sky.
- **Structures for business.** With the spread of civilization in ancient times came the need for places to carry on business. In our own time that need is often met by vertical creations such as skyscrapers.

CRAFTS

In ages past, artists worked not only out of a desire to create but also out of a need to provide items required for everyday use. Clothing, cooking pots, and whatever other goods people needed were handmade.

Artistic craftspeople still make functional items that are often considered aesthetically pleasing works of art. The useful and decorative goods these artists make, and *the different areas of applied art in which craftspeople work* are called **crafts**.

Craft Areas

Craftspeople today, like those long ago, work in a number of special areas. Some of these are:

- **Pottery**. This is the making of objects from clay. Before objects of pottery can be used, they must be hardened by heat, or fired. This takes place in a special oven called a kiln. Ceramics is the name of objects made in this fashion. The vase shown in Figure 2–12 is an example of modern American ceramics.
- **Weaving**. This is the interlocking of fiber strands to create objects. Fibers such as wool, cotton, plant materials, and synthetic materials are used in weaving. Weaving is done on a special machine called a loom, which holds the threads in place as they are woven together. The weaving in Figure 2–13 was done by twentieth-century Spanish artist Joan Miró (zhoh-**ahn** mee-**roh**).
- **Glassblowing**. This is the shaping of melted glass into objects. Glassblowers work by forcing air through a tube into globs of melted glass.

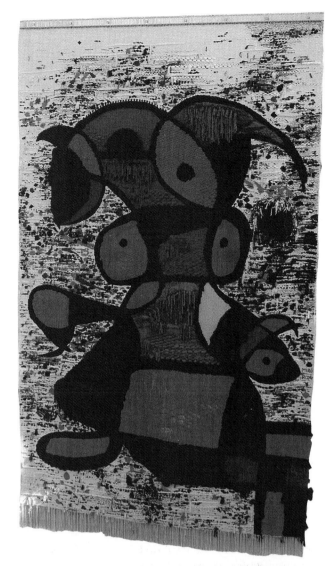

▲ **Figure 2–13** This weaving shows large areas of color against a textured background. Can you see a woman in the tapestry?

Joan Miró, Josep Royo. *Woman*. 1977. Dyed New Zealand Wool. 105.3 x 604.3 cm (415 x 238″). National Gallery of Art, Washington, D.C. Gift of the Collectors Committee and George L. Erion.

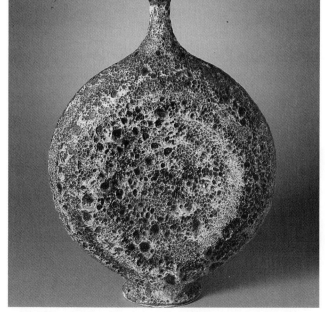

▲ **Figure 2–12** The Natzlers are famous for their glazes. They called this a crater glaze.

Gertrud Natzler/Otto Natzler. *Pilgrim Bottle*. c. 1956. Earthenware. 43 x 33 cm (17x 13″). Los Angeles County Museum of Art, Los Angeles, California. Gift of Howard and Gwen Laurie Smits.

✔CHECK YOUR UNDERSTANDING

1. What are the two main types of sculpture?
2. What are the four basic sculpting methods?
3. Define *architecture*. How is the success of a work of architecture measured?
4. Define *crafts*. Name three areas in which craftspeople work.

Computer Landscape Drawing

The computer is a new medium or art tool for students and artists. While not intended to replace paint, pens, chalk, pastels, or other drawing and painting media, computer software makes ordinary drawing tasks easier. Artists use tools and **menus,** *drop-down boxes on the computer screen that list selections available in the software program.* The artist can then manipulate lines, shapes, and forms as well as add colors and textures. The artist still makes all the choices and decisions.

Your classroom computer may have either a Paint or Draw program for you to work with. You will use a mouse or a stylus or drawing pen to create your drawing. The best way to learn how to manipulate the computer tools is to experiment with them. In this lesson you will be able to work with several of the tools available on your computer.

WHAT YOU WILL LEARN

Working individually or with a partner, you will explore the computer's tools and menus to discover the many effects and texture combinations available. Using the tools you like best, you will create a landscape. You will determine landforms and objects you want to include such as mountains, plants, people, or animals. The scene can be a real or imaginary subject. You will select colors, textures, and special effects that emphasize the mood of the landscape.

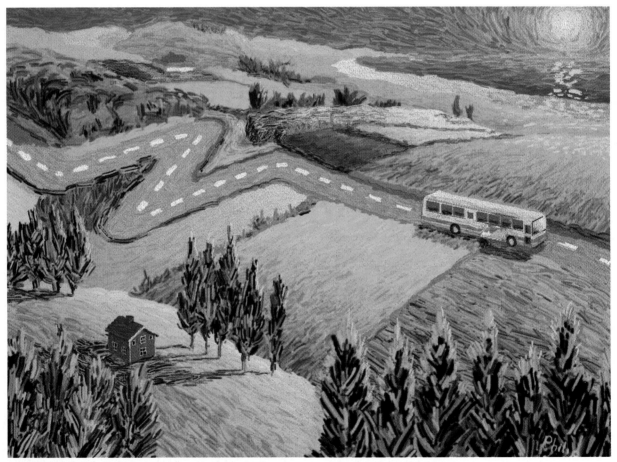

▲ **Figure 2–14 Notice how the artist included the elements of line, color, and texture in his work by using computer software tools.**

Philip Nicholson. *Landscape.* Philip Nicholson Illustrations AB. Träslövsläge, Sweden.

WHAT YOU WILL NEED

- Computer with an art application
- Mouse or graphics tablet with a stylus or drawing pen
- Floppy disk to save your work
- Color printer to make a hard copy of your work

WHAT YOU WILL DO

1. Begin by exploring the Brush tools: chalk, pastels, pens, spray paint, and so on. Change the Brush sizes, shapes, and types, as well as colors and textures, to discover effects made by different combinations. Try drawing or painting on rough or smooth paper textures, if available. Change the opacity of the paint: make some hues transparent. Record combinations that you like so you can remember them later.
2. Use the Pencil or Brush tools to sketch a landscape. Draw important objects, plants, or animals, and the background with the Shape or Brush tools. Add colors and textures directly with the Brush tool or use the Bucket tool to Flood-fill spaces.
3. Title and save your work. This will enable you to return to this point and begin again to try other tools, menus, and solutions.
4. Continue to save the work by using the "Save As" command, retitling and saving often as you work. If the original title is "Landscape," subsequent saved files can be numbered: "Landscape 1," "Landscape 2," "Landscape 3," and so on. Not only does this allow you to redo the landscape from any saved point, it also records the history of its production.
5. Save, print, and display your final landscape.

EXAMINING YOUR WORK

- **Describe** Describe the hues, objects, and textures in your landscape. Explain how to title and save your work to a file or disk.
- **Analyze** Identify the colors and textures and the tools or menus used to create these effects. Explain how your work is organized and the sequence you followed—which part was drawn first, last, and so on.
- **Interpret** Tell what is happening in the landscape. Does the scene remind you of a time, event, or place you know? What mood or feeling is created by the objects, colors, and textures? What title did you choose?
- **Judge** Did you explore the computer's tools and menus to discover colors and textures to make an interesting landscape? What worked best? What would you change?

▲ Figure 2–15 Student work. Computer landscape.

 Try This! ## STUDIO OPTION

■ If you don't have a computer, combine a variety of art materials to create a landscape. Choose from oil pastels, crayons, colored pencils, chalks, pens, watercolors, and tempera. Explore textures with soft and hard brushes, thick and thin, wet and dry brush, spattering and layering colors. Work directly on one sheet of paper, combining several media. Make several texture papers. Cut and arrange shapes to make a landscape collage.

How is 3-D Computer Art Created?

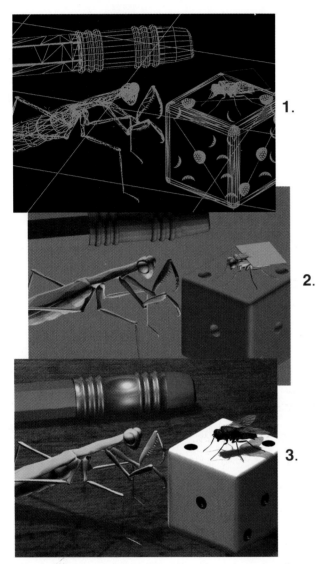

1.

2.

3.

Edward Harvey. *Mantis and Fly.* 1996. Three-dimensional ray-traced image.

Scientists understand how light travels. It originates from a source such as the sun or a light bulb and bounces off objects. It is the light that is bounced off of objects that allows us to see them as three-dimensional (3-D) objects. Formulas for how light bounces off different types of objects are used by scientists when designing mirrors and lenses (for example, those used in microscopes).

With the invention of modern computers and software, a tool became available to create images of objects that look three-dimensional. Recreating an image requires tracing many rays of light from their source to their destinations. This process is known as *ray tracing.* Only a computer can make the millions of calculations necessary to trace the path of all the rays of light in a scene.

Today low-cost desktop computers are powerful enough to do ray tracing. Many artists have begun to use these formulas in their art work. First, they use 3-D graphics design software to create "wire frames" of objects (see Step 1). Next, they create "skins" for the wire frames, identifying textures and the reflective qualities of the covering material (see Step 2). Then they set up the lights that they will use in the scene. Finally, they "render" the picture by directing the computer to compute the ray tracing. This provides a final picture that is photo-realistic (see Step 3).

MAKING THE CONNECTION

- What does ray tracing mean and how does it help us see objects as three-dimensional?
- Look at the illustration and use it to explain the steps involved in rendering three-dimensional images.
- There are other types of animation used by artists, such as cell frame animation (painting one frame at a time), or clay animation. Find out more about these techniques and how they are used.

INTERNET ACTIVITY

Visit Glencoe's Fine Arts Web Site for students at:

http://www.glencoe.com/sec/art/students

BUILDING VOCABULARY

Number a sheet of paper from 1 to 13. After each number, write the term from the list that best matches each description below.

architecture mixed media
binder menus
crafts pigment
edition pixels
freestanding printmaking
 sculpture relief sculpture
medium of art solvent

1. A material used to create a work of art.
2. A finely ground powder that gives every paint its color.
3. A liquid that holds together the grains of pigment in paint.
4. A material used to thin a paint's binder.
5. Drop-down boxes that list selections available in the software program.
6. A technique in which an inked image from a prepared surface is transferred onto another surface.
7. A series of identical prints made from a single plate.
8. Sculpture surrounded on all sides by space.
9. Sculpture partly enclosed by space.
10. The planning and creating of buildings.
11. The different areas of applied art in which craftspeople work.
12. The use of more than one medium in a work of art.
13. Individual squares on the computer screen.

REVIEWING ART FACTS

Number a sheet of paper from 14 to 20. Answer each question in a complete sentence.

14. What are the two main ways in which artists use drawing?
15. Working with computer Paint programs is similar to sketching with what familiar media?
16. Describe the steps in printmaking.
17. What is a lithograph? What is a serigraph? What is a woodcut?
18. What is "in the round" a substitute term for?
19. In what method of sculpting is a melted-down metal poured into a mold?
20. What are three types of architecture?

THINKING ABOUT ART

On a sheet of paper, answer each question in a sentence or two.

1. **Compare and contrast.** Some paints, as you learned, dry slowly and others dry quickly. What would be some of the advantages and disadvantages of each type?
2. **Extend.** In attempting to define *art* over the centuries, scholars have often noted that an art work is a one-of-a-kind creation. Does accepting this view rule out prints or computer drawings as forms of art? Explain your answer.
3. **Analyze.** Which of the methods of sculpting you learned about would be best for making a sand castle? Explain your choice.

MAKING ART CONNECTIONS

1. **Social Studies.** Many people today create crafts as a leisure activity. Try to find an individual you know who is interested in a craft. Interview him or her and make a report for your class. Tell how the craft affects the life of the person you interviewed.

2. **Science.** Find out how the study of anatomy contributes to the work of a sculptor. Compare an anatomical drawing from a science book to a freestanding sculpture of the same subject. What similarities and differences do you see?

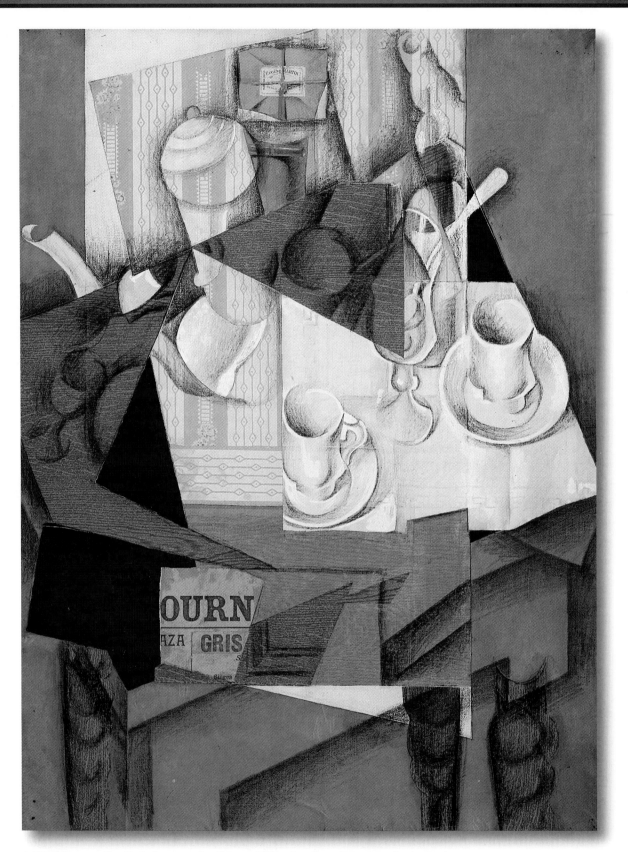

▲ What do you notice first when you view this work? How has the artist emphasized color in his work? How many different kinds of line do you see?

Juan Gris. *Breakfast*. 1914. Cut and pasted paper, crayon, and oil over canvas. 80.9 x 59.7 cm (31⅞ x 23½"). The Museum of Modern Art, New York, New York. Acquired through the Lillie P. Bliss Bequest.

Art Criticism, Aesthetics, and Art History

Imagine you were visiting the museum where the painting on the left is hung. What questions might you ask as you look at the painting? You might ask:

- With what media and how was the painting made?
- What elements and principles of art are used?
- How does the painting make me feel?
- Who is the artist, and when and where was the art work made?

What other questions might you ask? In this chapter you will learn how to find your own answers to the questions about works of art.

PORTFOLIO IDEAS

Find an art work in your book that catches your eye, that interests you. What do you see? What is the subject matter? How does the art work make you feel? What was it that caught your eye in the first place? Who created the art work? When was it created? After you have answered these questions, answer this one. Do you think this is a successful work of art? Explain why. Date your written responses and put them in your portfolio.

OBJECTIVES

After completing this chapter, you will be able to:
- Describe the four steps used in art criticism.
- Identify three aesthetic views.
- Explain the four steps used by art historians.
- Create paintings based on art criticism and art history.

WORDS YOU WILL LEARN

aesthetic view
art criticism
art history
composition
content
style
subject

Art Criticism and Aesthetics

You have heard the saying "Don't judge a book by its cover." What this saying means is that to judge something fairly, you need to have all the facts. It is not enough to look at the surface of the object. You need to dig beneath the surface — to understand as much as you can about the object.

In this lesson you will learn ways of looking at art that will help increase your understanding and appreciation of it.

ART CRITICISM

Have you ever looked at a work of art and wondered if there was more to the painting than you understood? You may have asked yourself this question when you looked at Figure 3–1. Works of art are sometimes like mysteries. Solving art mysteries is one of the jobs of people in the field called art criticism. **Art criticism** is *studying, understanding, and judging works of art*.

In carrying out their work, art critics often use a four-step system. The four steps are describing, analyzing, interpreting, and judging.

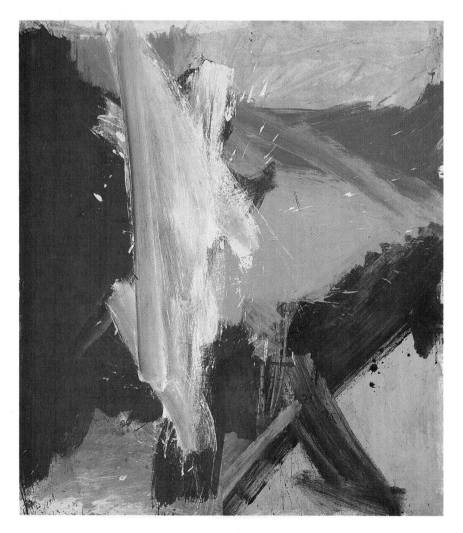

▶ **Figure 3–1** In describing this art work, what element would you choose to discuss first? What do you think the artist was most interested in as he created this oil painting?

Willem de Kooning. *Merritt Parkway*. 1959. Oil on canvas. 203.2 x 179.1 cm (80 x 70½"). The Detroit Institute of Arts, Detroit, Michigan.

Describing an Art Work

In describing an art work, the critic notes certain key facts. These include the following:

- **The size of the work, the medium, and the process used.** The credit line gives the viewer information about the size of the work and the medium used. It also lists the process, such as serigraph or woodcut.
- **The subject, object, and details.** The **subject** is *the image viewers can easily identify in an art work*. The subject answers the question "What do I see when I look at this work?" The subject in Figure 3–2 is a group of people, probably a family, at a holiday gathering. What other objects and details might the art critic mention? What subject, object, and details would be described in Figure 3–3 on page **36**?

- **The elements used in the work.** Look again at Figure 3–2. Line and color are two of the elements of art that play an important part in this work. Can you identify the other art elements? What elements can you point out in Figure 3–3?

Notice that while every work of art uses elements, not all have subjects. Figure 3–1 is a painting without a recognized subject. Because such works are not "about" something, some viewers are uncertain how to describe them. These viewers should learn to focus attention on the elements of art. This is what the critic—or anyone else—will see in this work. This is called describing the formal aspects of the work.

◄ **Figure 3–2 Notice the title of the work. What American holiday is similar to the one being celebrated in this picture? What do you think the man at the right is pointing to?**

Jan Steen. *Eve of St. Nicholas.* c. 1667. Canvas. 81.9 x 70.5 cm (32¼ x 27¾"). Rijksmuseum, Amsterdam.

▲ **Figure 3–3** Is this work successful because it looks lifelike or because it expresses an idea or mood? Why is it necessary to use more than one aesthetic view when judging works of art?

Beatrice Whitney van Ness. *Summer Sunlight.* c. 1936. Oil on canvas. 99.1 x 124.5 cm (39 x 49"). National Museum of Women in the Arts, Washington, D.C. Gift of Wallace and Wilhelmina Holladay.

Analyzing an Art Work

In analyzing an art work, the critic focuses on the work's composition. **Composition** is *the way the art principles are used to organize the art elements of color, line, shape, form, space, and texture.* Look once again at the painting in Figure 3–2 on page **35.** Find the long loaf of bread in the lower left and the chair in the lower right. Notice how the diagonal lines of these and other objects lead your eye to the center of the picture. There you find a small child grinning and looking out at you. The child is one of the most important figures in the work. How are the elements organized in the painting in Figure 3–3?

Interpreting an Art Work

In interpreting an art work, the critic focuses on the work's **content**. This is *the message, idea, or feeling expressed by an art work.* Each art critic may interpret an art work differently, according to individual feelings. Your interpretation of an art work will be based on your personal opinions and experiences.

Look once more at Figure 3–2. Notice that the grinning child is pointing at another child, who is crying. It appears that this second boy has received no presents. His smiling sister holds his wooden shoe in which his gifts were to be placed. But the shoe holds

only a hickory stick instead of presents. Maybe the artist's message to children of all ages is that gifts come only to those who behave. What mood or feeling does the painting in Figure 3–3 communicate to you?

Judging an Art Work

In judging an art work, the critic tells whether the work succeeds. He or she answers the question "Is this a successful work of art?"

How, exactly, the critic answers this question depends on his or her particular aesthetic (ess-**thet**-ik) view. An **aesthetic view** is *an idea, or school of thought, on what is important in a work of art*. Such views help critics better understand and explain the meaning of art to others.

AESTHETICS AND ART

Through the ages, scholars have put forth many different aesthetic views. The following are three common ones:

- **The subject view.** In this aesthetic view, a successful work of art is one with a lifelike subject. Look yet again at the picture in Figure 3–2. The members of the family are painted to look like real people. Critics holding this aesthetic view would praise this work for being true to life. How do you think these same critics would react to the painting in Figure 3–3? How would they judge the painting in Figure 3–1?
- **The composition view.** In this view, what is most important in an art work is its composition. Notice how light and dark

values of hue in Figure 3–2 create a feeling of depth. Critics taking this view would praise the artist's use of the elements and principles of art to create a visually pleasing design. How do you suppose these same critics would respond to the work in Figure 3–3? How might they react to the picture in Figure 3–1?
- **The content view.** In this view, what counts most is the content, or the mood or feeling, an art work communicates. Critics supporting this view would praise the work in Figure 3–2 for the joyous holiday mood it captures. What do you imagine these critics would have to say about the painting in Figure 3–3? What might their response be to the painting in Figure 3–1?

Keep in mind that few critics limit themselves to a single aesthetic view. Most feel that learning as much as possible from an art work requires keeping an open mind. How might a critic accepting all three views above react to the painting that opened this chapter on page **32**?

✔CHECK YOUR UNDERSTANDING

1. What is art criticism? Name the four steps used by art critics.
2. What are subject, composition, and content?
3. What is an aesthetic view?
4. Describe the three commonly held aesthetic views detailed in this lesson.

Painting an Expressive Scene

Study the painting in Figure 3–4. The work is by American painter Edward Hopper. How do you think an art critic would react to this painting? What is the work's subject? What elements are emphasized? What principles are used to organize the elements? What mood or feeling does the work express? Does the work succeed? Why, or why not? One last question: How do you think the painting would look if the artist had extended its left boundary?

WHAT YOU WILL LEARN

You will create a painting that continues the row of empty shops in Figure 3–4. You will use the same hues, values, and intensities in your work. You will create harmony by repeating the same vertical and horizontal lines. You will add variety by placing a circular shape somewhere in your work. Finally, you will try to capture the same feeling of loneliness. (See Figure 3–5.)

WHAT YOU WILL NEED

- Pencil, sketch paper, and eraser
- Sheet of white drawing paper, 8 x 13 inches (20 x 33 cm)
- Tempera paint and several brushes
- Mixing tray

WHAT YOU WILL DO

1. Imagine the scene in Figure 3–4 as it might appear if the artist had continued it on the left side. Make several pencil sketches of possibilities you imagine. Use horizontal and vertical lines like the ones in the painting to outline shapes. For variety, include somewhere in each sketch an object with a circular shape. (Did you discover the circular shape in Hopper's painting when you examined its elements?) Let your imagination guide you.

▶ **Figure 3–4** Do you think the mood of this painting would have been different if the artist had added people? Can you find the circular shape? How does this shape add variety to the work? What has the artist done to give the painting harmony?

Edward Hopper. *Early Sunday Morning.* 1930. Oil on canvas. 88.9 x 152.4 cm (35 x 60"). Whitney Museum of American Art, New York, New York. Gertrude Vanderbilt Whitney Funds.

2. Place the sheet of drawing paper alongside the photograph of Figure 3–4. Line up the paper so that it touches the left edge of the photograph. Starting at the edge of the paper, carefully continue the horizontal lines of the buildings and sidewalk. Working lightly in pencil, draw details from the best of your sketches.

3. Mix tempera colors to match the hues, values, and intensities of Figure 3–4. Use a brush to fill in the shapes of your drawing with color. (For information on using a brush see Technique Tip **4**, *Handbook* page **277**.)

4. Allow time for your painting to dry. Display the finished work alongside those created by other members of your class. Discuss your works using the steps in art criticism.

▲ **Figure 3–5 Student work. Expressive scene.**

EXAMINING YOUR WORK

- **Describe** Point out the row of buildings and empty streets in your picture. Explain how they resemble the buildings and streets in Figure 3–4. Identify the hues, values, and intensities in your work. Show where these same elements are found in Figure 3–4.
- **Analyze** Explain how you used the principles of harmony and variety. Point to places in Figure 3–4 where these same principles have been used.
- **Interpret** Ask other students to describe the mood expressed by your picture. See if they are able to identify a mood of loneliness.
- **Judge** Tell whether your picture looks like the one in Figure 3–4. State whether it uses many of the same elements and principles. Tell whether your work is successful in expressing the same mood of loneliness.

Try This!

COMPUTER OPTION

■ Pretend you live in an apartment above the barber shop. Change the Page Setup to Horizontal, and draw the view of the opposite side of the street with the Pencil or Brush tool. Draw long, low buildings. Repeat window and door shapes by using Select, Copy, and Paste. Choose dark color values to depict mood and time of day. Add a circular shape for variety. Save and title your work.

Art History

Look briefly again at the painting in Figure 3–4 on page **38**. Having created an "extension" to the work, you now have a better understanding of its composition and content. What do you know about its artist, Edward Hopper? When and where did he live? Did his other paintings look like the one in Figure 3–6? Is he thought to be an important artist?

Answering these and similar questions is the goal of art history. In this lesson you will learn ways of answering these questions.

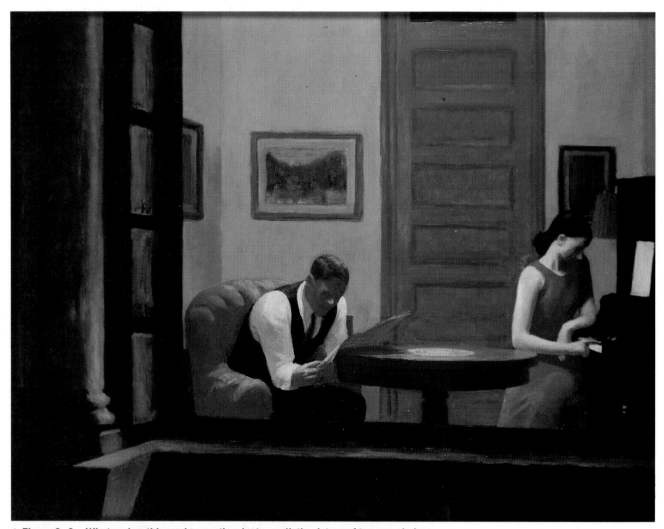

▲ **Figure 3–6** **What makes this work more than just a realistic picture of two people in a room? How do these people behave toward each other? How do their actions make you feel?**

Edward Hopper. *Room in New York.* 1932. Oil on canvas. 71.1 x 91.4 cm (28 x 36"). Sheldon Memorial Art Gallery, University of Nebraska, Lincoln, Nebraska. F. M. Hall Collection.

ART HISTORY AND YOU

To understand an art work completely, you need to do more than just look at it. You need to look beyond it. You need to know when and where the work was done. You need to know something about the artist who created it. Searching of this sort is the job of people in the field of art history. **Art history** is *the study of art from past to present*.

When they study art, art historians often use the same four steps art critics use: they describe, analyze, interpret, and judge. Unlike art critics, however, art historians do not use these steps to learn *from* art. They use them to learn *about* art.

Describing an Art Work

In describing an art work, art historians answer the questions "Who?" "Where?" and "When?" In other words, "Who painted the work, and when and where was it painted?" Look at the painting in Figure 3–6. Acting as an art historian, you can answer the first two of these questions by reading the credit line. The "who" is, again, Edward Hopper. The "when" is 1932. A visit to your school or local library will give you more information about the artist. There you will find that Hopper was an American painter who lived from 1882 to 1967.

Analyzing an Art Work

In analyzing an art work, the historian focuses on questions of style. **Style** is *an artist's personal way of using the elements and principles of art and expressing feelings and ideas in art*. Two typical questions the historian asks when analyzing a work are the following:

- What style did the artist use?
- Did the artist use the same style in other works?

Look again at the painting in Figure 3–6. An art historian would describe the style of this work as realistic. Compare this work with Figure 3–4 on page **38**. Would you say that both are done in a realistic style? Do you sense the same feeling of quiet loneliness in each?

Interpreting an Art Work

In interpreting an art work, the historian tries to determine how time and place may have affected the artist's style. Usually, this requires some research on the art historian's part. A trip to the library would reveal that:

- The painting in Figure 3–6 was completed during a period called the Great Depression.
- The Depression was a time during the 1930s when many people were out of work and money was scarce.
- To many people living through the Depression, the future looked hopeless.

In this work, Hopper captures the loneliness many people felt during that bleak time. The painting shows two people in a room. Notice that they do not face one another. Each, in fact, seems to be ignoring the other. A large door seems further to separate them. The people share the room but little else. Each is neglected and alone.

Judging an Art Work

In judging an art work, the historian notes its place in all art history. The historian decides whether the work and its artist make an important contribution to art. One way in which an artist can make a contribution is by introducing new materials or perfecting a style. Hopper is noted for developing a style that captured the mood of the times more effectively than most artists of that period.

✔ CHECK YOUR UNDERSTANDING

1. What is art history?
2. Explain *describing, analyzing, interpreting,* and *judging* as the terms are used by art historians.
3. Define *style*.

Painting in the Cubist Style

Study the painting in Figure 3–7 using the four art history questions to learn about the work and the artist who created it. The painting is an example of Cubism. The subject appears to be broken into different shapes and then put back together in new ways. The development of Cubism had an important effect on the course of art history.

WHAT YOU WILL LEARN

Using tempera, you will enlarge and re-create a section of the painting in Figure 3–7 or of another Cubist painting. You will use the same colors, lines, shapes, and textures in your work that were used in the original. You will use the principles of variety and harmony to organize these elements. Your section will be added to those completed by your classmates to form a large version of the work. (See Figure 3–8.)

WHAT YOU WILL NEED
- Tracing paper, pencil, and ruler
- Sheet of white drawing paper, 8 x 24 inches (20 x 61 cm)
- Tempera paint and several brushes
- Mixing tray

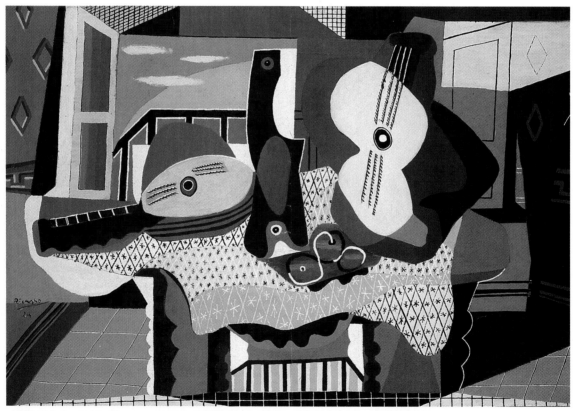

▲ **Figure 3–7** Pablo Picasso was one of the leading artists of the Cubist movement. Can you find the three primary colors in this painting? Notice how using hues widely separated on the color wheel results in a contrasting and lively composition. Which aesthetic view would you use when judging this work of art?

Pablo Picasso. *Mandolin and Guitar.* 1924. Oil with sand on canvas. 140.6 x 200.4 cm (55⅜ x 78⅞″). Solomon R. Guggenheim Museum, New York, New York. Photograph by David Heald, © The Solomon R. Guggenheim Foundation, New York. FN53.1358

WHAT YOU WILL DO

1. Lay a sheet of tracing paper over the painting in Figure 3-7. Using pencil, lightly and carefully trace the lines and shapes of the picture.
2. Using a ruler, divide your drawing into sections measuring 3 x 1 inches (8 x 2.5 cm). Your teacher will assign you one of the sections. Enlarge and draw freehand the lines and shapes of your section onto the sheet of drawing paper. Stay as close as you can to the original work.
3. Mix tempera colors to match the hues used in Figure 3-7. (For information on mixing paints, see Technique Tip **12**, *Handbook* page **280**). As you work, try also to use the same lines, textures, and shapes found in the original painting.
4. When your section is dry, add it to those completed by other members of your class. Compare your class effort with the original work. Decide whether it is made up of the same features as the original.

EXAMINING YOUR WORK

- **Describe** Identify the objects in your section of the class painting. Show where these same objects are found in the matching section of the original art. Point out the colors, lines, textures, and shapes in your section. Show where these same elements are found in the matching section of the original.
- **Analyze** Did your use of the principles of harmony and variety match the way they were used in the original painting? What could you have done to add *more* harmony? *More* variety?
- **Judge** Tell whether your section of the painting blends in with those completed by classmates. If it does not, explain why. Tell whether the class effort as a whole succeeds. Explain your answer.

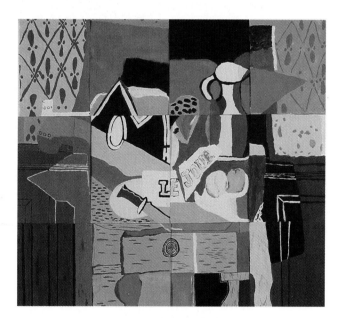

▶ **Figure 3–8 Student work. Cubist style painting using another Cubist work.**

STUDIO OPTIONS

▓ Make another painting of your section. This time limit yourself to different values of a single hue. Be prepared to discuss in what ways this new version is different from the original.

▓ Pick another painting from this chapter. Using tracing paper, copy a section of the work measuring 2 x 2 inches (5 x 5 cm). Enlarge the drawing to fit a larger square sheet of drawing paper. Paint the section using tempera. See if classmates can identify the original work of art and the section of the work you used.

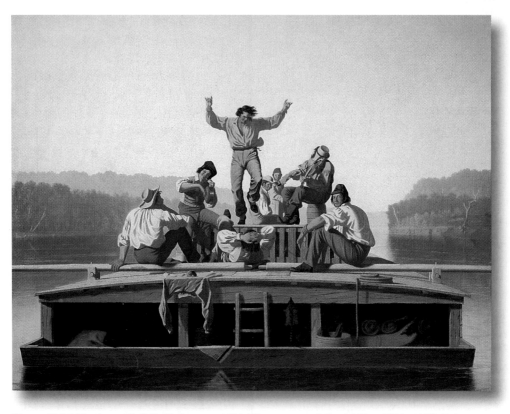

George Caleb Bingham. *The Jolly Flatboatmen.* 1846. Oil on canvas. .969 x 1.232 m (38⅛ x 48½"). Private collection on loan to the National Gallery of Art, Washington, D.C.

How Do Time and Place Affect an Artist's Work?

In 1806, Lewis and Clark completed their successful expedition west along the Missouri River. After this, thousands of adventurous fur traders, mountaineers, and settlers made their way along the Missouri River, the Oregon Trail, and the Santa Fe Trail to seek their fortunes on the great Western frontier. The push west brought prosperity to the growing nation, but it also triggered many wars with the Native Americans. St. Louis, along the Mississippi River, became the gateway to the expansion westward.

George Caleb Bingham was born in 1811. While he was growing up in Missouri, a strong wave of nationalism was spreading across the United States. The country was expanding by leaps and bounds. Farmers, traders, and trappers of the western territories contributed to the economy. The rivers played an important part in expedition and trade for settlers of these new lands. Bingham and other artists of the time tried to capture this spirit of national pride and adventure in their realistic paintings of life along the Missouri and Mississippi rivers.

MAKING THE CONNECTION

- ✔ What feeling do you think Bingham was trying to communicate in *The Jolly Flatboatmen*?
- ✔ How did the lives and work of people along the river affect the growing nation?
- ✔ Find out about the doctrine of Manifest Destiny. Do you think Bingham's work shows how this idea affected the spirit of the times?

INTERNET ACTIVITY

Visit Glencoe's Fine Arts Web Site for students at:

http://www.glencoe.com/sec/art/students

CHAPTER 3
REVIEW

BUILDING VOCABULARY

Number a sheet of paper from 1 to 7. After each number, write the term from the list that best matches each description below.

aesthetic view content
art criticism style
art history subject
composition

1. Studying, understanding, and judging works of art.
2. The image viewers can easily identify in an art work.
3. The way art principles are used to orga- *Composition* nize the elements of art in an art work.
4. The idea, feeling, mood, or message expressed by an art work. *content*
5. An idea, or school of thought, on what is important in a work of art. *aesthetic*
6. The study of art from past to present. *Art history*
7. An artist's personal way of using the elements and principles of art and expressing feelings and ideas in art.

REVIEWING ART FACTS

Number a sheet of paper from 8 to 17. Answer each question in a complete sentence.

8. What is *describing*, as the term is defined by art critics? What are two key facts a critic would note when describing a work?
9. What is *analyzing*, as the term is defined by art critics?
10. What is *interpreting*, as the term is defined by art critics?

11. What question is asked by art critics when judging a work?
12. Summarize the three aesthetic views discussed in the chapter.
13. What are three questions an art historian would answer when describing a work?
14. What are two typical questions an art historian would ask when analyzing a work?
15. What is *interpreting*, as the term is defined by art historians?
16. What questions do art historians ask when interpreting an art work?
17. What do art historians decide during the judging stage?

THINKING ABOUT ART

On a sheet of paper, answer each question in a sentence or two.

1. **Interpret.** Could two art critics using the four-step system of art criticism come up with different judgments of a work? Explain your answer.
2. **Interpret.** Is any one step in art criticism more or less important than any other step? Which step? Explain your answer.
3. **Extend.** Art, it is often said, is not created in a vacuum. To which lesson in this chapter does this statement apply? Explain your answer.
4. **Analyze.** Give an example of events taking place in the world right now that could affect an artist's style.
5. **Compare and contrast.** In what ways is the judging of art similar for art critics and art historians? In what ways is the task different?

MAKING ART CONNECTIONS

1. **Social Studies.** Visit the library and learn what you can about the artist of the sculpture in Figure 2–8 on page **24**. How would an art historian say that time and place affected the artist's work?

2. **Language Arts.** Pretend you are an art critic. Write an article you could submit to a magazine judging the work in Figure 3–4 by Edward Hopper.

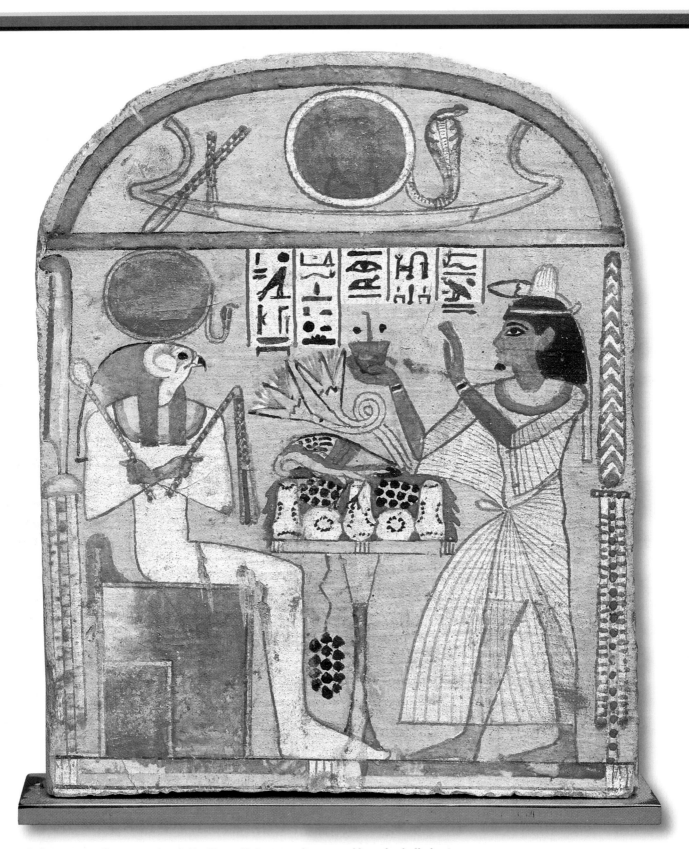

▲ Aafenmut, a scribe or secretary in the Pharaoh's treasury, is seen making a food offering to the falcon-headed lord of heaven. How does the artist show the sun making its daily journey across the sky?

Funerary Stela of Aafenmut. *Aafenmut Offering before Horus, above Sun's Barque.* Thebes, Khokha, Third Intermediate Period, Dynasty 22, ca 924–715 B.C. Painted wood. 23 x 18.2 x 3.5 cm (9 x 7¼ x 1⅜"). The Metropolitan Museum of Art, New York. Rogers Fund, 1928.

Art of Earliest Times

Before they could write or fashion a metal knife, our earliest ancestors were seeking ways to express their ideas and feelings in visual form. Paintings on the walls of prehistoric caves and ancient Egyptian tombs like the one at the left are like windows through which we can peer into the distant past. Art is the oldest form of human record and, throughout history, one of the highest achievements of human beings.

In the pages that follow you will learn about the artistic achievements of the past, beginning, in this chapter, with the art of earliest times.

OBJECTIVES

After completing this chapter, you will be able to:
● Define the term *culture*.
● Describe life during ancient times.
● Tell what kinds of art were created during ancient times.
● Create art works with media in the art styles of early civilizations.

WORDS YOU WILL LEARN

culture
hieroglyphic
megaliths
post and lintel system
stele
urban planning
ziggurat

PORTFOLIO IDEAS

Look at the art works in this chapter. Find one that you like. Do a quick sketch of it. Then describe how it uses the elements of color, line, space, shape, form, and texture. Find another that you like and sketch it. Compare how it uses one or more of the elements of art. Date your sketches and written entries and place them in your portfolio. Refer to these later and note how the use of elements and principles changes in different cultures.

Prehistoric Art

As long as there have been people, there has been art. The need to create has always been a driving force among people. In this lesson you will look at prehistoric art. This is art dating back to the time before people kept written records. By studying this art, you will find out about the civilizations of early times. You will learn about their **culture**, or *ideas, beliefs, and living customs.*

ART OF THE OLD STONE AGE

The earliest art works modern experts have uncovered date back to the Old Stone Age. Also known as the Paleolithic (pay-lee-uh-**lith**-ik) period, the Old Stone Age lasted from around 30,000 until about 10,000 B.C.

The lives of people during the Old Stone Age were filled with danger, hunger, and fear. Each day meant a new struggle just to survive. In the winter they searched for shelter against the snow and cold. In the summer they battled the heat and the sudden rains that flooded their caves. Those lucky enough to survive were old by age 40. Few lived past their fiftieth year.

Painting

Many of the Old Stone age art works that have lasted into recent times are paintings. The animal painting in Figure 4–1 is one such work. It was discovered on the wall of a cave in France. Others like it have been found in Spain and elsewhere in western Europe. Examples of cave art have been found on every continent, from the Sahara desert to the Arctic. Notice also how lifelike the animals look.

No one knows the real reason behind the creation of paintings like this one. Such works have always been found deep within caves, far from entrances and daylight. Their

▲ **Figure 4–1** **The cave which houses this painting was discovered by two boys playing ball. What do you suppose was their first reaction to this painting?**

Cave painting. c. 15,000–10,000 B.C. Lascaux, Dordogne, France.

location has led experts to think they were not created merely as decoration. Some think the paintings played a part in hunting rituals. Many have imagined scenes like the following . . .

The evening meal over, the men of the tribe stood. The boy — now a man — stood with them. One by one, they moved away from the warm cooking fires and into the cool, shadowy depths of the cave. Suddenly the boy felt himself being shoved to his knees. As he groped forward, he found himself crawling through a narrow passageway.

By and by, the path widened again. In the distance ahead, the boy could see the glow of a fire. Soon he found himself in a great hall lighted by torches. On one wall was a huge bison. In the flickering light, the beast seemed to be charging toward him. The boy's heart raced.

As the boy watched with wide eyes, an artist began creating a second bison. With a sharp-ended stick, the artist scratched the outlines of the animal into the wall. Using clumps of fur and moss, he filled in the body with a variety of reds and browns. Using a bit of coal, he added a single fierce eye.

▲ **Figure 4–2** These figures are copies of the original sculptures found in a chamber one mile underground. In what ways did their location help preserve them?

Clay Bison from Le Tuc d'Audoubert Cave, France. c. 17,000 B.C. Archeological Museum, Madrid, Spain.

At last the second beast was finished. The men, now excited about the promise of tomorrow's hunt, began to chant. The boy chanted with them. He picked up the spear his father had carved for him. With his fellow hunters, he attacked the "spirit" of the bison up on the wall, just as he would attack the real bison during the hunt.

Sculpture and Crafts

Old Stone Age artists were skilled not only at painting, but equally talented at sculpture and crafts. Notice the attention to detail in the bison shown in Figure 4–2. These remarkable sculptures, which are thought to date to around 17,000 B.C., were modeled out of clay.

The necklace in Figure 4–3 was found in an ancient grave. It is made of animal teeth and shells. Stone, ivory, and bone were some other media used by early sculptors and craftspeople.

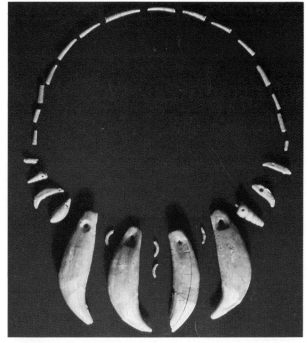

▲ **Figure 4–3** During prehistoric times, there were many animals to hunt. Bear and lion teeth such as those in this necklace were easy to find.

Bear-tooth necklace. c. 13,000 B.C. Private collection.

ART OF THE NEW STONE AGE

People gradually began to change as civilizations moved into the New Stone Age. Prehistoric peoples stopped wandering and formed villages. They learned to raise livestock and started growing their own food. Ways of making art changed, too.

Crafts

In the area of crafts, people learned to spin fibers, weave, and make pottery. Figure 4–4 shows a vase made about 6000 B.C. Note the potter's use of formal balance in this piece. Notice how the geometric design and balance combine to give the work a sense of unity.

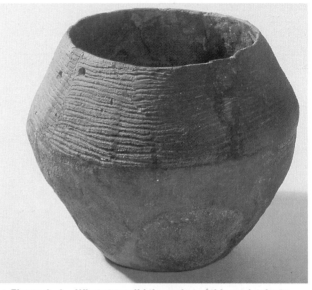

▲ **Figure 4–4** What steps did the maker of this work take to obtain harmony? How was variety achieved?

Neolithic pottery. Vase with flat base. Ceramique armoricaine. St. Germainen Lays.

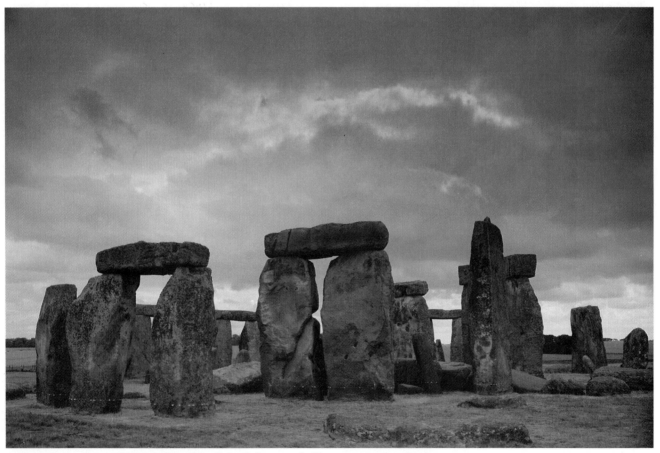

▲ **Figure 4–5** Some scholars believe this circle of stone was built as an accurate calendar. What other purpose might it have served?

Stonehenge. Salisbury Plain, Wiltshire, England.

Architecture

The New Stone Age, or Neolithic (nee-uh-**lith**-ik) period, also saw the first attempts at architecture. One kind of early building took the form of *large stone monuments* called **megaliths** (**meg**-uh-liths). The most famous of these is Stonehenge in England (Figure 4–5). This style of construction demonstrated the **post and lintel system**. This is *an approach to building in which a crossbeam is placed above two uprights*. As with the early cave paintings, the reason behind the creation of Stonehenge is unknown. As much a mystery is how the stones, many of which weigh 50 tons, were set in place. To this day, we can only guess and wonder.

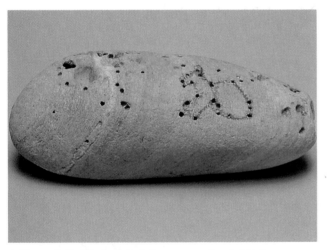

▲ **Figure 4–6 Student work. Image on natural object.**

STUDIO ACTIVITY

Finding Natural Forms

Bring a rounded stone about the size of your fist to class. Look at it carefully from every angle until the natural form suggests a simplified real or imaginary animal to you. Use a black marker or pencil to lightly draw the animal on the stone. Add color by using tempera or acrylic paints. Details can be added with a black marker. For a durable finish, paint your piece with varnish or acrylic medium after the tempera has dried.

P O R T F O L I O

Exchange art works with a classmate. Use what you see in the art work to write a short paragraph describing the animal your classmate created. Review your classmate's written description of your imaginary animal. Does it match the feeling or idea you wanted to convey? Write one or two sentences explaining how your art work was successful and what you might do differently next time. Include your classmate's description, your written statement, and a drawing or photograph of your art work in your portfolio.

✔ CHECK YOUR UNDERSTANDING

1. Define the term *culture*.
2. Describe life during the Old Stone Age.
3. What is a possible explanation for the creation of the cave paintings?
4. What changes in the way people lived took place in the New Stone Age?
5. What is a megalith? What is the name of the most famous megalith? Where is it found?

Painting Using Earth Pigments

When prehistoric artists created their cave paintings, they weren't able simply to open paint jars. They made use of natural sources of pigment around them. For reds, browns, and golds, they mixed ground-up earth minerals in animal fat, vegetable juices, and egg whites. For black they used charcoal from burned firewood. Minerals like these do not fade over time as other materials do. Notice how the painting in Figure 4–7 has kept its brilliant color for 15,000 years.

WHAT YOU WILL LEARN

You will create a painting about your environment using earth pigment paints that you have made from local earth minerals. At least half the paint you use in your work will be made from natural earth pigments. Use thin and built-up layers of this paint to obtain different textures that will add variety to your painting. For the remaining paint, you will use two hues of school acrylics plus black and white. (See Figure 4–8.)

WHAT YOU WILL NEED

- Pencil and sheets of sketch paper
- Yellow chalk
- Sheet of white paper, 12 x 18 inches (30 x 46 cm)
- Natural pigments
- School acrylic paint, several brushes, and palette
- Diluted white glue and a small jar
- Painting knife
- Water and paper towels

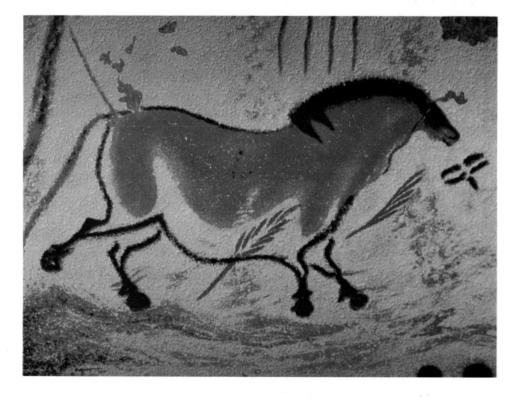

▶ **Figure 4–7 Can you identify the main features of this animal? Does it appear to be standing still or moving? How do you know?**

Horse from Cave Painting. c. 15,000–10,000 B.C. Lascaux, Dordogne, France.

WHAT YOU WILL DO

1. Collect and grind your own earth pigment. (See Technique Tip **11**, *Handbook* page **280**.)
2. Make several sketches of scenes from your environment that would make good use of these colors. White sand would be good for a beach scene. Gray dirt could be used to show city sidewalks. Reddish-brown colors would work well for brick walls. Look at the colors you have, and let the colors give you ideas.
3. Select your best sketch. Using yellow chalk, draw the outline shapes of your sketch on the sheet of white paper.
4. Choose the colors of paint you will use. Remember to limit yourself to two hues of school acrylic, plus black and white. Prepare the earth pigment paints. Take care to mix no more than what you will use in a single day.
5. Paint your scene. Experiment with different ways of using the earth pigments. For a thin smooth area, use only the liquid part of the paint. For a built-up, textured area, make a thick binder using extra glue and add plenty of powder. Apply the thick paint with the painting knife.
6. Display your work when it is dry. Look for ways in which your work is similar to and different from those of your classmates. Take note of any unusual effects created using the earth pigments.

- **Describe** Tell what scene from your environment you chose to make. Identify the different earth colors you used. Name the hues of school acrylic paint you used.
- **Analyze** Point out areas in which you used thick and thin layers of paint to create different textures. Explain how these different textures add variety to your picture.
- **Interpret** Explain why this scene represents your environment.
- **Judge** Tell whether you feel your work succeeds. Explain your answer.

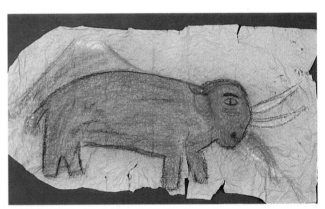

▲ **Figure 4–8** Student work. Earth pigments.

Try This! COMPUTER OPTION 🖳

■ Explore the Air Brush tool and settings. Choose earth colors. Use small width of Air Brush and dense setting to draw animal shapes. Experiment with other settings. Build up layers of paint to simulate an uneven rock surface. Make notes of what settings you use and record the effects for future use. Save and title your work.

Art of Ancient Egypt

During prehistoric times the chief enemy of the human race was nature. Unfriendly weather and fierce beasts of prey kept early humans always on their guard. By the time people began keeping written records, they had a new enemy. That enemy was other people.

As tribes learned to herd animals and grow crops, they also learned to live in harmony with their surroundings. This peaceful balance was upset by population growth. Small tribes began to fight over grazing land and soil suitable for growing crops. They were forced to band together into more organized groups for protection and also to be able to produce more food. By around 3000 B.C. four major civilizations had developed at different points on the globe. The ancient civilizations of Egypt, China, India, and Mesopotamia (mes-uh-puh-**tay**-mee-uh) emerged at this time.

In this lesson you will learn about the culture and art of ancient Egypt.

ANCIENT EGYPTIAN CULTURE

Ancient Egypt developed along the banks of the Nile before 3000 B.C. Find this area on the map in Figure 4–9. This civilization lasted for almost 3000 years. The arts of ancient Egypt reflect the endurance and solid foundation of that culture.

Egypt was ruled by a leader called a pharaoh (**fehr**-oh). The pharaoh was not merely a king in the eyes of the Egyptian people, he was also a god. After death he was believed to join other gods, whom the Egyptians identified with forces of nature. The afterlife of the pharaoh and other important people is a theme running through much of ancient Egyptian art.

Architecture

There can be little doubt that ancient Egypt's greatest achievement in art was in architecture. Figure 4–10 shows the civilization's most remarkable achievement of all, the great pyramids. These magnificent structures were built as tombs for the pharaohs. Thousands upon thousands of workers toiled for decades to build a single pyramid. Today the pyramids remain among the true wonders of the world.

Proof of the genius of later Egyptian architects is found in temples like the one in Figure 4–11. This temple is named in honor of the Egyptian sun god, Re (**Ray**). Apart from their beauty, temples like this were among the first buildings ever to use the post and lintel system. What structure of the New Stone Age that you studied also used posts and lintels?

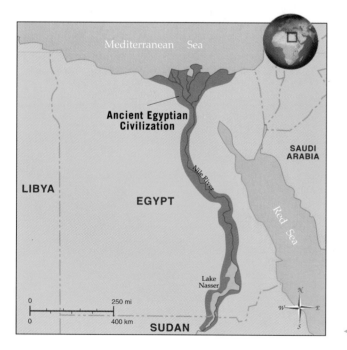

◀Figure 4–9 Ancient Egypt.

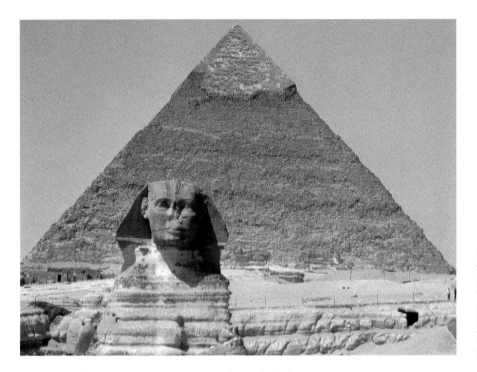

◄ **Figure 4–10** In ancient times, these pyramids were each covered with a layer of polished white limestone. What do you suppose happened to this outer layer?

Sphinx and Pyramid of Khafre. c. 2600 B.C. Giza.

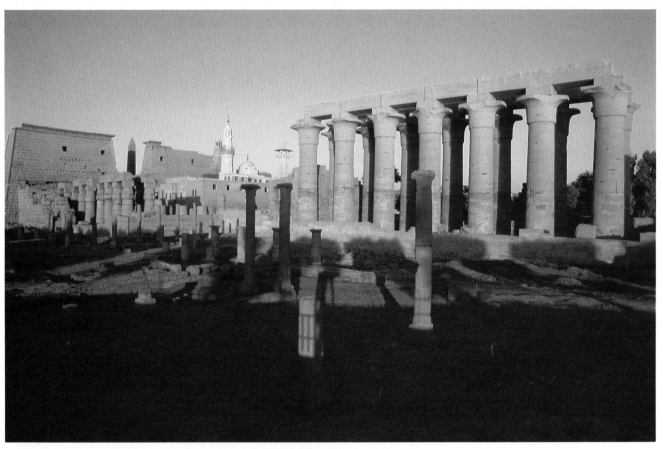

▲ **Figure 4–11** It is thought that the post and lintel system dates back to prehistoric times. Trees and bundles of stalks may have served as the first posts and lintels.

Built by Amenophis III. *Temple of Luxor.* Pylon and Hypostyle Hall. Egypt.

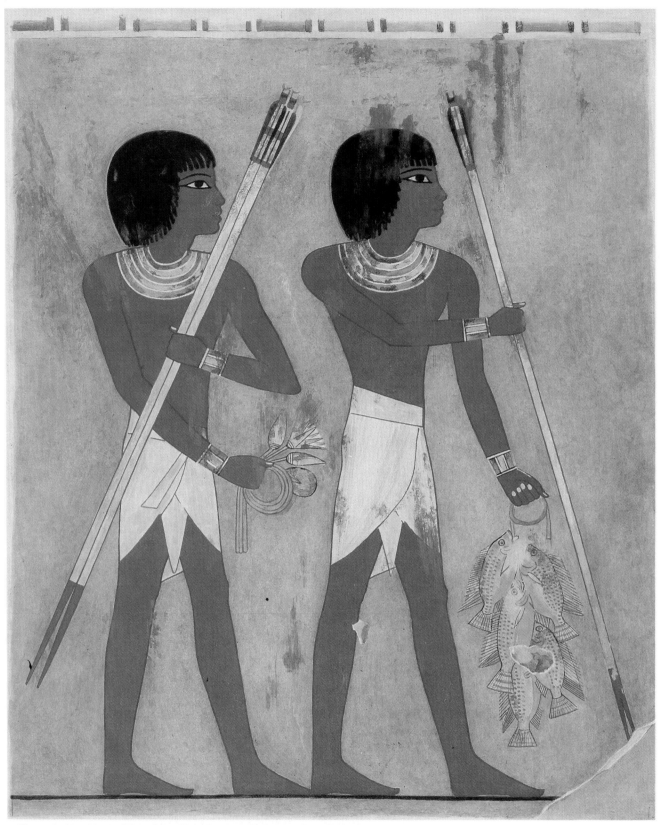

▲ **Figure 4–12 Much of the information we have about daily life in Egypt comes from paintings on walls and coffins found in tombs.**

Egyptian. *Fishing Scene: Attendants with harpoons and string of fish*. 1436–1411 B.C. Wall painting from the Tomb of Kenamun. 43.5 x 53 cm (17 x 21"). Egyptian Expedition of The Metropolitan Museum of Art, New York, New York. Rogers Fund.

Sculpture

In Egypt it became customary to decorate the tombs of rich or important people. Often this was done with painted relief sculptures. An example of this type of art appears in the illustration that opened this chapter (page **46**). This is a **stele** (**stee**-lee), *an upright monument, usually a carved stone slab.* Each frame shows a different part of a person's life or preoccupation for the afterlife. The frame closest to the top shows the subject seated at his own funeral banquet.

Painting

The wall paintings found in the tombs of royalty and the wealthy tell us about the daily life of the Egyptians. Figure 4–12 shows a typical Egyptian painting. Scenes from the buried person's life were painted on the walls. Notice that some body parts are painted as they would appear from the side. The head, arms, and legs are three such parts. Other parts appear as they would if we were seeing the people head-on. The single eye and shoulders demonstrate this. These views show the strict rules that artists of ancient Egypt followed. One of these was to show every body part from its most visible angle.

STUDIO ACTIVITY

Creating a Writing System

Look once again at the stele on page **46**. Notice the rows and columns of small birds and other shapes. These are examples of **hieroglyphic** (hy-ruh-**glif**-ik), *an early form of picture writing.* In this writing system, shapes stand not for sounds, as in our modern alphabet, but for ideas. (A heart shape, for instance, might be used to mean "love.") Here the symbols provide a written record of the achievements of the stele's subject.

Imagine that you are a citizen of a future civilization who has been called upon to create a new writing system. As you begin to work on this task, remember that you know nothing of modern alphabets. Think about what ideas you will need to express in your culture. Create a shape for each idea. When your system is complete, create a sentence and see if anyone in your class can read the message.

P O R T F O L I O

Copy your new writing system and your sentence or message and keep them in your portfolio. As a self-reflection, explain what you learned about how writing helps in communication.

✔ CHECK YOUR UNDERSTANDING

1. When did ancient Egypt come into being? How long did the civilization survive?
2. Who were the pharaohs? What part did they play in the art of ancient Egypt?
3. Name two achievements in ancient Egyptian architecture.
4. What is a stele?
5. How did Egyptian artists show the human figure in their work? What was their reason for doing this?

Ancient China, India, and Mesopotamia

Like Egypt, the ancient civilizations of China, India, and Mesopotamia each developed in a river valley. Like Egypt, each had a king and a religion that was based on nature.

Yet, despite some similarities, each civilization had its own separate culture and ways of making art. In this lesson you will learn about the culture and art of these civilizations.

ANCIENT CHINESE CULTURE

The first Egyptian pyramids were built around 2600 B.C. Around that time another new civilization was emerging a continent away, in the Yellow River valley. Can you find the Yellow River on the map in Figure 4–13? This civilization, China, is still alive today. It boasts the oldest continuous culture in the history of the world.

The history of China, until modern times, is divided into periods known as dynasties. Dynasties are named for ruling families of emperors. The first of these, the Shang dynasty, began around 1766 B.C. The last of them, the Ch'ing, ended in fairly recent times. Like the history of China itself, the art of China is grouped by dynasties.

ANCIENT CHINESE ART

The ancient Chinese were skilled in all areas of art. Legends show that Chinese artists were creating pictures as early as 2200 B.C. The works we have today were made in bronze and on stone and pottery instead of silk or paper, which has not survived. The architecture of this early period has also vanished, though large building foundations have been unearthed.

Sculpture and Crafts

The single greatest achievement of early Chinese artists was their work in bronze. A bronze pitcher dating from the Shang Dynasty is shown in Figure 4–14. Like most art of the time, the work is covered with motifs and squared spirals. Experts today believe the spirals to stand for clouds, rain, or water. What do these images seem to say about the ancient Chinese view of nature?

◀ **Figure 4–13 Ancient China, India, and Mesopotamia.**

ANCIENT INDIAN CULTURE

Like that of the Shang dynasty, the culture of ancient India remained a legend until modern times. In 1856 railroad workers laying track in the Indus River valley made a discovery. Near the city of Harappa (huh-**rap**-uh), they found a hill of crumbling fired clay bricks. These bricks date to between 2500 and 1500 B.C. Can you find the city of Harappa on the map in Figure 4–13? In what modern country is it located?

In addition to bricks, the railroad workers found a number of small relief carvings in soapstone. One of these is shown in Figure 4–15. These carvings are the oldest examples of Indian art.

Did you notice the odd lines and shapes above the animal form? These are known to be letters from an ancient system of writing. Scholars have yet to decipher the Harappan language.

◄ **Figure 4–14** Would you describe the images shown on this pitcher as realistic? If not, how would you describe them?

Chinese. Ritual Wine Vessel, with Spout. Shang Dynasty, 14th Century B.C. Bronze. 21.6 cm (8½"). The Metropolitan Museum of Art, New York, New York. Gift of Ernest Erickson Foundation, Inc.

◄ **Figure 4–15** Soapstone seals may have been used as personal adornment. Could the symbols have identified the owner?

Soapstone seal from Mohenjo-daro showing a Brahmani bull. Harappan culture. c. 2300–1750 B.C. 3.5 cm (18½"). British Museum, London, England.

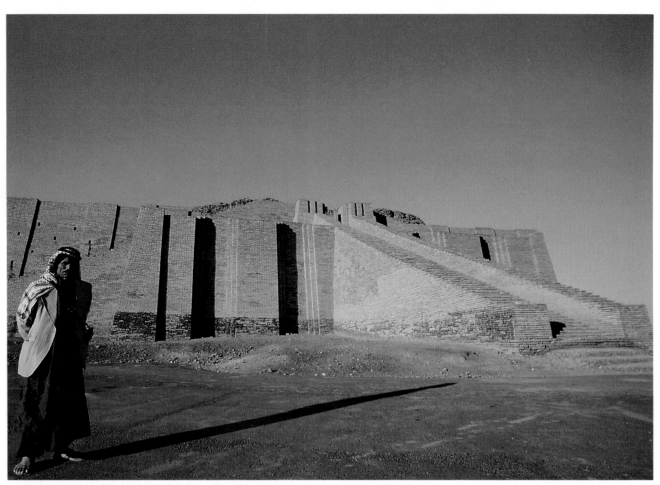

▲ **Figure 4–16** Perhaps the most famous ziggurat of all is the one recorded in the Bible. It is the tower of Babylon.

Ziggurat at Ur, Iraq.

Architecture

In 1922 a second ancient city was found in the area of Harappa. Its name is Mohenjo-Daro (moh-hen-joh-**dahr**-oh), which means "Hill of the Dead." The city is believed to have had a population of 35,000.

Mohenjo-Daro is an early example of the art of **urban planning**. This is *arranging the construction and services of a city to best meet its people's needs*. The ancient city had wide, open streets dividing it into large blocks about the size of four football fields. There were homes, shops, and large buildings thought to be houses of worship.

MESOPOTAMIAN CULTURE

The culture of Mesopotamia was more the culture of a region than of a people. The region was the fertile crescent of land between the Tigris (**ty**-gruhs) and Euphrates (yoo-**frayt**-eez) Rivers. This land is shared today by Syria and Iraq. (See Figure 4–13.) The people of Mesopotamia lived in city states that each had their own king. Sometimes these city states fought with each other and one would become more powerful.

The first important group to live in Mesopotamia was the Sumerians (soo-**mehr**-ee-uhns). Where the Sumerians came from is unclear. There is evidence that they learned to control the floods that were common in the fertile crescent. They also built strong walled cities, each with its own king.

The Sumerians were the first people to have a system of writing. Called cuneiform (kyoo-**nee**-uh-form), the system was made up of wedge-shaped characters. The Sumerians did not have paper so they wrote the cuneiform upon clay tablets.

Other city states that later became important were Babylon and Assyria.

Architecture

At the center of the Sumerian city, and of their form of art, was the **ziggurat** (**zig**-uh-rat). This was *a stepped mountain made of brick-covered earth.* A temple honoring the god of the city was placed at the top of the ziggurat. Figure 4–16 shows a ziggurat dating from 2100 B.C. What other ancient building does the ziggurat resemble?

Sculpture

As with other ancient cultures, the tribes of Mesopotamia often expressed their religious beliefs in their art. Study the sculpture in Figure 4–17. This marble figure stands for a Sumerian goddess or worshipper. This work has been dated from between 2700 and 2600 B.C. What other art that you studied in this chapter was completed around the same time? How does the style of that work compare with this?

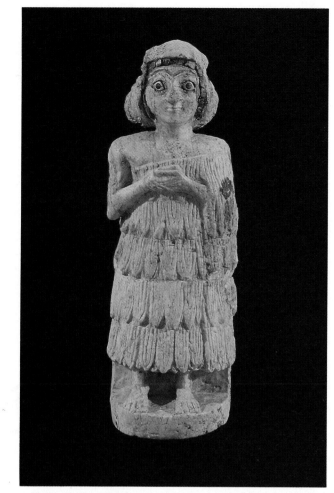

▲ Figure 4–17 What type of balance is used in this figure? Can you point to places where different textures are used? How does this figure make you feel?

Statua di Donna. c. 2700–2600 B.C. Marble. The Iraq Museum, Baghdad, Iraq.

✔ CHECK YOUR UNDERSTANDING

1. What are dynasties? How do they relate to the art of China?
2. How was the Harappan culture of ancient India discovered?
3. Why is the ancient city of Mohenjo-Daro important?
4. What is a ziggurat? In what culture were ziggurats built?

LESSON 5

Creating a Picture Story

Egyptian artists, as you have read, followed strict rules when they worked. One rule required that they show human body parts from their most familiar angle. Another required artists to make the most important people in a work the largest. Both these rules are followed in the wall painting in Figure 4–18. The important man and woman at the left are observing a hunting and fishing scene. The smaller figures are the servants. The painting tells a story.

WHAT YOU WILL LEARN

You will paint a picture story about the important events in your life. You will use the rules of Egyptian art shown in Figure 4–18. (For example, make your proportions larger to emphasize your importance.) Select lines and shapes to look stiff and dignified. Use contrasting colors to draw attention to the center of interest. Do *not* show depth of space in your painting. Instead, give it the same flat look as an Egyptian work. (See Figure 4–19.)

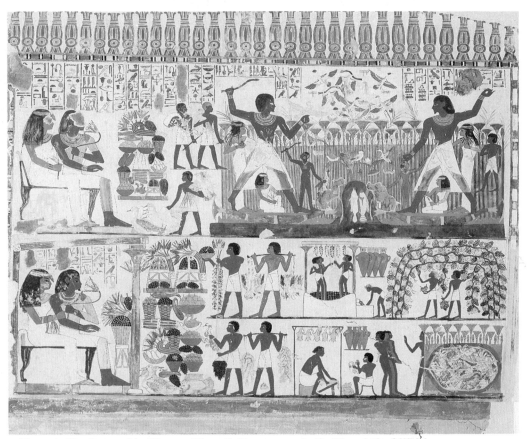

▲ **Figure 4–18** Can you identify any of the activities represented in this painting? Which figures do you think are meant to be the Pharaoh and his queen? Did you notice that little shading is used? The images look flat, as though they are cut from paper.

Wall painting from the Tomb of Nakht. *Nakht and his Wife.* Egypt. c. 1425 B.C. The Metropolitan Museum of Art, New York, New York.

WHAT YOU WILL NEED

- Pencil, sheets of sketch paper, and an eraser
- Watercolor paints and several watercolor brushes, some thick and some thin
- Sheet of white paper, 18 x 24 inches (46 x 61 cm)
- Paper towels

WHAT YOU WILL DO

1. Brainstorm with your class about ideas for your story painting. Some possibilities might be a birthday party, a school dance, a ride on your bike, a family get-together, passing an important test, and taking part in a class play or athletic event. You may want to pick more than one event for your work.
2. Study the figures in Figure 4–18. Make some rough pencil sketches that show figures in the same way. These should help you plan not only the story but also the size, location, and proportion of figures. The pictures do not have to read across the paper like the lines in a story. Rather, you may, if you like, place the most important scene in the center. Let your imagination guide you.
3. Choose your best plan. Working lightly in pencil, sketch it on the sheet of white paper.
4. Use your watercolors to paint the scene. Using your brushes, paint the areas. Take care not to smear any areas of paint. (For information on using watercolors, see Technique Tip **14**, *Handbook* page **281**.)
5. When your work has dried, display it. See if any of your classmates can "read" your picture story.

EXAMINING YOUR WORK

- **Describe** Describe the events in your painting. Tell how you used size to emphasize the most important person — you.
- **Analyze** Tell whether your lines and shapes give a feeling of stiffness. Explain how you used contrasting color to create a center of interest. Tell how you used proportion to emphasize yourself.
- **Interpret** State whether a viewer will be able to "read" your picture story and identify the important events in your life. Give your work a title.
- **Judge** Tell whether you feel your work succeeds. Explain your answer.

▲ Figure 4–19 Student work. Picture story.

Try This!

COMPUTER OPTION

■ Change Page Setup to Horizontal. Use your own story idea. Use Selection and Transformation tools to Copy and Paste duplicate figures in varying sizes from large to small. Choose a variety of Brush, Chalk, Marker tools and patterns, textures, and special effects to fill in objects and background. Save and title your work.

How Did the Egyptians Make Mummies?

Mummification was the process of preserving the dead for an anticipated afterlife. For thousands of years it was a major part of Egyptian culture. How was a body "mummified"?

Mummification could take up to 70 days. Embalmers first drained the blood from the body and removed all internal organs, including the brain. Any moisture left would be a breeding ground for bacteria, causing decay. After cleaning the body out, the embalmers packed it with *natron*, a salt found in the Egyptian desert. The body was then left to dry for about 40 days, and then cleansed with water, wine, and sweet spices.

Next the embalmers stuffed the body with sawdust or wads of linen and covered the body with molten resin. Then they painted the body, using red ocher for men, yellow for women.

The last step was the wrapping. The body was covered in layer after layer of linen, head to foot. The embalmers used as much as 3,850 square feet (375 sq m) of linen in this process. Then resin was poured on each layer for waterproofing. Finally, a red shroud was wound around the mummy and a painted portrait mask was attached.

Over time, more decorative masks, ornate coffins, and elaborate tombs became more important to the Egyptian death ritual than the actual mummification.

Inner coffin of Tutankhamun's sarcophagus. From the tomb of Tutankhamun, Valley of the Kings. Dynasty 18, 1336–1327 B.C.E. Gold inlaid with glass and semiprecious stones. Egyptian Museum, Cairo, Egypt.

The inner coffin of Tutankhamun's sarcophagus is made of several hundred pounds of solid gold. It is decorated with colored enamel, gemstones, and hieroglyphic inscriptions.

MAKING THE CONNECTION

✔ The photograph on this page is the inner coffin of King Tutankhamun's sarcophagus. His mummy was inside. Read the credit line. How old is this mummy?

✔ Why do you think it is so important to remove the blood and internal organs from the body?

✔ Find out more about natron. Why did it make a good preservative?

INTERNET ACTIVITY

Visit Glencoe's Fine Arts Web Site for students at:

http://www.glencoe.com/sec/art/students

CHAPTER 4
REVIEW

BUILDING VOCABULARY

Number a sheet of paper from 1 to 7. After each number, write the term from the box that best matches each description below.

culture ✓ stele ✓
hieroglyphic ✓ urban planning ✓
megaliths ✓ ziggurat ✓
post and lintel ✓
 system

1. The ideas, beliefs, and living customs of a people.
2. Large stone monuments, such as Stonehenge in England.
3. Approach to building in which a cross-beam is placed above two uprights.
4. Carved upright stone slab used as a monument.
5. An early form of picture writing.
6. Arranging the construction and services of a city to best meet its people's needs.
7. Stepped mountain made of brick-covered earth.

REVIEWING ART FACTS

Number a sheet of paper from 8 to 15. Answer each question in a complete sentence.

8. What is another term for the Paleolithic period, and when did it begin?
9. What fact about the cave paintings has led experts to suspect they were not created for decoration alone?
10. Name three media used by sculptors and craftspeople during the Old Stone Age.
11. How did the style of art change by the time of the Neolithic period?
12. What are two mysteries surrounding Stonehenge?
13. How did ancient Egyptian artists show the human body in their works? Why?
14. Name two ways in which ancient China, India, and Mesopotamia were like ancient Egypt.
15. What was the greatest achievement of early China?

THINKING ABOUT ART

On a sheet of paper, answer each question in a sentence or two.

1. **Summarize.** From a historical standpoint, why are the soapstone carvings of the Harappan culture important?
2. **Extend.** Suppose you learned of the discovery of a new civilization dating to 3000 B.C. Based on your reading of this chapter, what themes might you expect to find running through its art?
3. **Compare and contrast.** Some art scholars, you will recall, believe a successful art work is one with a realistic subject. Which of the ancient periods and civilizations you studied would appeal most to such a person? Which would appeal least? Explain your answers.

MAKING ART CONNECTIONS

1. **Mathematics.** Construction of the ancient pyramids was based on specific mathematical formulas. This is one reason why they have existed so long. Look up *pyramid* in an encyclopedia. What math facts and principles were used in designing these architectural structures?

2. **Language Arts.** Find out how pottery was made and used in ancient times by reading *Fired Up! Making Pottery in Ancient Times* by Rirka Gonen. Then research and compare the methods used by ancient artists with how pottery is made today.

▲ **Can you find any evidence of people in this landscape? Why do you think the artist made the figures so small?**

Artist unknown. *Gazing at a Waterfall.* 1127–1279. Album leaf, ink and color on silk. 23.8 x 25.2 cm (9⅜ x 9⅞″). The Nelson-Atkins Museum of Art, Kansas City, Missouri. Gift of Robert H. Ellsworth.

Art of the Far East

At roughly the same time the seeds of civilization were being planted along the banks of the Nile in Egypt, others were taking root half a world away in China. The art of early China was natural and gentle. Later, Japanese artists adopted and built upon the achievements of the Chinese to create works of art in their own unique style. In this chapter you will learn about the remarkable artistic achievements that took place in these far-off countries.

PORTFOLIO IDEAS

Select one of the art works that you make in this chapter as a portfolio entry. On a sheet of paper answer the following questions: Is the art work a drawing, painting, or sculpture? How does it show an influence of the art of the Far East? How did you make the art work? What materials did you use? What elements and principles did you use? Do you think this is a successful work of art? Explain why. Date your written responses and put them in your portfolio.

OBJECTIVES

After completing this chapter, you will be able to:
- Describe the role of religion in the art of China and Japan.
- Identify key developments in Chinese painting, sculpture, and crafts.
- Identify key developments in Japanese architecture, sculpture, painting, and printmaking.
- Create art objects that record experiences or events in your world.

WORDS YOU WILL LEARN

glaze
pagoda
perceive
porcelain
screen
scroll
Ukiyo-e
woodblock printing
Yamato-e

67

The Art of China

The Chinese have a long history of being highly creative. Two thousand years before the invention of the seismograph, they were recording earthquakes. Long before the first Texas oil wells were drilled, they were drilling holes 2000 feet deep. The compass and kite are two other early Chinese inventions.

Added proof of the Chinese gift for creating can be found in their art. In this lesson you will learn about the important contributions they have made.

MODERN CHINESE CULTURE

The "modern" period of Chinese civilization is thought to have begun with the Han dynasty. This dynasty lasted from 206 B.C. to A.D. 220. To this day, the Chinese still refer to themselves as the "Han people."

During this period a new religion came to China, called Buddhism (**boo**-diz-uhm), which stressed the oneness of humans with nature. An important part of Buddhism is meditation, focusing one's thoughts on a single object or idea. This experience allows the person to know the inner beauty of the object or idea. Chinese art of the last 2000 years has been greatly influenced by Buddhism and meditation.

Scroll Painting

The Chinese were the first people to think of "picture painting" as honorable work. This was because many artists were also scholars. They wrote with brushes that could make thick and thin lines. They used the same brush and line technique to paint pictures. They painted fans, pages of books, and scrolls. A **scroll** is *a long roll of illustrated parchment or silk*. Some scrolls were meant to hang on walls. Other scrolls were made of long rolls of silk or paper. They were meant to be unrolled a little at a time and read like a book.

Like other Chinese artists, scroll painters began a work only after a long period of meditation. The work itself was an attempt to capture a feeling, not an image. Shapes and figures were limited to the barest essentials. The artist included only those lines and shapes needed to capture the mood of the scene. (See Figure 5–3 on page **70**.)

Landscape Painting

The earliest Chinese paintings were filled with images of people illustrating the beliefs that people should live together peacefully and be respectful of their elders. With the influence of a new religion, the focus of painting began shifting away from humans and toward nature. By around A.D. 1100, the landscape was the main theme of Chinese painting.

The work that opened this chapter on page **66** is a landscape painting. Look closely at the work. Can you find a covered deck, or pavilion (puh-**vil**-yuhn), nestled within the hills? Studying the painting more closely still, do you see a small shape inside the pavilion? This is meant to be seen as the head of a person. What statement is the artist making about the place of humans in nature?

Sculpture

For many centuries important people in China were buried in tombs with objects they could use in the afterworld. These figures were made from clay. Many, like the horses in Figure 5–1, were of animals. Notice how the artist creates a sense of movement in the clay sculptures of horses and riders.

After the collapse of the Han Dynasty, China fell into chaos. It remained this way until the mighty T'ang (**tahng**) dynasty rose to power some 400 years later. It was during this new dynasty that Chinese sculpture flourished.

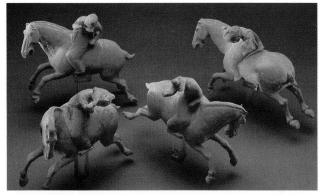

▲ **Figure 5–1** Notice how these figures show action. Centuries ago they played games similar to those we play today. What kind of game do you think they are playing?

Four Ladies of the Court Playing Polo. T'ang Dynasty. A.D. 618–906. Painted terra cotta. Nelson-Atkins Museum of Art, Kansas City, Missouri.

Crafts

The T'ang dynasty was followed in A.D. 960 by another powerful dynasty, the Sung (**soong**). Landscape painting soared to new heights during the Sung dynasty. So did the making of **porcelain** (**pore**-suh-luhn), *a fine-grained, high-quality form of pottery.* Porcelain is made from a fine and fairly hard-to-find white clay called kaolin (**kay**-uh-luhn).

Work in porcelain reached its highest point ever during the Ming dynasty (1368–1644).

▲ **Figure 5–2** The blue pigment came from Persia. Unless the timing was precise, the blue could turn black or brown during the firing.

Pair of Vases, Meiping. Reign of Xuande. Ming Dynasty. 1426–1435. Porcelain with underglaze blue decoration. Nelson-Atkins Museum of Art, Kansas City, Missouri.

STUDIO ACTIVITY

Perceiving an Object

Chinese artists, you have learned, began a work only after long meditation on an object. This helped the artist capture the mood he wanted to show. Many artists train themselves to **perceive,** or *to become aware of objects through the senses.* Artists think about and study the properties of the subject that might otherwise go unnoticed.

Bring a natural object, such as a leaf, rock, or pine cone, to class. Sit silently for five minutes and study the object from every angle. Notice the object's lines, form, and textures. Do the lines curve around the form? Is the object rough or smooth? Are there shiny highlights? Now place the object out of sight. Using brush and ink, draw what you perceived on a sheet of paper.

P O R T F O L I O

Write a short paragraph describing how you used the elements and principles of art to draw the object. Keep the paragraph and the drawing together in your portfolio.

The remarkable matched vases shown in Figure 5–2 date from this period. The painted dragon designs are protected by a *glass-like finish,* or **glaze,** on these Ming porcelains. What kind of balance does each of the vases have? What kind of balance do they have as a matched set?

✔ CHECK YOUR UNDERSTANDING

1. Name two inventions credited to the early Chinese.
2. What religion was introduced to China during the Han dynasty?
3. What is meditation? What has been its role in Chinese art of the last 2000 years?
4. What are scrolls?
5. What art form flourished during the T'ang and Sung dynasties?
6. What art form reached its highest point during the Ming dynasty?

LESSON 2

Making a Scroll

Look at the Chinese scroll painting in Figure 5–3. The work is by Zhu Derun, and shows a man and his servant approaching a bridge. It presents a popular theme in the art of this time, the artist-scholar retreating from the distractions of the world to enjoy the peace and quiet of the countryside. Though the artist trained himself to paint quickly, this work was meant to be viewed slowly. Viewing it slowly from right to left, a person was meant to meditate on each scene just as the artist did before painting it.

WHAT YOU WILL LEARN

You will create a scroll recording the events of a nature walk in the manner of the Chinese painter. Record scenes of your walk on a long strip of paper, using pencils and markers. Leave large areas of negative space around the shapes. Shapes to be emphasized will be filled with color. (See Figure 5–4.)

WHAT YOU WILL NEED

- Sheet of white paper, 1 x 6 feet (30 cm x 2 m)
- Pencil, watercolor markers, and transparent tape
- 2 dowels, 14 inches (36 cm)
- Piece of ribbon, 24 inches (61 cm)

WHAT YOU WILL DO

1. Set aside time to walk slowly through your school and around the school grounds. Gaze at objects and scenes as though you are seeing them for the first time. Stop as necessary to perceive the visual impression of the texture of a bush or the color of a flower. Try to focus on the feeling or mood each scene communicates. This feeling may come to you in a small detail, such as the texture of a wall or the line of the path you walk.

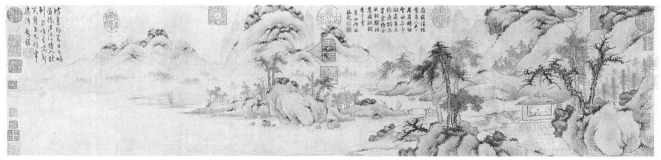

▲ **Figure 5–3** Did you notice how you are invited into this scene from the right foreground? What does this painting have in common with the one on page 66? Of course, both have pavilions from which one can view and marvel at the beauty of nature.

Zhu Derun (Chu Te-Jen). *Returning from a Visit.* Yuan Dynasty. 1270–1368. Ink on paper. 28.2 x 119.3 cm (11¼ x 47″). Kimbell Art Museum, Fort Worth, Texas.

2. Roll the large sheet of paper into a scroll. Close your eyes and try to picture one of the scenes and the mood attached to it. Keep the lines, shapes, colors, and textures uppermost in your mind. Unroll 10 inches (25 cm) of your scroll and, using pencil, very lightly draw the scene. The scene should not fill the section of paper. You should, in other words, have plenty of negative space around shapes and objects.

3. Using markers, trace over the pencil lines. Make sure no pencil marks are left showing. Fill in the shapes you want to emphasize with color. Do not color everything in the scene.

4. When you are satisfied with your work, unroll another 10 inches (25 cm) of scroll. Close your eyes again and try to picture another scene. Again record the scene in pencil and trace over the lines with markers. Continue to work in this fashion until you have used up all your paper.

5. Using tape, fasten each end of your scroll to a dowel. Roll up the scroll and tie it with the ribbon.

6. Exchange scrolls with a friend. Study the works slowly and silently. See if you can identify the scenes in the other person's work.

SAFETY TIP

When a project calls for the use of markers, always make sure to use the water-based kind. Permanent markers have chemicals in them that can be harmful when inhaled.

EXAMINING YOUR WORK

- **Describe** Tell what scenes you chose to show. State whether your work has any pencil lines showing.
- **Analyze** Point to the places where you used negative space in your scroll. Point to places where you used color for emphasis. Identify other elements you used.
- **Interpret** Show features in your work that would help a viewer understand how it captures a mood. Identify the different moods of the scenes.
- **Judge** Tell whether you feel your work succeeds. Explain your answer.

▲ **Figure 5–4** Student work. Scroll painting.

STUDIO OPTIONS

■ Using a brush and one hue of watercolor, paint the scenes in your scroll. (For information on working with watercolors, see Technique Tip **14**, *Handbook* page **281**.)

■ Create a vertical scroll. Start with the scene at ground level in front of your feet. Shift your eyes upward little by little. The last scene in your scroll should be the sky. At each level, search for and include details that capture the mood of the scene.

The Art of Japan

The history of Japanese art began around 5000 B.C. In the years that followed, art influenced every aspect of Japanese life. In this lesson you will learn about the one-of-a-kind culture and art of the "floating world" called Japan.

JAPANESE CULTURE

Japan makes its home on an island group in the North Pacific. Find Japan on the map in Figure 5–5.

In most civilizations, art follows culture. In a sense, the reverse is true of Japan. In A.D. 552 the ruler of a kingdom in nearby Korea sent the Emperor of Japan a gift. The gift was a piece of art. More specifically, it was a bronze figure of Buddha (**bood**-uh), the founder of Buddhism. Along with the sculpture came priests to spread Buddhist teachings. Eventually the people of Japan came to accept this new religion. They also learned about different ways of making art. For the next 250 years Japanese art would show strong traces of Korean, Chinese, and other Asian styles.

Architecture

Before the arrival of the bronze Buddha, the only Japanese art worth noting was prehistoric. Clay objects created by artists of the ancient Jomon (**joh**-muhn) culture are thought to date as early as 3000 B.C.

The first important Japanese art of "modern" times began being created in A.D. 594. These were magnificent Buddhist temples like the one shown in Figure 5–6. These temples were designed by Chinese or Chinese-trained architects and show a strong Chinese influence. Since the islands have little usable rock, wood was the main building material, except for the roofs which were made from tile. One of the most interesting features of early Japanese temples was the **pagoda** (puh-**gohd**-uh). This is *a tower several stories high with roofs curving slightly upward at the edges.* Figure 5–7 shows a pagoda from one of the greatest temples of the day. It is exactly like the first pagoda built at this temple. What does this fact reveal about the design of the building and how the Japanese feel about the past?

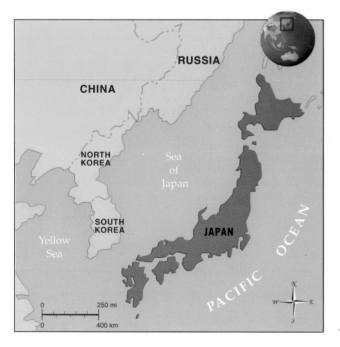

◀Figure 5–5 Japan.

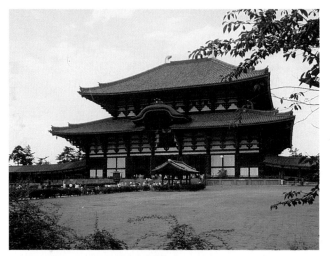

▲ **Figure 5–6** At least 10,000 pieces of the art of the period have been stored at this temple for over a thousand years.

Nara Todai-Ji Temple. c. A.D. 600. Japan.

Sculpture

The Japanese of this early period modeled small sculptures out of clay. They also carved images of wood and cast them in bronze. Most, like the one in Figure 5–8, featured the figure of the Buddha. As a new emperor came into power he would order a new Buddha to be cast. Each emperor would order his Buddha to be made larger than before to emphasize the emperor's own importance.

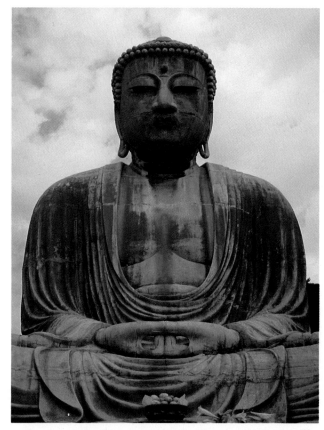

▲ **Figure 5–8** Huge images of the Buddha sometimes were 70 feet (21 m) tall. What does the Buddha appear to be doing?

Bronze Buddha of Todai-Ji. Japan.

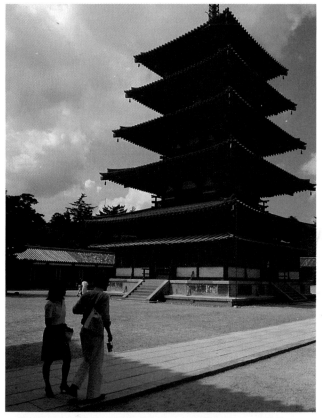

▲ **Figure 5–7** This temple complex contained two pagodas, a main hall containing a sculpture of the Buddha, a lecture hall, a library, and a bell tower. It is considered to be among the greatest architectural achievements in Japan's history.

Nara Horyu-Ji Temple Pagoda. A.D. 700. Japan.

Painting

In 784 Japan entered its golden age of art. During this period, which lasted some 400 years, countless new temples were built. The period also witnessed, around 898, the birth of a new painting style. Its name, **Yamato-e** (yah-**mah**-toh-ay), means *pictures in the Japanese manner.* Paintings done in this style were the first true examples of pure Japanese art.

Figure 5–9 shows a Yamato-e screen painting. A **screen** is *a partition used as a wall to divide a room.* Painted screens like this were often made in sections and were used to brighten the dimly lit interiors of temples and homes as a temporary wall to divide a room. Screens made it easy to rearrange a house and use space more efficiently. Once in place they were meant to be viewed from right to left in the same manner as scrolls.

The Ivy Lane shows travelers on a golden-colored road that winds magically through a rocky landscape. Do you think it is painted in a realistic way? Do the rocks look solid and three-dimensional, or flat like stage props? Do you think the artist did this intentionally?

Printmaking

The outbreak of civil war brought the golden age to an end in 1185. Japan remained in a state of political unrest for the next 430 years. The art of these stormy times focused both on the harsh realities of war and on escaping those realities. When peace came at last, another new style of art came with it. This style was called **Ukiyo-e** (oo-**kee**-yoh-ay), meaning *pictures of the floating world.* These pictures show different ways the Japanese enjoyed life.

The demand for art works in the new style was great. To meet this demand, artists turned to a new technique, **woodblock printing**. This is *making prints by carving images in blocks of wood.* The prints, or woodcuts, were made by a team of artists and craftspeople. Figure 5–10 shows a woodcut in the Ukiyo-e style. Notice the artist's use of strong lines and flat areas of color. Both were typical of such works. Equally typical was the balance shown here. What kind of balance has the artist of this print used?

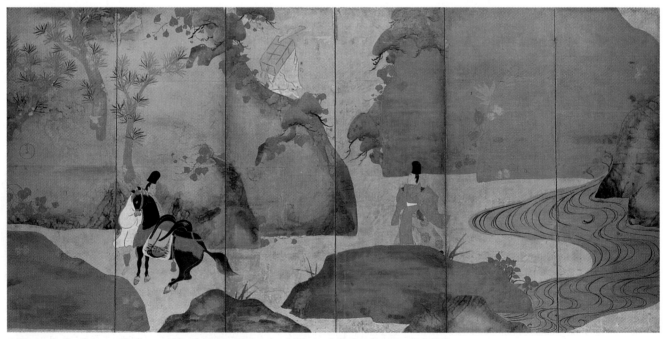

▲ **Figure 5–9** **Can you find something repeated throughout this work that helps give it unity?**

Fakaya Roshu. *Tsuta-no-hosomichi (The Ivy Lane).* Edo period, 1699–1755. Six-fold screen, opaque color on gold ground. 133 x 271.8 cm (52⅜ x 107″). Cleveland Museum of Art, Cleveland, Ohio. John L. Severance Fund.

▲ Figure 5–10 What does this figure appear to be doing? Why do you think such dramatic, violent action by an actor is sometimes necessary?

Torii Kiyotada. *An Actor of the Ichikawa Clan.* Woodcut, hand colored. 28.6 x 15.2 cm (11¼ x 6"). The Metropolitan Museum of Art, New York, New York. Harris Brisbane Dick Fund.

STUDIO ACTIVITY

Decorate a Headband

The print in Figure 5–10 is of a Kabuki (kuh-**boo**-kee) actor. Kabuki is a form of popular Japanese theater. Notice the richly decorated costume. Another Japanese stage tradition with even more spectacular costumes is the Nō (**noh**) drama. Figure 5–11 shows the type of headbands worn by a Nō actor. Notice the highly decorative pattern in the headband. Design a decorative pattern using symbols of an activity you enjoy. Using school acrylic paint, transfer the pattern to a headband made of paper or cloth.

PORTFOLIO

Mount your headband following the instructions in the Technique Tips section of the *Handbook.* Keep the mounted art work in your portfolio.

✔ CHECK YOUR UNDERSTANDING

1. What important event in the history of Japanese art happened in A.D. 552?
2. What is a pagoda?
3. When did the golden age of Japanese art begin? What painting style came into being during that period?
4. What is Ukiyo-e? What technique was most commonly used for Ukiyo-e art?

◀ Figure 5–11 What do you think the purpose of these headbands might have been? What is the purpose of headbands today?

Headbands for Nō costumes. Japanese. Edo Period. 1615–1867. Embroidered in silk on satin., 40 x 3.2 cm (15¾ x 1¾"). The Metropolitan Museum of Art, New York, New York. Gift of Mr. and Mrs. Teigi Ito.

Creating a Time Capsule

In 1974 well diggers in central China accidentally uncovered part of the tomb of the first emperor of China. Guarding the tomb was an army of life-size clay soldiers, horses, and attendants—at least 7000 of them (Figure 5–12).

Imagine that students of your school have been asked by community leaders to create clay objects. These are to be buried in a time capsule to tell future cultures about our own. Working in small groups, you will create a clay model of a teenager's room. You may use your own room at home or you may invent the room of your dreams. In the room you will include objects that represent the lifestyle of your group.

WHAT YOU WILL LEARN

You will make and join together clay slabs to create a teen's room. Your model will have a floor and three walls. Furniture and other details will be modeled from clay. In designing your room you must consider the elements of space, shape, form, and texture. Use the principles of proportion and variety to organize the elements. (See Figure 5–13.)

WHAT YOU WILL NEED

- Pencil, notepad, and sheets of sketch paper
- 2 guide sticks, each about ½ inch (13 mm) thick
- Newspaper
- Clay
- Rolling pin, needle tool, modeling tools, and ruler
- Sheet of plastic
- Slip (a mixture of water and clay used for joining clay pieces) and container of water
- Scissors and scrap of fabric

WHAT YOU WILL DO

1. On the notepad, list the furniture, objects, and details your room will have. Note also the different shapes, forms, and textures you will use. Make pencil sketches of the room and its contents.

► **Figure 5–12** Does the soldier look relaxed or is he at attention? Why would figures like these have been placed in the tomb of the emperor? These lifelike clay figures, buried since 210 B.C., offer us a wealth of clues about early Chinese civilization.

Cavalryman and Saddle Horse from Earthenware Army of First Emperor of Qin. c. 210 B.C. Terra cotta. Cultural Relics Bureau, Beijing, and The Metropolitan Museum of Art, New York, New York.

2. Set up the guide sticks 10 inches (25 cm) apart on the sheet of newspaper. Using the slab method, place the clay between these two guide sticks. Flatten the lump with the heel of your hand. Resting a rolling pin on the guide sticks, roll out the clay. This will help keep the thickness of the slab even. Using a ruler and knife or other sharp object, make four rectangles, each measuring 10 x 10 inches (25 x 25 cm). Cover the slabs loosely with the sheet of plastic. Leave them out overnight to firm up to the leather hard stage. This is the stage where clay is still damp but too hard to model.

3. The next day, score one of the slabs along three of its edges. This slab is to be the floor. Working a slab at a time, score each of the other slabs along its bottom. Use slip to join the walls to the floor. (For information on joining clay slabs and pieces, see Technique Tip **17**, *Handbook* page **281**.)

4. Model the furniture and other objects and details. Use proper joining methods for such tasks as adding legs to chairs. Using slip, attach the furniture and other objects to the floor.

5. When the clay is totally dry, fire the work. Complete your room by adding details — window coverings and a bedspread, for example — cut from the fabric.

6. Display your finished work. Look for similarities and differences between your work and that of other students.

- **Describe** Point to the floor and walls of your room. Describe the furniture and details you chose to include. Tell whether you followed the rules for making clay slabs and joining pieces.
- **Analyze** Show where you used the elements of space, shape, form, and texture. Explain how you used the principles of proportion and variety. Point out examples of each.
- **Interpret** Show what features in your work would help a viewer of the future understand this to be a teenager's room.
- **Judge** Tell whether you feel your work succeeds. Explain your answer.

▲ Figure 5–13 Student work. Model of classroom.

STUDIO OPTIONS

Try This!

▨ Choose a room in your school. Some possibilities are the gym, the cafeteria, or the art room. Think about what furniture and other objects you find in that room. Make a clay model of the room.

▨ Make a clay model of a whole single-story building. You might base your work on an actual building in your town or city, or you might invent your own. Think about what furniture and other objects you would find in each of the rooms. Add these details to your work.

How is Culture Preserved in Art Forms?

Ishiwata Kōitsu. *View of Koyasuchō in Kanagawa Prefecture (Vegetable Shop).* 1931. Color woodblock print. Paper. 39.2 x 26.6 cm (15¹⁄₁₆ x 10¼"). Los Angeles County Museum of Art, Los Angeles, California. Anonymous gift.

This colorful woodblock print by Ishiwata Kōitsu is a reflection of traditional Japanese values and customs. It shows in delicate detail the everyday routine of the marketplace. Modern artists and writers alike try to preserve timeless Japanese images. They include rural landscapes, twilight lake scenes, majestic mountains, and simple village life in their works of art.

For centuries Japanese writers have used unique poetry forms to express their simple yet intricate view of nature and cultural values. These poems follow a special format of syllables and lines. Each word is carefully chosen, and the grammar must be precise. The poems express deep personal feelings and experiences.

In the seventeenth century, the *haiku* became popular in Japan. This poetic form is written in 17 syllables, with three lines of 5, 7, and 5 syllables each. Haiku combines images of nature with personal insights. Haiku poetry is similar to Japanese painting. Like a delicate Japanese ink drawing, haiku uses clean outlines to depict an image, mood, or sensation.

Modern haiku, like modern Japanese art, reflects strong Japanese traditions, yet its appeal crosses many cultures.

MAKING THE CONNECTION

- How would you describe the scene in the print? What do the details tell you about Japanese culture?
- Write a haiku of your own, describing something in your neighborhood. Remember to use the precise form and include an image from nature.
- Learn more about haiku. Discover a well-known Japanese poet and read some of his or her poetry.

INTERNET ACTIVITY

Visit Glencoe's Fine Arts Web Site for students at:

http://www.glencoe.com/sec/art/students

CHAPTER 5
REVIEW

BUILDING VOCABULARY

Number a sheet of paper from 1 to 9. After each number, write the term from the box that best matches each description below.

glaze scroll
pagoda Ukiyo-e
perceive woodblock
porcelain printing
screen Yamato-e

1. A long roll of illustrated parchment or silk.
2. A fine-grained, high-quality form of pottery.
3. A glass-like finish on pottery.
4. Become aware through the senses.
5. A tower several stories high with roofs curving slightly upward at the edges.
6. An art style which means "pictures in the Japanese manner."
7. An art style which means "pictures of the floating world."
8. Making prints by carving images in blocks of wood.
9. A partition used as a wall to divide a room.

REVIEWING ART FACTS

Number a sheet of paper from 10 to 15. Answer each question in a complete sentence.

10. With what dynasty is the "modern" period of Chinese civilization sometimes connected?
11. What was the goal of Chinese scroll painting?
12. During which dynasty did work in porcelain reach its highest point?
13. Who sent the Emperor of Japan a gift in 552? What was the gift?
14. What date is associated with the earliest Jomon examples of Japanese art?
15. What culture strongly influenced the design of the first Buddhist temples in Japan? Where did the architects who designed these temples come from?

THINKING ABOUT ART

On a sheet of paper, answer each question in a sentence or two.

1. **Interpret.** Review the three aesthetic views that you studied in Chapter 3 (see page **37**). Tell how art critics of the three different views would each react to the painting that opened the chapter.
2. **Analyze.** It has been said that no artist works in a vacuum. Name three events or happenings you read about in this chapter that support this statement. Explain your choices.
3. **Analyze.** Look at the scroll painting in Figure 5–3. Review the four stages of work in the art historian's job (see page **41**). Then describe the scroll painting.

MAKING ART CONNECTIONS

1. **Language Arts.** Read *The Boy Who Drew Cats* by Arthur A. Levine. The story is based on a legend from Japan and is illustrated with paintings and calligraphy. Work with a partner to illustrate a favorite story or legend.

2. **Social Studies.** Look in the encyclopedia or history books to learn about the Great Wall of China. Prepare a short oral report for your class. Explain some of the features of the Great Wall, such as how and where it was constructed and why.

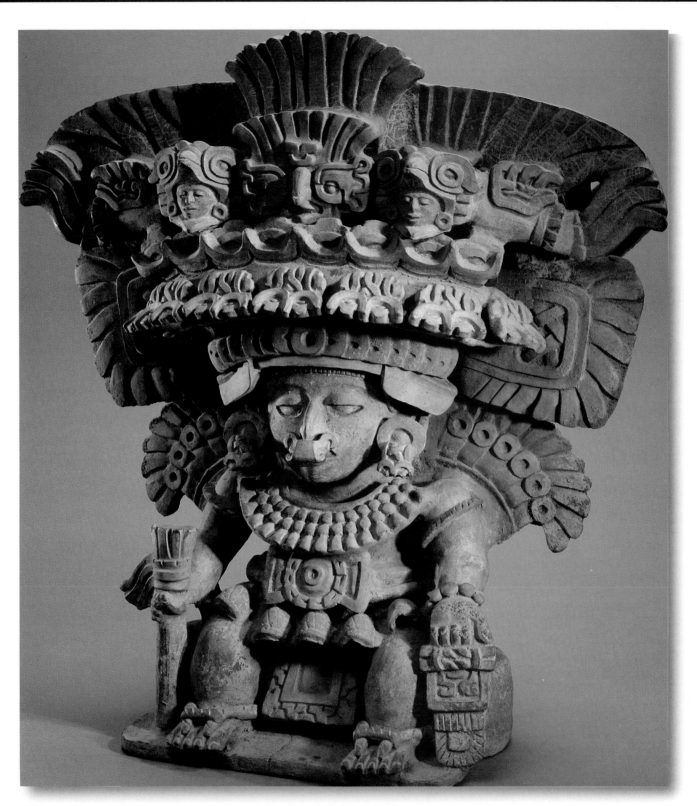

▲ The headdress on this figure represents an ancient goddess. What kind of balance was used? How are harmony and variety demonstrated? Do you think the lack of movement adds to the dignity of this seated figure?

Mexican (Zapotec) from Monte Alban. Funerary Urn. A.D. 500–700. Terra cotta with traces of polychrome. Nelson-Atkins Museum of Art, Kansas City, Missouri.

Art of Pre-Columbian America

Can you name an important event that took place in the year 1492? If you said this was the year Columbus discovered the New World, you were *almost* right. In 1492 Christopher Columbus did explore the lands in the western hemisphere. Long before Columbus's arrival, however, civilizations were developing in this part of the globe. Many tribes and peoples were already living here. All were part of a rich heritage or culture, and all created art, such as the work shown at the left. In this chapter you will learn about these peoples and their art.

OBJECTIVES

After completing this chapter, you will be able to:
- Name and describe four major Pre-Columbian cultures.
- Identify the contributions the various Pre-Columbian cultures made to the art world.
- Work in the art styles of early Mesoamerican peoples.

WORDS YOU WILL LEARN

adobe
artifacts
effigy
funerary urn
genre pieces
monolith
motif
stylized

PORTFOLIO IDEAS

Select one of your art works from this chapter for your portfolio. Evaluate it by answering the following questions:
- Does this art work meet the requirements of the assignment?
- How did I use the elements and principles of art in this work? Was I successful?
- What do I like best about this work?
- What improvements could I make next time?

Date and store this entry in your portfolio. In the future, review your responses to see how you have grown as an artist.

Art of Mesoamerica

You can probably guess the meaning of the word *Pre-Columbian*. This term means "before Columbus." However, art historians use the term in a special way. They use it to refer to the art of early Mexico, Central America, and South America. Less is known about the cultures of these regions than about most others you have studied so far. This is because scientists have only recently begun to find and examine evidence of them.

In this lesson you will read about four major cultures of ancient Mexico and Central America. These are the Olmec, West Mexican, Mayan, and Aztec cultures.

OLMEC CULTURE

The Olmec (**ol**-mek) people lived on the Gulf of Mexico nearly 3000 years ago. Find the center of their civilization on the map in Figure 6–1. Olmec culture is often called the "mother culture" of Mexico. This is because the **artifacts**, or *simple handmade tools or objects*, found in the region where the Olmecs lived are the most ancient. The artifacts left by the Olmecs had an influence on all the civilizations that were to follow.

Like other Pre-Columbian civilizations, the Olmecs were not a prehistoric race. They had a very important culture and a very accurate calendar. They also left behind a number of interesting works of art.

Sculpture

Among the most interesting of the Olmec creations are four huge human heads carved from rock. These were discovered at La Venta, a center for religious ceremonies. One of these sculptures is shown in Figure 6–2. Notice the childlike features on this giant face. The full lips, which seem almost to be pouting, are typical of the Olmec style.

WEST MEXICAN CULTURE

After the Olmecs, the next oldest civilization seems to have been that of West Mexico. The center of West Mexican culture was the city of Colima (koh-**leem**-uh). Find Colima on the map in Figure 6–1. For many years scientists ignored this region. Much of what we know of West Mexican culture was discovered when scientists studied the artifacts accidentally turned up by grave diggers.

Sculpture

Among the West Mexican art that has surfaced are many small clay sculptures of dogs. One of these is shown in Figure 6–3. Study the figure. Would you describe the work as realistic?

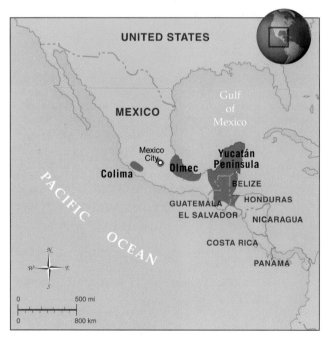

▲ **Figure 6–1** Mesoamerica.

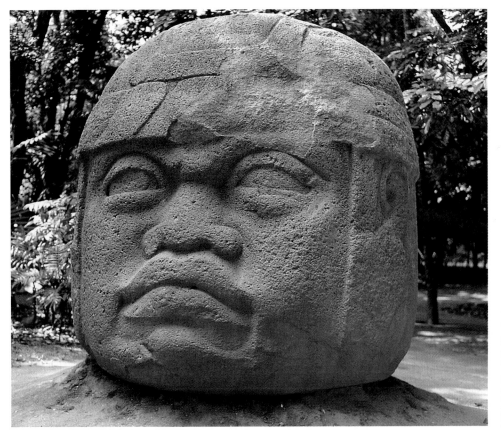

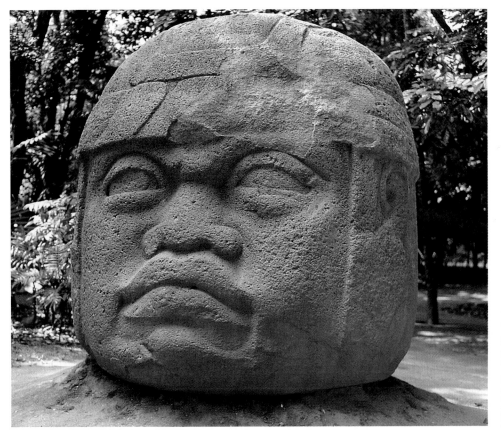

◀ **Figure 6–2** Records show that this 40-ton (40,000-kg) stone head was moved 60 miles (96 km), through swampland. What does this tell you about the Olmecs?

Olmec Head. 1500–800 B.C. Basalt. La Venta Archeology Museum, Mexico.

At one time these sculptures were thought to be **genre** (**zhahn**-ruh) **pieces**. These are *art works that focus on a subject or scene from everyday life*. It is now known that ancient Mexicans viewed dogs as having special powers. Specifically, the animals were believed to serve the dead. A sculpture of this type is called an **effigy** (**eff**-uh-jee), *an image that stands for ideas or beliefs*.

MAYAN CULTURE

The first great Pre-Columbian civilization was that of the Mayas (**my**-uhs). By around A.D. 800 their empire covered the Yucatán (yoo-kuh-**tahn**) peninsula, modern Belize (buh-**leez**), Guatemala, and Honduras. Find these places on the map in Figure 6–1. The Mayas were gifted mathematicians. They had the most accurate calendar of any people in history. They were also great builders. The Mayas erected huge temples and cities with tools of wood, stone, and bone.

▲ **Figure 6–3** This is a hollow clay form. The swollen lower body is typical of Colima figures.

Effigy Vessel. c. A.D. 250. Ceramic. Fowler Museum of Cultural History, UCLA, Los Angeles, California.

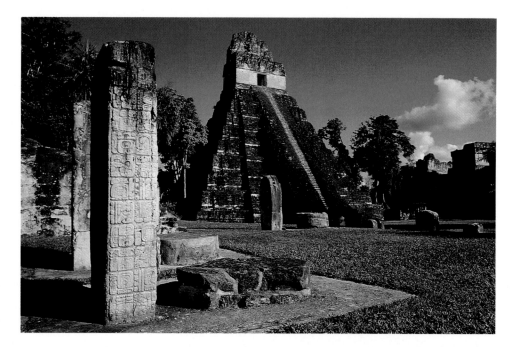

► **Figure 6–4** **The project to dig up this ancient city is one of the biggest in history. Why do you think scientists spend so much time and effort digging up lost civilizations?**

Mayan-Tikal Site. Jaguar Temple. c. A.D. 800. Peten, Guatemala.

Architecture

In the late 1800s scientists digging in northern Guatemala found traces of an ancient city. This Mayan city, Tikal (tih-**kahl**), is known to have covered an area of 50 square miles (130 sq km). The city is thought to have been home to some 55,000 people. Figure 6–4 shows a view of the site.

Mayan architects not only built outward but they also built upward. Look again at Figure 6–4. The pyramid in the background has a temple on top of it. It is typical of many temples built throughout the Mayan civilization. Two others have been discovered at Tikal alone. Amazing structures like these rose at times to heights of 175 feet (53 m). What kind of balance did Mayan architects use in designing these impressive temples?

Sculpture

Most of the Mayan sculpture that has lasted is relief carvings on buildings and monuments. In the early stages of the Mayan civilization, these carvings were mostly simple and realistic. In some later temples a more complex, geometric style came to be the rule.

The surviving works of Mayan civilization range from the smallest objects to great temples covered with relief carvings. Among the smallest art works of the Maya are many beautifully designed clay figures only a few inches high.

The one illustrated in Figure 6–5 represents a Maya ruler dressed to look like a mythical king of the past. His complex costume identifies his rank, his association with the gods, and his own important position in the universe.

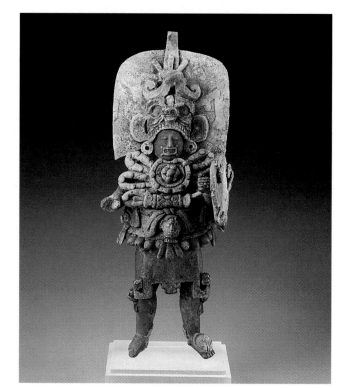

▲ **Figure 6–5** **Can you see the god represented in the elaborate headdress worn by this Maya ruler? He is Chac-Xib-Chac, a god associated with war, sacrifice, dancing, and fishing.**

Ruler Dressed as Chac-Xib-Chac and the Holmul Dancer. Maya, c. A.D. 600–800. Ceramic with traces of paint. 23.8 cm (9⅜″) high. Kimbell Art Museum, Fort Worth, Texas.

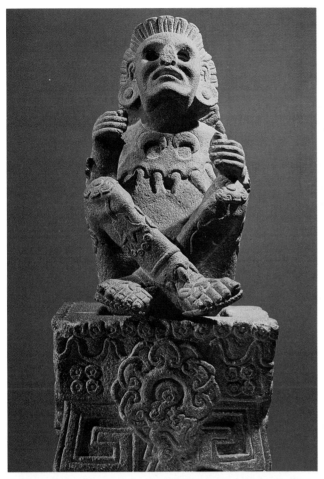

▲ **Figure 6–6** This sculpture and its base are decorated with a number of designs. Can you see any that look like flowers?

Xochipilli, Lord of the Flowers. Aztec. National Museum of Anthropology, Mexico City, Mexico.

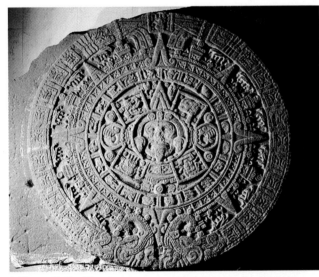

▲ **Figure 6–7** The stone was more than a calendar. It told the story of the universe. It stated when the Aztec world began and predicted when it would end.

Stone of the Sun. Aztec Calendar Stone. c. 1500. National Museum of Anthropology, Mexico City, Mexico. Photograph by Michael Zabe. Art Resource, New York.

The largest of the cultures of ancient Mexico and Central America was the Aztec. This civilization emerged sometime between A.D. 1200 and 1325. The Aztecs were a warlike tribe. Like other Pre-Columbian peoples, they were very religious. When their god told them to leave their comfortable homeland and settle where they saw an eagle perched on a cactus, they did. A swampy island, which they called Tenochtitlán (tay-noch-tee-**tlahn**), became the center of their great empire. By the time Spanish conquerors arrived in 1519, their island city covered over 25 square miles (66 sq km). Today we know the city, which is no longer on an island, as Mexico City. Find Mexico City on the map in Figure 6–1.

Sculpture

The Aztecs adopted many of the ways of making art used by the people they conquered. They carved huge ceremonial sculptures like the one shown in Figure 6–6. This sculpture is one of 1600 gods and goddesses in the Aztec religion.

One unusual piece of Aztec art is the calendar stone, shown in Figure 6–7. The work is so called because its rim is decorated with signs for the 20 days of the Aztec month. The stone measures 12 feet (3.6 m) in diameter and weighs over 24 tons (22,000 kg).

✔ CHECK YOUR UNDERSTANDING

1. Which culture is the mother culture of Mexico?
2. What is a genre piece? What is an effigy?
3. What was the first great Pre-Columbian civilization? What huge structures did the people of this civilization build?
4. What is the calendar stone? What Pre-Columbian civilization created the calendar stone?

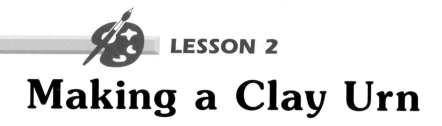

LESSON 2

Making a Clay Urn

Look again at the work that opened this chapter on page **80**. It is a **funerary** (**fyoo-nuh-rehr-ee**) **urn**, *a decorative vase or vessel found at burial sites.* Compare it with the clay vessel in Figure 6–8. The works were created by different Pre-Columbian cultures, but they have much in common. Both use formal balance and are covered with a repeated motif (moh-**teef**). A **motif** is *part of a design that is repeated over and over in a pattern or visual rhythm.* Finally, both works are rich with symbols that had special meaning for members of their cultures.

WHAT YOU WILL LEARN

You will make a cylinder-shaped container at least 6 inches (15 cm) high using the clay slab method. You will decorate your container with a figure wearing symbols that represent your life. You will use formal balance and repeating patterns in your work. The pattern will be in the style of an ancient Mexican culture. You may paint your figure using school acrylics, or you may glaze it. (See Figure 6–9.)

WHAT YOU WILL NEED

- Pencil and sheets of sketch paper
- 2 guide sticks, each about 1/2 inch (13 mm) thick
- Newspaper
- Clay
- Rolling pin, ruler, needle tool, paper towel, and modeling tools
- Slip (a mixture of water and clay used for joining clay pieces), and container of water
- Plastic bag
- *Optional:* Glaze or school acrylics

WHAT YOU WILL DO

1. Brainstorm with your classmates for ideas for personal symbols to be used to decorate your figure. For example, if you play football, the figure could be wearing a helmet. You could decorate the helmet with a pattern of footballs for a headdress. If your major interest is math, the headdress might be covered with numbers. The hands might hold pencils and a notebook to symbolize the student. Make pencil sketches of the figure and the different decorations you will use.

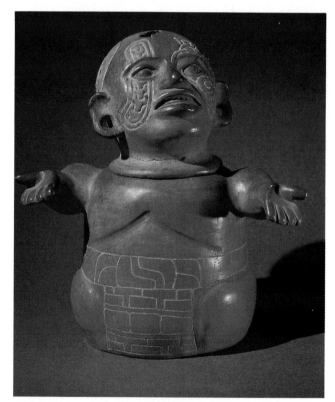

▲ **Figure 6–8** **What relationship do you suppose existed between the figure of the clay vessel and what it was used for?**

Pottery jar with removable head. Teotihuacan, Mexico. American Museum of Natural History, New York, New York.

2. Set up the guide sticks 6 inches (15 cm) apart on the sheet of newspaper. Using the slab method, make a rectangle, 6 x 12 inches (15 x 30 cm). Keep the unused clay damp by covering it with a lightly moistened towel. Score the short edges of your rectangle. Carefully bend your slab into a cylinder. Apply slip to the scored surfaces and press them together. Smooth both the inside and outside surfaces of the cylinder along the seams.

3. Using a portion of the remaining clay, roll out a slab measuring 10 inches square (625 sq cm). Stand the cylinder on top of the square. Using the needle tool, lightly trace around the cylinder. Score the surface of the circle you have created and the edges of the cylinder. Apply slip, and press the two surfaces together. Add a thin coil of clay inside your cylinder along the bottom. Press it gently into the seam to make the cylinder stronger. Cut off the excess clay from around the base of the cylinder.

4. Model the head, arms, legs, and headdress for your figure. Attach them using scoring and slip. With modeling tools add patterned markings to create rhythm to your work. Note that you may need to support the head and headdress as the work dries. Prop these in place using an object of the right height.

5. When your clay container is bone dry, fire it in a kiln.

6. *Optional*: Glaze or paint the fired container using acrylics.

7. Place the finished work on display. See if your friends can guess what the decorations on your work stand for.

EXAMINING YOUR WORK

- **Describe** Show that your container is at least 6 inches (15 cm) high. Show that the parts are properly joined. Describe the figure and symbols you used to decorate your container. Identify the hues used to color your figure.
- **Analyze** Describe the kind of balance you used. Identify the repeating rhythmic pattern in your work.
- **Interpret** Identify the features of your work that are similar to those of the ancient Mexican culture you used as a model. Explain how the symbols represent your life.
- **Judge** Tell whether you feel your work succeeds. Explain your answer.

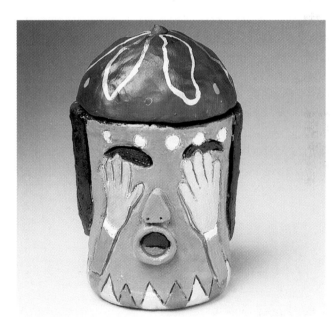

▲ Figure 6–9 Student work. Clay urn.

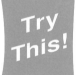

STUDIO OPTIONS

■ Make a second container, this time using the medium of paper. (For information on making paper sculptures, see Technique Tip **21**, *Handbook* page **284**.)

■ Using construction paper or poster board, design and make a piece of jewelry in the style of the Mesoamerican cultures.

Art of the Andes

Taken together, the four major cultures of Mesoamerica spanned a period of several thousand years. While these civilizations were developing, parallel developments were taking place in the Andes (**an**-deez) Mountains of South America.

In this lesson you will read about the culture and art of the Chavín, Moche, Tiahuanaco, and Inca Tribes.

CHAVÍN CULTURE

The earliest of the Andes civilizations, the Chavín (chuh-**veen**), made their home in the highlands of present-day Peru. The discovery of artifacts places the beginning of Chavín civilization at around 1000 B.C. Their name is taken from their ceremonial center, Chavín de Huántar (**hwahn**-tahr). Today stone pyramids and stone sculpture can still be found at that site. Find this place on the map in Figure 6–10.

Crafts

Like other Andean cultures, the Chavín held the jaguar to be sacred. Images of the cat turn up in much of their art.

One area of art in which the Chavín were especially skilled was crafts. The clay jaguar pitcher in Figure 6–11 is an example of one of their works. Notice the unusual stirrup-shaped spout. This design feature, used by later Andean cultures, was typical of Chavín pottery.

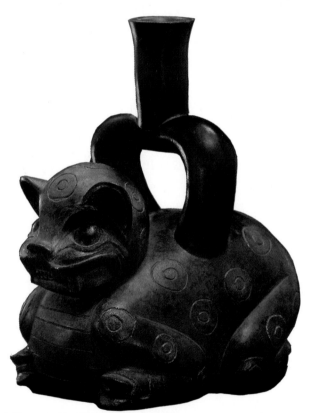

▲ **Figure 6–11** This hollow vase is decorated with relief designs. Why do you think the Chavín developed the stirrup spout? What motif is used to help identify the animal as a jaguar?

Peru. Stirrup-Spout Vessel, Feline. 700–500 B.C. Ceramic. 23.5 x 14.1 x 20.9 cm (9⅛ x 5⅝ x 8⅛"). The Metropolitan Museum of Art, New York, New York. Michael C. Rockefeller Memorial Collection.

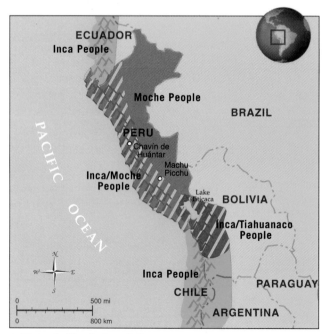

▲ **Figure 6–10** Andean Cultures.

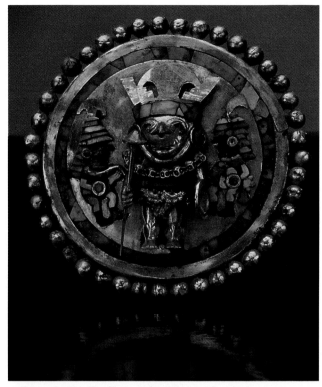

▲ **Figure 6–12** The figure is the size of a thumb. It wears a movable nosepiece and carries a movable war club.

Earring. National Geographic Society, Washington, D.C.

Another way in which this object is typical is in the stylized look of its subject. **Stylized** means *simplified or exaggerated to fit a specific set of rules of design*. Did you notice the circles on the head and body? These were meant to stand for the jaguar's spots.

MOCHE CULTURE

West Mexican culture developed roughly between A.D. 100 and 700. Approximately these same years, interestingly, mark the rise and fall of Moche (**moh**-chay) culture. The Mochica (moh-**cheek**-uh), as these people were called, lived on the northern coast of what is now Peru. Find this area on the map in Figure 6–10.

The Mochica were farmers who irrigated the strips of desert between the Andes and the Pacific Coast. They grew corn, beans, squash, and peanuts. They built great pyramids and platforms with **adobe** (uh-**doh**-bee), or *sun-dried clay*. Here they buried their nobles.

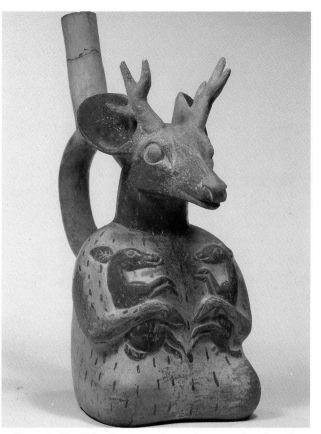

▲ **Figure 6–13** This stirrup-spout vessel represents a deer. It shows two figures having a conversation. One has the head of a frog.

Peru, Moche. Stirrup-Spout Vessel in the Form of a Seated Deer. A.D. 200–500. Ceramic. 27.9 cm (11"). The Metropolitan Museum of Art, New York, New York. Gift of Nathan Cummings.

Crafts

The Mochica buried fine works of gold and pottery with their dead. One of these, a gold and turquoise earring, is shown in Figure 6–12. The object was found in 1987 in a tomb near Sipan (see-**pahn**), Peru. The tomb is one of few untouched by thieves that scientists have located. In it, they discovered the remains of a warrior-priest, several servants, and a dog. Did you notice the headdress and necklace worn by the human figure on the earring? One of the skeletons in the tomb was dressed in much the same way.

In the design of their pottery, the Mochica borrowed from the Chavín. A Mochica stirrup-spout pitcher is shown in Figure 6–13. Compare this object with the jaguar pitcher in Figure 6–11. Which spout do you find more graceful? Which of the two ways of showing figures do you find the more stylized?

TIAHUANACO CULTURE

The Tiahuanaco (tee-uh-wahn-**ahk**-oh) civilization developed around the time the Mayas were coming to power. The Tiahuanaco made their home in the Andes highlands of modern Bolivia, just below Lake Titicaca (tee-tee-**kahk**-uh). Find Lake Titicaca on the map in Figure 6–10.

Architecture

Like the Mayas, the Tiahuanaco were master builders. The gateway to their great ceremonial center is a **monolith,** *a structure created from a single stone slab.* A doorway was cut through and a large, richly carved stone laid across the top. See Figure 6–14. Carved in the center of this stone is the image of the sky god, a short figure standing on a carved pedestal holding staffs in both hands. On either side are running figures with weapons, ready to answer the sun god's commands.

Crafts

The unusually dry climate of the Andes highlands has helped preserve another side of Tiahuanaco art. That is the civilization's work in weaving. Figure 6–15 shows a detail from a shirt of the culture. Notice how many colors the weaver used. Would you describe the shapes in this design as organic or geometric?

INCAN CULTURE

About 1450 the Incas conquered the other Andean tribes. The Incan empire stretched more than 2500 miles (4023 km) from north to south. It included present-day Peru plus parts of Ecuador, Chile, Argentina, and Bolivia. Find these countries on the map in Figure 6–10. Each tribe the Incas conquered was forced to learn their language, Quechuan (**kech**-wahn). Today 6 million people speak this language.

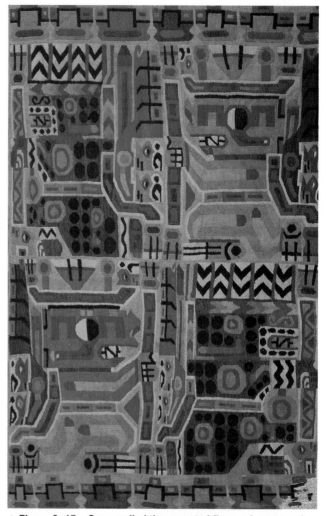

▲ **Figure 6–15** Can you find the repeated figure of a crowned cat carrying a staff in its paw? Notice how the details change in each figure. In what way is this design similar to the designs used in relief carvings such as those seen in Figure 6–14?

Peru, Coastal Huari-Tiahuanaco. Shirt Section. A.D. 600–1000. Wool, cotton. 53.5 cm (21″). The Metropolitan Museum of Art, New York, New York. Michael C. Rockefeller Memorial Collection.

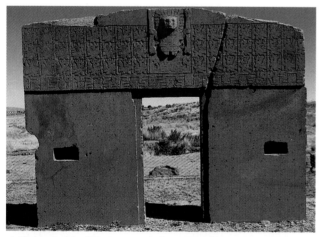

▲ **Figure 6–14** What two techniques has the carver used to emphasize the importance of the sun god carved in the center of this gateway?

Gate of Sun Creator. Tiahuanaco. A.D. 600. Virachocha, Aymara Culture, Bolivia. Photo © by Robert Frerk.

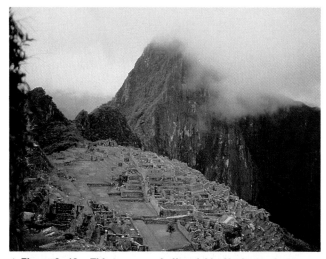

▲ **Figure 6–16** This town was built quickly. Yet it stood up to all invaders. What does this reveal about the skill of its builders?

Machu-Picchu, Peru.

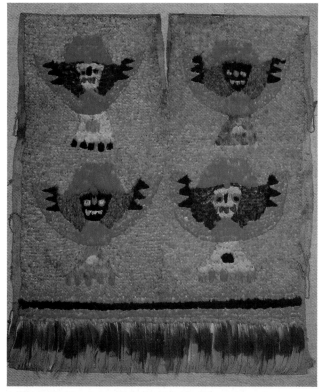

▲ **Figure 6–17** Some of the feathers in this work are from tropical birds that lived far from the Incan capital of Cuzco. Some experts believe that this demonstrates that the Inca may have carried on trade with other civilizations.

Peru, South Coast. Pre-Inca period. A.D. 800–1300. Tunic. Feathers on canvas. 75.9 x 59.1 cm (29⅞ x 23¼"). The Metropolitan Museum of Art, New York, New York. Fletcher Fund.

The Incas never developed a true writing system. They did, however, develop a method for counting called quipu (**kee**-poo). In quipu, knotted strings were used to stand for numbers. These knots were also used as memory aids in reciting Incan history. The Incas' abilities with numbers is reflected in their art. Incan artifacts were made with great mathematical precision.

Architecture

The Incas were masters of shaping and fitting stone. They were also highly skilled urban planners. Proof of both talents can be found in the walled city of Machu Picchu (**mahch**-oo **peek**-choo). Figure 6–16 provides a view of this ancient city. Built on a mountainside to discourage would-be attackers, the city has withstood five centuries of earthquakes. The stones of its buildings were so carefully matched a knife blade cannot be slipped between any two.

Crafts

Like the Tiahuanaco, the Incas were also gifted weavers. Figure 6–17 shows a woven panel covered with feathers. The colors in the work are the natural ones found in the feathers. Why do you think the Incas chose feathers to decorate their works?

✔ CHECK YOUR UNDERSTANDING

1. Which Andean tribe was the earliest? When did it come into being?
2. What is the meaning of *stylized*? What art works did you study in this lesson that were stylized?
3. For what types of art work are the Tiahuanaco best known?
4. The Incas were masters of what type of skills?

Making a Stylized Motif

Animals, as you have seen, play an important role in Pre-Columbian art. Look at Figure 6–18. The artist has used a stylized pairing of a man and animal as a motif. Notice how the man in the motif is holding a torch. Notice also how the motif is repeated through the use of shapes and colors.

WHAT YOU WILL LEARN

You will pick two related objects that are important in modern life. You will stylize and combine these into a motif that could be used in a design for fabric or wallpaper. Pick colors that add harmony to your design and carry over shapes from one object to the other to create a feeling of unity in your design. (See Figure 6–19.)

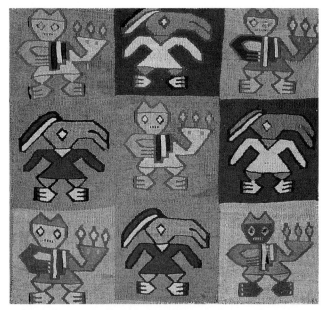

▲ **Figure 6–18** Motifs may be simple or complex. Which word would you use to describe the motif in this shirt? Can you find motifs in any of the items of clothing you are wearing right now?

Peru. Textile fragments. Late Chimu. c. A.D. 1000. Cotton, wool. The Metropolitan Museum of Art, New York, New York. Gift of Henry G. Marquand.

WHAT YOU WILL NEED

- Pencil and sketch paper
- Sheet of white paper, 6 x 9 inches (15 x 23 cm)
- Sheets of construction paper in assorted colors, 12 x 18 inches (30 x 46 cm)
- Ruler, scissors, and white glue

WHAT YOU WILL DO

1. Brainstorm with members of your class to identify objects associated with late twentieth-century living. Some possibilities are cars, telephones, computers, and radios. Pick one object that holds particular importance for you. Then think of a second object that in some way is related to it. A car, for example, might be paired with a gasoline pump; a telephone might be paired with a teenager.
2. Make rough pencil sketches for a motif that combines the objects you picked. Connect the two in some manner. The curly wire of a telephone, for instance, could become the hair of a teenager. Draw one of the objects larger than the other. If possible, simplify some of the larger shapes or forms to geometric ones. Carry one or more shapes from one object over to the other. (Notice how the diamond shapes appearing as eyes on the animal in Figure 6–18 also appear on the man.) This will help lend a feeling of unity to your design.
3. Pick your best motif. Transfer it to the sheet of white paper. Draw the design large enough to fill most of the paper. Cut it out. This is your motif pattern.
4. Pick hues of construction paper that suit the mood of your design. Use one of these colors to serve as a background for

your work. Using the ruler and working lightly in pencil, divide a sheet in this color into four equal boxes.

5. Trace your motif pattern onto your remaining sheets of construction paper. You will need four copies in all. You may use the same color for each motif or use a different color for each. (See Figure 6–20.) Using scissors, carefully cut out the motifs you have drawn.

6. Experiment with arranging your motifs in the four boxes on your background sheet. Try turning two of the motifs upside down. When you have found an arrangement that satisfies you, glue the motifs in place.

7. Use leftover scraps of construction paper to make designs for your motif. Whatever designs you add to one must appear on all others.

8. Place your work on display. Can you identify the stylized objects in your classmates' works?

▲ Figure 6–19 Student work. Stylized motif.

EXAMINING YOUR WORK

- **Describe** Tell what objects you chose for your motif. Tell how you connected them. State whether you stylized your objects. Identify the hues you selected.
- **Analyze** Tell how the colors you picked add harmony to your design. Point out the shape or shapes you carried from one object to the other to create unity.
- **Interpret** Name one or more ways in which your design might be used. Tell whether your design is similar in style to the one in Figure 6–18.
- **Judge** Tell whether you feel your motif succeeds. Explain why you feel it does or does not.

▲ Figure 6–20 Student work. Stylized motif.

Try This!

COMPUTER OPTION

■ Use Paint or Shape tools. Make a line drawing of two objects for your motif. Use Selection tool and Transformation menu to Flip, Turn, and Rotate design. Choose an analogous or complementary color scheme, use earth tones, or tints and shades. Flood-fill shapes in your motif with Bucket tool. Save and title your work.

How Do You Read the Aztec Calendar?

The Aztecs actually used two calendars. One was based on the sun and was tied to the agricultural cycle. The other was a sacred calendar, used by astrologers for making predictions and planning ceremonies. The two were used in combination like two interlocking cog wheels. Every 52 years the first days of the two calendars coincided. Great ceremonies were planned to please the gods because the Aztecs feared that the world might come to an end on this date.

Twenty day signs are represented on the inner ring. Each day sign had an animal symbol and also was associated with a god.

The face of Tonatiuh, the Sun God, is represented in the center of the stone.

Quetzalcoatl was the god of wind and air, represented by a feathered serpent.

The twenty day-signs were divided into four sections that coincided with the four compass directions, North, South, East, and West.

Tomas Filsinger. *Aztec Cosmos.* 1984. Colored paper. 90 x 90 cm (36 x 36″). Celestial Arts, Berkeley, California. Excerpted from Aztec Cosmos ©1984 by Tomas Filsinger. Reprinted by permission of Celestial Arts.

MAKING THE CONNECTION

- ✔ What figures are shown on the painting of the calendar stone? What do they tell you about Aztec life?
- ✔ Why do you think the compass directions would be important to an agricultural calendar?
- ✔ Find out more about the Aztec rituals and sacrifices that took place at the end of each 52-year cycle.

INTERNET ACTIVITY

Visit Glencoe's Fine Arts Web Site for students at:

http://www.glencoe.com/sec/art/students

CHAPTER 6
REVIEW

BUILDING VOCABULARY

Number a sheet of paper from 1 to 8. After each number, write the term from the list that best matches each description below.

adobe genre pieces
artifacts monolith
effigy motif
funerary urn stylized

1. Simple handmade tools or objects.
2. Art works that focus on a subject or scene from everyday life.
3. An image that stands for ideas or beliefs.
4. A decorative vase or vessel found at burial sites.
5. Simplified or exaggerated to fit a specific set of rules of design.
6. Sun-dried clay.
7. A structure created from a single stone slab.
8. Part of a design that is repeated over and over in a pattern or visual rhythm.

REVIEWING ART FACTS

Number a sheet of paper from 9 to 17. Answer each question in a complete sentence.

9. What does the term *Pre-Columbian* mean? How do art historians use the term?
10. What is an artifact?
11. Why is the Olmec culture often called the "mother culture" of Mexico?
12. What city was the center of West Mexican culture?

13. What ancient city did scientists discover in northern Guatemala in the late 1800s? To what culture did this city belong?
14. What was the largest civilization of ancient Mexico and Central America?
15. What animal did the Chavín hold to be sacred?
16. What design feature did the Chavín create in their works that was later used by other cultures?
17. Why was Machu Picchu built on a mountainside? What evidence can be used to support the claim that the builders were talented architects?

THINKING ABOUT ART

On a sheet of paper, answer each question in a sentence or two.

1. **Summarize.** Tell how developments taking place throughout Pre-Columbian America were expressed through the art of the following time periods: 1000 B.C. to A.D. 100; A.D. 300 to 1000; A.D. 1000 to 1500.
2. **Compare and contrast.** Which of the two cultures of Mesoamerica that you read about were most alike? Which were the least alike? Support your answers with information from the chapter.
3. **Compare and contrast.** Review what you learned about the great Egyptian pyramids in Chapter 4. Which of the Pre-Columbian cultures built pyramids for the same reason? Which built pyramids for other reasons?

MAKING ART CONNECTIONS

1. **Language Arts.** Imagine you are touring the parts of present-day South America you studied in this chapter. Write a letter to a friend back home expressing your reactions to the art of ancient peoples of the region. Use the descriptions and pictures from this chapter as a starting point.
2. **Social Studies.** Research cultural and religious traditions of the Incan or Aztec cultures. Report your findings to the class.

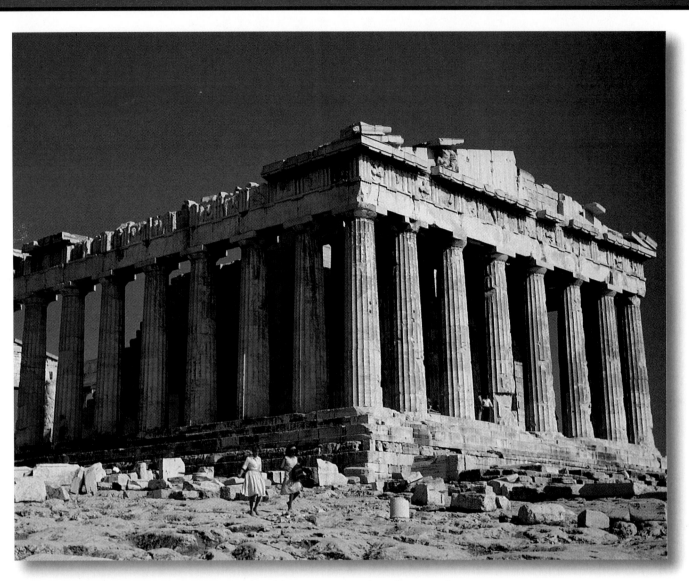

▲ This temple was once used as a Christian church and then as a mosque. Later it was used to store ammunition. It was partly destroyed when an artillery shell exploded in its center.

Parthenon. Temple of Athena. 5th Century B.C. Acropolis, Athens, Greece.

Art of Greece and Rome

What did you think of when you read the title for this chapter—grand buildings like the Greek Parthenon and the Roman Colosseum? Perhaps your thoughts turned to splendid sculptures of winged goddesses or powerful emperors. Chances are that you *did not* think of Greek vase paintings or Roman triumphal arches. You may be familiar with more famous works by Greek and Roman artists and architects.

In this chapter you will discover that there is a great deal to see in *all* forms of ancient art. You may even find that some of your most rewarding discoveries are made while viewing Greek vases or Roman triumphal arches.

PORTFOLIO IDEAS

Create an art work for your portfolio that represents the influence of Greek or Roman art. Exchange your finished art work with a classmate and ask for a peer evaluation. This helps you get different viewpoints and opinions about your art work. Peers can tell you what they like about your art work and offer suggestions for revising the work. Decide whether you want to revise or change your art work based on the peer review. Then store the peer evaluation, your preliminary sketches, and the final art work in your portfolio.

OBJECTIVES

After completing this chapter, you will be able to:
- Identify the contributions of the ancient Greeks and Romans to the history of art.
- Name some important works by ancient Greek and Roman artists.
- Paint in the style of Greek and Roman artists.
- Model in the architectural style of ancient Greece and Rome.

WORDS YOU WILL LEARN

amphora
aqueduct
concrete
frieze
round arch
triumphal arch

Art of Ancient Greece

Why study events that happened over 3000 years ago in a country the size of Arizona? Why bother learning the names of artists whose works no longer exist? The reason in both cases is that the country — Greece — was the birthplace of Western civilization. The influences of ancient Greek culture and art can still be felt and seen today.

In this lesson you will learn about that culture and art.

THE BEGINNING OF GREEK CULTURE

The story of ancient Greece begins around 1500 B.C. It was around this time that different groups from the north settled in the region bordering the Aegean (ih-**jee**-uhn) Sea. Find the Aegean on the map in Figure 7–1.

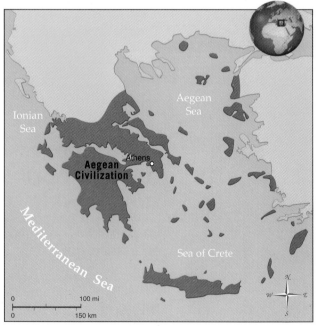

▲ Figure 7–1 Aegean Civilization.

Greece never became a nation. Instead, the tribes that formed it remained small, separately ruled powers called city-states.

Part of the reason for this was geography. High, rocky mountains and miles of sea divided the different city-states. Two other, and more important, factors were self-pride and jealousy. It was loyalty to their own and distrust of others that prevented the city-states from banding together to form a nation.

One of the largest and most powerful of the city-states was Athens. Athens was also the most important in the history of art.

Architecture

The artists of Greece valued above all else grace, harmony, and precision. These qualities are present in the work that opened this chapter on page **96**. This famous building is the Parthenon. The Parthenon was a temple built in honor of the Greek goddess Athena (uh-**thee**-nuh). It stood along with other temples on a sacred hill known as the Acropolis (uh-**krop**-uh-luhs). (See Figure 7–2.) The word *acropolis* means "high city."

The Parthenon is thought to be the most perfect building ever created. Take a moment to study this art treasure. Like other works of Greek architecture, it uses the post and lintel system. Do you remember learning about this system of building in Chapter 4? Can you find the posts in the Parthenon? Can you find the lintels?

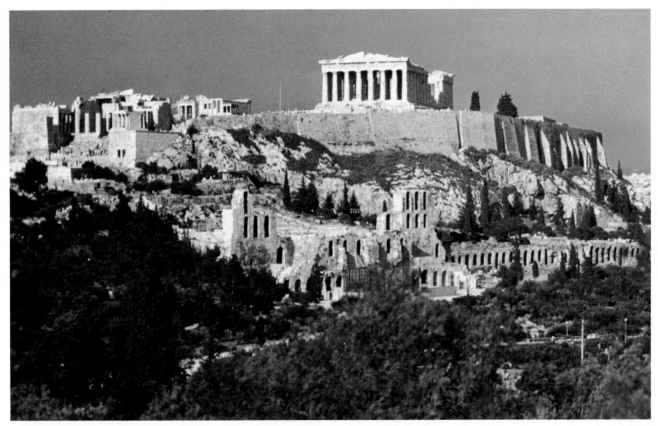

▲ Figure 7–2 The Acropolis rises 500 feet (150 m) above Athens. It was once filled with magnificent buildings. The Parthenon is the large building in the center.

Acropolis, Athens, Greece.

Sculpture

Sculpture was another of the outstanding achievements of ancient Greek art. At first sculptures were stiff and awkward. In time, however, as Greek sculptors gained skill and confidence, they began creating works that were remarkably lifelike and natural. Figure 7–3 shows one such work. Notice the attention to detail. Even the veins in the arm have been made to stand out in sharp relief. Carved in marble, sculptures like this looked even more realistic because sometimes their surfaces were painted.

Another example of Greek sculpture can be found in Figure 2–9 on page **25**. This long horizontal relief carving is a frieze (**freez**) from the Parthenon. A **frieze** is *a decorative band running across the upper part of a wall*. See how the horses almost seem to gallop across the work. The carving of this frieze was over-

seen by a sculptor named Phidias (**fid**-ee-uhs). Art historians agree that Phidias was among the greatest of all Greek sculptors. One of his most famous works was a magnificent statue of the goddess Athena created for the Parthenon. Made of gold and ivory, the statue rose 40 feet (12 m) to the ceiling. Sadly, this statue and almost all of Phidias's other individual works have been lost. The only knowledge we have of them comes through ancient written descriptions.

Painting and Crafts

Even more famous than the sculptors of ancient Greece were its painters. Like the sculptors, the painters sought to make their pictures as realistic as possible. None of the works of the great Greek painters have survived, however. As with the sculpture of Phidias, these works exist for us only in the words of ancient writers.

Some examples of ancient Greek painting do exist, however, in the pictures found on surviving pottery. The earliest Greek vases were decorated with bands of geometric patterns. One of these objects is shown in Figure 7–4. Found in a cemetery in Athens, this **amphora** (**am**-fuh-ruh), or *twin-handled vase*, was used as a grave marker. The small scene toward the center shows a burial ceremony.

Human figures were later added to the decorations on vases. At first these were little more than stick figures. Later they became more realistic and lively. Often the subjects were gods and goddesses or popular heroes. Scenes from sports and battles were also popular. The amphora in Figure 7–5 shows runners in a race. Notice how the repeated pattern of running figures adds a sense of movement. The curved surface of the vase adds to this feeling. Vases like this were sometimes used as prizes at the games held each summer in Athens. They were filled with olive oil from sacred groves and presented to victorious athletes.

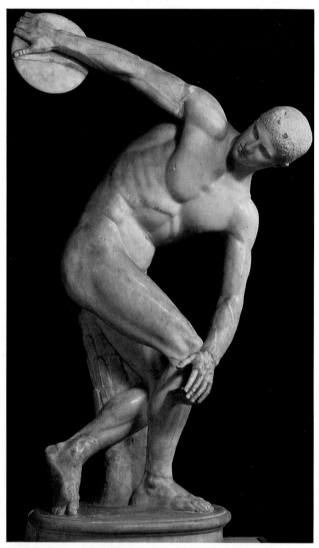

▲ **Figure 7–3** The original statue by Myron is known only through descriptions and reconstructed copies. Notice how the sculptor used balance and rhythm to show harmonious form.

Myron. *The Discus Thrower.* Roman copy of a bronze original of c. 450 B.C. Life-size. Museo Nazionale Romano, Rome, Italy.

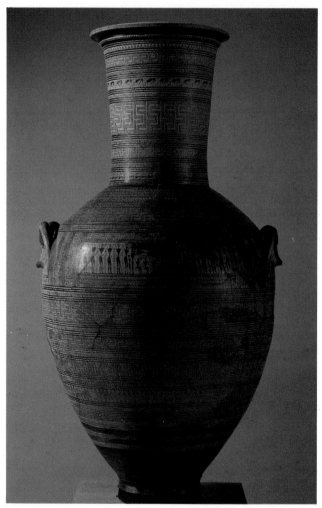

▲ **Figure 7–4** Notice the geometric patterning. Does this design remind you of those created by any cultures you have read about? If so, which ones? This vase was used as a grave marker in much the same way tombstones are used today.

Amphora. Geometric Style. Athens National Museum, Athens, Greece.

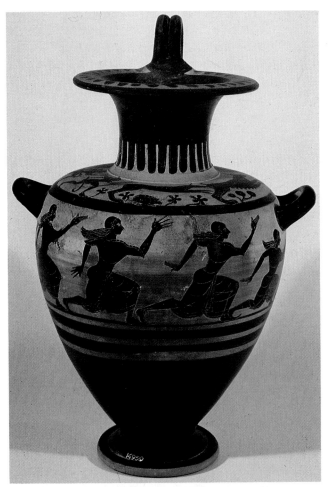

▲ **Figure 7–5** Are all the figures on this vase alike? Notice how the curved surface of the vase makes it appear as if the runners are racing over a circular course.

Amphora. *Runners in a Race.* Etruscan. Vatican Museum.

▲ **Figure 7–6** Examples of Greek vase shapes.

STUDIO ACTIVITY

Shaping a Vase

Greek craftspeople designed their pottery for many different purposes. They created large jars for storage and delicate cups for drinking. Examples of these and other vase shapes are shown in Figure 7–6.

Fold a large rectangular sheet of white paper in half. Pick one of the vase shapes in Figure 7–6. Place the point of your pencil at the folded edge of the paper. Draw *one half* of the vase as accurately as you can. Make sure your drawing ends at the crease. Leaving the paper folded, cut out your vase shape along the line you have drawn. When the paper is unfolded, you will have a symmetrical cutout of the vase.

P O R T F O L I O

Imagine your vase served a purpose in ancient Greek history. Write a short paragraph telling what it would have been used for, and where it would have been kept. Keep your written description with your vase cutout in your portfolio.

✔ CHECK YOUR UNDERSTANDING

1. Why did the city-states of ancient Greece never join together to form a nation?
2. What three qualities did the artists of Greece value most?
3. What was the Parthenon? On what sacred hill is it found?
4. What is a frieze? What famous artist oversaw the work on the Parthenon's frieze? What other contribution to the Parthenon did he make?
5. What sorts of designs were painted on early Greek vases? What was painted on later Greek vases?

Making a Painting for a Greek Vase

Art critics, you will recall, judge works in terms of different aesthetic views. Look carefully at the Greek amphora pictured in Figure 7–7. How might a critic stressing the importance of the subject of a work react to this vase? Do the figures on the vase look real? Are their actions lifelike?

Think next about how a critic emphasizing composition might respond to the work. Can you find the *X* made of real and imaginary lines? Do you notice how these lines link the warriors to each other and to the amphora's handles? Note, finally, how a critic stressing content might react to this vase. Did you notice the two women at either side of the work? Could these be the mothers of the two warriors? Could it be they are weeping and pleading for their sons to stop fighting?

A measure of this amphora's greatness is that it succeeds in terms of all three aesthetic views.

WHAT YOU WILL LEARN

You will use tempera to paint one of the following: a scene of warriors in battle, a wedding, an athletic event. Your picture will have at least two figures. Make these figures as realistic as you can. Use the principle of movement to organize the lines and shapes. Finally, your scene will communicate a meaning, mood, or feeling. Paint your scene on a vase cutout like the one you made for the Studio Experience in Lesson 1. (See Figure 7–8.)

WHAT YOU WILL NEED

- Pencil and sheets of sketch paper
- Scissors
- Sheet of white paper, 18 x 24 inches (45 x 61 cm)
- Black tempera paint, several brushes, and mixing tray

▲ **Figure 7–7** This is one of two scenes of combat painted on this vase. Both show warriors of the Trojan war. Have you ever heard of that war? Do you know which sides fought in it?

Black Figured Panel Amphora. Painter of the Medea Group, Greek. 520–510 B.C. Terra cotta, glazed. Lip 19.7 x Base 16.4 x Height 46.4 x Diameter 27.9 cm (Lip 7¾ x Base 6⁷⁄₁₆ x Height 18¼ x Diameter 11″.) Dallas Art Museum, Dallas, Texas. Munger Fund.

SAFETY TIP

When a project calls for paints, use watercolors, liquid tempera, or school acrylics. If you must use powdered tempera, wear a dust mask. Try also to work away from other class members.

WHAT YOU WILL DO

1. Pick one of the three themes for your painting. Make several pencil sketches of scenes that have this theme. Use the vase painting in Figure 7–7 as a model. In your design, create real and imaginary lines that add a sense of movement to it. Keep your design simple. Make sure to emphasize the figures in it. Choose your best sketch.

2. Review the vase shapes in Figure 7–6 on page **101**. Decide which of the shapes would be best suited to your sketch. Using scissors, create this shape out of the large sheet of white paper. Follow the instructions given in the Studio Experience on page **101**.

3. Transfer your sketch to the cutout. Using a fine-pointed brush and black tempera, trace over the outlines of your figures. Carefully paint around lines that are to appear within figures. These lines will appear white in the finished painting.

4. Decorate and paint the rest of your vase using black only. (*Hint:* The neck, handles, and foot of the vase are well suited to decorations.)

5. When your vase painting is dry, display it. Note ways in which it is similar to and different from those created by your classmates.

► Figure 7–8 Student work. Greek vase painting.

EXAMINING YOUR WORK

- **Describe** Tell which of the three scenes you picked for your work. Describe the shape of amphora you chose. Tell whether the figures in your work look lifelike.
- **Analyze** Tell whether you used the principle of movement to organize the lines and shapes in your picture. Tell whether the shape of the vase is well suited to the picture you created.
- **Interpret** State whether your picture communicates a meaning, mood, or feeling. Note whether your classmates are able to identify this mood or feeling.
- **Judge** Tell whether you feel your work succeeds. Explain your answer.

Try This!

COMPUTER OPTION 🖥

▨ Begin with the Symmetry tool or menu. Choose Mirrors or Bilateral Symmetry. Draw a vase using ideas shown on page 101. Save. Design an active figure in profile. Select, Move, Copy, and Repeat figure. Add a small border to frame the figures. Use the Bucket Flood-fill tool or a Brush to color the figures and vase with contrasting black and earth tones.

Art of Ancient Rome

The Greek city-states were not only unable to band together to form a nation, they were also unable to keep the peace among themselves for long. Frequent outbreaks of fighting over a 1300–year period weakened the country. It made Greece helpless against attack from outside forces. Finally in 197 B.C., Greece fell to the Romans.

Although the Greek empire was defeated, Greek influence continued. The Romans were influenced by Greek ideas about art and used them in their own works.

In this lesson you will learn about some of those works.

ANCIENT ROMAN CULTURE

By the time of its takeover of Greece, Rome was the greatest power in the civilized world. At its peak, the city had a population of over one million people. Find this city on the map in Figure 7–9.

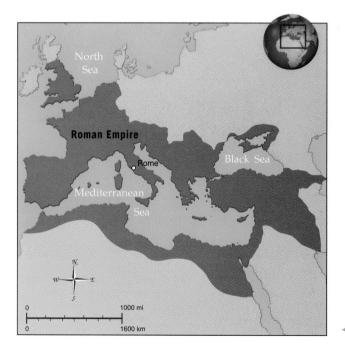

Rome was a city of contrasts. There were magnificent public buildings, baths, and parks, but there were also narrow streets crammed with shabby dwellings.

The Romans were a practical-minded people. They were more interested in such things as engineering, law, and government than in art. Romans did, however, make some very important contributions to the world of art.

Architecture

Rome's greatest contributions were in the field of architecture. Among its accomplishments were:

- **Concrete.** This *mixture of powdered minerals and small stones* was used to create buildings with great domes and ceilings. One such building is shown in Figures 7–10 and 7–11. This is the Pantheon. It was a temple built to honor all the Roman gods. Concrete made it possible for Roman architects to build a huge dome over this temple. The Pantheon is the largest domed building from ancient times still standing.
- **The round arch.** This *curved arrangement of stones over an open space* opened up new building possibilities. A series of round arches could be used to build bridges and other structures.

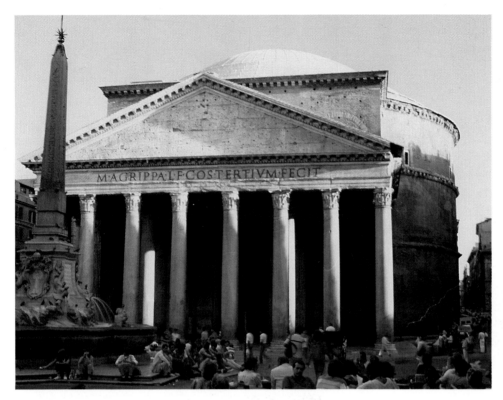

◄ **Figure 7–10** Greek temples were built to be "used" only by their gods. Roman temples like this one were built to be used by the people for prayer. The building is large enough to hold 3000 people.

Restored by Hadrian. Pantheon Facade and Piazza della Rotunda. A.D. 118–125. Rome, Italy.

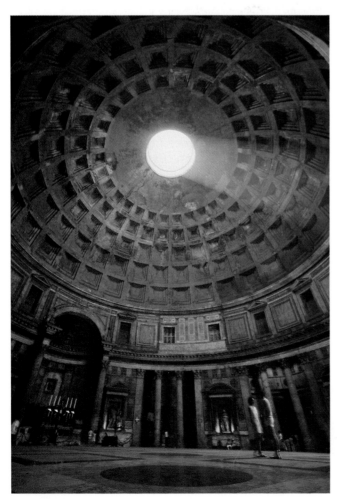

◄ **Figure 7–11** The dome of the Pantheon soars to a height of 144 feet (44 m). The hole at its center is the building's only source of light. Though the hole looks small, it is actually 30 feet (9 m) across.

Restored by Hadrian. Pantheon Interior. A.D. 118–125. Rome, Italy.

Lesson 3 *Art of Ancient Rome* **105**

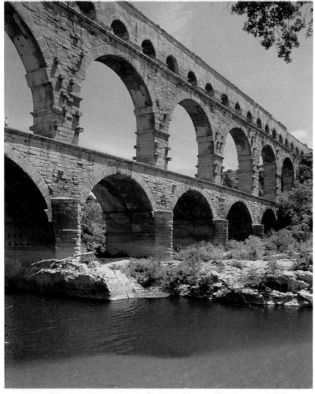

▲ **Figure 7–12** Aqueducts sloped ever so slightly. This allowed gravity to carry the water on its way. This aqueduct was part of a system 25 miles long that carried water to the city of Nimes.

Pont du Gard. 20–16 B.C. Near Nimes, France.

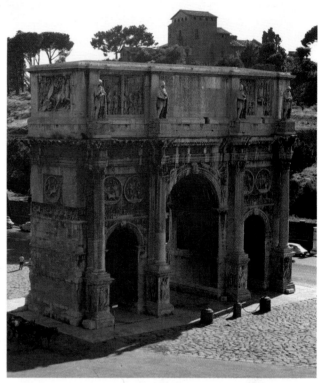

▲ **Figure 7–13** Roman arches like this one have been copied in later periods all over Europe. This arch was the largest and most elaborate of those erected by the Romans.

Arch of Constantine. A.D. 312–15. Rome, Italy.

- **The aqueduct** (ak-wuh-duhkt). This *network of channels, meant to carry water to a city*, was another type of structure that used round arches. The aqueduct in Figure 7–12 was built to carry water over a valley 600 yards (548 m) wide. This impressive structure is 160 feet (48 m) high. Note how the arches are placed side by side. This allowed them to support each other and carry the weight to the ground.
- **The triumphal** (try-**uhm**-fuhl) **arch**. This was *a monument built to celebrate great army victories*. The largest ever built was the Arch of Constantine, shown in Figure 7–13. The round arch was used here by the ancient Romans for purely decorative reasons. Notice how the structure uses three round arches. The emperor and his officers would ride chariots or horses through the large center one. Foot soldiers would march through the smaller side arches as the people of Rome cheered.

Sculpture

Like the Greeks before them, the Romans aimed for realism in their sculpture. A number of the works that remain are portrait sculptures. One of these is pictured in Figure 7–14. Study this work. Notice the care the sculptor has taken to capture not just lifelike detail but also the features of a specific individual. The eyes look as though they might blink at any moment. What mood or feeling does this sculpture communicate?

The Romans also excelled at relief sculpture. The ones shown in Figure 7–15 are from the Arch of Constantine. These reliefs tell of the deeds of the emperor in battle. What events seem to be taking place in the section of the story shown?

▲ **Figure 7–14** What is there about this face that makes it look like someone you might see on the street?

Bust of Philip the Arab dressed in a toga. A.D. 244–249. Marble. Vatican Museum, Rome, Italy.

◀ **Figure 7–15** Many of the relief carvings on this arch were taken from earlier monuments. Some of the figures on them were changed so they would look more like the emperor Constantine.

Arch of Constantine. A.D. 312–15. (Detail.) Rome, Italy.

STUDIO ACTIVITY

Designing an Arch

Suppose one of your school's sports teams has just scored an important victory. You have been asked to design a triumphal arch to be built in the school gym.

Study the Roman arch in Figure 7–13, noticing the different features. Then, working in pencil in your sketchbook, design your arch using the same features. Make sure your work has three rounded arches and columns. Draw in some freestanding sculpture of the coach and star players. Then sketch relief carvings on the arches that focus on highlights of the winning game.

PORTFOLIO

In your sketchbook, list other events that might be commemorated with a triumphal arch. Write one or two sentences comparing a triumphal arch to ways people celebrate triumph today. Keep your notes with your architectural design in your portfolio.

✔ CHECK YOUR UNDERSTANDING

1. What led to the downfall of Greece? When was Greece finally conquered?
2. What were Rome's three main contributions to the history of architecture?
3. What was the Pantheon?
4. What is an aqueduct? What is a triumphal arch? What was the triumphal arch used for?
5. What was a key aim of Roman sculpture?

Making a Model of a Roman Triumphal Arch

Art critics often approach their study of architecture just as they do the study of paintings or sculptures. They begin by describing what they see, and then they analyze the ways the principles have been used to organize the elements. After that they interpret the meanings, moods, and feelings the work communicates. Finally, they judge whether the work succeeds and explain why. Doing this helps the critic understand and appreciate a work of architecture.

Look at the triumphal arch pictured in Figure 7–16. What do you think an art critic would say about this arch during each of the four steps of art criticism? How would you, as an art critic, describe, analyze, interpret, and judge it?

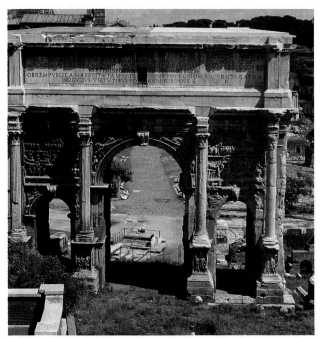

▲ **Figure 7–16** Describe how the light creates different values on the surface of this monument. How does repetition of shapes add to the harmony of the arch?

Arch of Septimus. Roman Forum.

WHAT YOU WILL LEARN

You will build a model of a triumphal arch out of cardboard and construction paper. Your arch will have all the features outlined in the Studio Experience in Lesson 3. You will use a variety of different shapes and forms. Some of these will be repeated to add harmony. Your work will have formal balance. (See Figure 7–17.)

WHAT YOU WILL NEED

- Empty cardboard soap or cereal box, taped shut
- Large sheets of colored construction paper, including gray and black
- Pencil, scissors, and white glue
- Assortment of magazines featuring sports illustrations
- Scraps of heavy cardboard

WHAT YOU WILL DO

1. Place the cardboard box down flat on a sheet of gray construction paper. With the pencil, trace around the box. Hold a second sheet of gray construction paper firmly against the first. Using scissors, carefully cut through both sheets along the line you drew. Glue the sheets to the front and back of the box. Cover the top and side panels of the box with gray construction paper.
2. Look back at the drawing you made for the Studio Experience in Lesson 3. Doubling two sheets of black construction paper, cut out two large rounded arches and four smaller ones. Glue these arches in place on the front and back of the box. Use your drawing as a guide.

3. Use construction paper to create columns and other decorations. Glue these in place.
4. Look through the sports magazines. Locate black-and-white photographs showing scenes of the sport you chose for your design drawing. Look for action shots that focus on athletes. Cut these out and trim them to fit on your arch. Glue those that are to work as reliefs directly to the arch. Glue those that are to work as free-standing sculpture to small scraps of heavy cardboard before gluing them in place on the arch. This will make them seem to project outward in space.
5. When the glue has dried, display your arch. Compare your work with that of your classmates.

SAFETY TIP
Be very careful when using cutting tools such as scissors and knives. Pick these up only by the handle, never by the blade. Make sure also to offer the handle when you are handing the tool to another person.

EXAMINING YOUR WORK

- **Describe** Point out the round arches on the front and back of your arch. Point out the columns. Point out the two different types of sculpture.
- **Analyze** Tell whether your arch has formal balance. Identify the variety of shapes and forms you used. Tell whether these add harmony to the work.
- **Interpret** State whether your arch tells the story of an important team win. Tell whether it communicates pride in this victory.
- **Judge** Tell whether you feel your work succeeds. Explain your answer.

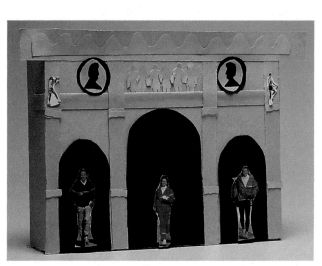

▲ Figure 7–17 Student work. Triumphal arch.

Try This! STUDIO OPTIONS

■ On a large sheet of poster board, draw the outline of a triumphal arch using a black felt-tipped marker. Decorate the arch with magazine cutouts standing for a personal victory. Possibilities include learning to play a musical instrument, making one of the school's athletic teams, or joining a school club.

■ Create another triumphal arch, this time out of clay. Use the clay slab method. Be sure to use proper joining techniques. Use a clay tool to carve decorations and relief sculptures on your arch.

How Did the Olympics Originate?

The people of ancient Greece valued grace, harmony, and precision not only in their art and architecture but also in their minds and bodies. A keen mind in a healthy, strong body was the ideal. The ancient Greeks described a backward person as someone who could "neither swim nor spell."

Education and athletic training were part of daily life. Physical exercise was just as important as intellectual development. Individual and team sports were offered at local gymnasiums, and libraries and reading rooms were also available there.

The Greeks' love of athletic competition was an important part of most religious festivals. The most famous of these was the festival in honor of the god Zeus. It was held every four years at Olympia, beginning in 776 B.C. Athletes from all over Greece competed in such events as foot races, wrestling, boxing, and the pentathlon. Though the Olympics were open to only men and boys, women had their own games held in honor of the goddess Hera.

In 1896, the first modern Olympic games were held in Athens, Greece, to promote individual character and world peace. Women competitors were included beginning in 1900.

Orsi. *Games of the VIIIth Olympiad, Paris.* 1924. Lithograph. 120.5 x 81.5 cm (47½ x 32″). Collection. Amateur Athletic Foundation of Los Angeles.

MAKING THE CONNECTION

- How does the Olympic athlete pictured here reflect the Greek ideals of grace, harmony, and physical development?
- In what ways are attitudes toward sports and education in today's society similar to or different from the Greeks' views?
- Find out more about the Olympic games of long ago as well as the modern games. How are they alike? How are they different?

INTERNET ACTIVITY

Visit Glencoe's Fine Arts Web Site for students at:

http://www.glencoe.com/sec/art/students

CHAPTER 7
REVIEW

◆ BUILDING VOCABULARY

Number a sheet of paper from 1 to 6. After each number, write the term from the list that best matches each description below.

amphora frieze
aqueduct round arch
concrete triumphal arch

1. A decorative band running across the upper part of a wall.
2. A twin-handled vase.
3. A mixture of powdered minerals and small stones used in building.
4. A curved arrangement of stones over an open space.
5. A network of channels meant to carry water to a city.
6. A monument built to celebrate great army victories.

◆ REVIEWING ART FACTS

Number a sheet of paper from 7 to 15. Answer each question in a complete sentence.

7. What are two reasons why the Greek city-states never banded together?
8. Which was the largest and most powerful of the Greek city-states?
9. What is the Acropolis? What does the word *acropolis* mean?
10. What goddess was the Parthenon built to honor?
11. To make their sculptures appear even more realistic, what did the Greeks do?

12. Who was Phidias? Name two contributions he made to the Parthenon.
13. In what area of art did the Romans make their greatest contribution?
14. What made possible the building of the dome on the Pantheon?
15. Name two structures in which the Romans used the round arch.

❓ THINKING ABOUT ART

On a sheet of paper, answer each question in a sentence or two.

1. **Interpret.** Look again at the sculpture in Figure 7–3 on page **100.** Tell what you think this figure is doing. Decide what word you would use to describe his feelings at this moment. Explain your answer.
2. **Compare and contrast.** Using the Parthenon and Pantheon as models, list the similarities and differences between Greek and Roman temples.
3. **Analyze.** Examine the aqueduct shown in Figure 7–12 on page **106.** What art elements can you identify in this structure? What principles of art have been used to organize the elements?
4. **Extend.** As you have read, the Romans were influenced by Greek ideas about art and used them in their own works. In which area of art do you find this influence to be most evident? Support your answer with facts and examples of specific works from the chapter.

⎯ MAKING ART CONNECTIONS ◀

1. **Social Studies.** In this chapter you learned that the Romans were very interested in law and government. In an encyclopedia or other library resource, read about these areas. Search for ties between Rome's system of government and its architecture. Write a short report on your findings.

2. **Language Arts.** The early Greeks and Romans created beautiful mosaic works, some of which have lasted for centuries. Read *Piece by Piece! Mosaics of the Ancient World,* by Michael Avi-Yonah, to learn about ancient and modern mosaic techniques.

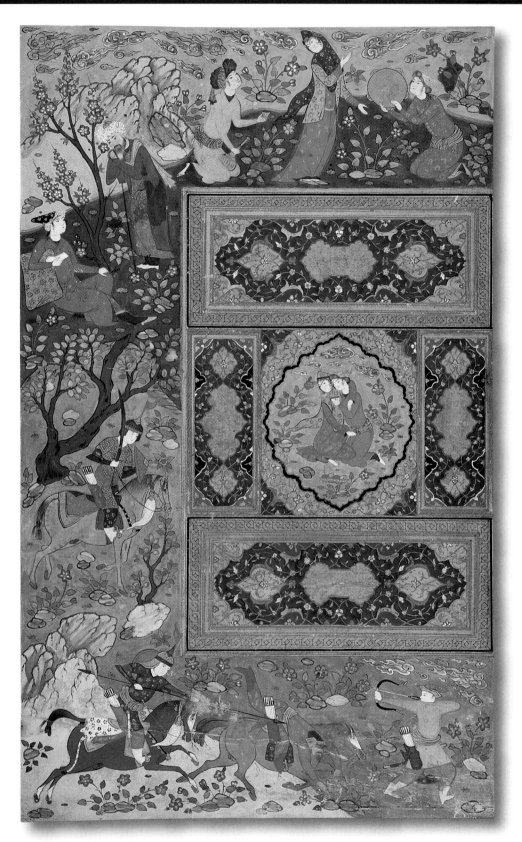

▲ This miniature painting was part of a collection noted for elaborate margins and brilliant coloration. Notice how the entire space is filled with objects and patterns.

A Pair of Lovers. Manuscript page from the Vignier Album, Iran. c. 1590–1610. Opaque watercolor, ink, and gold on paper, mounted on board. 40.2 x 27.8 cm (15⅞ x 10⅞"). Smithsonian Institution, Washington, D.C. Arthur M. Sachler Gallery.

Art of India and Islam

In a way, the frame around a work of art is like a window. The miniature painting on the left contains a scene within a scene. The couple within the smaller window is separated from the scenes of hunting and feasting that surround them. The panels surrounding them are filled with patterns of arabesque decoration as if to set them apart.

This miniature is from an album of paintings that illustrate the legends of Iran and its leaders. The artist used intricate details and rich colors to enhance this story.

You will learn to interpret images like this one in the pages that follow.

OBJECTIVES

After completing this chapter, you will be able to:
- Identify the major Indian contributions to architecture and sculpture.
- Explain how Islamic culture began.
- Identify the major Islamic contributions to painting, architecture, and crafts.
- Create a design in the Hindu style.
- Make an art work in the Islamic style.

WORDS YOU WILL LEARN

arabesques
calligraphy
collage
mihrab
minaret
mosque
stupas

PORTFOLIO IDEAS

Select one of your art works from this chapter for a portfolio entry. Explain how the art work represents the influence of Indian or Islamic art. Is the art work a drawing, painting, or sculpture? Explain how you made the art work. What elements or principles of art did you emphasize? Date and store your written entry along with the art work in your portfolio.

Art of India

India is a land of opposites. It is a country of snow-capped peaks and tropical lowlands, of parched deserts and rain-soaked valleys.

Yet, for all its differences, India is a land joined by the strong religious beliefs of its people. These beliefs have in large measure shaped Indian art since the dawn of civilization. In this lesson you will learn about the religion and art of India.

THE RELIGIONS OF INDIA

Indian culture has long been guided by two religions. One of these, Buddhism, you read about in Chapter 5. The other, and older, of India's religions, Hinduism (**hin**-doo-iz-uhm), has its roots in prehistoric times. It was as an outgrowth of Hinduism that Buddhism emerged around 500 B.C.

Unlike Buddhism, Hinduism is not based on the teachings of a single leader. Rather, it is the collected ideas and beliefs of many peoples and cultures over thousands of years. A key belief of Hinduism is that the individual can come to know the powers of the universe through worship. Another is that the soul never dies. Instead, it is reincarnated (ree-uhn-**kahr**-nayt-uhd), or reborn, into a lower or higher life form depending on a person's behavior during his or her previous life.

Hinduism and Buddhism — sometimes together, sometimes separately — have influenced Indian art over the last 2500 years.

Architecture

Among the earliest, and most important, examples of modern Indian architecture are **stupas** (**stoop**-uhs), which are *beehive-shaped domed places of worship*. These were built by Buddhist architects to honor their religion's founder and other important leaders. Each stupa was reached through four gates covered with relief sculptures. Figure 8–1 shows the Great Stupa at Sanchi (san-**chee**). Find Sanchi on the map in Figure 8–2. Completed before A.D. 1, this impressive structure rises to 50 feet (15 m) at its highest point. Notice the contrast between the dome's smooth surface and the detailed carvings of the gate.

▶ Figure 8–1 Believers would pass through one of the gates, then slowly walk around the dome. All the while they would meditate. Do you recall what meditation is?

The Great Stupa. c. A.D. 1. Sanchi, India.

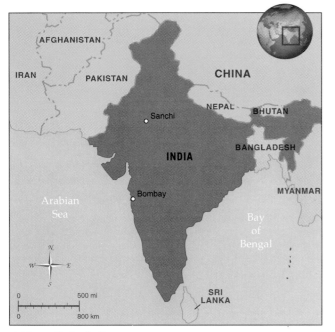

▲ Figure 8–2 India.

No less impressive were the great temples Hindu architects created some 600 years later. One of the most striking facts about these temples is how some of them were built. They were cut directly into solid natural rock formations.

Figure 8–3 shows an important achievement of Hindu temple building. This amazing structure was cut from a hilltop by many craftspeople. Its hall, almost 100 feet (30 m) square, is decorated with deeply carved religious panels. Yet, like other early Hindu temples, it was made to be viewed mainly from the outside. To the Hindus, a temple was as much sculpture as it was architecture.

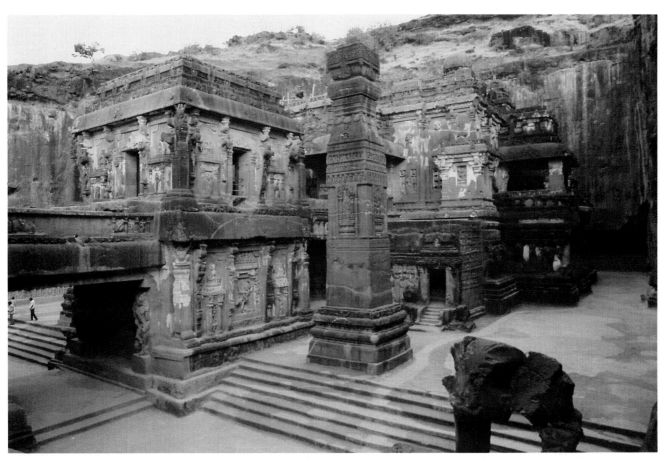

▲ Figure 8–3 Temples like these were cut from solid rock and needed no structural support. However, they were made to look like earlier wooden buildings.

Rock Cut Temple, India.

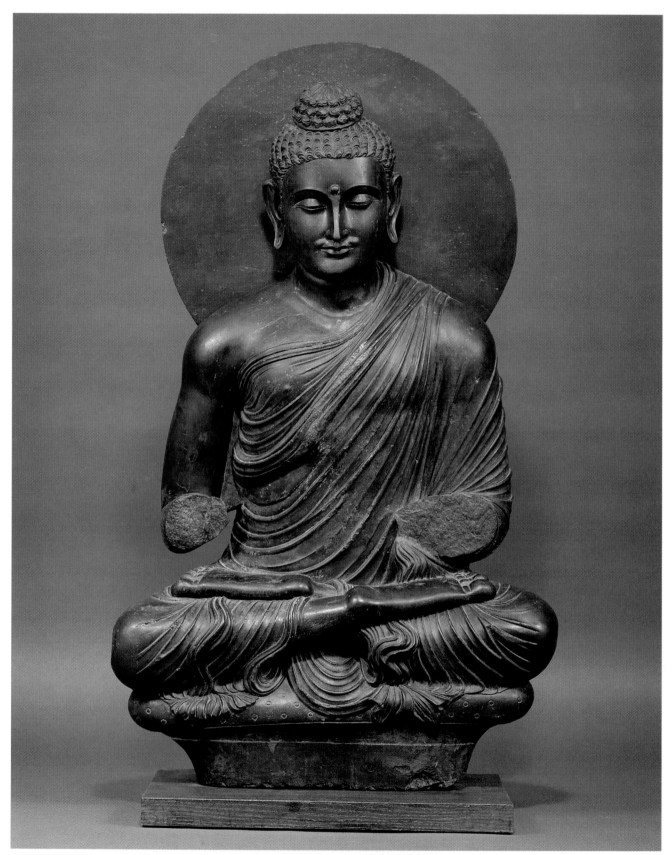

▲ **Figure 8–4** **Born around 563 B.C., a rich Indian prince named Siddhartha Gautama went out in search of knowledge. His search eventually led the prince to reform the Hindu religion. He became known as Buddha, or "The Enlightened One," and he preached a simple message of salvation, which was to meditate, give up worldly possessions, and do good works.**

Seated Buddha. Indian, Gandhara region. Kushan Period. First half of 3rd Century A.D. Gray schist. 100 x 29.5 cm (39⅜ x 11⅝"). The Cleveland Museum of Art, Cleveland, Ohio. Leonard C. Hanna, Jr. Fund.

Sculpture

Many sculptures, such as the work in Figure 8–4, show the Buddha seated in meditation. Look closely at this sculpture. Notice the dot on the forehead, the seated pose, and the unusually long earlobes of the figure. All are standard features of the Buddha image, each having its own special meaning. The earlobes, for instance, are a reminder of the heavy earrings the Buddha, who was born an Indian prince, wore before he gave up worldly possessions.

In sharp contrast to the weighty stone Buddha figures are the light, open sculptures of cast metal created later by Hindu sculptors. One of these works, the *Tree of Life and Knowledge*, is pictured in Figure 8–5. This sculpture expresses the Hindu belief in the creative force of the universe. Many animals were sacred to the Hindus, especially the cow. Can you find the cows in this work? What other creatures and birds do you notice? What kind of balance has the sculptor used?

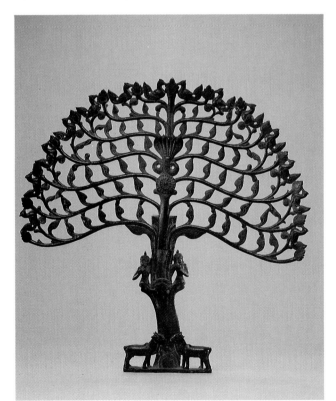

◀ **Figure 8–5** The "tree of life" ties in with the Hindu belief in reincarnation. Since Hinduism teaches that animals have souls, they too can be reborn into higher or lower forms.

Tree of Life and Knowledge. Southern India, Late 1500–1600 A.D. Bronze. Nelson-Atkins Museum of Art, Kansas City, Missouri. Given anonymously.

STUDIO ACTIVITY

Decorating Your Tree of Life

Look again at Figure 8–5. Each animal in the work plays a special part in the Hindu view of life. The goose at the end of each branch stands for the soul's ability to "take flight." The five-headed serpent at the center is a sign of evil and danger.

With a pencil and fine-tipped markers, create your own tree of life. Use the same kind of balance noted in the *Tree of Life and Knowledge.* Fill the branches of your tree with objects that play a part in your personal happiness: pets, symbols of favorite pastimes, or good luck charms. Create decorative patterns of repeated objects similar to the patterns in Figure 8–5. Indicate the importance of objects based upon where they appear on your tree.

PORTFOLIO

Mount your tree of life on poster board to keep it in your portfolio. In your sketchbook, tell why you included the items that you did. Review your tree of life in a month, to see if you would add or delete any of the items you included.

✔ CHECK YOUR UNDERSTANDING

1. What are two key beliefs of Hinduism?
2. What is a stupa?
3. How was the temple shown in Figure 8–3 created?
4. Name three standard features of early Indian Buddhist sculptures.

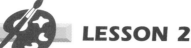 **LESSON 2**

Making a Life-Size Dancing Figure

Hindu art is full of contrasts. Study the sculpture in Figure 8–6. This is Shiva (**shee-vuh**), one of three main gods of the Hindu religion. Notice the contrast between the vertical calm of Shiva's head and the diagonal movement of his arms, legs, and body. His pose captures the feeling of Hindu dance.

WHAT YOU WILL LEARN

You will create a life-size dancing figure based on the style of the Hindu sculpture. You will contrast the vertical calm of the head with the diagonal movements of the arms, legs, and body. Tempera paint in two contrasting hues will be used to paint the figure. You and your classmates will work together to create the shapes of your figures. When completed, the dancing figures may be combined to create a dramatic display.

WHAT YOU WILL NEED

- Section of butcher paper large enough to accommodate your entire body
- Pencil
- Scissors
- Tempera paint, large and small brushes, mixing tray, and paint cloth
- Black marker with a medium point

WHAT YOU WILL DO

1. Study carefully the sculpture of Shiva. Notice the position of the head, arms, and legs.
2. Place the butcher paper on the floor and lie down on it. Keep your head in a vertical position but adjust your arms and legs to look as if you are dancing.
3. Have another student use a pencil to trace a line completely around your body. Then trace around the other student's body.

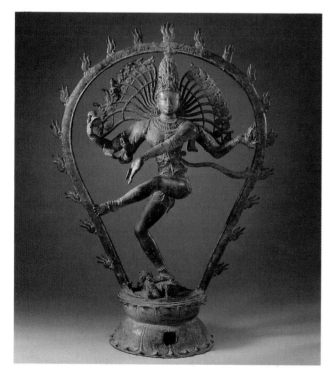

◀ **Figure 8–6 Every part of this sculpture has a meaning. The arch and its three-tongued flames stand for the universe and its destruction by fire. The drum in the figure's "upper right" hand stands for the sound of the bang beginning the universe.**

Tamil Nadu. *Shiva, King of the Dancers* (Nataraja). Chole Dynasty, 10th Century. Bronze. 76.2 x 57.1 x 17.8 cm (30 x 22½ x 7"). Los Angeles County Museum of Art, Los Angeles, California. Given anonymously.

4. Use scissors to cut out the figure.
5. Select two *complementary colors* of tempera with which to paint a decorative costume. Use a black marker to add details and simplified facial features.
6. Arrange all the cut-out figures in your class along a wall to suggest a ceremonial dance.

EXAMINING YOUR WORK

- **Describe** Can you easily identify the arms, legs, body and head of your figure? Does it look as if it is dancing?
- **Analyze** How does your figure show movement? Does the vertical calm of the head contrast with the diagonal movements suggested by the arms, legs, and body?
- **Interpret** What kind of dance does your figure suggest—slow and graceful, or fast and lively?
- **Judge** Using subject and content as the basis for judgment, do you think your work is successful? What could have been done to make it even better?

▲ Figure 8–7 Examples of student work.

Try This! ## STUDIO OPTIONS

■ Do a second version of your dancing figure, this time using a monochromatic color scheme with tempera paint. Describe in what ways this design differs from your original.

■ Draw the figure and cover it with a chalk line pattern. Paint between the lines and paint the negative space.

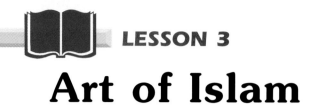

Art of Islam

Hinduism, which had lost favor in India with the rise of Buddhism, began making a comeback around A.D. 600. During this same period another religion was taking shape 2000 miles (3220 km) to the west. This new religion would grow into one of the world's largest, with some half billion followers. Its name is Islam (**iz**-lam).

THE GROWTH OF ISLAM

The birthplace of Islam is the city of Mecca (**mek**-uh), located on the Arabian peninsula. Find Mecca on the map in Figure 8–8. There in A.D. 613 a merchant named Muhammad (moh-**ham**-uhd) began preaching a faith centering on one god. This god, called Allah, had revealed himself to Muhammad during meditation. People who came to share Muhammad's beliefs recognized him as Allah's holy messenger. The followers of Muhammad are called Muslims (**muhz**-luhms).

Muhammad's lifelong dream was a world united under Islam. By the early 700s, his followers had spread his message to the Middle East, North Africa, Europe, and Asia.

Painting

The Koran (kuh-**ran**) is a collection of sacred writings of Islam. It is a record of the beliefs of Muhammad. A page from the Koran is shown in Figure 8–9. Some of the finest examples of early calligraphy (kuh-**lig**-ruh-fee) are found in this book. **Calligraphy** is *a method of beautiful handwriting sometimes using a brush.* Notice the circular gold decorations among the flowing letters. **Arabesques** (ar-uh-**besks**) are the *swirling geometric patterns of plant life used as decorations.* These became a popular decoration because the early Muslim teachings forbade picturing humans or animals.

Architecture

Muhammad taught that dying in battle for the faith guaranteed Muslims entrance into Paradise. As a result, Islam was often spread through force rather than preaching. Each new conquest was celebrated by the building of a **mosque,** a *Muslim house of worship.* By the 800s the Muslim capital of Córdoba (**kord**-uh-vuh), Spain, alone was reported to have 300 mosques.

▲ **Figure 8–8 The lands of Islam.**

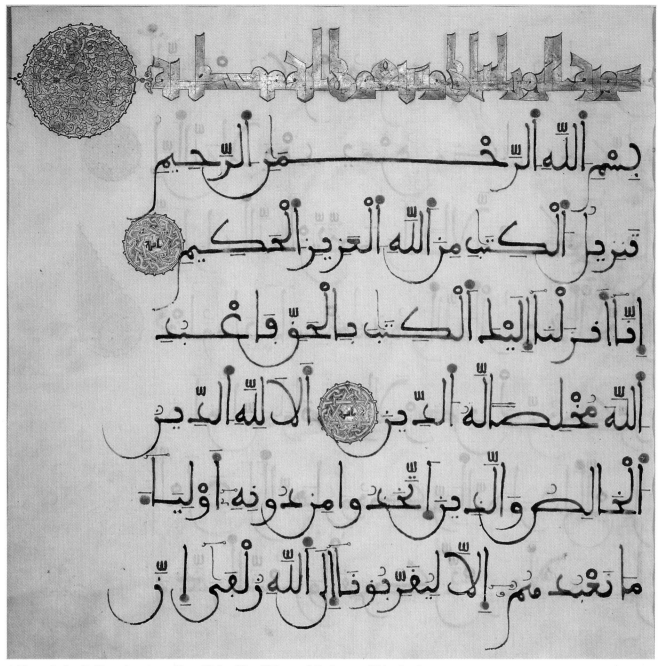

▲ **Figure 8–9** Calligraphy means "beautiful writing." The work that opened this chapter on page 112 also makes use of calligraphy. Can you find it in among the figures?

Leaf from Qur'an (Koran), in Maghribi Script. Islamic, North African. c. 1300. Ink, colors and gold on parchment. 53.3 x 55.8 cm (21 x 22"). The Metropolitan Museum of Art, New York, New York. Rogers Fund.

Figures 8–10 and 8–11 show two views of a Spanish mosque begun in the 700s. In Figure 8–10 you can see a **mihrab** (**mee**-ruhb), which is *a highly decorated nook found in a mosque.* Covered with calligraphic inscriptions from the Koran, the mihrab is found on the wall closest to the holy city of Mecca. The origin and purpose of the mihrab is still a mystery. Some scholars feel it may honor the place where Muhammad stood in his own house when he led his followers in prayer. It became a standard feature of all mosques. Rising above the outside of such mosques are found one or more minarets (min-uh-**rets**). A **minaret** is a *slender tower from which Muslims are called to prayer* five times a day. Can you

▲ **Figure 8–11** The exterior of the Great Mosque in Córdoba offers little hint of the glories inside. The interior is filled with a forest of columns creating aisles that guide the visitor to the mihrab, the most important part of the mosque.

The Great Mosque and Roman Bridge. Córdoba, Spain.

▲ **Figure 8–10** Muslims always turn toward Mecca while praying. An arched dome in the mosque frames the mihrab, which is visible at the bottom of the picture.

The Great Mosque of Abd-ar-Rahman. 8–12th Century. Moorish. Mihrab with arched dome. Córdoba, Spain.

▶ **Figure 8–12** This work was built by a Muslim leader as a memorial to his wife. Notice the perfect symmetry of the building and all that surrounds it.

Taj Mahal, garden and pools. c. 1650. Agra, India.

find the minarets in the famous structure in Figure 8–12? Do you know the name and location of this famous building?

Crafts

One of the great contributions of Islamic art is the knotted-pile, or Persian, carpet. The knots in this type of carpet are so close together that when the pile (raised loops of yarn) is worn away the colors of the design are still visible. The shimmering surface of the carpet in Figure 8–13 is filled with a delicate pattern of vines and blossoms, some in full bloom and others emerging from buds.

▲ **Figure 8–13** **This carpet is considered to be among the world's great works of art. In sixteenth-century Iran the arts, particularly textiles and book arts, flourished.**

The Ardabil Carpet. Maqsud of Kashan, Persia, Tabriz. Safavid Dynasty. 1540. Silk and wool. 8.7 x 4.9 m (23'11" x 13'5"). Los Angeles County Museum of Art, Los Angeles, California. Gift of J. Paul Getty.

STUDIO ACTIVITY

Making Persian Knots

Look again at Figure 8–13. A feature common to carpets like this is the Persian knot, illustrated in Figure 8–14. Using knots like these, the weaver was able to create an unusually tight weave.

Make a very small cardboard loom and make a warp. (See Chapter 13, Lesson 2, for a description of how to make a warp.) Using a tapestry needle and yarn, alternate rows of Persian knots with rows of tabby (simple over, under, over, under) weave.

P O R T F O L I O

You can keep your weaving in your portfolio. If you prefer to display your sample, photograph it for portfolio use.

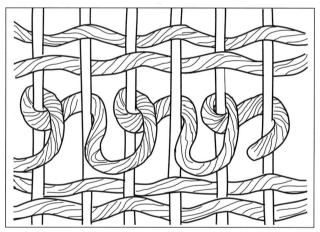

▲ **Figure 8–14** **Persian knot diagram.**

✔ CHECK YOUR UNDERSTANDING

1. Who was Muhammad? When and where did he begin preaching his new faith?
2. What are his followers called?
3. What is the Koran? What is calligraphy?
4. What is an arabesque? Why did arabesques become popular?
5. What is a mosque? What are two standard features of mosques?
6. What kind of carpets are Islamic artists famous for?

Making a Collage in the Islamic Style

Look at the Islamic miniature painting in Figure 8–15. Everything seems to be flat on the picture plane. The colors are intensely bright. How many different scenes or images do you see? Notice how the artist presents many points of view in the same work of art. A variety of patterns are used to fill the background spaces. Shapes, colors, and patterns are emphasized. By doing so, the illusion of depth is not felt.

WHAT YOU WILL LEARN

In this lesson you will create a **collage**, *an art work made up of bits and pieces of two-dimensional materials pasted to a surface*. Your collage will focus on several scenes related to a current event or activity. The work will be organized, however, in the manner of a flat, patterned Islamic miniature painting. You will use bright colors, decorative patterns, and flat shapes as in Figure 8–15. You will create the background shapes using patterned fabrics and papers. People and other objects can be made by drawing and painting them on white paper. See Figure 8–16.

WHAT YOU WILL NEED

- Pencil, sketch paper, ruler, scissors
- Sheet of white paper or poster board, 22 x 28 inches (56 x 71 cm)
- A variety of patterned fabrics and papers
- White glue, colored pencils
- Small pieces of white drawing paper

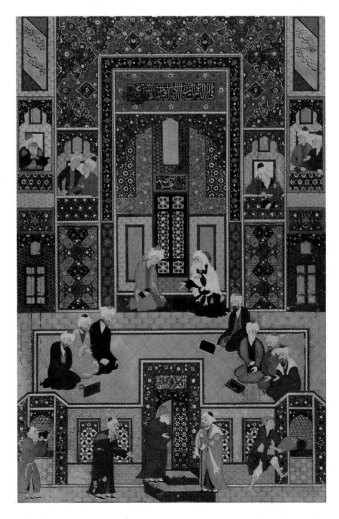

◀ **Figure 8–15** This is a page of a book meant to be held in the hand and studied closely. Notice the patterns, rhythmic designs, and bright colors. Some of the pigments for the work were made by grinding precious metals such as gold and silver.

'Abd Allah Musawwir. *The Meeting of the Theologians*. c. 1540–1549. Colors on paper. Bokhara. Nelson-Atkins Museum of Fine Arts, Kansas City, Missouri.

WHAT YOU WILL DO

1. Brainstorm with classmates for ideas that could best be explained by showing several different scenes. For example, to show a football game you might have one scene of a huddle, one of a tackle, and one of the ball being kicked. Pick an event, such as a school dance, a parade, or a wedding. Make pencil sketches of different objects and scenes from the event you picked.

2. Make a plan to arrange your best ideas within rectangles of different sizes. Using the ruler and pencil, lightly draw these rectangles on the poster board.

3. Measure each shape and cut out patterned fabric or paper to fit each shape. As you select each pattern for the background, consider how one will look next to another. Look for contrast in the fabric so that you can see the distinction between each shape. If you wish, you may draw and color patterns in some of the spaces. Glue the pieces of fabric and paper to the poster board.

4. Draw and color figures and objects to place in each scene. Measure first to be sure that the figure will fit inside its area. Cut out the drawn objects and glue them onto the design.

5. When the glue is dry display your work. See whether classmates can guess what event your collage celebrates.

▶ **Figure 8–16 Student art. Collage in the Islamic style.**

EXAMINING YOUR WORK

- **Describe** Identify the different scenes and objects related to your events. Explain why you placed each scene or object where you did.
- **Analyze** Show where you used contrast in your design. Identify how you used the element of space. Explain how the many different patterned areas made your work look different from other art works you have created.
- **Interpret** State what feeling or mood your work communicates to viewers.
- **Judge** Tell whether you feel your work succeeds. Explain your answer.

 COMPUTER OPTION

■ Make patterned papers on the computer to use in your collage. Cover the page with patterns and textures using tools, menus, and special effects provided in your software. If available, scan and import fabrics, pictures, or photos. Use a digital camera to capture people or objects you want to add. Once imported, these images can be resized for your collage. Print. Follow directions in the Studio Lesson.

How Is Geometry Used in Art?

Living creatures have always depended on geometry for survival. Spider webs, beehives, and nests are all examples of geometry at work in nature. Everything around us reflects the balance, order, and symmetry of geometry.

The use of geometry developed from practical human needs. In the fourteenth century B.C., for example, King Sesostris of Egypt divided the land equally among his subjects. Each received a rectangle of the same size of land and it was taxed accordingly. If a person lost land due to the annual flooding of the Nile River, the king sent someone to measure, and the owner's taxes were reduced. In ancient Greece, the study of geometry was the cornerstone of one's education. It still is.

Geometry is used to solve everyday problems, but it is also used to create beautiful designs. The designs found in Islamic art often use geometric shapes like the circle, triangle, square, hexagon, and six-pointed star. Such designs were based on the belief that art should embellish rather than imitate real life. Working with geometric shapes gives an artist an infinite variety of combinations, limited only by the artist's imagination.

Molded Tile Panel. Kashan, Iran, 13th–14th Century. Design of six-pointed star and hexagonal tiles. Ceramic, turquoise, and cobalt glaze. 60.9 x 105 cm (24 x 41½"). Excavations of The Metropolitan Museum of Art, 1936, and Rogers Fund, 1937.

MAKING THE CONNECTION

- Identify the geometric shapes used in the Islamic wall panel shown here.
- What other images did the artist use in the wall panel besides geometric shapes? Why do you think the artist chose these images?
- Find additional examples of Islamic wall panels and tiles. Compare the artists' use of geometric shapes and images.

INTERNET ACTIVITY

Visit Glencoe's Fine Arts Web Site for students at:

http://www.glencoe.com/sec/art/students

CHAPTER 8
REVIEW

BUILDING VOCABULARY

Number a sheet of paper from 1 to 7. After each number, write the term from the list that best matches each description below.

arabesques minaret
calligraphy mosque
collage stupas
mihrab

1. Beehive-shaped domed places of worship.
2. A method of beautiful handwriting sometimes using a brush.
3. Swirling geometric patterns of plant life used as decorations.
4. A Muslim house of worship.
5. A highly decorated nook found in a mosque.
6. A slender tower from which Muslims are called to prayer.
7. An art work made up of bits and pieces of two-dimensional materials pasted to a surface.

REVIEWING ART FACTS

Number a sheet of paper from 8 to 15. Answer each question in a complete sentence.

8. What two religions have played a major role in the art of India over the last 2500 years?
9. How were Hindu temples like the one shown in Figure 8–3 created?
10. What is the explanation for the unusually long earlobes found on Buddha sculptures?
11. What Hindu belief is revealed in the *Tree of Life and Knowledge* sculpture?
12. What is the name of the god of Islam? How did Muhammad come to know this god?
13. In what book central to the Islam faith was calligraphy used?
14. What buildings did Muslim conquerors raise after each new conquest?
15. What can you see in Persian carpets that reveals the special weaving method with which they were made?

THINKING ABOUT ART

On a sheet of paper, answer each question in a sentence or two.

1. **Interpret.** Read the following statement: "To appreciate fully a work of religious art, you must be a member of the religion." Tell whether you agree or disagree. Defend your position with information and examples from this and other chapters.
2. **Compare and contrast.** What common features can you find between Buddhist and Hindu temples? What differences between the two can you note?
3. **Analyze.** Pick one art work from the chapter. Note how the elements of art and principles of art were used in the work. Identify the way they were used.

MAKING ART CONNECTIONS

1. **Social Studies.** Like Islam, Buddhism spread far from its birthplace. Compare the Japanese sculpture of Buddha you studied in Chapter 5 on page **73** with Figure 8–4. List the ways the two works are alike and different. Note the style features of each sculpture.

2. **Language Arts.** Create a verse for a greeting card. Write your poem using a calligraphy style. Illustrate your card with arabesque decorations. Add small details and fill your illustrations with color.

▲ Headaddresses like this were made to be worn during ceremonies as a sign of magical power. This one celebrates the power of Orangun, a mythic warrior-king. Note the importance placed on the central figure.

Bamgboye of Odo-Owa. *Epa Cult Mask.* c. 1920–1930. Wood. 121.9 cm (48″) high. Detroit Institute of Arts, Detroit, Michigan. Founders Society Purchase, Friends of African Art Fund.

Art of Africa

The art of Africa gives us a glimpse into the traditions, ideas, and beliefs of the many cultures from across this vast continent. African artists use materials from the natural environment to create art works that serve a practical function in the day-to-day activities of peoples from each geographic region.

Much of the African art you see in museums today was created for decoration or display. Works like the one pictured at the left are a tribute to the imagination and skill of recent African artists. They honor the tradition of generations of artists who came before. In this chapter you will learn about figure sculptures, masks, headpieces, and Kente cloth.

OBJECTIVES

After completing this chapter, you will be able to:
- Describe the figures in wood and bronze made by African tribal sculptors.
- Name the three kinds of masks made by African tribal sculptors.
- Work with different media to create abstract and imaginative art objects.

WORDS YOU WILL LEARN

abstract work
face mask
headpieces
papier-mâché
shoulder masks

PORTFOLIO IDEAS

Create an entry for your portfolio that shows the influence of African art. Think of something you *really like*—an animal, object or place. Using the art works in this chapter as sources of inspiration, create an art work using the media of your choice. Provide a brief explanation of how the African art work influenced your final product. Put your name and date on it, and place it in your portfolio. If it is a three-dimensional art work, take a picture of it and mount the photo on tagboard with the date and title. Store it in your portfolio.

The Figure Sculptures of Africa

African art works represent centuries of history and culture. Africa is the second largest continent in the world, and the population is divided into almost a thousand different cultural groups. Figure sculptures and carvings of humans and animals were created for traditions and events that relate to everyday lives of the artists. For this reason, the sculpture of Africa is an important contribution to the world's cultural heritage.

THE CULTURES OF AFRICA

The peoples of Africa below the Sahara live in many different nations and kingdoms. (See the map in Figure 9–1.) Each culture has made its own unique contribution to the world of art. Rock carvings and etchings in the south were created 27,000 years ago. The Mombasu and Lamu create ornate wood carvings influenced by trade with India. From the Kongo in central Africa come examples of masks, textiles, carvings, and funerary figures. In this lesson, you will read about the human figure sculptures created by African artists of the Western regions.

Carved Wood Figures

A favored medium of the early African sculptor was wood. Carvings were usually made from a single log. This technique is found in art from many different areas, including headrests from Ethiopia and Konso grave figures. The original shape of the log was often suggested in the finished works.

Figure 9–2 shows a carving by an artist from northeastern Angola. Like all African wood figures, the work is boldly carved. It is also typically abstract. An **abstract work** is *a work in which the artist uses a recognizable subject but portrays it in an unrealistic manner.*

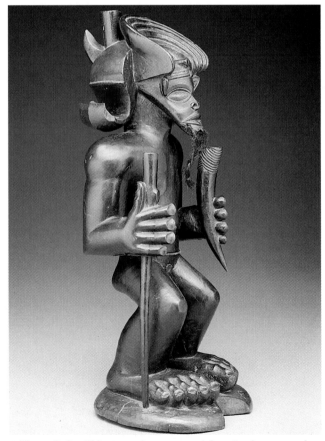

▲ Figure 9–2 African carvings were not done to please people living in the real world. They were done to satisfy spirits living in the next world.

Chibinda (The Hunter) Ilunga Katele. Chokwe, from northeastern Angola. Middle 19th Century. Wood, hair, hide. 40.6 cm (16") high. Kimbell Art Museum, Fort Worth, Texas.

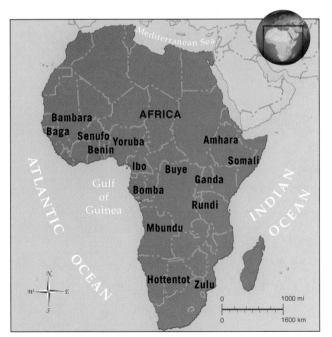

▲ Figure 9–1 Africa. Major cultural groups.

Figure 9–3 shows a Senufo carving. This one appears to be a man on a horse. Actually, it is much more than that. Legend has it that the rider is a magician. His powers allow him to travel between the spirit world and the real world. Notice how this carving seems almost to reveal the artist at work. You can almost picture the artist's knife slashing the forms of horse and rider from the log. The finished work captures the dignity and pride of the rider with his shoulders back and his chest and chin thrust forward.

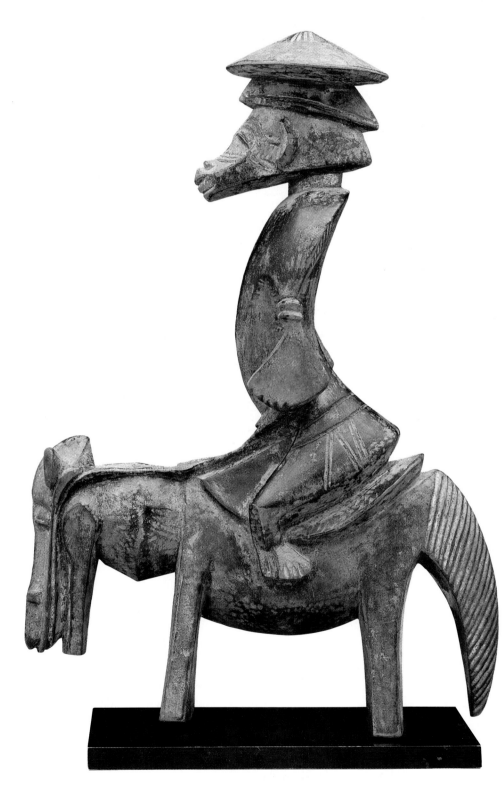

◀ **Figure 9–3** In creating figures like this, the artist would perform certain rituals. One was making an offering to the tree the wood was taken from.

Equestrian Figure. Africa, Ivory Coast, Senufo Tribe. 19th-20th Century. Wood, patination. 32.08 x 7.3 x 22.23 cm (12⅝ x 2⅞ x 8¾"). Dallas Museum of Art, Dallas, Texas. Gustave and Franyo Schindler Collection of African Sculpture. Gift of the McDermott Foundation in honor of Eugene McDermott.

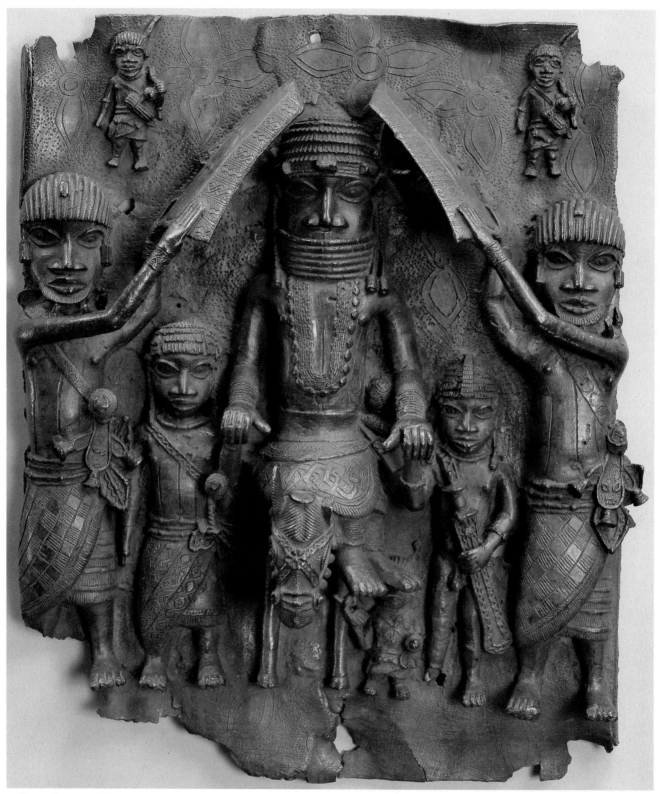

▲ **Figure 9–4** In addition to his size, what other clues are provided to emphasize the importance of the Benin king? Note the rich textures and patterns created on this high relief sculpture.

Africa. Nigeria. Court of Benin, Bini Tribe. *Mounted King and Attendants.* c. 1550–1680. Bronze. 49.5 x 41.9 x 11.3 cm (19½ x 16½ x 4½"). The Metropolitan Museum of Art, New York, New York. The Michael C. Rockefeller Memorial Collection. Gift of Nelson A. Rockefeller.

Cast Bronze Figures

The art of Africa first came to the attention of Western Europe in the late 1400s when the Portuguese explored the continent. Archaeological research continues to uncover the rich diversity and skill of African sculptors.

During the 1800s, bronze sculptures were first brought to Europe. These sculptures were made by artists of the Benin (buh-**neen**) Empire. Among the most remarkable of the works were reliefs used to decorate the wooden pillars of the palace. One of these appears in Figure 9–4. It shows the powerful king of the tribe on horseback. Two servants protect him from the sun with their shields. Two others support him with their hands, while still another supports the king's feet with his head. Notice the sculptor has made the figure of the king larger than those of the servants. This was done to emphasize the king's importance. What ancient culture that you read about had a similar practice?

Not all bronze castings by African artists are reliefs. Some, like the sculpture in Figure 9–5, are freestanding. Bronze heads like this one were placed on an altar as memorials to the king's ancestors. Notice the lifelike quality of this sculpture. What kind of balance has the artist used?

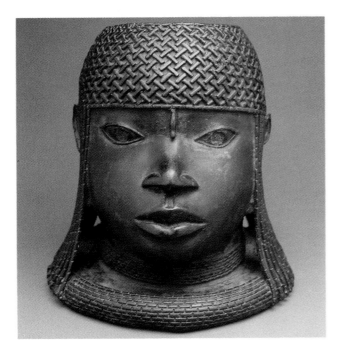

◀ **Figure 9–5** Bronze sculptures like this one demonstrate the skill of Benin artists. Notice how the different textures add to this work's visual appeal.

Africa, Nigeria. Court of Benin, Bini Tribe. Head. c. 1550. Bronze. 23.5 x 22 x 22.9 cm (9¼ x 8⅝ x 9″). The Metropolitan Museum of Art, New York, New York. Bequest of Nelson A. Rockefeller.

STUDIO ACTIVITY

Drawing Your Personality

Study Figures 9–2 and 9–3 again. Works like these were created to honor family ancestors. Suppose you lived in a place where images of past relatives were kept in every home. Think of how you would like future generations of your family to remember you. Then complete a pencil drawing of yourself as seen from the front. Show yourself in an activity that reveals your personality. The figure does not need to be a perfect likeness. It must, however, tell viewers about the kind of person you were. Try to use facial expression and stance as the artists in Figures 9–2 and 9–3 have done. Your personality, not your appearance, should be shown.

P O R T F O L I O

Ask two or three classmates to describe your work in one word. List their words in your sketchbook, and compare them to the image you wanted to show. Then tell what, if anything, you might do differently if you drew yourself again.

✔ CHECK YOUR UNDERSTANDING

1. Explain why the art of each African tribe has been an important contribution to the art world.
2. What is the meaning of *abstract work?*
3. How was the bronze relief casting in Figure 9–4 used? Explain how the details in the work help us understand the traditions of the Benin Empire.

Abstract Self-Portrait Cutout

The African figure sculptures you studied in Lesson 1 were made to honor past tribe members. They were also made to hold the spirits of past tribe members. Figure 9–6 shows another of these figure sculptures. Notice that, like other African standing figures, it is highly abstract. This work goes a step further, however. The artist here has simplified the human figure into a series of flat shapes and simple forms. You may be able to see how this abstract style had an effect on the later development of cubism in European art.

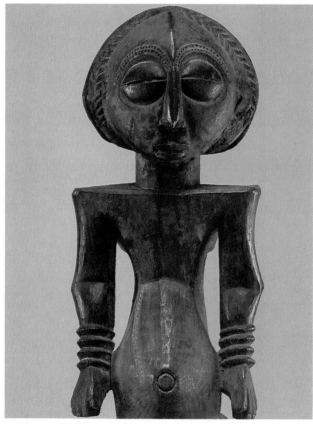

▲ **Figure 9–6 Did you notice how the features have been stylized? What has been done to simplify the figure?**

Africa, Zaire. Buye style. 19th-20th Century. Wood, kaolin. (Detail.) 77.5 x 28.9 x 21.6 (30½ x 11⅜ x 8½"). The Metropolitan Museum of Art, New York, New York. The Michael C. Rockefeller Memorial Collection. Gift of Nelson A. Rockefeller.

WHAT YOU WILL LEARN

You will create an abstract cardboard cutout self-portrait as seen from the front. Show yourself in a posture or activity that tells something about your personality. You will use flat shapes and simple forms for body parts and features. You will give the work a three-dimensional look by painting certain parts of the figure in black and white. You will add harmony by using only sharp-angled shapes and forms. (See Figure 9–7.)

WHAT YOU WILL NEED

- Pencil and sheets of sketch paper
- Piece of cardboard, 6 x 12 inches (15 x 30 cm)
- Ruler and scissors
- Black and white tempera paint
- Brushes and polymer gloss medium
- Scrap of heavy cardboard and transparent tape

WHAT YOU WILL DO

1. Look back at the drawing you made for the Studio Experience in Lesson 1. Do another drawing, this time replacing all curved lines with straight ones. Simplify the facial expression, but make sure your new version still shows a pose or expression that tells viewers about the kind of person you are. Make several sketches.
2. Draw the best of your sketches on the piece of cardboard. Use the ruler to make sure all the lines in your drawing are straight. Take care also to create shapes that are flat and angled.

3. Using the scissors, cut out your shape. Add more straight lines *within* the shapes on your cutout. These should suggest flat surfaces at different angles to each other. This will make the shapes seem more like three-dimensional forms.
4. Study the carving in Figure 9–6. Decide which shapes in your work could be painted either black or white to give it a sense of depth. Paint the cutout with black and white tempera.
5. When the paint has dried, apply a coat of polymer gloss to your cutout. Cut a wedge shape from the scrap of heavy cardboard. Using tape, attach the wedge to the back of your cutout. This will allow you to stand the cutout for display.

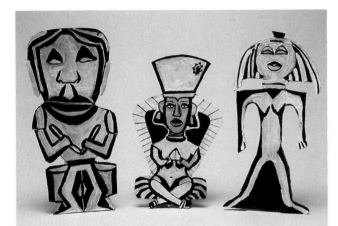

▲ **Figure 9–7 Student work. Abstract self-portrait.**

EXAMINING YOUR WORK

- **Describe** Tell how you created your cutout to be a standing figure as seen from the front. Tell whether your work is abstract. Explain why your work is considered an abstract piece.
- **Analyze** Point out the flat shapes and simple forms in your work. Identify the places where you used black or white paint to add a three-dimensional look to the work. Explain why the use of angled shapes and forms throughout adds harmony to the work.
- **Interpret** Show what features in your work would help a viewer understand what kind of person you are.
- **Judge** Identify what is most successful about your cutout. Explain whether the work succeeds because of its abstract look. Tell whether its success arises out of your use of art elements and principles. State, finally, whether its most successful feature is the message it communicates about you as a person.

Try This!

STUDIO OPTIONS

▓ On a sheet of white paper, make a pencil drawing of another standing figure. The subject this time should be a friend or relative you admire. Decide what qualities you admire most in the person. Decide how best to show these qualities in your work.

▓ Make another cardboard cutout, this time of a figure on horseback. Your figure should exhibit an emotion or feeling, such as pride, humility, or anger. Use the sculpture in Figure 9–3 on page **131** as your model. Again, simplify each of the figures into a series of flat shapes and forms. Paint your cutout with two complementary colors.

The Masks of Africa

African tribespeople had several ways of relating to the spirit world through art. One, which you read about in Lesson 1, was through figure sculptures. Another was through masks. Like the figure sculptures, the masks made by African tribal artists were richly carved. They are among the finest and most remarkable art forms of Africa. The masks also held great supernatural importance.

The artists of Africa created three different types of masks. These were the face mask; the headpiece, or headdress; and the shoulder mask.

▲ **Figure 9–8** What do you think is the most impressive feature of this face mask? How do you think a dancer wearing this mask would appear to those watching?

Africa. Chumbanndu, Buluba. Face Mask. American Museum of Natural History, New York, New York.

THE FACE MASK

The **face mask** was *a mask worn to hide the identity of the wearer.* The wearer even changed his or her voice so as not to be recognized. An example of a face mask is shown in Figure 9–8. Animal furs, feathers, and shells are included in its decoration. The decorations were chosen according to the resources available in each region.

The face mask was used in a number of different tribal ceremonies. These ceremonies were held to protect the tribe from unknown forces of nature, or to ensure a good harvest. Yoruba masks honored gods of warfare. The Bundu masks were made to celebrate female beauty and power. Creation of face masks continues today in celebration of African tradition and culture.

THE HEADPIECE

Not all African masks were made to hide the wearer's identity. The headpieces created by artists of the Bambara tribe of west Africa were made with an abstract animal design. **Headpieces** were *masks carved of wood and worn on the head like a cap.* In Bambara culture the antelope is a symbol for a rich harvest and appeared as the model for their headpieces. Figure 9–9 shows examples of these headpieces.

Bambara headpieces were used in a ritual performed when a new field was readied for planting. This ritual honored Tyi Wara, a mythical being who was credited with having taught the Bambara how to plant and grow crops. The design of the headpiece was meant to blend the speed and grace of the antelope with the powerful spirit of Tyi Wara. Study the headpiece in Figure 9–9. What element in the work is used to capture a feeling of grace? What art element is used to capture a feeling of power?

▲ **Figure 9–9** **The antelope on the right is male. Notice its beautiful, flowing mane. The female carries a baby on her back.**

Africa, Mali, Bamana Tribe. Two Antelope Headpieces. 19th-20th Century. Wood, metal bands. Left: 71.2 x 30.9 x 5.4 cm (28 x 12⅛ x 2⅛"). Right: 90.7 x 40 x 8.5 cm (35¾ x 15¾ x 3⅜"). The Metropolitan Museum of Art, New York, New York. The Michael C. Rockefeller Memorial Collection. Gift of Nelson A. Rockefeller.

THE SHOULDER MASK

Face masks were meant to cover the face of the wearer. Headpieces were meant to cover the wearer's head. The third kind of African mask, shoulder masks, were meant to do both. **Shoulder masks** were *large, carved masks made to rest on the shoulders of the wearer*.

They are sometimes called helmet masks. A shoulder mask of the Baga tribe is shown in Figure 9–10. It was used during a dance performed as part of a ceremony to guarantee a successful harvest. Notice how the face in this work is highly stylized.

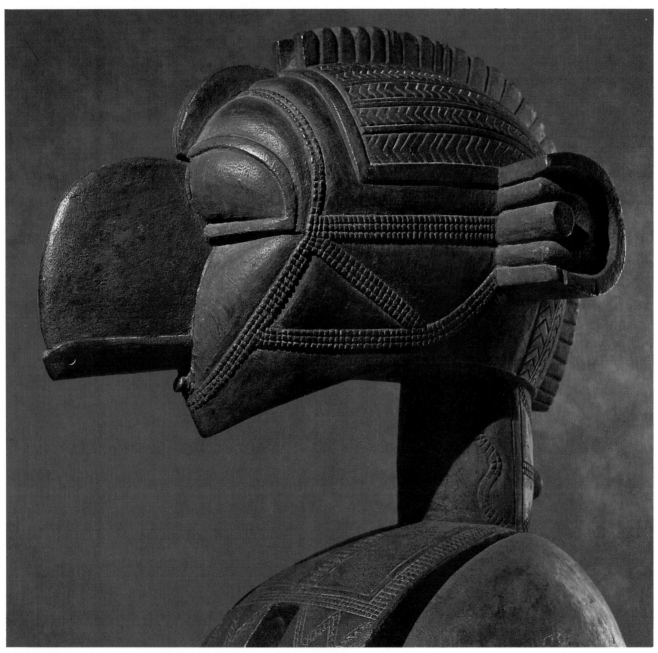

▲ Figure 9–10 Masks are meant to be seen in motion. They were thought to have great magical powers.

Africa, Guinea, Baga Tribe. Headdress. 19th-20th Century. Wood. 122.6 x 40.9 x 70.3 cm (48¼ x 16⅛ x 27⅝"). Dallas Museum of Art, Dallas, Texas. The Gustave and Franyo Schindler Collection. Gift of the McDermott Foundation in honor of Eugene McDermott.

The wearer of a shoulder mask peered out through holes cut in the chest. Like face masks and headpieces, shoulder masks were part of a complete costume. Long strips of fiber were used to cover the body of the wearer. Unlike the other masks, shoulder masks were quite heavy, often weighing 75 pounds (34 kg) or more. When the mask was in place, the wearer stood over 8 feet (243 cm) tall. Wearing such a mask called for very strong performers. Even so, they could perform in rituals for only a short time.

▲ **Figure 9–11 Student work. Cardboard mask.**

STUDIO ACTIVITY

Constructing a Mask

What happens when you cover your face with a mask? Do you feel and act differently? Can you hide your identity from others when the mask is in place?

Design a mask using thin cardboard. Cut strips of the material and staple them into cones and cylinders large enough to fit over your head. (See Figure 9–11). Cut holes or slits to see through. Use construction paper, tempera paint, and found objects to create facial features and decorations. Compare your mask with those created by classmates.

PORTFOLIO

If your mask will not fit in your portfolio, take a photograph, make a drawing or diagram, or write a detailed description of your art work. In your sketchbook, discuss how you feel when you are wearing your mask.

✔ CHECK YOUR UNDERSTANDING

1. What are face masks? What were face masks used for?
2. What role did the antelope play in Bambara culture? Who or what was Tyi Wara?
3. In what way were shoulder masks different from face masks and headpieces?

Making a Mood Mask Relief

The goal of African artists was to make expressive art. Masks were meant to communicate a mood or feeling to the viewer. Study the helmet mask shown in Figure 9–12. It is known as the "Firespitter." What mood does this half-animal, half-human mask communicate?

WHAT YOU WILL LEARN

You will create a mask relief that communicates a particular feeling or mood. You will model your mask out of papier-mâché (pap-yay-muh-**shay**). **Papier-mâché** is *a sculpting technique using newspaper and liquid paste*. You will use a variety of different shapes, forms, and textures. You will exaggerate the proportions of the shapes and forms used for the face features. Your shapes and forms will be organized into patterns to decorate the whole mask. (See Figure 9–13.)

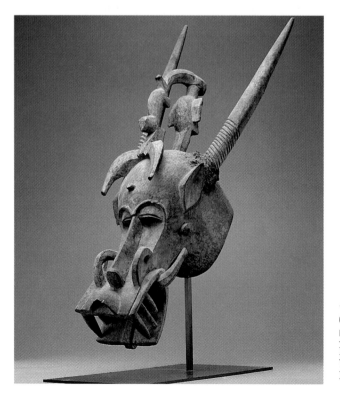

WHAT YOU WILL NEED

- Pencil and sheets of sketch paper
- Heavy-duty aluminum foil and newspaper
- Masking tape and a large sheet of cardboard
- Non-toxic commercially prepared papier-mâché paste or white glue
- Plastic mixing bowl and water
- Newspaper torn into strips about 1/2 inch x 1 1/2 inches (13 x 39 mm)
- Fine-grain sandpaper
- Scissors or other sharp cutting tool
- Tempera paint and brushes
- Yarn, cloth, and cotton for decoration
- Polymer gloss medium

WHAT YOU WILL DO

1. Pretend that you belong to a tribe that has been having a series of misfortunes. The crops are dying and the water supply is low. Create a mask to be used in a ceremony your tribe might perform to restore your tribe's good fortune.
2. Do sketches for a mood mask expressing joy and happiness to attract the spirit of good fortune. Exaggerate the proportions of the features of the face. Use lines and shapes to create decorative patterns.

◀ **Figure 9–12** **Notice the care with which this work was designed. Real and imaginary lines of the horns, tusks, and mouth are used to unify the work.**

Helmet Mask. African, Ivory Coast, Senufo. 19th–20th Century. Wood. 96.5 cm (38″). The Detroit Institute of Arts, Detroit, Michigan. Gift of Governor and Mrs. G. Mennen Williams.

3. Cut a sheet of heavy-duty aluminum foil large enough to cover your face. Using your fingers, gently press the foil around your eyes, nose, and mouth.

4. Place the foil mask on the cardboard and stuff wads of newspaper under it. This will help it keep its shape when the papier-mâché is applied. Using masking tape, fasten the stuffed foil to the cardboard.

5. Follow the instructions for applying papier mâché in Technique Tip **20**, *Handbook* page **283**. As you work, take care not to press too hard on the foil. If you do, the raised areas may collapse. Set the mask aside overnight to dry.

6. The next day sand your mask lightly with the fine-grain sandpaper. Trim the edges with scissors and carefully cut holes or slits for eyes. If you do not wish to wear your mask you might want to paint the eyes on your mask instead.

7. Look back at your sketches. Working in pencil, transfer the other face features and decorative patterns from your best sketch.

8. Pick colors of tempera paint for your mask. Your color choices should emphasize the joyous mood of the work. Paint your mask and add yarn, cloth, or cotton to create texture. Apply a coat of polymer gloss to add sheen to the mask.

SAFETY TIP

Avoid using wallpaper paste and similar glues for your work in papier-mâché. These glues have poisons in them that can enter the body through the skin.

EXAMINING YOUR WORK

- **Describe** Point to the different face features of your mask.
- **Analyze** Identify where your mask has a variety of different shapes, forms, and textures. Explain how shapes and forms are organized into decorative patterns. Point out the exaggerated proportions of shapes and forms in the face features of your mask.
- **Interpret** Point to the features in your work that would help a viewer understand its joyous mood. Explain how exaggeration helped communicate this mood.
- **Judge** Tell whether you feel your work succeeds. Identify the best features of your mask.

▲ Figure 9–13 Student work. Mood mask.

Try This! COMPUTER OPTION

▪ Decide on the mood and purpose of your mask. Use the Symmetry tool or menu. Exaggerate and fill page with mask shape, or, if your program allows, draw the image to cover several pages. Print and mount on light cardboard. Slit and overlap the top edge to make a three-dimensional mask. Glue on grasses, yarns, and other objects to create texture and mood.

Kente Cloth. Wrapper. Ashanti culture, Ghana. 20th Century. Silk. 209.6 x 130.8 cm (82⅖₆ x 51⅕₆ "). National Museum of African Art and National Museum of Natural History, Washington, D.C. Purchased with funds provided by the Smithsonian Collections Acquisition Program.

What Is Ashanti Kente Cloth?

The Kente cloth pictured here represents another example of traditional African art. As in other African art forms, this piece is created for a purpose: to be used on special occasions and religious ceremonies, or to honor ancestors, a king, or queen.

The famous Kente fabrics of Ghana were originally worn by Ashanti royalty. Although both Ashanti men and women were accomplished weavers, they produced different kinds of fabric. Women wove wide strips of colorful cotton fabric for everyday use. The male weaver, however, was considered a master of his craft, creating Kente cloth for tribal leaders. On a special loom, he wove long, thin strips of dazzling silk or cotton that were then sewn together. Master weavers of Kente were highly respected and favored by members of the royal court and high officials in the Ashanti tribe.

Each pattern, color, and design used in Kente cloth has its own special meaning. One pattern, for example, is called "wise old woman." It symbolizes old age and wisdom. Blue represents love; ivory stands for joy. Today, traditional Kente cloth is the national costume of Ghana, worn on special occasions, and the fine art of weaving Kente cloth is still passed down from one generation to the next.

MAKING THE CONNECTION

- In the example of Kente cloth shown here, how has the weaver achieved balance? How would you describe the pattern the artist used?
- If you could design a unique cloth pattern for yourself, what special meaning would you want it to have? When would you want to wear it?

INTERNET ACTIVITY

Visit Glencoe's Fine Arts Web Site for students at:

http://www.glencoe.com/ sec/art/students

REVIEW

◆ BUILDING VOCABULARY

Number a sheet of paper from 1 to 5. After each number, write the term from the list that best matches each description below.

abstract work papier-mâché
face mask shoulder masks
headpieces

1. A work in which the artist uses a recognizable subject but portrays it in an unrealistic manner.
2. A mask worn to hide the identity of the wearer.
3. Masks carved of wood and worn on the head like a cap.
4. Large, carved masks made to rest on the shoulders of the wearer.
5. A sculpting technique using newspaper and liquid paste.

◆ REVIEWING ART FACTS

Number a sheet of paper from 6 to 13. Answer each question in a complete sentence.

6. When did Portuguese explorers first come to Africa?
7. What is the favored medium among African tribal sculptors?
8. As a result of choosing this medium, what form did the art work often take?
9. Which African tribe created the remarkable bronze sculptures that arrived in Europe in the 1800s?
10. What three kinds of masks were created by African artists?
11. Name two ceremonies in which face masks were used. In what ceremonies were Bambara headpieces used?
12. What mysterious being did the Bambara credit with having taught them about planting?
13. Why did rituals calling for shoulder masks require strong tribe members?

? THINKING ABOUT ART

On a sheet of paper, answer each question in a sentence or two.

1. **Extend.** You read in this chapter that the antelope has a special meaning among the Bambara of Africa. In what other cultures that you read about were animals important?
2. **Analyze.** Which of the works in this chapter do you find the most stylized? The least stylized? Explain your answers.
3. **Compare and contrast.** Look back at the works in Figures 9–3 and 9–12. Both were created by artists of the Senufo tribe. Make a list of the similarities and differences between the two objects.

— MAKING ART CONNECTIONS ◄█

1. **Social Studies.** You read in this chapter that the African continent provides natural resources from varied geographic regions. Look up Africa in an encyclopedia or atlas. Learn what you can about the regions and what types of natural resources artists might use to create their works.

2. **Science.** Artists all over Africa were able to choose from a large variety of wildlife for inspiration. List some animal forms unique to the continent of Africa. Choose an animal that interests you and research its habitat and lifestyle. Write a one-page report on your animal. Comment on its traits and how those traits might be admired by an artist and represented in an art work.

▲ This illumination is from a French book of Psalms, or sacred poems. The simple pictures teach a story from the Bible. Does the arrangement of scenes remind you of a stained glass panel?

Scenes from the Life of King David. Psalter, Paris. c. 1250–1260. Ink, tempera colors and gold leaf on vellum, bound between pasteboard covered with deep violet morocco. 19.2 x 13.4 cm (7⁹⁄₁₆ x 5¼"). J. Paul Getty Museum, Malibu, California. Ms. Ludwig VIII 4.

Art of the Middle Ages

The period of history beginning about A.D. 500 is known by several names. One is the Middle Ages. Another is Medieval (mid-**ee**-vuhl) times. This period has been referred to as the Dark Ages but, in the world of art, these times were anything but dark. Sculpture and painting were used to express ideas of society and religion. Architecture found expression in magnificent churches. Stained glass and sculpture added splendor to these cathedrals. Illuminations like the one on the facing page decorated books of the period. In this chapter you will learn about the art of this period.

PORTFOLIO IDEAS

From time to time, you may want to review the contents of your portfolio. If you have been using it to hold all of your notes, sketches, and finished art works, you may decide to add or take out some of your entries. You may decide to keep an art work because it represents your best example of using the elements and principles of art. You may keep other entries because they show growth in a specific medium. You may want to keep your Gothic Gargoyle work (page **156**) because it demonstrates a process—working with clay.

OBJECTIVES

After completing this chapter, you will be able to:
- Tell how life in Romanesque times affected the art of the period.
- Identify the role of Romanesque sculpture and illuminations.
- Describe the contributions of Gothic artists to architecture and painting.
- Work with Romanesque and Gothic styles of architecture and sculpture.

WORDS YOU WILL LEARN

buttress
castles
cathedral
fresco
gargoyle
illuminations
pointed arch
stained glass

Art of the Romanesque Period

History teaches many meaningful lessons. One is that even the most powerful empires, in time, weaken and crumble. Rome was no exception. The Roman Empire fell to invading armies around A.D. 400. Both the style of life as well as the art of this period were affected by these historical changes. Temples and palaces were torn down and the stone was used to build fortresses to keep out the invaders.

Shortly before Rome fell, the practice of Christianity became widely accepted. The Catholic Church stood as the single most important influence in western Europe. Its influence on people and events was widespread throughout the span of history now called the Middle Ages. The art and architecture at the end of the Middle Ages is divided into two periods: the Romanesque (roh-muh-**nesk**), from around 1050 to around 1150, and the Gothic from around 1150 to about 1500. In this lesson you will learn about the art of the Romanesque period.

LIFE IN ROMANESQUE TIMES

Warfare was common during the Romanesque period. Since land was the main source of power and wealth, kings and rich landowners were forever fighting among themselves to protect or add to their holdings.

Architecture

To protect themselves, the rich lived in **castles**, or *fortlike dwellings with high walls and towers*. These castles were often protected further by a moat and drawbridge. One of these structures is pictured in Figure 10–1. Notice how sturdy the castle looks even now, some 600 to 700 years after it was built. The structure has few windows. Why do you suppose this is so? Do you think the builder was more interested in constructing a structure that was comfortable or well fortified?

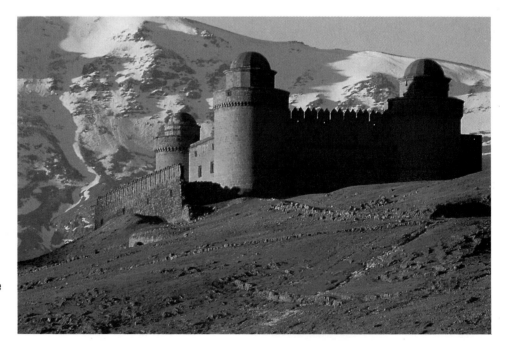

▶ **Figure 10–1** **Early castles like this were massive and strong. They were also dark and drafty. Instead of windows, narrow slits were cut into the walls. These helped those inside detect, and attack, intruders.**

La Calahorra Castle. Andalucia, Spain. 16th Century.

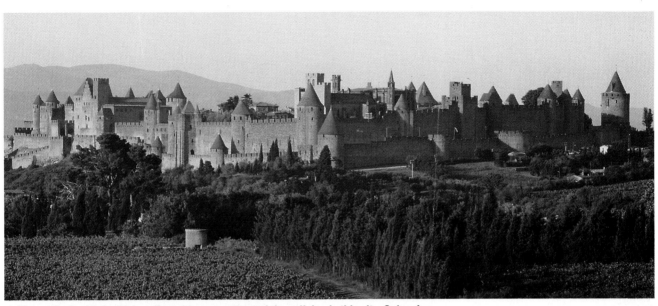

▲ Figure 10–2 High, thick walls and towers protected those living in this city. Only a few well-protected gates allowed people to enter or leave the city.

Walled City of Carcassone. c. 1100. Southern France.

The leaders and rulers lived in the castles during the Middle Ages. Communities of people living outside the castles were left open to attack. For this reason, whole towns and cities were surrounded by walls for protection. At first these walls were made of wood. In the 1100s and 1200s stone began to be used. One of the most impressive of these walled cities is shown in Figure 10–2. Today this city looks much as it did during the Middle Ages.

During this time the Catholic Church also had a great influence on the architecture. As early as A.D. 400 churches were springing up in towns and villages across Europe. All, like the one shown in Figures 10–3 and 10–4, were low and thick-walled. Windows, which might weaken the walls and bring the heavy stone roof crashing down, were avoided. As a result, these churches were dark and somber inside.

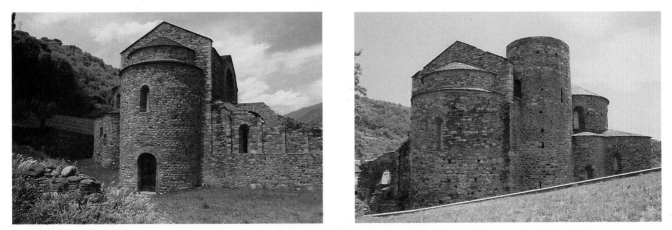

▲ Figure 10–3 (Left) and Figure 10–4 (Right) Thick walls and lack of windows made these churches look like forts, or fortresses. This may be the origin of the phrase "fortresses of God," used to describe these churches.

Anersall-Romanesque Church.

Sculpture

The Church was also responsible for the development of sculpture during this period. Since most people were unable to read, sculpture was used to teach religion. The exteriors of churches were covered with reliefs and statues like the ones in Figure 10–5. These sculptures portrayed the same Bible teachings that were taught verbally. Look closely at Figure 10–5. Notice the detailed figures shown in the half-round space above the doorway.

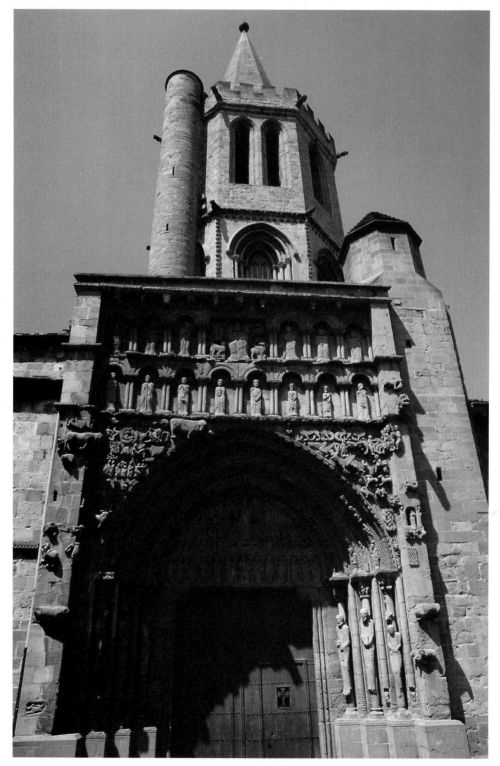

▶ Figure 10–5 Can you see from this example why churches built in the Middle Ages were called "bibles in stone?" The many sculptures on the outside of these churches were meant to teach people who could not read about the Christian faith.

Santa Maria la Real Church. 13th Century. Sanguesa, near Pamplona, Spain.

Painting

In addition to being portrayed in sculpture, the teachings of the Church were spread through hand-lettered books, which contained illuminations. **Illuminations** are *hand-painted book illustrations*. For nearly a thousand years, these illustrations were the most important paintings created in Europe. Figure 10–6 shows an illumination from a prayer book. The work shows a scene from the life of Moses. In the illustration, Moses is looking up to receive the word of the Lord. His upturned face and outstretched arms suggest his willingness to accept the teachings for his people. Would you describe the work as realistic? What do you suppose was the artist's main goal in creating this illumination? Which aesthetic view would you use if someone asked you to judge this work?

▲ **Figure 10–6** The story in this work was told simply so it could be understood by anyone who knew the Bible. The picture does not look real because the story was more important to the artist than was a lifelike subject.

Illuminated Page of the Bible. *The Tablets of the Law.* 13th Century. Psalter of Ingeburg of Denmark. France.

STUDIO ACTIVITY

Illustrating a Story

The story illustrated in Figure 10–6 is from the Old Testament. Notice how the artist in portraying this story includes only those details needed in its telling.

Working in pencil in your sketchbook, draw an illustration of a scene from a favorite story from literature or a movie. As in the illumination, leave out all unnecessary details. Keep your figures flat, and outline them with a variety of thick and thin black lines. Add bright colors to your picture with oil pastels. Share your finished work with classmates. See if anyone can identify the scene or story you have illustrated.

P O R T F O L I O

Critique your illumination by explaining how you combined the elements and principles of art to create your painting. Include your critique with your painting in your portfolio.

✔ CHECK YOUR UNDERSTANDING

1. In what century did Rome fall? What became the single most important influence in western Europe after its collapse?
2. When did the Romanesque period begin? When did it end?
3. What fact of life in the Middle Ages led to the building of castles?
4. Why were Romanesque churches thick-walled and without windows?
5. What was the purpose of sculpture during the Romanesque period? What other art form had the same purpose?

Romanesque Castle Relief

Castles, as you have read, were common in Europe during the Romanesque period. Two more of these structures are shown in Figures 10–7 and 10–8. The ridged geometric pattern along the top of each is called a battlement. Can you guess what battlements were used for? Can you identify any other features in these castles?

WHAT YOU WILL LEARN

You will design a castle of your own. You will create a relief of your castle using heavy cord and aluminum foil. Focus on the use of line to highlight the different features of your castle. Use the element of line to add harmony to your design. (See Figure 10–9.) Your castle should look strong and safe.

WHAT YOU WILL NEED

- Pencil and notepad
- Sheets of sketch paper
- Sheet of cardboard, 12 x 18 inches (30 x 45 cm)
- Scissors, tape, and heavy wrapping cord
- White glue
- Sheet of aluminum foil, 16 x 20 inches (41 x 50 cm)

WHAT YOU WILL DO

1. Begin by studying the castles in Figures 10–1 (on page **146**), 10–7, and 10–8. On your notepad, list the features common to these buildings. One common feature

▲ **Figure 10–7** How many features can you find that helped make these castles safe?

Castle at Penafiel, Spain. c. 14th Century.

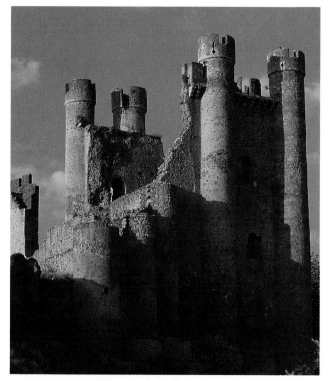

▲ **Figure 10–8** Notice how the vertical lines give a sense of strength to this structure.

Gothic Castle on Rio Esla, south of Leon, Spain. 15th Century.

in the castles shown here, for example, is the battlement. On a sheet of sketch paper, make several drawings of an original castle. Show the building as it appears from the front. Draw all the features included on your list.

2. Choose your best design. Make a line drawing of this sketch on the sheet of cardboard. Fill the surface of the cardboard with your drawing.

3. Glue cord along the lines in your drawing. To do this, squeeze a thin band of glue along the line. Press the piece of cord into place. Repeat this process until all lines are covered.

4. Small pieces of cardboard can be glued to your castle design to give it more detail.

5. Cover your design with the sheet of aluminum foil. Wrap the foil around the ends and sides of the cardboard. Using tape, fasten the foil to the cardboard along the back.

6. Using the end of your pencil, carefully but firmly press down on the foil along the cord lines and around the cardboard shapes. Display your finished work to your class. Note ways in which your castle relief is similar to and different from those of other class artists.

EXAMINING YOUR WORK

- **Describe** Point out the features of your castle listed on your notepad.
- **Analyze** Tell whether the use of line adds harmony to your design.
- **Interpret** State whether your castle communicates the ideas of strength and safety. Tell whether the castle shown would succeed in protecting those inside from attackers.
- **Judge** Tell whether you feel your work succeeds. Explain your answer.

▲ Figure 10–9 Student work. Castle relief.

 Try This! **STUDIO OPTIONS**

■ Spray your castle with black paint. When the paint is dry, lightly rub the relief with steel wool. This will remove the paint from the raised surfaces, creating an interesting effect.

■ Create another castle relief, this time out of a continuous piece of 14-gauge steel wire. Show each feature in your castle by bending and twisting the wire until it has the right shape.

Art of the Gothic Period

Throughout history an important part of creating art has been solving problems. A key problem facing artists of the Romanesque period was mentioned in Lesson 1. This was figuring out how to build walls that could both contain windows and support a heavy roof.

Romanesque builders never solved this problem. Architects of the Gothic period did, however. In this lesson you will learn about this and other contributions of artists of the Gothic period.

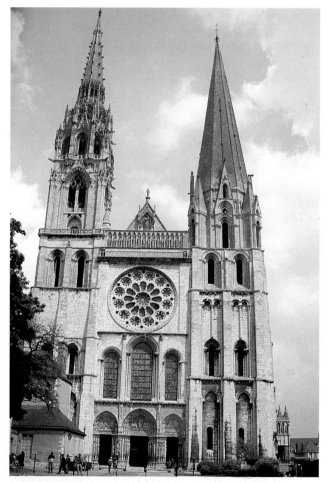

▲ **Figure 10–10** The two towers seen from the front of this cathedral are from different periods. The one on the left was begun in 1135 and completed in the 16th century. The tower on the right dates from about 1145.

Facade, Chartres Cathedral. France. Vanni/Art Resource, New York.

LIFE IN GOTHIC TIMES

Toward the end of the Romanesque period, Europe began to change. With the growth of trade, money replaced land as the measure of wealth. Castles became unpopular as cities grew and thrived. Many of these cities developed into large population centers by the year 1200.

The Church continued to have a great effect on the people as well as on the art of these new European cities.

Architecture

One structure that exists as a great contribution of Gothic artists is the cathedral. A **cathedral** is *a large, complex church created as a seat of office for a bishop.* The bishop would have several parishes, or congregations, under his leadership. An example of one of these huge structures is shown in Figure 10–10. Notice the openness of this building. Note the rose window design. Notice how the two towers seem to soar upward. Magnificent works of architecture like these were possible thanks to two improvements made by Gothic French architects. These were:

- **The pointed arch.** The **pointed arch** is *a curved arrangement of stones reaching up to a central point.* Gothic architects found that the vertical shape of this design feature allowed it to carry weight downward. Examine the inside view of a cathedral in Figure 10–11 and find the pointed arches.
- **The flying buttress.** A **buttress** (**buh-truhs**) is *a brace or support placed on the outside of a building.* Such supports are said to "fly" when they arch out over other parts of a building. In Gothic cathedrals, flying buttresses took on some of the load of the heavy roof. Which structures in Figure 10–12 are flying buttresses?

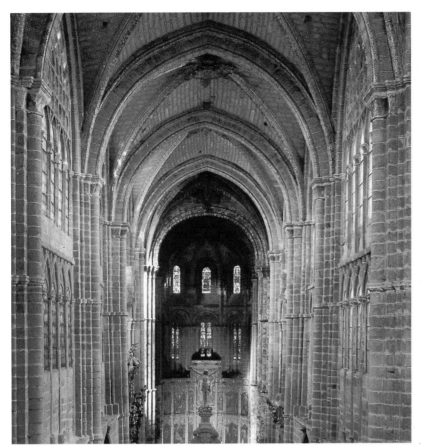

◀ **Figure 10–11** The weight of the roof is carried by the pointed arches and transferred to columns inside the building. Can you find the pointed arches in this church?

Avila Cathedral. Avila, Spain.

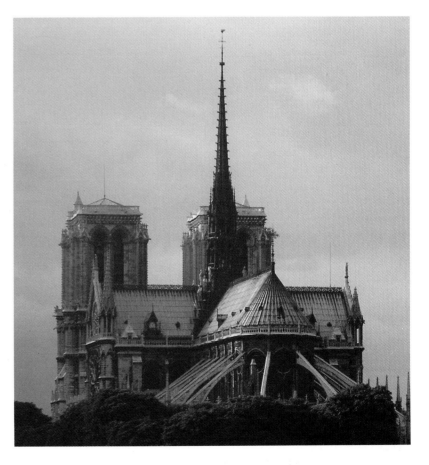

▶ **Figure 10–12** Flying buttresses like these helped make thick solid walls unnecessary in Gothic cathedrals. What replaced these walls?

Notre Dame Cathedral. Paris, France.

Crafts

The pointed arch and flying buttress did away with the need for solid walls. They also opened up the possibility of having many windows in churches and cathedrals. This created yet another outlet for expression by artists and craftspeople of the day. Brilliantly colored stained glass windows like those in Figure 10–13 began gracing the walls of cathedrals. **Stained glass** is made of *colored glass pieces held in place with lead strips*. These windows filled the cathedrals with softly tinted light. The pictures in these windows, focusing on religious figures and events, also helped teach the Bible. Do you recall which art forms of the Romanesque period showed Bible stories?

▲ **Figure 10–13** The lead strips appear as dark lines in the finished design. Do you feel these lines add to or take away from the beauty of the work? Explain your answer.

Stained Glass from Cathedral of Leon — *Head of a Prophet.* Leon, Spain.

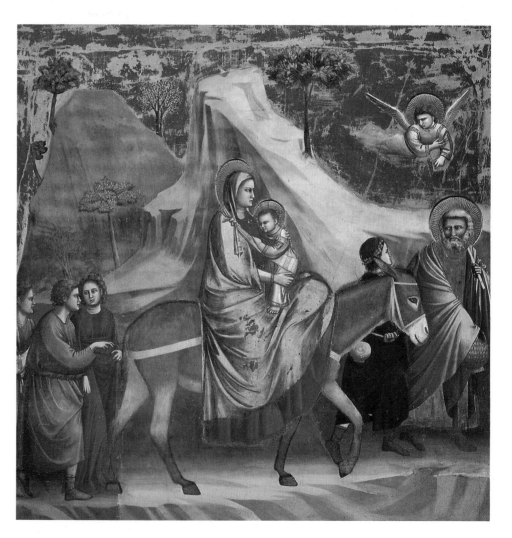

▶ **Figure 10–14** What has the artist done to make the people in this work look lifelike? What has he done to emphasize the woman, child, and donkey?

Giotto. *The Flight Into Egypt.* c. 1305–06. Fresco. Arena Chapel, Padua, Italy.

Painting

The Gothic style of building cathedrals never fully caught on in Italy. There churches continued to be built in the Romanesque manner with large, unbroken walls. Instead of stained glass, religious decoration was added with a form of painting known as fresco. **Fresco** (fres-koh) is *a painting created when pigment is applied to a section of wall spread with fresh plaster. Fresco is the Italian word for* "fresh." This technique required the artist to work quickly before the plaster dried. The pigment was absorbed and the painting was permanently preserved.

The work in Figure 10–14 is a fresco. It is one of a series found on the walls of a chapel in Padua, Italy. All were done by a gifted artist named Giotto (**jah**-toh). Take a moment to study this work. In creating this and other frescoes, Giotto wished to do more than tell Bible stories. His goal was to make the people in his pictures come alive. His genius was such that a century would pass before an artist of equal skill would appear.

▲ Figure 10–15 Student work. Rose window design.

STUDIO ACTIVITY

Rose Window Cutout

Make a pencil sketch in your sketchbook based on a rose window design. Rose windows sometimes appear on the front of a church or cathedral. They are round, so your design should have either symmetrical or radial balance. Leave out all unnecessary details in your work. Transfer your sketch to a sheet of black construction paper. Go over all the lines with white chalk. Make some of the lines thicker than others.

Using scissors, cut out all the spaces between the chalk lines. Cut out patches of tissue paper in the shape of the spaces, only slightly larger. Pick different colors of paper for different spaces. Using white glue, attach these patches to the construction paper along their edges. You may want to use two thicknesses of black construction paper and sandwich pieces of tissue paper between the outlined areas. Turn your work over to reveal your own stained glass window. (See Figure 10–15.)

PORTFOLIO

Write a short paragraph explaining how you chose colors, shapes, and use of space. Keep your description and your stained glass window together in your portfolio.

✔ CHECK YOUR UNDERSTANDING

1. What problem faced architects of the Romanesque period? What two improvements allowed Gothic architects to solve this problem?
2. What is a cathedral?
3. What is stained glass? For what purpose did Gothic artists use stained glass?
4. What is a fresco? How were frescoes created?
5. Who was Giotto? What was his goal?

Making a Gothic Gargoyle

If you look up to the highest point of a Gothic cathedral, you will see creatures known as gargoyles. Look at Figure 10–16. A **gargoyle** is *a projecting ornament on a building carved in the shape of a fantastic animal or grotesque creature.* Gargoyles were made of carved stone and metal. They were meant to look like spirits fleeing, or being driven, from the holy building. However, these strange creations actually served a very practical purpose. They are really rain spouts that carried rainwater from the roof of the cathedral.

Creating these fascinating, sometimes frightening creatures required a great deal of imagination. In this lesson you will have an opportunity to design a gargoyle like the ones that appeared on Gothic cathedrals. (See Figure 10–17.)

WHAT YOU WILL LEARN

You will use clay to model and carve a gargoyle that will have imaginary rather than realistic proportions. Surface patterns will be created with a variety of textures to suggest fur, hair, scales, or feathers. Your model will be a freestanding sculpture.

WHAT YOU WILL NEED

- Pencil and sketchbook
- Slips of paper and small box
- Clay and clay modeling tools
- Burlap or cloth cut into sections, 14 x 14 inches, (36 x 36 cm)

▶ **Figure 10–16 How do you suppose someone of Gothic times would have felt to look up and find these odd-looking figures overhead?**

Gargoyles at Narbonne, France.

WHAT YOU WILL DO

1. Find examples of gargoyles in books from the library. Make a list of the animals or parts of animals used in these gargoyles.
2. On three separate slips of paper, write the name of a different animal. Place these slips of paper, along with those completed by other students, in a box.
3. Pass the box around the room. Without looking, pick out two slips.
4. Complete several pencil sketches in which you combine the animals named on your slips of paper to create a gargoyle design. Use your imagination to draw a creature unlike anything seen in real life. Add details such as hair, fur, scales, and feathers.
5. Complete a three-dimensional version of your gargoyle in clay. Begin by modeling the basic form of the gargoyle. Add details using both modeling and carving techniques.
6. Add interesting textures and surface patterns with modeling tools. These can be made to look like hair, fur, scales, feathers, or a combination of these.
7. Hollow out your model so it will dry more quickly and thoroughly. Work from the back to create a channel through the sculpture that exits through the open mouth. This channel can represent the passage through which rainwater would flow in a real gargoyle.
8. Fire your sculpture.
9. *Optional:* You may wish to add color by glazing in one or several colors. After glazing, fire the gargoyle again.

EXAMINING YOUR WORK

- **Describe** Show how your gargoyle combines more than one animal. Does it have fantastic proportions?
- **Analyze** Did you use a variety of actual textures to create an interesting surface pattern?
- **Interpret** Does your gargoyle resemble any animal seen in real life? How does it make you feel?
- **Judge** Does your sculpture look as though it belongs as a decoration of a Gothic cathedral?

▲ Figure 10–17 **Student work. Gargoyle.**

 Try This!

STUDIO OPTIONS

■ If you choose not to glaze your gargoyle, shoe polish may be applied to the fired piece and rubbed to a shine with a soft cloth.

■ Make another gargoyle, this time as a relief sculpture. Use the slab method. Trace your design onto the soft clay with a pencil. Use modeling tools to carve your picture out of the clay. Add textures to the surface of your relief.

What Was the Purpose of a Coat of Arms?

In ancient civilizations, symbols on emblems and flags were often used to show loyalty. In the Middle Ages, the use of symbols expanded as feudal lords in Europe put unique images on their shields and banners. These images were meant to represent them and their kinsmen. The study of the symbols used in this way is called heraldry. Such symbolic emblems are called coats of arms.

Coats of arms were commonly displayed on the shields of knights during the early 1100s to identify the knights in tournaments and military campaigns. Christian knights who fought in the Crusades relied on their coats of arms to identify one another on the battlefield. As heraldry grew, rules were established for the design and use of coats of arms, not only for individuals, but also for towns, guilds, and other groups. Some coats of arms could be inherited, but others had to be officially granted. The elements of most coats of arms are often highly stylized and exclusive to that family or group.

The main element of a coat of arms is the **shield**.

The **motto** is shown below the coat of arms.

A **crest** appears above the helmet, and a **crown** below. The shield is supported by spears.

You can see the **helmet** above the shield at the top, flanked by red plumes.

Look for the symbols that appear on this shield: the quarter moon, a checkered field called *chequy*, a tower, and an animal or bird figure.

LOCHIS DI BERGAMO

Heraldry Shield. Image from PhotoDisc Fine Art, Series 3. Antique Maps and Heraldic Images.

MAKING THE CONNECTION

- In the coat of arms pictured here, what animal figure is featured on the shield? Why do you think this symbol was chosen?
- The lines, colors, designs, and symbols used on shields became standardized. Certain combinations had standard meanings and placements. Do you think standardizing features could limit creativity?
- Find out more about coats of arms. How were shields designed? What was the purpose of the motto?

INTERNET ACTIVITY

Visit Glencoe's Fine Arts Web Site for students at:

http://www.glencoe.com/sec/art/students

REVIEW

◆ BUILDING VOCABULARY

Number a sheet of paper from 1 to 8. After each number, write the term from the list that best matches each description below.

√ buttress √ gargoyle
√ castles √ illuminations
√ cathedral √ pointed arch
√ fresco √ stained glass

1. Fortlike dwellings with high walls and towers.
2. Hand-painted book illustrations.
3. A large, complex church created as a seat of office for a bishop.
4. A curved arrangement of stones reaching up to a central point.
5. A brace or support placed on the outside of a building.
6. Colored glass pieces held in place with lead strips.
7. A painting created when pigment is applied to a section of wall spread with fresh plaster.
8. A projecting ornament on a building carved in the shape of a fantastic animal or grotesque creature.

◆ REVIEWING ART FACTS

Number a sheet of paper from 9 to 13. Answer each question in a complete sentence.

9. Name three common features of a Romanesque castle.
10. What was the purpose of the sculptures found on the outside of Romanesque churches?
11. Where were illuminations found? What were they used for?
12. Under what circumstances can a buttress be said to "fly"?
13. What subjects appeared in the stained glass windows of Gothic cathedrals?

THINKING ABOUT ART

On a sheet of paper, answer each question in a sentence or two.

1. **Analyze.** Look back at the picture of a castle in Figure 10–1. What changes in society would have had to take place in order for this building's architects to add more windows?
2. **Compare and contrast.** What are the most important differences between Romanesque churches and Gothic cathedrals?
3. **Extend.** Imagine yourself walking through one of the Gothic cathedrals pictured in this chapter. What feature do you think would impress you most?

— MAKING ART CONNECTIONS

1. **Language Arts.** Acting as an art critic, describe, analyze, interpret, and judge the illumination in Figure 10–6 on page **149.** Use these questions to guide you: Do the people in the picture look lifelike? Why, or why not? Which elements of art are important in this picture? What clues tell you this is a religious work? In judging the work, tell whether your reaction is based on subject, composition, or content.

2. **History.** Find the term *fresco* in an encyclopedia or art history book in your library. Learn as much as you can about how frescoes are made and what difficulties fresco painters experienced. If you can, make photocopies of several different frescoes showing the range of possibilities within the medium. Share your findings with your class in an audiovisual presentation.

▲ This artist's portraits were highly praised in her day. One writer stated that they were "so lifelike that they lack only speech."

Sofonisba Anguissola. *Portrait of the Artist's Sister, Minerva.* c. 1559. Oil on canvas. 85 x 66 cm (33½ x 26"). Milwaukee Art Museum, Milwaukee, Wisconsin. Gift of the Family of Mrs. Fred Vogel, Jr.

Art of the Renaissance

The years following the Middle Ages in Europe were a time of great growth and discovery. Trade spread, and so did knowledge. New discoveries were made in every field, including science and geography. One of the most startling was the discovery of the New World by Christopher Columbus.

This period also saw great discoveries in art. Among the most important were ways of making art works look more lifelike. It was during this period too that women began to gain recognition as artists. The painting at the left is by Sofonisba Anguissola, the first of these women artists to gain an international reputation. In the chapters to follow, you will learn about many more.

OBJECTIVES

After completing this chapter, you will be able to:

- Identify artists of the Italian Renaissance and describe their contributions.
- Identify the contributions of artists working in northern Europe during the Renaissance.
- Use details and symbolism in studio experiences.

WORDS YOU WILL LEARN

linear perspective
Madonna
oil paint
Pietà
Renaissance
symbolism

PORTFOLIO IDEAS

Choose two art works from the Renaissance period. Compare and contrast the works of art. What is the subject matter? How do the artists use the elements of line, color, texture, space, and shape/form? How do they use the principles of art? What media were used to create the art works? Describe the mood or feeling of the art works. Date your written entries and place them in your portfolio. At a later date, compare these art works with ones created from a different time period.

Art of the Italian Renaissance

During the Middle Ages the teachings of the Catholic Church were the focus of much of the art work. By the beginning of the 1400s, however, artists gradually began to change their style. After centuries of creating religious works, artists began to paint pictures to look as realistic as possible. The emphasis was not always on religious subjects. This time is known as the **Renaissance** (ren-uh-sahns), *a period of great awakening*. The word renaissance means "rebirth."

THE RENAISSANCE IN ITALY

The shift in interests that took place during the Renaissance was especially noticeable in Italy. There, a number of cities grew into trading and business centers. One of these, Florence, became the capital of Europe's cloth trade and home to its richest bank. Find Florence on the map in Figure 11–1.

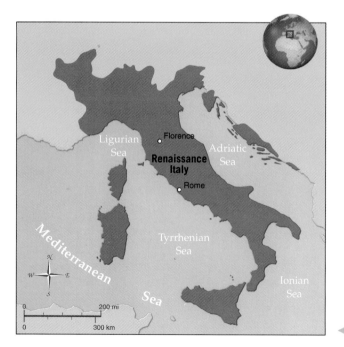

◀ **Figure 11–1 Renaissance Italy.**

Florence also became a center for art during the Renaissance. In this lesson you will read about the contributions of its artists.

Painting

Among the people living in Florence during the early 1400s was a young artist named Masaccio (muh-**zahch**-ee-oh). Masaccio continued where Giotto had left off a century earlier. He made the figures in his works seem solid and real. (See Figure 11–2.)

Masaccio also sought to add a true-to-life, three-dimensional quality using a technique called linear perspective (puhr-**spek**-tiv). **Linear perspective** is *the use of slanted lines to make objects appear to extend back into space.* (See Figure 11–3.) The technique was discovered by an architect and friend of Masaccio named Filippo Brunelleschi (fi-**leep**-oh broon-uhl-**ess**-kee).

The artist adds to this realistic appearance by giving the subject an expression of genuine grief. This combination of three-dimensional form and emotion became a trademark of Renaissance art.

Masaccio died suddenly at the age of 27. Some believe he may have been poisoned by a jealous rival. Luckily, there were other artists with the talent to build upon Masaccio's discoveries. One of these was a man whose talents were not limited to art. He was also skilled in science, literature, and music. The name of this gifted man was Leonardo da Vinci (lee-uh-**nard**-oh duh **vin**-chee).

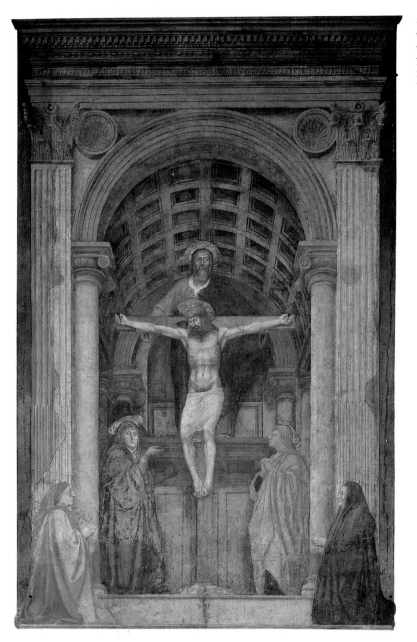

◀ **Figure 11–2** Look at this painting and identify where Masaccio has used slanted lines to produce a three-dimensional quality.

Masaccio. *The Holy Trinity*. Fresco. Church of Santa Maria Novella, Florence, Italy.

◀ **Figure 11–3** Diagram showing linear perspective. Linear perspective is based on a trick the eyes play on us. This trick causes the sides of a highway, for example, to seem to come together in the distance. The point at which such lines appear to meet at the horizon is called the vanishing point.

Eye level

Vanishing point

Leonardo's most famous work is a portrait, the *Mona Lisa*. Figure 11–4 shows another of his haunting portraits. In this painting Leonardo uses light and dark values in the manner developed by Giotto and Masaccio. The blending is so precise, however, that it is impossible to tell where one value ends and the next begins. Notice how these gently changing values help make the sad face seem three-dimensional. Notice how the figure of the woman stands out dramatically against the dark background.

Leonardo was recognized as a great artist even in his own day. Artists from all over flocked to Florence in the hopes of learning from him. One of these was a young painter named Raphael (**raf**-ee-el). Figure 11–5 is one of over 300 Madonnas that Raphael painted. A **Madonna** is *a work showing the Virgin Mary with the Christ Child*. In this one, Leonardo's influence can be seen in the soft change from light to dark values. Notice the expressions of the faces of the different people. How would you describe each one?

Sculpture

Like Leonardo, Michelangelo Buonarroti (my-kuh-**lan**-juh-loh bwon-nar-**roe**-tee) excelled in many fields, including poetry, painting, and architecture. As an artist, however, he thought of himself as a sculptor first. One of Michelangelo's greatest and best-known works is his *Pietà* (pee-ay-**tah**), pictured in Figure 11–6. A **Pietà** is *a work showing Mary mourning over the body of Christ*. Michelangelo carved his *Pietà* when he was 24 years old.

Study this work. Can you find anything unusual about the proportion of the two figures? Did you notice that Mary is much larger than her son, a full-grown man? In fact, if the figure were to stand, she would be nearly 9 feet (3 m) tall! Michelangelo purposely planned the sculpture this way. He wanted the viewer to focus on the work's mood—not on Mary's struggle to support the weight of Jesus' body. How would you describe the mood of Michelangelo's *Pietà*?

▲ **Figure 11–4** Who is this woman, and why is she so sad? Some historians claim she was the daughter of a rich banker abandoned by the man she loved.

Leonardo da Vinci. *Ginevra de 'Benci*. c. 1474. Wood. 38.8 x 36.7 cm (15¼ x 14½"). National Gallery of Art, Washington, D.C. Ailsa Mellon Bruce Fund.

▲ **Figure 11–5** Where has the artist used linear perspective? How has the use of linear perspective added to this painting?

Raphael. *Madonna and Child Enthroned with Saints*. Tempera on wood. 169.2 x 169.5 cm (66⅝ x 66¾"). The Metropolitan Museum of Art, New York, New York. Gift of J. Pierpont Morgan.

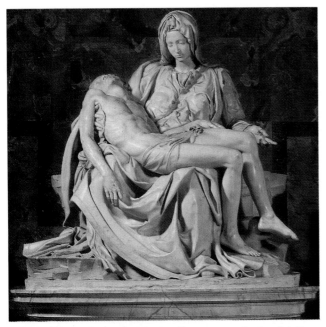

▲ **Figure 11–6** Notice that the two figures — one horizontal, the other vertical — seem almost to form a pyramid. Can you trace the lines of that pyramid with your finger?

Michelangelo. *Pietà*. c. 1501. Marble. St. Peter's Basilica, Rome, Italy.

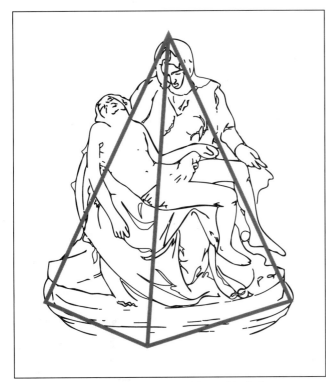

▲ **Figure 11–7** Triangles and pyramids used for balance.

STUDIO ACTIVITY

Using the Triangle

Many Renaissance artists followed a triangular or pyramid plan to organize the main figures in their works. This can be seen in the *Pietà* (see Figure 11–7). Find a similar plan in other works in this lesson.

Using pencil and ruler, draw a large triangle on a sheet of white paper. Within this shape, fit one or more of the letters that make up your initials. Fill as much of the space inside the triangle as you can. Use only straight, ruled lines for your letters.

Now continue some of the lines beyond the triangle to the edge of the paper. This will divide the rest of your composition into various shapes. Paint the shapes within the triangle with different values of a single hue. Paint the outside shapes with different values of the complementary hue.

PORTFOLIO

For your portfolio, write what you learned by creating this painting. Does your work reflect the same balance and organization as that of the Renaissance painters? Explain.

✔ CHECK YOUR UNDERSTANDING

1. How did the art in Europe at the beginning of the 1400s differ from that of the Middle Ages?
2. What was the Renaissance? What city was its center in Italy?
3. What is linear perspective? Who discovered it? Who was one of the first artists to use it in a painting?
4. What is remarkable about the portraits painted by Leonardo da Vinci?
5. What is a Madonna? What Renaissance artist was influenced by Leonardo in his painting of Madonnas?
6. What is a Pietà? What is unusual about the use of proportion in Michelangelo's *Pietà*?

LESSON 2

Drawing a Still Life

Many artists use sketch pads to record sights and ideas that interest them. In his lifetime Leonardo da Vinci filled some 100 sketchbooks with drawings on many subjects. Some of these were of storm clouds. Some were of rock formations and the action of waves. Some—like the one in Figure 11–8—were of the human body. What sets Leonardo's drawings apart was how precisely he captured every detail of an object. Clearly, this Renaissance master had remarkable powers of concentration.

WHAT YOU WILL LEARN

You will make a pencil drawing of a still life, using your powers of concentration to make the drawing as accurate as possible. Gradual and sudden changes of value will be used to suggest rounded and angular forms. Space will be shown by overlapping these forms. Differences in texture will be emphasized. (See Figure 11–9.)

▶ **Figure 11–8 Leonardo was left handed. He wrote the notes you see backward to keep his ideas private. A mirror was needed to read them.**

Leonardo da Vinci. *Studies of Male Shoulder.* Royal Library, Windsor Castle, England.

WHAT YOU WILL NEED

- Pencil and sheets of sketch paper
- Sheet of white drawing paper, 12 x 18 inches (30 x 46 cm)

WHAT YOU WILL DO

1. Bring an unusual found object to class, something that is broken or in some other way altered. Possibilities are a crushed can, a broken toy, or an old hand tool.
2. Set your object on a table in front of you. Place the point of your pencil on a sheet of sketch paper. Without taking your eyes off the object, begin to draw it. Attempt to feel the lines of the object with your pencil as you draw. Concentrate on and draw each object in accurate detail. Make several more drawings on the same sheet until your work looks like your object.
3. Working with four other students, arrange your five objects in an interesting way. Some of the objects should overlap others. Make a drawing of the arrangement. Concentrate on overlapping objects to create an illusion of space. (See Technique Tip 2, *Handbook* page 277.)
4. Carefully draw the key lines of your sketch onto the large sheet of drawing paper. Include in this finished version as many details as you can, including differences in texture. Use your pencil to add gradual and sudden changes of value to show rounded and angular forms.
5. Display your work along with those of your classmates. Discuss how this drawing has helped you to better see details.

EXAMINING YOUR WORK

- **Describe** Tell what objects you sketched. Point to the features of your drawing that would help others identify the objects.
- **Analyze** Point to the objects in your still life that overlap others. Explain whether this overlapping adds a feeling of space to the work. Tell how gradual and sudden changes of value suggest rounded and angular forms. Show the different textures you have emphasized.
- **Interpret** Give a name to your work that reflects the feelings you experienced while doing it.
- **Judge** Tell whether you feel your work as a whole succeeds as an accurate still life. Point to the most successful parts of your drawing. Explain why you think these parts are successful.

▲ Figure 11–9 Student work. Still life.

COMPUTER OPTION

Try This!

■ Work in groups of 3 to 4 students at the computer. Each student should take a turn to draw and arrange a familiar object using a mouse or drawing pen (stylus). After each student has a turn, title and save the work as a Line Drawing. Determine the light source. Use a pressure-sensitive tool such as a drawing pen to create different values. Apply colors and shades with choice of Brushes (Chalk, Watercolor, or Markers) and paper textures. Retitle, save, and print the work.

Art of the Northern Renaissance

The shift from a Gothic to a Renaissance art style happened in northern Europe later than in Italy. The changes were also slower to develop and found different forms of expression.

In this lesson you will read about the contributions of Renaissance artists of northern Europe.

THE RENAISSANCE IN THE NORTH

The Northern Renaissance was concentrated in the area of Europe known as Flanders. It had as its center the modern Belgian capital of Brussels. Find Flanders and the city of Brussels on the map in Figure 11–10.

▲ **Figure 11–10 Renaissance Europe.**

The art of the Northern Renaissance continued to make use of several Gothic techniques and features. One of these was symbolism. **Symbolism** is *the use of an image to stand for a quality or an idea.* A dog, for example, was a symbol of loyalty; a lily could mean purity.

In other ways Northern Renaissance artists experimented with new ideas. This was especially true in the area of painting.

Painting

The most important contribution of the Northern Renaissance was a new painting technique. Artists discovered that **oil paint**, *a mixture of pigment, linseed oil, and turpentine,* gave them a slow-drying paint. This oil-based paint was far easier to use than tempera. It allowed the artist to work more slowly and add more details. Colors, moreover, could be mixed right on the canvas.

Jan van Eyck

The person often credited with discovering the oil painting technique was a Flemish artist named Jan van Eyck (**yahn** van **ike**). Like painters working in Italy, those in the North were fascinated with precision. Van Eyck was no exception. He would spend hours using the smallest brushes he could find to paint patterns of bark on a tree or the blades of grass in a meadow. Notice the attention to detail in the brilliantly colored work in Figure 11–11. Look especially at the textures of the cloak and the sparkling glass. The paint is applied so skillfully that not a single brush stroke can be seen. Can you tell from the painting that the man shown is a religious figure?

▲ Figure 11–11 This work is rich in details. The books and articles on the table seem to glow softly in the mellow light. Notice the deep colors of green in the tablecloth, the reds and blues of the cloak and drapery. Even the textures in the paper, wool, leather, and glass add to the precise detail of van Eyck's work, a style that has never been equaled.

Jan van Eyck. *Saint Gerome in His Study.* 1435. Oil on linen paper, mounted on oak panel. 20.6 x 13.3 cm (8⅛ x 5¼"). Detroit Institute of Arts, Detroit, Michigan. City of Detroit Purchase.

▲ **Figure 11–12** Who do you think the woman in blue might be? Study her pose closely. Can you find another figure in the painting with the same pose? Why do you think the artist did this?

Rogier van der Weyden. *Descent from the Cross.* c. 1435. Museo del Prado, Madrid, Spain.

Rogier van der Weyden

Another important Northern Renaissance painter is Rogier van der Weyden (roh-**jehr** van duhr **vyd**-uhn). Van der Weyden was greatly influenced by van Eyck. Like van Eyck, he was able to reproduce each hair, each stitch in his paintings. Unlike van Eyck, whose pictures are calm and quiet, van der Weyden painted powerful, emotional scenes.

One of these is shown in Figure 11–12. In this picture, 10 life-size figures are placed in a shallow nook. The nook is just wide enough to hold them. The wall behind pushes the figures forward, bringing them closer to the viewer. In this way the artist forces the viewer to look at and experience this emotional scene from the Bible. Notice how the different people are reacting to the death of Christ. What has just happened to the woman in the blue dress in the foreground?

▲ **Figure 11–13** **Student work. Detail drawing.**

✔ CHECK YOUR UNDERSTANDING

1. What area became the center of the Northern Renaissance?
2. What Gothic feature continued to be used by Northern Renaissance artists?
3. What was a major contribution of artists of the Northern Renaissance? Who is credited with having discovered it?
4. In what ways were the religious paintings of Jan van Eyck and Rogier van der Weyden similar? In what ways were they different?

STUDIO ACTIVITY

Sketching Details

Look again at the paintings by van Eyck and van der Weyden in Figures 11–11 and 11–12. Notice how every detail in both pictures is captured in sharp focus, demonstrating the artists' powers of observation.

Exercise your own powers of observation by drawing two detailed, close-up views of a pencil on separate sheets of paper measuring 3 x 1½ inches (7 x 3.5 cm). Show the pencil point in one drawing and the eraser end in the other. Complete both drawings in sharp focus and use shading to suggest the three-dimensional form of the pencil. Mount both drawings on a sheet of black construction paper.

P O R T F O L I O

On a separate piece of paper, use descriptive words and phrases to list your observations as you drew the pencil. What do your results tell you about the powers of observation? Were you successful in capturing those observations in your drawings? How did you use the elements and principles of art to create sharp focus and three-dimensional form? What might you do differently if you drew the pencil again? Include your written observations with your drawings in your portfolio.

Designing a Visual Symbol

Symbolism, as you have read, was an important feature of Northern Renaissance art. Its importance can be seen in the picture by Jan van Eyck in Figure 11–14. The painting, which shows a wedding ceremony, is heavy with symbols. The dog stands for the loyalty the marriage partners have promised each other. The single burning candle in the chandelier symbolizes the presence of God at the event. Even the shoes on the floor have meaning. They have been removed to show that the couple is standing on ground made holy by the exchange of vows.

Symbolism is as popular today as it was over 500 years ago. Think of all the symbols you see every day for cars, fast-food chains, and brands of clothing. Can you think of other products in our culture that use symbols? What symbols do these products use?

Imagine you have been asked to design a symbol for a shoe company. The design is to be colorful, detailed, and easy to recognize. It is also to be strictly visual—without any lettering.

WHAT YOU WILL LEARN

You will create a visual symbol for a shoe company. You will use repeated flat shapes to give harmony to your design. Variety will be obtained by making the shapes in different sizes. Use color to emphasize the most important shoe in your design. (See Figure 11–15.)

WHAT YOU WILL NEED

- Pencil and sheets of sketch paper
- Ruler and scissors
- Shoe box lid
- Sheet of white paper, 12 x 18 inches (30 x 46 cm)
- Tempera paint and several brushes
- White glue

WHAT YOU WILL DO

1. Look at the table of shoes that your teacher has arranged.
2. Make several pencil sketches of the shoe pile. Use only lines in your sketches. Do not fill in any of the shapes with shading.

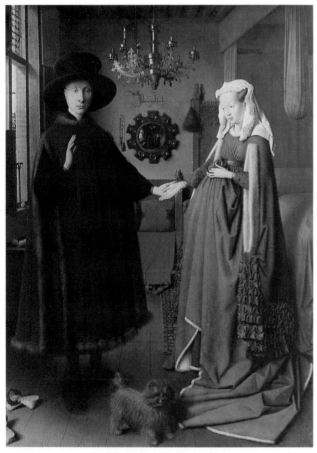

▲ **Figure 11–14** The translation of the words above the mirror is: "Jan van Eyck was here." Experts have put forth the idea that this painting might have been an official wedding document. If it was, what importance would these words have?

Jan van Eyck. *Giovanni Arnolfini and His Bride.* 1434. National Gallery, London, England.

3. Choose the best of your sketches and study it. Using the ruler, draw a rectangle around the part of your sketch that seems most interesting. This is to be your design.
4. Using the ruler, measure the length and width of the shoe box lid. Rule off a rectangle with the same measurements on the sheet of white paper. With scissors, cut out the rectangle.
5. Draw your design sketch on the rectangle, filling the space. Keep the shapes flat to give your design harmony. Make some of the shapes larger than others to add variety. Pick out one shoe that you would like to emphasize. Add details to this shoe.
6. Paint your design using tempera. Paint the different shoes so they look flat. Use a contrasting hue for the shoe you want to emphasize.
7. When the paint is dry, glue your painting to the shoe box lid. Display your finished work along with those of your classmates. Include some professionally designed shoe box lids in the display. Discuss which of the designs works best as a symbol for a shoe company. Try to identify the reasons for your opinions.

EXAMINING YOUR WORK

- **Describe** Tell whether you can instantly identify your design as a symbol for shoes. Are the shoes in your design easily recognized?
- **Analyze** Tell whether you used only flat shapes in your design. State whether the repeated use of these flat shapes adds to the harmony of the design. Point out the different-sized shapes in your work. Explain how these add variety to the design. Point out the one shoe you emphasized. Tell what you did to emphasize this shoe.
- **Interpret** Tell whether your design is unique enough to be identified with a particular shoe company.
- **Judge** Tell whether you feel your work succeeds. Explain your answer. Tell what changes you would make if you had a chance to do the design over.

▲ **Figure 11–15 Student work. Design of a visual symbol.**

Try This! COMPUTER OPTION 🖥

■ Design an inventive shoe that has special features or attributes. Perhaps the shoe has wings, small wheels, batteries, or levers. Draw a large shoe, filling the computer page, with Pencil or Brush. Think of a brand name that symbolizes the shoe and emphasizes its special ability. Use the Text tool to add letters and Transform commands to Flip, Rotate, Distort, or change size of letters. Save and title your work. Choose solid colors or use patterns. Color shoe and letters in bright hues. Add lighter or contrasting background hues. Save, title, and print your work.

How Is the Dome Supported?

Filippo Brunelleschi created the extraordinary dome on the Florence cathedral. Construction of this huge dome was revolutionary for architecture of the time.

As the construction of the cathedral in Florence neared completion, a competition was held to see who would design the dome. Brunelleschi won, but he knew it would be no easy task to build. The drum, or walls on which the dome was to rest, was a polygon. It spanned 138½ feet (42.2 m) across and was 180 feet (54.9 m) high. This was a problem, because the span was too wide for the temporary wooden scaffolds that workers typically needed. Also a dome of this size would be too heavy to use wood in such a way. Brunelleschi converted his octagonal dome into a circle at the base. Using precise measurements and detailed drawings, he built a ribbed inner dome that was connected to an outer dome. This approach helped distribute the enormous weight, estimated to be over 25,000 tons!

Brunelleschi was not just a brilliant architect. He also invented innovative machines and hoists. His creative construction techniques were less costly, more efficient, and safer than ever before.

Filippo Brunelleschi. View of Dome, Duomo. Florence, Italy.

MAKING THE CONNECTION

- Filippo Brunelleschi included passages and stairs between the two dome shells. How do you think such features would have been useful?
- Brunelleschi was educated as a sculptor and a goldsmith. How might such a background, combined with his discovery of linear perspective, have helped him as an architect?
- There are many different kinds of domes. Each kind depends on the shape of the base and the shape of the cross-section of the dome. Find out about some other kinds of domes. What are some famous ones you are familiar with?

INTERNET ACTIVITY

Visit Glencoe's Fine Arts Web Site for students at:

http://www.glencoe.com/sec/art/students

C H A P T E R 11
REVIEW

BUILDING VOCABULARY

Number a sheet of paper from 1 to 6. After each number, write the term from the list that best matches each description below.

linear perspective Pietà
Madonna Renaissance
oil paint symbolism

1. A period of great awakening.
2. The use of slanted lines to make objects appear to extend back into space.
3. A work showing the Virgin Mary with the Christ Child.
4. A work showing Mary mourning over the body of Christ.
5. The use of an image to stand for a quality or an idea.
6. A mixture of pigment, linseed oil, and turpentine.

REVIEWING ART FACTS

Number a sheet of paper from 7 to 14. Answer each question in a complete sentence.

7. Name three things the city of Florence was noted for in the 1400s.
8. Who was Masaccio? What is he remembered for?
9. Name two areas besides art in which Leonardo da Vinci was skilled.
10. In what way can Leonardo's influence be seen in the works of Raphael?

11. What is unusual about the proportions of the two figures in Michelangelo's *Pietà?*
12. What geometric shape did Renaissance artists use as a way of planning their works?
13. What feature of Gothic art did Northern Renaissance artists continue to use in their works?
14. What Northern Renaissance painter is credited for discovering oil paint?

THINKING ABOUT ART

On a sheet of paper, answer each question in a sentence or two.

1. **Interpret.** Read the following statement: "Art of the present would not be possible without art of the past." Describe three facts about artists or events of the Renaissance that you would use to support this statement.
2. **Analyze.** Look once again at the two paintings by Jan van Eyck (Figures 11–11 and 11–14). Which has the most lifelike details? Which particular details struck you as looking most like a photograph?
3. **Compare and contrast.** In what ways were the art styles of the Renaissance in Italy and in the North similar? In what ways were they different?

— MAKING ART CONNECTIONS

1. **Language Arts.** Another artist of the Northern Renaissance, Hieronymus Bosch, painted imagery and symbolism into his works. Read *Pish, Posh, Said Hieronymus Bosch*, by Nancy Willard. Discover in this poem how creatures in his paintings come to life and upset the woman who cares for his household.
2. **Social Studies.** Michelangelo, as you read in this chapter, was gifted in many fields. Two of these were painting and architecture. In an art history book or encyclopedia, read about his contributions in these two areas. Note names of specific projects and, if possible, make photocopies of pictures of the works. In addition, gather details of Michelangelo's life. Combine your findings with information on his sculpture into a book.

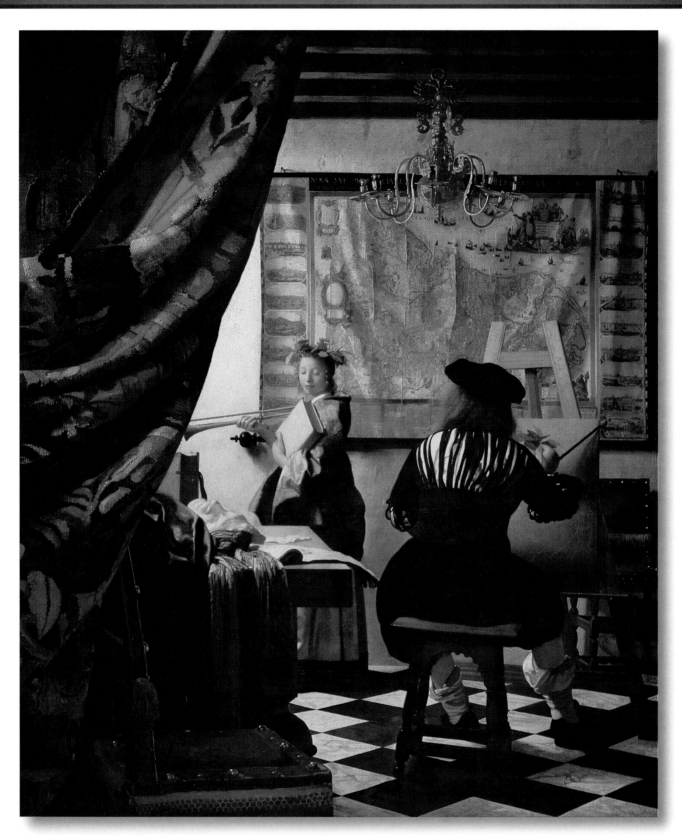

▲ Notice the careful use of light in this work. The viewer's eye is directed to the subject of the artist's attention, the model he is painting.

Jan Vermeer. *The Painter and his Model as Klio.* 1665–66. Oil on canvas. 120 x 100 cm (47¼ x 39⅜"). Kunsthistoriches Museum, Vienna.

European Art of the 1600s and 1700s

The mood of unrest in Europe following the Renaissance resulted in a religious revolution during the 1500s. This was followed a century later by yet another revolution.

This second revolution resulted in a new, peaceful atmosphere. It also resulted in a new wave of artists and new ways of making art. The picture at the left was done in a style of the age. Can you identify any of its features? You will soon be able to recognize them.

PORTFOLIO IDEAS

Find an art work in this chapter that has a dramatic feel. What elements of art did the artist use to create the expressive qualities? What principles of art were used? Create your own dramatic art work for your portfolio entry. Include your preliminary sketches and any notes you made to show the processes and techniques you used.

OBJECTIVES

After completing this chapter, you will be able to:
- Explain what new ways of creating art were brought about by the Counter-Reformation.
- Identify features of the Baroque style and name important artists who practiced it.
- Describe features of the Rococo style and identify important artists of the period.
- Create art works in the expressive style of Rembrandt.
- Experiment with art in the Rococo style.

WORDS YOU WILL LEARN

Baroque
etching
facade
portrait
Rococo

Art of the 1600s

When Rome collapsed, you will recall, the Catholic Church became more influential. It remained this way until the early 1500s, when the Church's power began to slip. A group of Christians led by a man named Martin Luther splintered off from the Church in revolt to form their own religion.

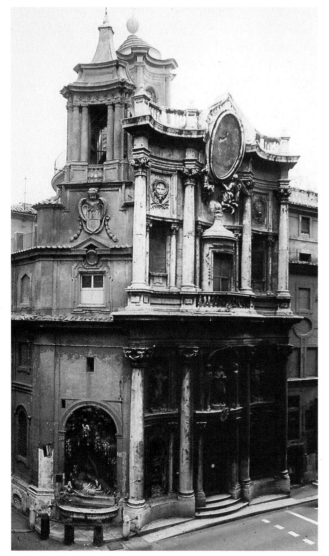

▲ **Figure 12–1** Study the changing light and dark values on the surface of this church. What principles are used to organize these different values?

Francesco Borromini. San Carlo alle Quattro Fontane. c. 1665–1676. Rome, Italy.

The Protestant Reformation, as this movement was called, drew many people away from the Catholic Church. In an effort to win them back, the Church started its own reform movement in the 1600s. This movement, which began in Italy, is known as the Counter-Reformation.

Art was an important part of the Counter-Reformation. Artists were called upon to create works that would renew religious spirit. A sense of flowing movement is one feature of a new art style of the day, **Baroque** (buh-**rohk**), or *an art style emphasizing movement, contrast, and variety.*

ARCHITECTURE AND PAINTING

In architecture the call to renew religious spirit was answered by, among others, an artist named Francesco Borromini (fran-**ches**-koh bor-uh-**meen**-ee). The church pictured in Figure 12–1 won Borromini great fame. He created the **facade** (fuh-**sahd**), *the outside front of a building*, to express his art. Do you notice how the surface seems to flow — first in, then out, then in again? Notice how the structure looks almost as though it were modeled from soft clay. This helps create a pattern of light and dark values across the whole facade. The Baroque emphasis on movement is also seen in painting of the period. Although the style originated in Italy, it spread to Spain and northern Europe.

Italy

The leader of the Baroque style in Italy was a young painter named Michelangelo Merisi da Caravaggio (kar-uh-**vahj**-yo). One of his key contributions was the use of light in a daring new way. This ability is combined with the artist's skill as a storyteller in the picture in Figure 12–2. Take a moment to study the work, which pictures the burial of

Christ. It is as if a spotlight has been shone on real actors on a stage. Find the man holding Christ's legs. This man, whose eyes meet yours, draws you into the painting. Notice the puzzled expression on his face. He seems about to ask you to identify yourself. Perhaps he will also ask if you intend to merely watch or to help in laying Christ in his tomb. In this way, Caravaggio makes you feel that you are a part of the drama.

Spain

Not all Baroque paintings showed such tense, dramatic movement. Movement of another sort is found in the works of Spanish painter Diego Velázquez (dee-**ay**-goh vuh-**las**-kez). One of these, a simple painting of a woman sewing, is pictured in Figure 12–3.

Examine this painting. Note how the fingers of both hands are blurred. This helps show that her fingers are moving rapidly as she sews.

Northern Europe

The major talents in Northern Europe, you will remember, developed during the Renaissance. This trend continued into the 1600s, led by a Flemish painter named Peter Paul Rubens. No other Baroque artist came close to Rubens in capturing the action and feeling of the new style. Notice his use of line in the work in Figure 12–4 on page 180. The picture shows the Virgin Mary rising toward heaven. Can you find the line—partly real, partly imaginary—beginning in the raised arm of the figure at the left? Where does this line lead? What kind of line is it? Notice how the line pulls the viewer into the work, making him or her feel present.

▲ **Figure 12–2** **Light is used to emphasize the most important details of this picture. These details are shown in shocking realism. Notice that even the soles of Christ's feet are painted to look dirty.**

Caravaggio. *The Deposition*. 1604. Vatican Museum, Pinacoteca, Rome, Italy.

▲ **Figure 12–3** **The young woman in this picture may be the artist's daughter. She is known to have married one of his pupils.**

Diego Velázquez. *The Needlewoman*. c. 1640–1650. Oil on canvas. 74 x 60 cm (29⅛ x 23⅝"). National Gallery of Art, Washington, D.C. Andrew W. Mellon Collection.

▲ Figure 12–4 Nothing seems to stand still in this painting. You are made to feel as though you are witnessing a moment in time.

Sir Peter Paul Rubens. *The Assumption of the Virgin.* c. 1626. Wood. 125.4 x 94.2 cm (49⅜ x 37⅛"). National Gallery of Art, Washington, D.C. Samuel H. Kress Collection.

In neighboring Holland, which remained a Protestant stronghold, a new subject matter for paintings was busily being explored. Genre pictures showing simple scenes from daily life were preferred over religious paintings. Other kinds of paintings that were popular were the **portrait,** *a painting of a person,* and the still life. A gifted young painter named Judith Leyster (**lye**-stuhr) specialized in portraits, using quick, dazzling brush strokes. This allowed her to catch the fleeting expressions on the faces of her subjects. Figure 12–5a shows a portrait she did of herself. Note how she seems to smile out of the picture at the viewer. Could she be eager for the viewer's reaction to the painting she is working on?

In seventeenth-century Holland, flowers were one of the most prized still-life subjects.

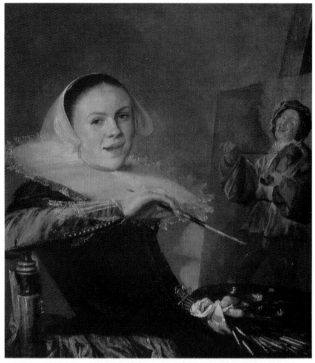

▲ **Figure 12–5a** By the time she was 17, the artist was already gaining fame as a painter. With her detailed style and careful brush work, Leyster created portraits that invite the viewer to interact with the subject.

Judith Leyster. *Self-Portrait.* c. 1635. Canvas. 72.3 x 65.3 cm (29⅞ x 25⅝"). National Gallery of Art, Washington, D.C. Gift of Mr. & Mrs. Robert Woods Bliss.

▲ **Figure 12–5b** Ruysch was interested in producing a faithful reproduction of nature, and she worked slowly and carefully toward that goal. She once spent seven years finishing three pictures as a wedding gift for her daughter.

Rachel Ruysch. *Roses, Bonvolvulus, Poppies, and Other Flowers in an Urn on a Stone Ledge.* c. 1745. Oil on canvas. 107.95 x 83.82 cm (42½ x 33"). The National Museum of Women in the Arts, Washington, D.C. Gift of Wallace and Wilhelmina Holladay.

One of the most highly respected flower painters of this century was Rachel Ruysch. Figure 12–5b is an excellent example of the realistic style. Notice how the flowers are arranged to form an S-curve. This was a technique Ruysch used in many of her paintings.

✔ CHECK YOUR UNDERSTANDING

1. What was the Protestant Reformation? Who was its leader?
2. What was the Counter-Reformation?
3. What new art style arose during the period of the Counter-Reformation? What are the main features of this style?
4. What was a main contribution of Caravaggio?
5. Name a major Baroque painter of northern Europe.
6. What is a portrait? What artist that you read about specialized in painting portraits?

Drawing Expressive Hands

The leading Dutch painter of the 1600s is a man named Rembrandt van Rijn (**ryn**). Figure 12–6 shows a portrait by this master. The artist uses a soft light to highlight the main parts of the picture. The subject, you will notice, is not beautiful. She seems, however, not to care about this. She is not bothered by the fact that others may be more attractive. If anything, she appears to be at peace with the world and her place in it. Notice how even her hands mirror this gentle calm. The artist has managed to make them look totally relaxed and at rest.

WHAT YOU WILL LEARN

You will make a drawing of your hand on black construction paper. Draw the hand to express a particular feeling. White crayon will be used to emphasize the three-dimensional form of the hand. (See Figure 12–7.)

WHAT YOU WILL NEED

- Pencil and sheets of sketch paper
- Sheet of black construction paper, 9 x 12 inches (23 x 30 cm)
- White crayon

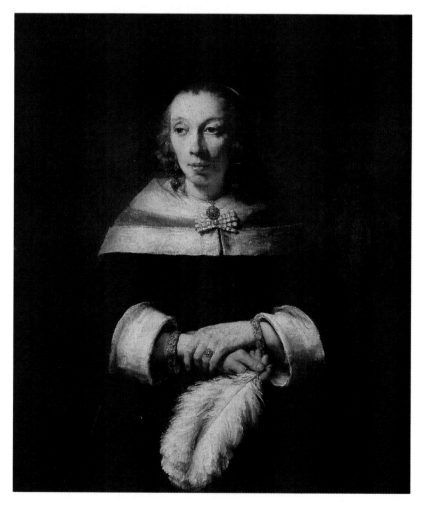

▶ **Figure 12–6** The artist uses a straight horizontal line in the center of this picture. He separates the linen scarf from the lady's clothing. Do you remember what kind of mood a straight line like this calls to mind?

Rembrandt van Rijn. *Portrait of a Lady with an Ostrich-Feather Fan.* c. 1660. Canvas. 99.5 x 83 cm (39¼ x 32⅝"). National Gallery of Art, Washington, D.C. Widener Collection.

WHAT YOU WILL DO

1. Brainstorm with your classmates on ways hands can show different moods and feelings. Some possibilities for discussion are surprise, anger, sadness, joy, and nervousness. Choose one of these moods or feelings. Do not tell anyone in your class which one you have picked.

2. Pose the hand you do not use to draw with in a way that shows the mood you have selected. It might be relaxed, clenched, or distorted in some way. With your drawing hand, make pencil sketches of the posed hand. Make your drawings as accurate as you can.

3. Still using pencil, draw the best of your sketches on the sheet of black paper. Make the drawing large enough to fill the sheet.

4. Switching to white crayon, add highlights to your drawing. Begin by coloring lightly. Gently blend the crayon around the fingers and other hand parts to make them look three-dimensional and lifelike. (For information on shading techniques, see Technique Tip **6**, *Handbook* page **278**.) Press lightly when coloring shadowed areas. Press harder on the crayon when coloring the most highly lighted areas.

5. Place your finished drawing on display with those of other students. Decide which of the drawings are most lifelike. Are your classmates able to guess the feeling or mood your hand drawing expresses?

EXAMINING YOUR WORK

- **Describe** Tell whether your drawing looks like your hand. Identify its most realistic features.
- **Analyze** Show where you used white crayon to highlight your drawing. State whether the light and dark values emphasize the three-dimensional form of the hand.
- **Interpret** Tell whether your drawing expresses a particular mood or feeling. Tell whether viewers were able to identify this feeling.
- **Judge** Identify the best feature of your drawing. Tell whether it is the realistic appearance of your work, the use of light and dark to give a sense of roundness, or the expressive content of your drawing.

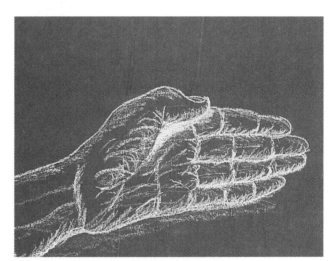

▲ Figure 12–7 Student work. Expressive hands.

Try This! **COMPUTER OPTION**

▨ Select a hand position that expresses a mood. Flood-fill page or canvas with a dark color. Use light chalk or charcoal Brush to draw hand with a mouse or light pen. Choose a rough paper texture if available.

Show hand and finger contours by adding light areas with small strokes of Brush tool. Gradually blend strokes to slowly move from very dark to lightest areas. Title, save, and print your work.

Art of the 1700s

Just as events of the 1500s brought in the Baroque style, so events of the 1600s brought about its end. The most important of these was the crowning of one of history's most colorful, pleasure-loving rulers. Because this king chose the sun as his emblem, he became known as the Sun King.

In this lesson you will learn about this king, the period in which he lived, and the new art style that he helped inspire.

EUROPE IN THE LATE 1600s

During the 1600s France emerged as Europe's strongest and wealthiest nation. Its capital, Paris, became the center of art. Find this city on the map shown in Figure 12–8.

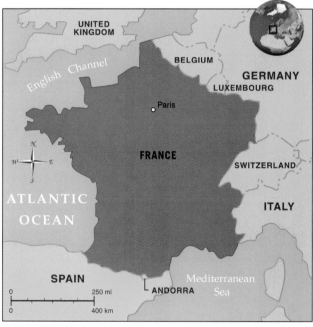

▲ **Figure 12–8 France.**

The force behind these changes was a powerful king with very rich tastes. He was Louis XIV, who ruled France for over 70 years. Louis' tastes were to help chart the course Western art would follow over the next 100 years.

Architecture

The beginnings of the new art style were put into motion in 1661. That year Louis ordered architects to build him the biggest, most elaborate palace in the world. It was built at Versailles (vuhr-**sye**), a short distance from Paris (Figure 12–9).

No photograph can begin to do the Palace of Versailles justice. The building covers 15 acres and contains enough rooms to house 10,000 people. The landscaped gardens around the palace cover another 250 acres. In Louis' time, 4 million flower bulbs were brought in each year from Holland to fill these gardens with the flowers the king loved.

Painting

Life for the king and his friends at Versailles was happy and carefree. This mood gave rise to a new style of art in the early 1700s. This style, which has come to be called **Rococo** (ruh-**koh**-koh), is *an art style stressing free, graceful movement; a playful use of line; and bright colors.*

The first artist to create works in the Rococo style was a painter named Antoine Watteau (an-**twahn** wah-**toh**). Watteau's pictures show a make-believe world peopled by untroubled members of France's ruling class. The painting in Figure 12–10 is one such picture. Like the figures in Watteau's other works, the people in this one appear to have not a care in the world. They are shown in a parklike garden listening to music. Notice

▲ Figure 12–9 The gardens at Versailles also included a small zoo with unusual animals and birds. Louis XIV spent nearly three-fourths of all taxes collected to pay for this and other luxuries of his palace.

Louis Le Vau and Jules Hardouin-Mansart. Palace at Versailles, France.

◄ Figure 12–10 This painting shows a group of aristocrats about to leave the legendary island of romance. Notice the delicate figures, rich costumes, and dreamlike setting. These, along with the soft colors, are typical of Watteau's Rococo style.

Antoine Watteau. *Embarkation from Cythera.* 1717–1719. Charlottemburg Museo, The Louvre, Paris, France.

▲ Figure 12–11 The artist lived to be 87. When she died, her will called for a relief carving of a painter's palette and brush on her tombstone.

Élisabeth Vigée-Lebrun. *Portrait of a Lady*. 1789. Wood. 107 x 83 cm (42⅛ x 32¾"). National Gallery of Art, Washington, D.C. Samuel H. Kress Collection.

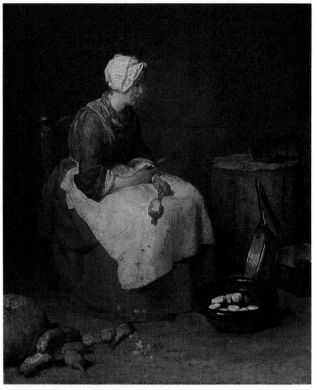

▲ Figure 12–12 Chardin painted many scenes like the one in this work. Each treats familiar scenes and ordinary objects with respect and affection.

Jean-Baptiste-Siméon Chardin. *The Kitchen Maid*. 1738. Canvas. 46.2 x 37.5 cm (18⅛ x 14¾"). National Gallery of Art, Washington, D.C. Samuel H. Kress Collection.

that the viewer seems to be looking at this scene from far off. What reason might the artist have had for removing us—and himself—from the events in the painting?

The members of the French ruling class enjoyed having their portraits painted. An artist who met this demand was Élisabeth Vigée-Lebrun (ay-**lee**-zah-bet vee-**zhay**-luh-**bruhn**). Before she was 20, Vigée-Lebrun had painted many important nobles. By the time she was 25, she was named the queen's personal portrait painter. Vigée-Lebrun's portraits often put the subject in a very favorable light. She also reveals, in works like the one in Figure 12–11, how successful a simple pose can be. Notice how the young woman appears to be watching and listening *to you*. How flattering this is. No doubt this attention adds to a warm feeling about her.

Another side of French life was shown in the Rococo paintings done by Jean-Baptiste Siméon Chardin (**zhahn**-bah-**teest** see-may-**ohnh** shahr-**danh**). His genre pictures take the viewer into the simple homes of everyday people. One of these works, Figure 12–12, shows a woman preparing a meal. She seems to be lost in dreamy thought as she works. Everyone has had similar experiences when a sound or image sets the mind wandering for a few moments. Notice how the artist blends mellow colors and carefully painted still-life objects to communicate a quiet mood. The world of Chardin's art is one where time stands still and nothing disturbs the peacefulness. The viewer is able to observe simple domestic scenes treated with respect and affection.

ROCOCO ART IN SPAIN

The Rococo style in painting was not limited to France. In Spain the style was picked up by a free-thinking artist named Francisco Goya (fran-**sis**-koh **goy**-uh). Through his early forties, Goya painted softly lighted portraits of people from Spanish high society. A glimpse of the horrors and suffering of war, however, changed all that.

In 1808 French troops attacked Spain. The bloody scenes Goya witnessed prompted a series of etchings. An **etching** is *an intaglio print made by scratching an image onto a specially treated copper plate*. The etching in Figure 12–13 shows a French firing squad taking aim at a captured war prisoner. The figures and weapons stand out against a darkened sky. Goya's view of war is stripped of brave warriors and glorious victories. It is a shocking vision of death and destruction.

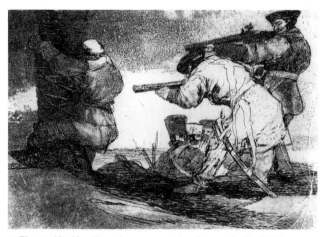

▲ **Figure 12–13** How do you suppose viewers in the 1800s reacted to the manner in which Goya chose to express scenes like this in his work?

Francisco de Goya. *Cornered (From the Disasters of War).* Barbares, Paris, France. Bibliotheque Nationale.

STUDIO ACTIVITY

Make It Extraordinary

Look once again at the painting in Figure 12–12 by Jean-Baptiste Siméon Chardin. The artist, it might be said, changes the ordinary into the extraordinary. With a little imagination, you can do the same.

Find a small, ordinary object. Focus your search on something you would not usually think of in connection with a painting. Some examples are a clothespin, a nail, or a safety pin. Study the object carefully, and then draw it on a sheet of white paper. The drawing should totally fill the page. It should also be as accurate as you can make it. Use tempera to add color. Work at capturing the color, form, and texture of the object. Paint the background a dark color so the object will stand out boldly.

PORTFOLIO

When your painting is complete, assess your work. Write your responses to the questions on page **177**. Keep your self-assessment and your painting together in your portfolio.

✔ CHECK YOUR UNDERSTANDING

1. What country became the center of art in the late 1600s? What king helped bring about the change?
2. What new art style grew out of the carefree life of the ruling class at Versailles? What are the main features of works done in this style?
3. What kinds of paintings were created by Antoine Watteau? What kind of paintings were done by Élisabeth Vigée-Lebrun and by Jean-Baptiste Siméon Chardin?
4. What are etchings? What events prompted Goya's etchings of war-related scenes? What do these etchings tell about Goya's view of war?

 LESSON 4

Constructing a Rococo Shoe

The 1700s were, above all else, a period of high fashion. It was said that if a woman left Paris on a short vacation, she would return to find all her clothes outdated. Hairdos grew taller and taller, and so did the heels on shoes—men's as well as women's. Architects began raising doors higher so people could pass through. Paintings by Antoine Watteau, like the one in Figure 12–14, mirror this concern for fashion. The figures in this painting look almost like fashion dolls.

Imagine that the president of a modern-day shoe company has decided to stage a contest. Designers are to come up with ideas for a shoe. It is to be of a type that might be found on the foot of a figure in a Watteau painting.

WHAT YOU WILL LEARN

You will design and create a Rococo shoe using cardboard and scrap materials. Use a variety of colors, shapes, and textures to create a highly decorative pattern. Your finished shoe will be a three-dimensional form. (See Figure 12–15.)

WHAT YOU WILL NEED

- Pencil and sheets of sketch paper
- Sheets of lightweight cardboard
- Scissors, heavy cardboard scraps, white glue, and stapler
- Pieces of brightly colored, richly patterned cloth
- Scrap materials, such as buckles, laces, bows, and sequins

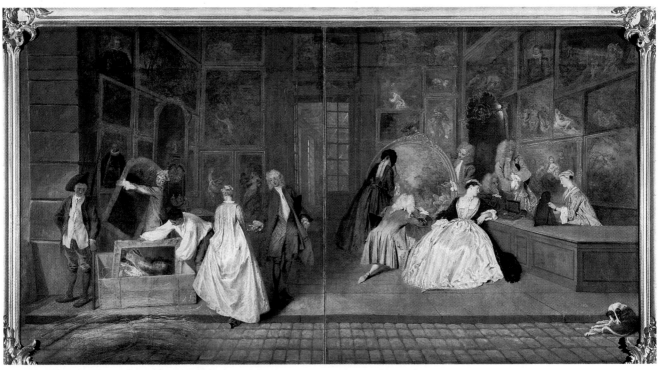

▲ **Figure 12–14** This painting was created as a signboard for an art gallery in Paris. Notice the elegant patrons dressed in rich costumes of the times.

Jean-Antoine Watteau. *The Signboard of Gersaint.* c. 1721. Oil on canvas. 163 x 308 cm (64⅛ x 121¼"). Charlottenburg Palace, Berlin, Germany. Charlottenburg Castle. Staatliche Scholoesser und Gaerten, Berlin, Germany.

WHAT YOU WILL DO

1. Make several pencil sketches of a shoe as seen from the side. Make your design as elaborate and unusual as you can. Use exaggerated heels, soles, laces, and decorative features. Let your imagination guide you.
2. Choose your best sketch. Draw the outline of the shoe on a sheet of cardboard. Make the shoe lifesize. Carefully cut out the shoe.
3. Place your cutout on a second piece of cardboard. Holding it firmly in place, carefully cut around it, creating a second identical shoe.
4. Glue strips of heavy cardboard between the two shoe cutouts. These will be hidden inside, and will give you the basic form of a shoe.
5. Using pieces of cloth in different colors and patterns, cover the shoe form. Curve the cloth pieces around the heel of the shoe and across the top and the toe. Staple the cloth in place. (*Hint:* Cutting the cloth scraps small will help add to the decorative look of the shoe.) Glue buckles, bows, laces, and other scrap items in place as added decoration.
6. When the glue is dry, place your shoe on display. Compare your finished shoe with those of your classmates.

EXAMINING YOUR WORK

- **Describe** Tell whether your finished object can be recognized as a shoe. State whether it has a heel, sole, and other shoe parts. Explain how your shoe is a three-dimensional form.
- **Analyze** Point out the variety of colors, shapes, and textures in your work.
- **Interpret** Identify the kind of person who would wear the shoe you designed. State whether you could imagine the shoe on the foot of a subject in Figure 12–14.
- **Judge** Tell whether you feel you have succeeded in creating a Rococo shoe. State whether you feel it would win the shoe company contest. Explain why.

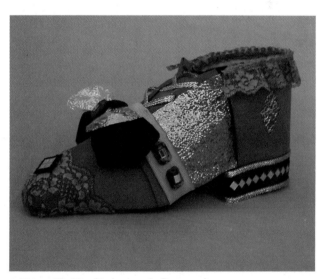

▲ **Figure 12–15 Student work. Rococo shoe.**

Try This! STUDIO OPTIONS

■ Create a shoe box with a design in the same Rococo style as your shoe. Follow the instructions given in Lesson 4 of Chapter 11.

■ How would an ancient Egyptian, Greek, or Roman shoe differ from your Rococo shoe?

Select a period you have read about, and design a shoe that reflects that period in a humorous way. Create a painting of your own design using tempera colors. Display your work, and ask if anyone can identify the period you selected.

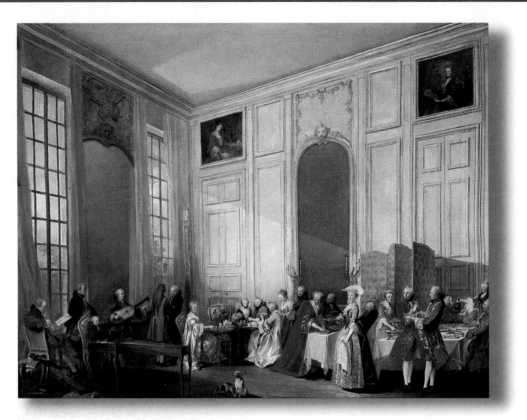

Oliver Michel Barthelemy. *Le Thé à l'Anglaise au Temple Chez le Prince de Conti.* 1766. Louvre, Paris, France. Lauros-Giraudon/Art Resource, New York.

How were Baroque Music and Art Similar?

From about 1600 to 1750, European music followed some of the same directions as art. It was vivid, expressive, and full of movement. The composers explored new avenues, using harmony and the major and minor scales more than before. For the first time, instrumental music was almost as popular as vocal music. As with art, much of the changes began in Italy with the introduction of the concerto and the opera.

Most composers of this time worked as organists and choirmasters in a church or were hired as musicians by aristocrats. Some of the most influential and successful composers of the time were Jean-Baptiste Lully of France, Henry Purcell of England, and Domenico Scarlatti and Antonio Vivaldi of Italy. Perhaps the most enduring musicians of the Baroque period, however, were Johann Sebastian Bach and Georg Friedrich Handel of Germany. In the late 1700s, the European middle class grew and public concerts became popular.

MAKING THE CONNECTION

- How can you tell the social status of the audience pictured here in Barthelemy's painting? What are they doing?
- What music from this period have you listened to? How would you describe some of the works you have heard?
- Find out more about the life and work of one of the composers listed above. Listen to a few of that person's compositions.

INTERNET ACTIVITY

Visit Glencoe's Fine Arts Web Site for students at:

http://www.glencoe.com/sec/art/students

REVIEW

◆ BUILDING VOCABULARY

Number a sheet of paper from 1 to 5. After each number, write the term from the list that best matches each description below.

Baroque portrait
etching Rococo
facade

1. The outside front of a building.
2. An art style emphasizing movement, contrast, and variety.
3. A painting of a person.
4. An art style stressing free, graceful movement; a playful use of line; and bright colors.
5. An intaglio print made by scratching an image onto a specially treated copper plate.

◆ REVIEWING ART FACTS

Number a sheet of paper from 6 to 13. Answer each question in a complete sentence.

6. What architectural art style was practiced by Francesco Borromini?
7. What was a key contribution of Caravaggio to the art of the 1600s?
8. What kinds of paintings were in demand in Holland during the 1600s?

9. What kinds of paintings were the specialty of Judith Leyster?
10. Who was the first artist to create Rococo paintings?
11. To what post was Élisabeth Vigée-Lebrun named as a young woman?
12. What side of French life of the 1700s is revealed in the paintings of Jean-Baptiste Siméon Chardin?
13. What sorts of paintings did Francisco Goya create through his early forties?

THINKING ABOUT ART

On a sheet of paper, answer each question in a sentence or two.

1. **Analyze.** Turn again to Caravaggio's painting of Christ's burial (Figure 12–2). Notice the artist's use of texture to add variety to the work. How many different textures can you find? On what objects in the work are these textures found?
2. **Compare and contrast.** Look once again at the portraits by Judith Leyster (Figure 12–5a) and Élisabeth Vigée-Lebrun (Figure 12–11). Tell in what ways the two works are alike. Explain how they are different. Which of these two artists' works do you find most successful? Explain.

─ MAKING ART CONNECTIONS

1. **Music.** The Baroque style was not limited to art. It is also found in music of the period. Working as part of a team of students, (1) find and tape-record a musical composition by the famous Baroque composer Johann Sebastian Bach (**yo**-hahn suh-**bast**-ee-uhn **bahk**), and (2) find and photocopy other works by several Baroque artists you learned about in this chapter. Stage a sound-and-sight presentation for your class.

2. **Social Studies.** Several of the painters you read about in this chapter created genre, rather than religious, works. Rembrandt, during the 1600s, was one. Chardin, during the 1700s, was another. Find a third genre artist from either of the two periods. Imagine that this person were living today. Based on what you know of the artist, describe what a twentieth-century work by him or her might look like. Give details about both the subject and style of the work.

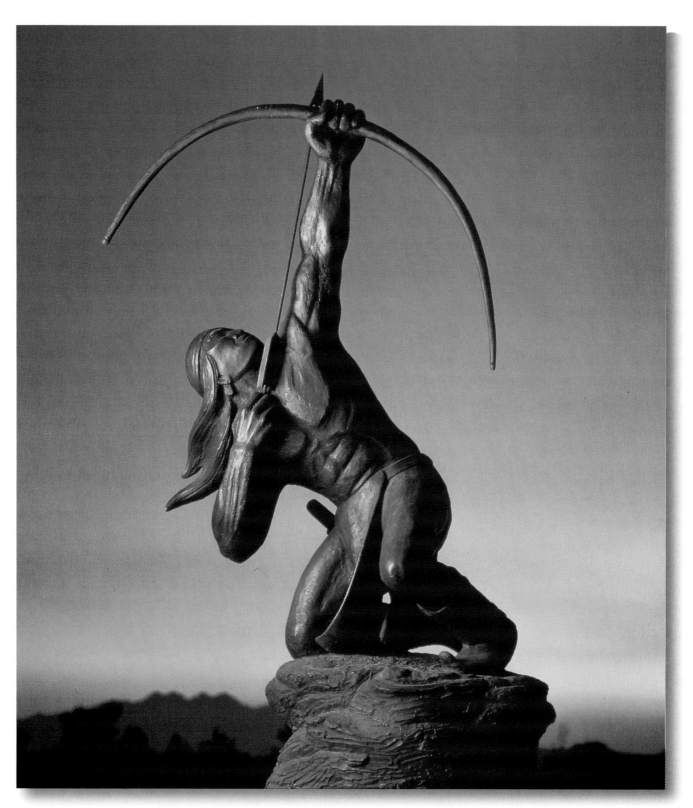

▲ This artist's father was the grandson of the Apache chief Mangus Colorado and a relative of Geronimo. Can you see any similarity when comparing this sculpture with the one by Byron in Figure 7–3?

Allan Houser. *Sacred Rain Arrow.* 1988. Bronze. 249 x 99 x 78.7 cm (98 x 39 x 31"). Glenn Green Galleries, Phoenix, Arizona.

Native American Art

In history books the part of the globe we live in is called the New World. To the peoples who have dwelled in this region since earliest times, there is nothing new about it. Some of these groups—from Central and South America—you learned about in Chapter 6.

In this chapter you will read about the first people of North America. You will learn about their culture. You will learn, finally, about the proud traditions that have led to the making of art works like the one shown on the left.

PORTFOLIO IDEAS

Select one or more art works from the studio activities and lessons in this chapter that express something about your personality or a tradition that is meaningful to you. Describe how you created the art work to tell about you, in the way that Native American art represents the traditions and values of the artist who created it. Keep your chosen art work together with your notes in your portfolio.

OBJECTIVES

After completing this chapter, you will be able to:

- Name and describe five major groups of Native Americans.
- Identify the contributions to art the different Native American cultures have made.
- Identify Native American artists working today.
- Create art in the style developed by the Native Americans.

WORDS YOU WILL LEARN

coiled pot
cradle board
Kachina
loom
petroglyphs
polychrome
pueblos
sand painting
tepee
totem pole
warp
weft

Native American Art of the Past

When Christopher Columbus reached North America in 1492, he thought his ships had landed on the east coast of India. He referred to the natives he found living there as Indians. Today these first settlers are called Native Americans.

In this lesson you will study four of the major Native American groups: the Pueblo, Northwest Coast Indians, Plains Indians, and Woodlands Indians. You will look at the art they produced hundreds of years ago and see how their contributions influence Native American art today.

PUEBLO CULTURE

Pueblo tradition tells us that in ancient times the ancestors of this group settled in what is now known as the Four Corners region of the United States. Find this region on the map in Figure 13–1. Like other Native American groups, the Pueblo are believed to have come from Asia.

Scientific records show they probably came by way of the Bering Sea some 20,000 to 30,000 years ago.

"The People," as the early Pueblo called themselves, were farmers. They wore clothes woven from cotton, had a democratic form of government, and traded with other cultures.

Crafts

It was through trade with Mexico around A.D. 400 that the Pueblo learned to make pottery. The earliest kind of pot, called a **coiled pot**, was *a pot formed by coiling long ropes of clay in a spiral*. An example of such a pot is shown in Figure 13–2. The careful pinching together of the coils was meant to be both decorative and useful. In what ways is this type of pot similar to the ones made by the Chavín of South America? (See Figure 6–11 on page **88**). In what ways is it different?

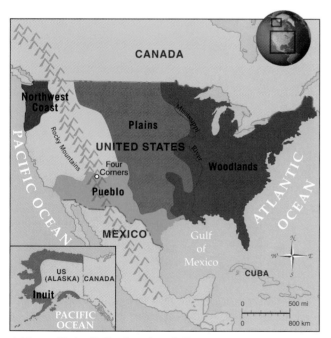

▲ Figure 13–1 Native American Cultures.

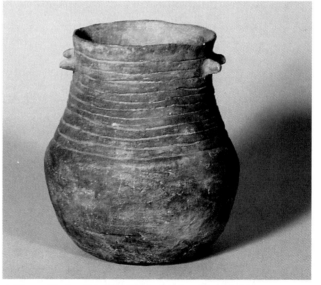

▲ Figure 13–2 Pots like this had to be able to hold water, which was precious in the dry hot southwestern desert. The pots were also used to store food and were buried with the dead to help them in the afterlife.

Coil pot. Pueblo. A.D. 1050–1200. Exterior: coiled neck; pinched coil underbody and base; lug handles on each side of neck; smoothed interior. 27.9 x 26.7 cm (11 x 10½"). Courtesy of the School of American Research, Indian Arts Research Center, Santa Fe, New Mexico. Gift of Maria Chabot, Albuquerque, New Mexico.

Petroglyphs

Although they were farmers, the early Pueblo also hunted for food. To ensure a good hunt, they made **petroglyphs** (peh-truh-glifs), or *rock carvings and paintings*, of their prey. This, they believed, would allow them to capture the animal's spirit. Can you think of another culture you learned about that shared this belief?

Examine the petroglyph of a bighorn sheep in Figure 13–3. Would you describe the work as realistic? Would you say it is stylized?

Architecture

The early inhabitants of the southwestern United States lived in round pit houses dug into the earth and covered with branches. Over the years the Indians learned to build with adobe, mud, and straw. When the Spanish arrived in the Southwest in 1540, they found *stacked, many-family dwellings made of adobe*. The Spaniards called these **pueblos**, after the Spanish word for "village." The same word was also used to refer to the Native American builders of these dwellings. Study the pueblo in Figure 13–4 on page **196**. Notice how the structure seems to grow out of the earth. What modern form of dwelling in our own culture has a purpose similar to the pueblo?

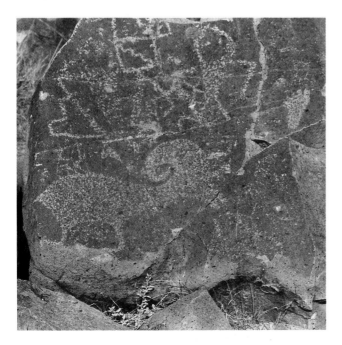

NORTHWEST COAST INDIAN CULTURE

The coastal sections of British Columbia and the states of Washington, Oregon, and northern California are rich with plant and animal life. Rain is plentiful, and cooling sea breezes keep temperatures mild. It is understandable that these features appealed to several groups of people heading south before 7000 B.C.

Today the collected groups of the region are known by the name of Northwest Coast Indians. Find the area settled by these early cultures on the map in Figure 13–1.

Like the Pueblos, the Northwest Coast Indians made use of the resources around them. They used the tall trees of the area to make boats and logs for houses. They also used the trees to create art works.

Sculpture

No art form is more unmistakably Native American than the totem pole. A **totem pole** is *an upright log carving picturing stories of different families or clans.* The word totem means "spirit or guardian." Figure 13–5 on page **196** shows a totem pole carved by an artist of a Northwest Coast tribe. Typically, this pole is meant to be read from top to bottom. The top figure identifies the clan to which the pole belongs. Notice how the facial features have been stylized to fit the available space.

PLAINS INDIAN CULTURE

Not all peoples who arrived here in Pre-Columbian times set up permanent villages. Some were wanderers who moved from place to place, following the food supply. One such group was the people known as the Plains Indians.

◀ **Figure 13–3 Petroglyphs like these have survived for many centuries. How are these rock paintings similar to the prehistoric cave paintings found in Lascaux (see Figure 4–1)?**

Petroglyph. Bighorn Sheep. A.D. 900–1100. Three Rivers Site, New Mexico.

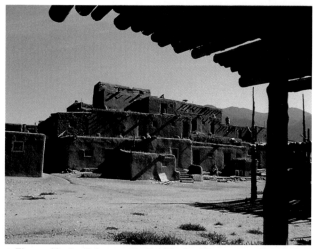

▲ Figure 13–4 Entrances to Pueblo dwellings were often holes in the roofs, with ladders leading down into the interiors.

Pueblo Dwellings. c. 1100. Taos, New Mexico.

The Plains Indians made their home in the large area bounded by the Mississippi River and the Rocky Mountains. Find these boundaries on the map in Figure 13–1. The Plains Indians hunted the bison. As the herds moved, so did the Plains people, dragging their possessions behind them on their custom-made sleds.

Architecture

Among the belongings the Plains people carried with them was the tepee. A **tepee** (**tee**-pee) was *a portable house.* As a rule, the tepee was cone-shaped and made of buffalo hide stretched over poles. The hides were covered with designs symbolizing the forces of nature.

At its base a tepee could range anywhere from 12 to 30 feet (4 to 9 m) in diameter. A large tepee contained about as much space as a standard living room of today. How many people do you think could live comfortably in such a space?

Crafts

Like the tepee, the crafts created by the Plains people were made to be easily carried. An example is the object pictured in Figure 13–6. This is a **cradle board**, a *harness worn on the shoulders and used to carry a small child.*

▶ Figure 13–5 The figures on this totem pole represent a man, a bear, and a frog at the bottom. These figures show status and rights of the family for which it was carved.

Tlingit Totem Pole. Mid-19th Century. Wood and pigment. Museum of American History, Smithsonian Institution, Washington, D.C.

Notice the care that went into the woven design. What kinds of shapes—organic or geometric—has the artist used in this design? What natural materials are used to decorate it?

WOODLANDS CULTURE

The Woodlands made up the largest cultural group of Native Americans. They settled in North America east of the Mississippi River. The Woodlands people combined

hunting and gathering with simple farming. The Iroquois, made up of six different Woodlands groups, combined to form the highly organized Iroquois nation.

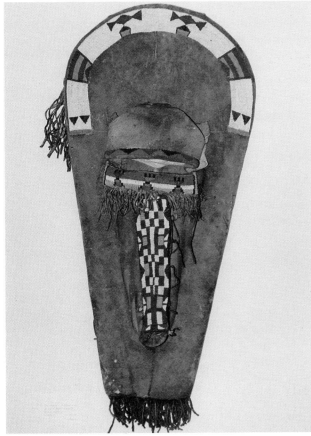

▲ **Figure 13–6** Even though their life was hard, the Plains Indians took great pride in their art. What features of this work reveal this pride?

Ute Cradle Board. c. 1870. Buffalo hide, trade beads. Channing, Dale, Throckmorton Gallery, Santa Fe, New Mexico.

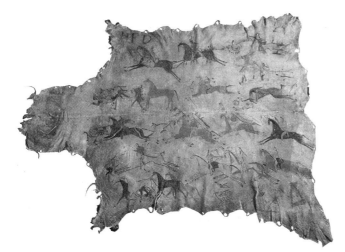

STUDIO ACTIVITY

Sketching an Event

Plains Indians painted tales of their battles on skins. Notice that the artist has used a birds-eye view in telling the tale shown in Figure 13–7.

Look through a newspaper or magazine for coverage of an important event in your city or in the world. On a sheet of paper, sketch the story behind this event. Carefully outline each object in your design. Color the work using watercolor markers.

PORTFOLIO

Exchange finished art works with a classmate for peer evaluation. To evaluate a peer's work, use criteria preset by your teacher or class group, or evaluate the use of elements and principles of art, use of media, and how well the artist has followed the directions of the assignment. Keep the peer evaluation of your work and the art work together in your portfolio.

✔ CHECK YOUR UNDERSTANDING

1. In what region do the Pueblo people live? Where are they and other Native American groups believed to have come from?
2. What are coiled pots? What are petroglyphs?
3. What form of architecture gave one Native American group its name? Why was this word chosen?
4. For what unmistakably Native American form of art are the Northwest Coast Indians known?
5. What are tepees? Why did the Plains Indians have a need for tepees?

◀ **Figure 13–7** This hide tells stories from the artist's own life. Can you tell what is happening? A robe made from a decorated hide was highly prized. Often, the person wearing it thought it would protect him from harm.

Exploits of a Sioux Leader. c. 1870–1875. Hide Painting. Philbrook Museum of Art, Tulsa, Oklahoma. Gift of Kills Eagle.

Making a Round Weaving

Some Native American craft styles and techniques are borrowed from other cultures. One you have learned about is Pueblo pottery, which came from artists in Mexico. Another craft, which also became an important art medium to many Native American cultures, is weaving. Woven materials were used for clothing and blankets. They were often highly decorated and expressed the artists' beliefs, customs, and traditions. Study the decorative weaving shown in Figure 13–8. It was created on a **loom**, or *frame holding a set of crisscrossing threads.* The loom holds two sets of threads. The **warp** threads are *threads running vertically and attached to the loom's frame.* The **weft** threads are those *threads passed horizontally over and under the warp.* The weaver of the object in Figure 13–8 was able to change colors and patterns by using different weaving techniques. This weaving was created on a circular loom.

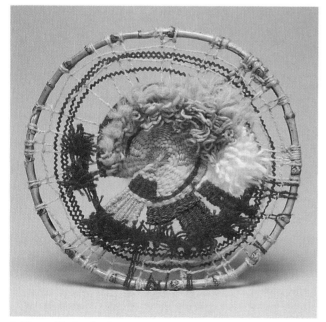

▲ **Figure 13–8 Student work. Round weaving.**

WHAT YOU WILL LEARN

You will make a round weaving on a loom made from wire coat hangers. Plan a color scheme for your weaving, and use weaving techniques to change colors in your design. Use a complementary, monochromatic, or analogous color scheme.

WHAT YOU WILL NEED

- 2 wire coat hangers
- Masking tape
- Assorted fibers
- 2 or more blunt tapestry needles

WHAT YOU WILL DO

1. Make a frame for your loom by putting two wire coat hangers together and bending them to form a flat circle. Connect the hangers in two places around the circle with masking tape. Bend the hook on one of the hangers into a loop. This will be used to hang your completed work.
2. Pick the colors of fiber you will use in your weaving. Choose a complementary, monochromatic, or analogous color scheme. Set the fibers aside.
3. Tie a long strand of fiber to your frame using an overhand knot. Wrap the fiber strand completely around the frame using half-hitch knots. (See Figure 13–9.) Thread the end of your fiber strand through a needle. Pull it through several of the knot loops to keep the fiber from coming undone. Cut off any extra fiber.

4. Create a warp by attaching a single long strand of fiber to the frame. Pass this across the circle at different points. Make sure each pass of the warp fiber crosses the center of the loom. (See Figure 13–10.) After six passes, begin a seventh. This time, take the warp strand only as far as the center. Tie all passes at this point.

5. Working from the center out, begin the weft using a tabby (over and under) weave. After several circuits, switch to one of the other techniques detailed in Figure 13–10. Experiment to create different color shapes or designs. You may leave some open spaces where the warp is not covered.

6. Display your weaving along with those done by classmates. See if you can identify the weaving techniques used in different works.

EXAMINING YOUR WORK

- **Describe** Explain how you created a loom using two wire coat hangers. Identify the different color shapes you created by switching weaves.
- **Analyze** Describe the shape of your loom. Tell what kind of color scheme you picked. Name the colors you used. Tell how you used weaving techniques to change the colors in your design.
- **Interpret** Explain how the colors you chose help communicate a certain mood to viewers. Give your work a title.
- **Judge** Tell whether your work succeeds. State what you might do differently in a second attempt at the assignment.

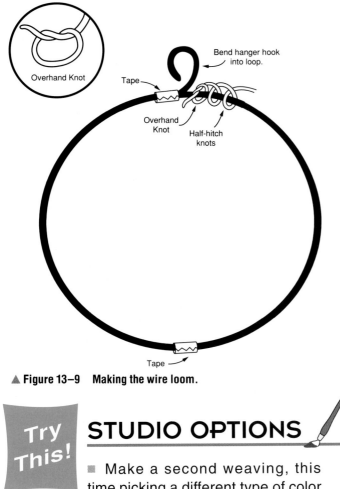

▲ **Figure 13–9 Making the wire loom.**

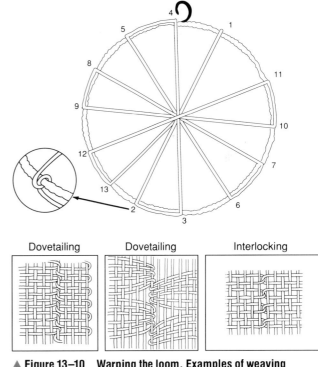

▲ **Figure 13–10 Warping the loom. Examples of weaving techniques are detailed.**

Try This! ## STUDIO OPTIONS

■ Make a second weaving, this time picking a different type of color scheme. Emphasize texture by using different fibers for your weaving.

■ Use a heavy-duty paper plate as a loom. Make an uneven number of notches around the edge. Warp it following the instructions in the lesson. Create another weaving.

Native American Art Today

During the 1600s, 1700s, and 1800s, America was explored and settled by newcomers from Europe. Native Americans fought to keep the lands they had lived on for generations. Their efforts were unsuccessful. As the land was settled by Europeans, the Native American population dwindled. Those who remained were eventually forced to live in limited areas called reservations.

Although the original Native American way of life has changed through contact with European cultures, much of the artistic tradition remains. It can be seen in the work created by contemporary Native American artists.

TRADITIONAL NATIVE AMERICAN ART

Traditional art is based on past forms and ideas. Some designs and techniques used by traditional artists today date from over a thousand years ago.

Crafts

Pueblo legend tells of supernatural spirits called Kachina (kuh-**chee**-nuh) who once lived among the people. The Kachina taught the Pueblo how to live in harmony with nature. This legend gave rise long ago to the making of Kachina figures. A **Kachina** is *a hand-carved statuette that represents spirits in Pueblo rituals.* Figure 13–11 shows a Kachina created late in this century. Like the figures of old, this object uses formal balance. What idea or mood does the figure communicate to the viewer?

Another tradition carried forward by craftspeople today is pottery. The **polychrome,** or *many-colored,* pots in Figure 13–12 are by Lucy Lewis, a leading twentieth-century Native American potter. Lewis created these pots

using the same skills she learned as a child watching her elders. Each step was carefully done by hand, from digging the clay to grinding the minerals for the paints she used. She worked without the aid of a potter's wheel. Look closely at these works. The patterns on the surface are adaptations of prehistoric designs. What images do you see in these abstract decorations?

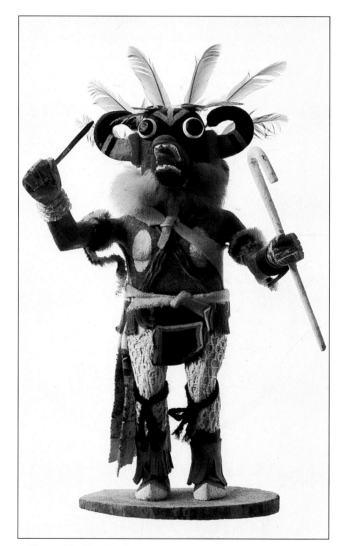

▲ **Figure 13–11** The Pueblo believe there are between 300 and 400 Kachinas. What other culture that you learned about believed in many spirits?

Hopi Kachina. c. 1975. Mixed-media. San Diego Museum of Man, San Diego, California. John Oldenkamp.

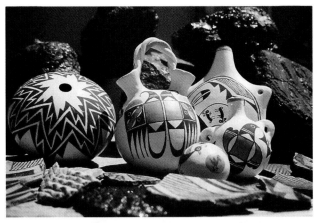

▲ **Figure 13–12** The artist learned to make pots from an aunt. What other skills besides art are learned through tradition?

Lucy Lewis. Polychrome Pots. Lewis Family. c. 1989/90. Acoma, New Mexico.

Margaret Tafoya is another Native American artist who has also preserved the traditional methods with modern experimental techniques. She has created the pottery water jar shown in Figure 13–13 using a method of intaglio molding and carving. Her jar is decorated with an ancient water-serpent design.

Painting

Some ancient art techniques still practiced today are associated with health and well-being. One of these, sand painting, is part of a healing ritual. **Sand painting** is *the pouring of different colors of powdered rock on a flat section of earth to create an image or design*. Examine the sand painting pictured in Figure 13–14. As with all creations of this type, this one is abstract in design.

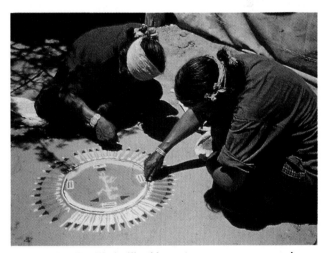

▲ **Figure 13–14** Works like this are temporary; a new one is made from scratch for each ritual.

Sand Painting. Medicine men placing feathers. American Museum of Natural History, New York, New York.

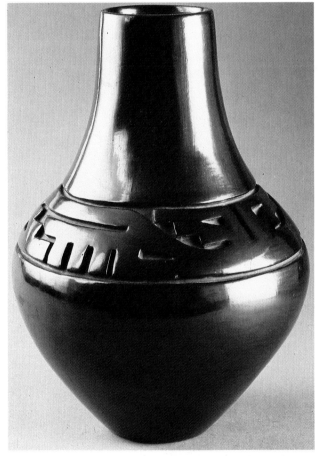

▲ **Figure 13–13** In what ways is this water jar similar to the ones by Lucy Lewis? How are they different?

Margaret Tafoya. Jar, Santa Clara. Pueblo, N.M. c. 1965. Blackware. 43 x 33 cm (17 x 13"). National Museum of Women in the Arts. Gift of Wallace & Wilhelmina Holladay.

MODERN NATIVE AMERICAN ART

Not all Native American artists of the twentieth century have been content to follow tradition. Many have studied at art schools and combined new media and techniques with their own cultural heritage.

Sculpture

One of the most influential Native American artists was Allan Houser (**ha**-oo-zohr). A Chiricahua Apache (chir-uh-**kah**-wuh uh-**pach**-ee), Houser was born in Oklahoma in 1914. As a child, he listened intently to stories about his people. After studying art, he went on to retell—usually in stone or bronze—the stories he had heard. Study the sculpture by Houser that opened this chapter, on page **192**. Can you imagine a story about this young warrior? How has Houser used line to move your eyes around the statue?

Painting

Portrait and landscape paintings are not parts of Native American art tradition. However, both played major roles in the brief life and career of twentieth-century painter T.C. Cannon. Cannon, a member of the Kiowa (**ky**-uh-waw) tribe, was born in 1946. A student of Allan Houser, he painted traditional subjects in brightly colored modern-day settings. Typical of his work is the portrait in Figure 13–15. Note the strong sense of design. What kind of detail has the artist shown in the man's clothing?

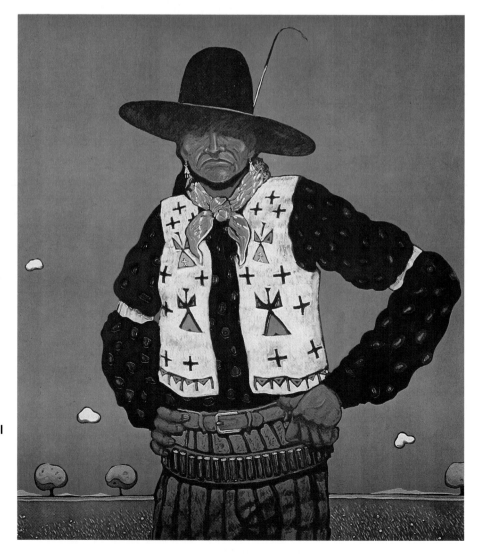

▶ **Figure 13–15 The artist skillfully incorporates traditional beliefs and symbols in his works. How has he done so in this painting?**

T.C. Cannon. *Turn of the Century Dandy.* 1976. Acrylic on canvas. 152.4 x 132.1 cm (60 x 52"). Aberbach Fine Arts, New York, New York. Private Collection.

In the painting shown in Figure 13–16, another artist, Oscar Howe, breaks with painting traditions imposed upon Native Americans by European teachers. Traditionally, Indians did not use a realistic style. They often depicted the spirit of animals and plants in symbolic, stylized designs. Howe uses line, shape, and color to show excitement. He expresses the powerful energy of the spirit of victory.

The painting by Dan Naminga, Figure 13–17, is yet another example of the blending of contemporary subject and traditional styles. This time the artist paints Pueblo dwellings in a rich, colorful landscape.

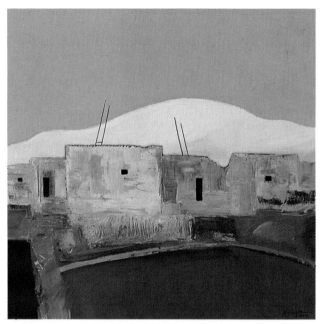

▲ **Figure 13–17** Does this dwelling remind you of one seen earlier? Can you see the tops of ladders extending upward? What were these used for?

Dan Namingha. *Hopi Dwelling.* Acrylic on canvas. 102 x 102 cm (40 x 40″).

✔CHECK YOUR UNDERSTANDING

1. What is traditional art?
2. What is a Kachina?
3. What is sand painting? For what is sand painting used?
4. In what area of art did Allan Houser specialize?
5. What was the art specialty of T.C. Cannon?

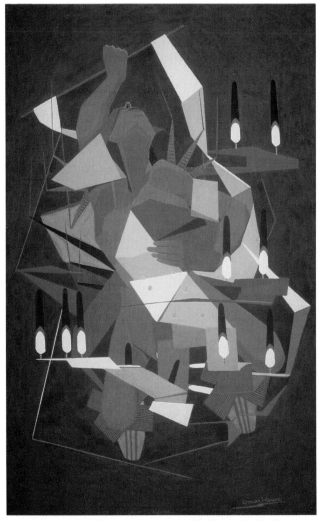

▲ **Figure 13–16** Compare this work with Figure 5–10. How are these two works similar? How do they differ?

Oscar Howe. *Victory Dance.* Philbrook Museum of Art, Tulsa, Oklahoma.

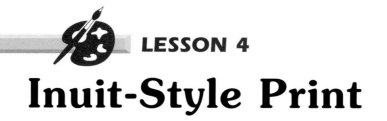

Inuit-Style Print

Another Native American group that has been around since earliest times is the Inuit (**in**-yuh-wuht). You probably know these people of Canada and Alaska better as Eskimos. The name "Eskimo" was used by explorers from other lands. The people from this group call themselves the Inuit. The Inuit have a tradition of carving bone, ivory, or stone to create abstract views of images from nature. This tradition is being upheld by artists working today. The print in Figure 13–18 is by a leading Inuit artist named Kenojuak (kuh-**noh**-joo-ak). Like all Native American artists, she combines nature, religion, and her own imagination.

WHAT YOU WILL LEARN

You will design a print based on your school mascot or some other school symbol. Your print will be abstract in design and should use line and shape to express your feelings about the animal. You will make an edition of three prints. (See Figure 13–19.)

WHAT YOU WILL NEED

- Pencil, eraser, and sheets of sketch paper
- 2 pieces of corrugated cardboard, 8 x 10 inches (20 x 25 cm)
- Paper-cutting knife and white glue
- Water-based printing ink
- Shallow pan and soft brayer
- Paper for printing
- Tablespoon

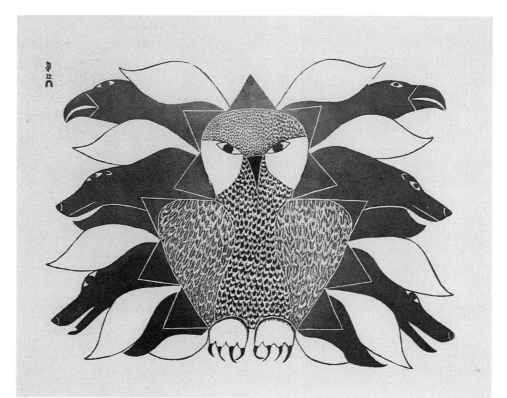

▶ **Figure 13–18** What kind of balance has the artist used? Point to areas where different textures are shown.

Kenojuak. *Owls, Ravens and Dogs.* Courtesy of Dorset Fine Arts. Toronto, Ontario, Canada.

WHAT YOU WILL DO

1. On sketch paper, do a drawing of the animal you chose. On a second sheet of sketch paper, create an abstract design based on your first sketch. Leave out all unneeded details. Use line and shape to express feelings. Round shapes can express gentleness, diagonal lines can show danger or quick movement.
2. Transfer your design to a piece of corrugated cardboard. Using the paper-cutting knife, carefully cut out the design. Glue it to the second piece of cardboard to form a printing plate.
3. Squeeze out a small amount of ink into the pan. Roll the brayer back and forth in the ink to coat it evenly. Roll the brayer lightly over your printing plate. If you press down too hard, you might collapse the relief.
4. Place a clean sheet of paper on your plate. Gently rub the paper with the back of the spoon or your fingertips. Work quickly. Carefully remove the print. Set it aside to dry. Repeat the process twice more to make an edition of three prints. When all the prints are dry, sign and number them.
5. Display your finished prints alongside those of classmates. Decide which design you feel best captures the appearance and the spirit of your school mascot.

EXAMINING YOUR WORK

- **Describe** Identify the sources of your ideas for abstraction. Identify the unnecessary details you eliminated to create an abstract design.
- **Analyze** Tell which elements stand out most in your design.
- **Interpret** State what feelings toward your mascot your print expresses. Identify the features that help communicate those feelings.
- **Judge** Tell whether you feel your work succeeds. If you could redo your work, tell what changes, if any, you would make.

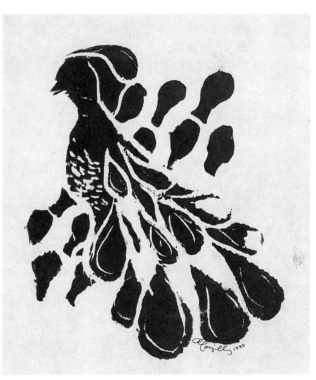

▲ **Figure 13–19 Student work. Inuit-style print.**

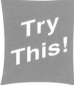

Try This!

COMPUTER OPTION

▪ Choose Mirror Symmetry tool or menu and small Brush size and shape. Draw an animal with simple, stylized lines and shapes to emphasize the mood of the animal. Continue adding other birds, animals, or fish to appear behind the first animal. Title and save work. Then use monochromatic colors, light and dark values of one color, to fill some spaces with solid color or color gradient. Add pattern and color to some areas. Leave some spaces white. Retitle, save, and print your work.

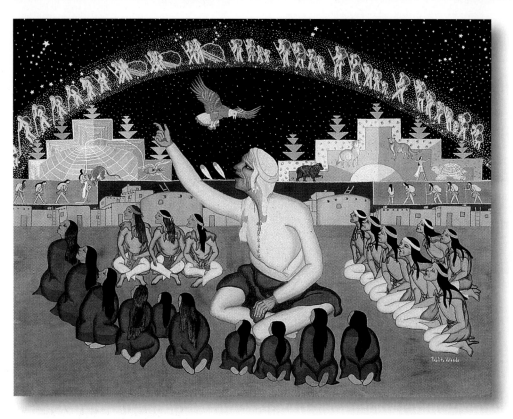

Pablita Velarde. *Old Father Story Teller.* 1960. Reprinted with permission from book titled *Old Father Story Teller* by Pablita Velarde, Clear Light Publishers.

Why Is Storytelling Important?

Storytelling has always been an important way for Native Americans to educate their people about their history and beliefs. For centuries, native peoples passed on stories orally from one generation to the next. The content of these oral narratives differed from tribe to tribe, but some of the themes were similar. One common theme was the creation of the world. Other stories dealt with heroes or tricksters. Many legends explained an aspect of nature or the universe. Many characters in the tales appeared as animals. In all stories, nature and the land were greatly cherished.

Pablita Velarde, the artist of this painting, grew up in a pueblo in New Mexico. She felt very fortunate to hear stories firsthand from her grandfather and great-grandfather. Today the Native American storytelling heritage continues, both orally and in writing. Entertaining and instructive, the stories help keep Native American cultures alive.

MAKING THE CONNECTION

- What elements of nature has the artist included in her work?
- What is the artist's opinion of the Old Father? How can you tell? How has the artist achieved balance in her painting?
- Find two books or stories that have been retold or illustrated by Native Americans. Compare the stories and illustrations.

INTERNET ACTIVITY

Visit Glencoe's Fine Arts Web Site for students at:

http://www.glencoe.com/sec/art/students

CHAPTER 13
REVIEW

BUILDING VOCABULARY

Number a sheet of paper from 1 to 12. After each number, write the term from the list that best matches each description below.

coiled pot	pueblos
cradle board	sand painting
Kachina	tepee
loom	totem pole
petroglyphs	warp
polychrome	weft

1. A pot formed by coiling long ropes of clay in a spiral.
2. Rock carvings and paintings.
3. Stacked, many-family dwellings made of adobe.
4. An upright log carving picturing stories of different families or clans.
5. A portable house.
6. A harness worn on the shoulders and used to carry a small child.
7. A hand-carved statuette that represents spirits in Pueblo rituals.
8. The pouring of different colors of powdered rock on a flat section of earth to create an image or design.
9. Having many colors.
10. A frame holding a set of crisscrossing threads.
11. Threads running vertically and attached to the loom's frame.
12. Threads passed horizontally over and under the warp.

REVIEWING ART FACTS

Number a sheet of paper from 13 to 19. Answer each question in a complete sentence.

13. In what areas did the early Pueblo people settle?
14. When did the Northwest Coast people reach the region they settled? What convinced them to remain in this region?
15. Which group of Woodlands people became organized as one large nation?
16. Which group of Native Americans is famous for its totem poles?
17. What are Kachina?
18. What Native American artist is famous for his portraits and landscapes?
19. Where do the Inuit live?

THINKING ABOUT ART

On a sheet of paper, answer each question in a sentence or two.

1. **Analyze.** One of the three aesthetic views holds that the most important feature of a work is its composition. Tell how an art critic accepting this view would react to the sculpture that opened this chapter (page **192**). Explain why you believe the critic would have this reaction.
2. **Extend.** Explain how the part of the world the Inuit live in is a factor in their artists' choice of media.

MAKING ART CONNECTIONS

1. **Science.** Find all the works in this chapter that make use of geometric patterns. Identify the number and kind of motifs that appear in each one. Discuss the use of patterns from nature in Native American design.
2. **Language Arts.** Enjoy the art of George Catlin as he captured the Native American culture in two books:

George Catlin: Painter of the Indian West by Mark Sufrin and *Buffalo Hunt* by Russell Freedman. You may also wish to read *When Clay Sings* by Byrd Baylor and Tom Bahti, or *Cities in the Sand: The Ancient Civilizations of the Southwest* by Scott S. Warren. How do these authors present the history of the Native American peoples?

▲ The artist once stated that his desire was to paint pictures that were happy and pretty. Do you think this work demonstrates this mood? Explain your answer.

Pierre Auguste Renoir. *Dance at Bougival.* 1883. Oil on canvas. 181.8 x 98.1 cm (71⅝ x 38⅝"). Picture Fund. Courtesy Museum of Fine Arts, Boston, Massachusetts.

European Art of the Early 1800s

The 1600s, you have learned, was the age of Baroque art; the 1700s of Rococo art. The 1800s can be thought of as an age of change. No single art style dominated. One was hardly in place before it was first challenged and then replaced by another.

The century began with artists looking to the past for ideas. They modeled their own versions of grand heroes and noble deeds on the works of ancient Greek and Roman artists. By mid-century, however, artists were roaming city streets and the countryside, painting everyday scenes with dabs and dashes of paint. One work done in this manner is shown at the left.

PORTFOLIO IDEAS

Go through this chapter and select an art work that you like. Is it from the Neoclassic, Romantic, or Impressionist art period? Create an entry for your portfolio that demonstrates this style. Exchange finished works with a classmate for peer evaluation. Peers can tell you what they like about your art work and offer suggestions for revising the work. Based on the peer review, you may want to revise or change your art work. When your peer evaluation is returned, review the comments, and keep them in your portfolio with your sketch.

OBJECTIVES

After completing this chapter, you will be able to:
- Describe the Neoclassic, Romantic, and Impressionist styles of art.
- Discuss the importance of the Salon to artists of the day.
- Create art work in the Neoclassic and Impressionist style.

WORDS YOU WILL LEARN

art movement
Impressionism
landscape
Neoclassic
Romanticism
Salon

Neoclassic and Romantic Art

The late 1700s and early 1800s were stormy times in France. Outraged by the shameless greed of the wealthy ruling class, the poor people rose up in revolt. This uprising, known as the French Revolution, began with a bloody reign of terror. Thousands lost their heads on the guillotine. The following 20 years, marked by war and struggle, were no less bitter. Finally, the troubled French government was turned over to a popular young general. His name was Napoléon Bonaparte (nuh-**pol**-yuhn **boh**-nuh-part).

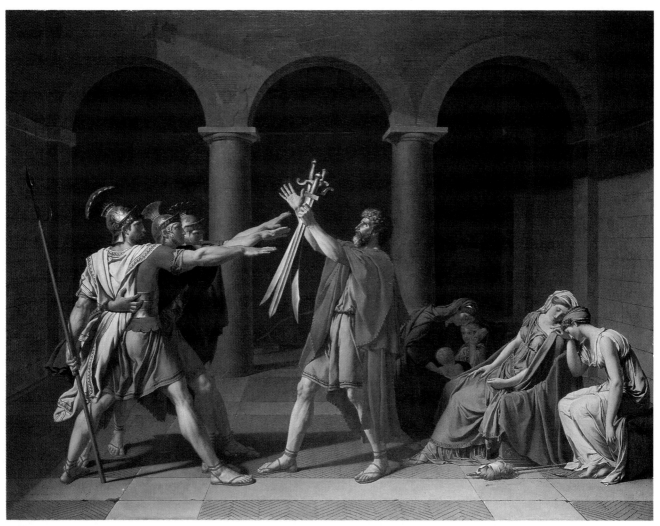

▲ **Figure 14–1** Notice how the artist arranged the three groups of figures. Do the arches and columns help unify the groups? Explain how dramatic contrasts of value help emphasize the most important parts of this work. In what way is this painting like a scene from a play?

Jacques Louis David. *The Oath of the Horatii.* 1786. Toledo Museum of Art, Toledo, Ohio.

NEOCLASSIC ART

Artists of the day believed these events were equal in importance to the rise and fall of ancient Greece and Rome. They even chose to show the events using an updated version of the styles of ancient Greece and Rome. As a result, their work became known as **Neoclassic** (nee-oh-**klas**-ik), meaning *"new classic," an art style that borrowed from the early classical period of ancient Greece and Rome.*

One of the most successful of the Neoclassic artists was Jacques Louis David (**zhahk** loo-**ee** dah-**veed**). Even though he later took part in the revolt against the French king, David was Louis XVI's painter. It was the king who asked David to paint what would become one of his most famous pictures. The painting, shown in Figure 14–1, shows two families living in neighboring ancient Roman cities. The families are related by marriage but divided by a war between their cities. A father and three sons of one family are shown pledging to fight to the death. All know their relatives will be among those they must battle. The women, helpless to prevent the tragedy, weep.

The picture is made up of three groups of figures. These are arranged across the canvas as though it were a stage. Notice David's skillful use of the background arches and columns to separate and frame these groups. The artist's careful painting of details — the swords, the helmets — adds to the picture's realism. His use of light adds drama to the picture.

ROMANTIC ART

As the 1800s wore on, people became weary of the political unrest and fighting. They looked for things that would take their minds off the upsetting events around them. Some artists shared this same desire. These artists were responsible for developing a new style of art called **Romanticism** (roh-**mant**-uh-siz-uhm). This is *a style of art that found its subjects in the world of the dramatic and exotic.*

France

To Romanticists, nothing stirred the imagination better than far-off places and colorful, action-filled adventures. The two are combined in the paintings of Eugène Delacroix (oo-**zhen** del-uh-**kwah**), a leader of the Romantic school. One of his paintings is pictured in Figure 14–2. In this work, Delacroix refused to allow his taste for action to interfere with his sense of design. He planned his painting so the viewer would miss none of its exciting details.

Study this work. Find the diagonal line beginning in the horse and rider at the lower left. This line leads your eye upward to the figures at the right. From there the gunsmoke pulls your gaze across the picture to the far-off figures and fortress.

England

Another artist who turned to his imagination for ideas was the English painter Joseph M. W. Turner. Unlike other Romanticists, however, Turner expected his viewers to use their imaginations as well. His glowing colors and blurred images free viewers to interpret his pictures in their own ways.

Turner spent his life painting landscapes. A **landscape** is *a drawing or painting focusing on mountains, trees, or other natural scenery.* He was fascinated in particular by sunlight and its shimmering reflection on water. This fascination can be seen in the painting in Figure 14–3. The work excites the viewer's curiosity with its dazzling sky and shimmering waters. There are ships in the center of the painting, and a church is visible on the right. With the use of light on the structures, the artist leads the viewer's eye down the canal and out to sea. As in all of Turner's best works, the real subjects are light and color.

▲ **Figure 14–2** **Delacroix often painted pictures that included action and adventure. Look at the figures in the foreground. Notice how they help to lead the viewer's eyes around the painting.**

Eugène Delacroix. *Arabs Skirmishing in the Mountains.* 1863. Canvas. 92.5 x 74.6 cm (36⅜ x 29⅜"). National Gallery of Art, Washington, D.C. Chester Dale Fund.

✔ CHECK YOUR UNDERSTANDING

1. Describe events in France in the late 1700s and early 1800s.
2. What is Neoclassic art? What led artists to begin creating art in this style?
3. What is Romantic art? What led artists to begin creating art in this style?

STUDIO ACTIVITY

Sketching a Sound

Using your imagination, sketch an image that goes with one of these sounds: a bird's song, the roar of the ocean, or breaking glass. Then brush water over your drawing and paint it with watercolors. Choose colors that best express the mood your work calls to mind.

PORTFOLIO

Write a short paragraph explaining whether you communicated a mood with blurred images.

▲ **Figure 14–3 Earlier in his career the artist painted pictures with more realistic subjects. What do you like about the way he painted this one?**

Joseph M. W. Turner. *The Grand Canal, Venice.* 1835. Canvas. 91.4 x 122.2 cm (36 x 48⅛"). The Metropolitan Museum of Art, New York, New York. Bequest of Cornelius Vanderbilt, 1899.

Designing a Neoclassic Stage Set

Look at the painting in Figure 14–4. It is by Jacques Louis David. As in the other work by this foremost Neoclassicist you studied (Figure 14–1), the figures appear almost as actors. The setting is like a stage.

Imagine for a moment that the stone dungeon in this work *is* part of a stage set. Imagine that just beyond the rightmost figure in the painting are wings — the area in a theater leading backstage. Imagine that to the left of the shadowed archway the set continues. What lies beyond the left edge of this painting? In this lesson you will invent a continuation of this scene.

WHAT YOU WILL LEARN

Design and build a three-dimensional model for a stage set. Your model will extend the stage in Figure 14–4. Match as closely as possible the colors, textures, and patterns of the walls and floor. Make two pieces of furniture to place in your model. These will emphasize the real space in the model. Your stage set will have the same feeling or mood suggested by David's painting.

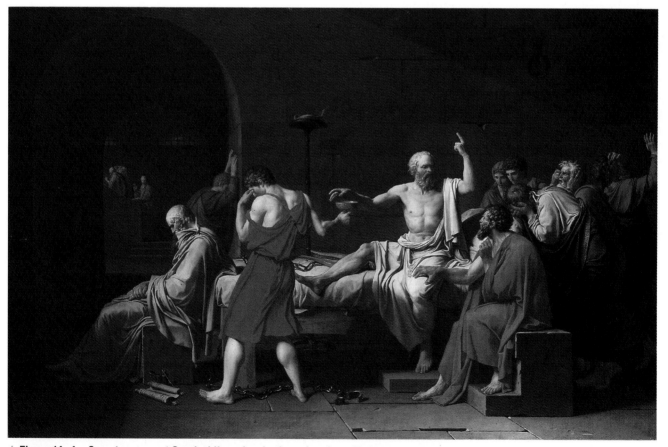

▲ **Figure 14–4** **Socrates, a great Greek philosopher, is shown in prison. He has been placed here after falsely being accused of denying the existence of Greek gods. His punishment is to drink poison.**

Jacques Louis David. *The Death of Socrates.* 1787. Oil on canvas. 129.5 x 196.2 cm (51 x 77¼"). The Metropolitan Museum of Art, New York, New York. Catherine Lorillard Wolfe Collection.

WHAT YOU WILL NEED

- Pencil and sheets of sketch paper
- Mixing tray, tempera paint, and 2 brushes — one wide, one fine-tipped
- Shoe box and 2 sheets of mat board
- Scissors and white glue

WHAT YOU WILL DO

1. Brainstorm with your classmates for possible answers to the question "What lies beyond the left border of this painting?" Then working by yourself, sketch several ideas for extending the stage. Create windows, doorways, stairs, arches, and other design features you like. Let your imagination and David's painting guide you. Choose your best sketch and set it aside.

2. Mix hues of tempera paint to match the lighted portions of the walls and the floor in David's painting. Create darker values of the same hue to match the shaded portions. Using the thick brush, paint the back, sides, and bottom of the shoe box. Using the fine-tipped brush, add the thin lines between stone blocks.

3. With scissors, cut from mat board doors, arches, and other design features appearing in your sketch. Make sure all added features match the colors, patterns, and textures found in the painting. Glue these features in place in your model.

4. Make furniture, such as a table, bench, or bed, to complete your design.

EXAMINING YOUR WORK

- **Describe** Tell whether the walls, floor, and other features of your model look real. Point out the features that help viewers identify your model as an extension of David's painting.
- **Analyze** State whether the colors and textures in your work match those in David's painting. Point out similarities between the patterns on the walls and floor in your model and those in the painting. Show ways in which you used real space in your model.
- **Interpret** Tell whether your stage set has the same mood or feeling as the one David's painting communicates. Decide what words you would use to describe that mood or feeling.
- **Judge** Decide in what way your model most succeeds. Tell whether it succeeds because of its realistic appearance, its composition, or its content.

5. When dry, display your model. Compare it with the stage set in the painting and with other student models. Decide which were most successful in matching the look of David's painting.

Try This! STUDIO OPTIONS

■ Look through a magazine to find figures to cut out and use as actors for your stage. Glue cardboard backings to your figures so they will stand. Pose them in your model so they appear to be relating to one another.

■ Imagine the words each of your actors is speaking. Write these on pieces of white paper cut to look like the dialogue balloons in comic strips. Glue these to each actor so the words seem to be coming from his or her mouth.

European Art — Late 1800s

Each age has its customs and fashions. One custom common in Paris and London during the 1800s was a yearly art show. The **Salon** (suh-**lahn**), *an annual exhibition of art*, was a major social event. An artist's reputation often depended upon whether or not his or her work was selected for showing at the Salon.

In this lesson you will read how the Salon led to the formation of an **art movement**, *a trend formed when a group of artists band together to create works of a single style.*

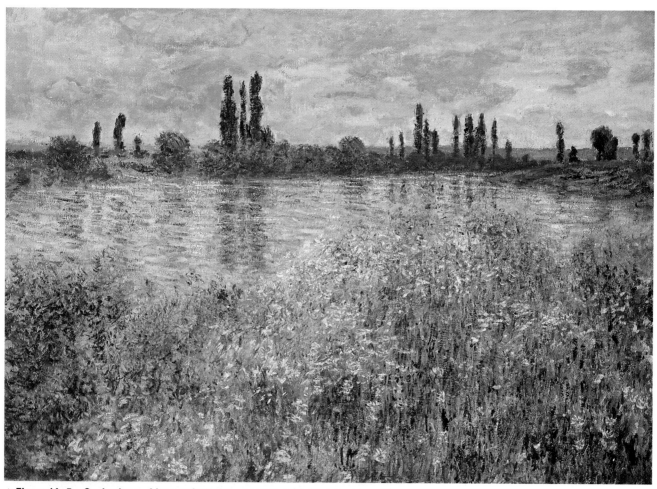

▲ **Figure 14–5** Cool colors — blues and greens — seem to move back in space. Warm colors — reds and yellows — seem to come forward. How has the artist used warm and cool colors in this work? Why do you think he made these choices?

Claude Monet. *Banks of the Seine, Vetheuil.* 1880. Canvas. 73.4 x 100.5 cm (28⅞ x 39⅝"). National Gallery of Art, Washington, D.C. Chester Dale Collection.

IMPRESSIONIST PAINTING

In 1874 a group of discouraged young artists decided to hold an exhibition of their own. They found an empty studio in Paris. There they hung pictures that had been rejected by the Salon. The people who came to view the exhibition reacted in different ways. Some were confused. Others laughed. Still others were angry. On one point most viewers were agreed: the paintings looked more like quick sketches than like finished art works. One angry critic, after viewing a painting titled *Impression: Sunrise*, referred to all the paintings as "impressionistic." The name stuck and continued to be used to identify paintings done in this new style.

This style, **Impressionism**, is *a style that attempted to capture the rapidly changing effects of light on objects*. Members of the Impressionist movement left their studios to paint outdoors. They looked at life around them and found subjects everywhere they looked. They painted landscapes and street scenes; they even set up their easels in cafes.

Claude Monet

The painting that gave Impressionism its name was the work of one of the movement's founders, Claude Monet (**klohd** moh-**nay**). Imagine Monet as he prepares to paint the landscape in Figure 14–5. He notes how the sunlight flickers on the gently swaying flowers. He notices how it reflects on rippling waters and glows through gray clouds. He observes, too, how the strongest sunlight blurs forms and blots out details. Now, taking brush in hand, he applies small dabs and dashes of paint to his canvas. He works quickly, trying to capture the effect of sunlight on every object. Each stroke of paint is a little different from the next in hue, value, and intensity. Monet knows the yellows and blues he is using will play against each other in the viewer's eye. They will give the painting a sparkle and brilliance to match that of the sun. Where does the artist use different values of yellow in the work? Where does he use different values of blue?

Pierre Auguste Renoir

One of the most productive of the Impressionists was a man named Pierre Auguste Renoir (pee-**ehr** oh-**goost** ren-**wahr**). Another of the movement's founders, Renoir painted right up to the day he died.

An area of painting Renoir explored using the Impressionist style was portraits. He was especially attracted to the eyes of his subject and often made these the focus of attention. Look at the portrait in Figure 14–6. The eyes, you will notice, are painted in sharp focus. The rest of the figure, meanwhile, is blurred. Renoir knew that when we look at a person or object, not all parts appear in focus at once. Only the part where our eyes rest at a given moment is seen sharply. Everything else appears fuzzy and slightly out of focus.

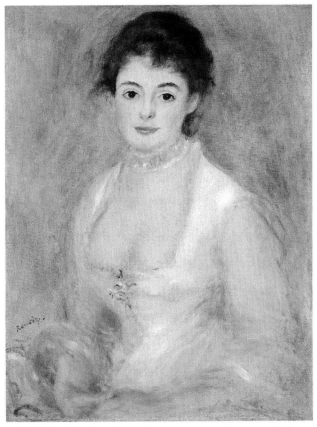

▲ **Figure 14–6** The eyes in this work look right out at you. Even when you glance at other parts of the painting, your attention is always attracted back to the eyes.

Pierre Auguste Renoir. *Madame Henriot.* c. 1876. 65.9 x 49.8 cm (26 x 19⅝"). National Gallery of Art, Washington D.C. Gift of Adele R. Levy Fund, Inc.

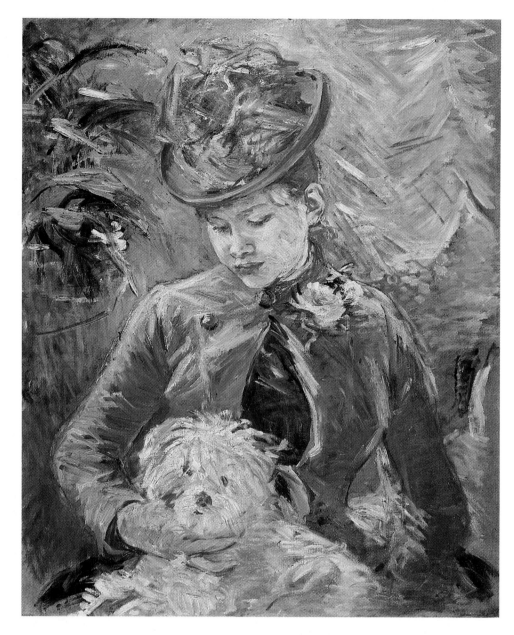

▶ **Figure 14–7** A writer once described this artist's painting technique as "Brushwork like fireworks." What do you think he meant by this? Do you agree? Why or why not?

Berthe Morisot. *Jeune Fille au Chien (Young Girl with a Dog).* c. 1887. Oil on canvas. 72.8 x 60.1 cm (28⅔ x 23⅔"). The Armand Hammer Collection, UCLA at the Armand Hammer Museum of Art and Cultural Center. Collection, Los Angeles, California.

Berthe Morisot

Another important member of the Impressionist movement, Berthe Morisot (**behrt maw-ree-zoh**), had strong family ties to art. Her great-grandfather, Jean Honoré Fragonard (**zhahnh** oh-nor-**ay** frah-goh-**nahrh**), was an important painter of the Rococo period. Her parents solidly supported her decision to follow a career as an artist. Like Renoir, Morisot chose portraits as a main avenue of expression for her work. One of these is pictured in Figure 14–7. Notice how the artist uses rapidly applied dabs of paint to capture her subject's expression. What mood does the artist communicate in this painting?

SCULPTURE

A sculptor working during the same time as the Impressionist movement was a man named Auguste Rodin (oh-**goost** roh-**dan**). Rodin used bits of wax or clay in his creations. Their rough, bumpy surfaces make his sculptures appear as though in a flickering light. Examine Rodin's work in Figure 14–8. Note how the sculpture looks as if it were created in an instant.

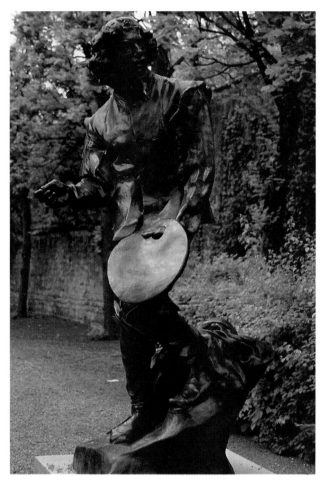

▲ Figure 14–8 Does this figure look as though it is standing still or moving? Describe what it is doing at this moment.

Auguste Rodin. *Claude Lorrain*. Musee Rodin. Paris, France.

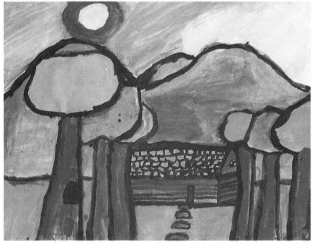

▲ Figure 14–9 Student work. Center of interest.

STUDIO ACTIVITY

Emphasizing Center of Interest

Pick a familiar object. Working lightly in pencil, draw the object large enough to fill a sheet of paper 9 x 12 inches (23 x 30 cm). Decide what part of the drawing is to be the center of interest. Add more detail to this area. Use short strokes of crayon, chalk, or paint to add color to the drawing. Make the center of interest stand out by coloring it carefully using your brightest hues. Make the colors duller the farther you get from the center of interest. (See Figure 14–9.)

PORTFOLIO

Write an explanation of how you used the elements and principles of art to create a center of interest in your painting. Discuss the aspects of the art work you think are the most successful, and those you feel need improvement. Tell what you might do differently the next time. Keep your written explanation with your finished art work in your portfolio.

✔ CHECK YOUR UNDERSTANDING

1. What was the Salon? How was the Salon tied to the beginning of the Impressionist movement?
2. What are some of the ways people reacted at the first showing of Impressionist works in 1874?
3. What did the Impressionists try to capture in their pictures? Where did they go to find subjects for their work?
4. What sorts of paintings did Renoir and Berthe Morisot specialize in?
5. In what area of art did August Rodin work? How did he give his works the look and feel of Impressionist paintings?

 LESSON 4

Painting an Impressionist Landscape

Impressionist artists, you have learned, were interested in painting everyday scenes they saw around them. To Claude Monet, in particular, it made little difference whether he was painting a haystack, a few ordinary trees, or—as in Figure 14–10—a bridge. What mattered was how best to show the colors reflected from these subjects. Study the painting in Figure 14–10. Up close the picture appears to be little more than dabs of color.

WHAT YOU WILL LEARN

Use tempera to paint a summer landscape. You will use a variety of colors, values, and intensities, applying these as dots of paint.

Warm colors—yellows, reds, oranges—will be used to paint foreground objects. Cool colors—blues, purples, greens—will be used for background objects. Together these colors will be used to create an illusion of space. (See Figure 14–11.)

WHAT YOU WILL NEED

- Pencil and sheets of sketch paper
- Sheet of white paper, 9 x 12 inches (23 x 30 cm)
- Several brushes, tempera paint, and mixing tray

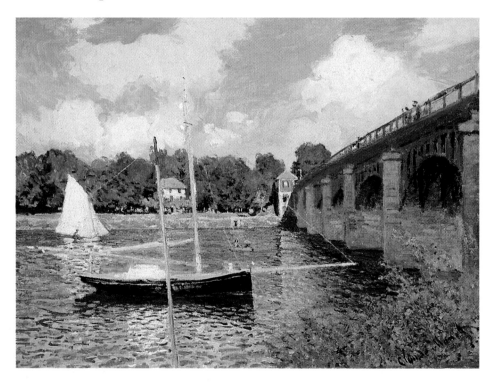

▶ **Figure 14–10 Monet painted many views of rivers and bridges. The scenes show the bridges at all times of the day, in sunlight or sometimes in rain or heavy fog. What reason might the artist have had for making so many paintings of the same type of scene?**

Claude Monet. *Bridge at Argenteuil.* 1874. Oil on canvas. 60 x 79.7 cm (23⅝ x 31⅜"). National Gallery of Art. Washington, D.C. Mr. and Mrs. Paul Mellon Collection.

WHAT YOU WILL DO

1. On a sheet of paper, list the different items that might be found in a landscape painting, such as a tree, stream, and valley. Pick three items from this list. Combine them in simple pencil sketches of warm, sunlit landscapes. Use the space technique of size to place some of the objects near to the viewer. Place others farther back. Draw only very light outlines or indications of your shapes.

2. Choose the best of your sketches. Draw it on the sheet of white paper. Fill the whole sheet with your drawing.

3. Without mixing colors, load a medium-pointed brush with a cool color of paint. Use dots and dabs of the brush to apply the paint to a background object. Pick a second cool hue that, when seen from a distance, will blend with the first to create a new hue. For example, dots of green placed next to dots of blue would create blue-green. Dots of complementary colors can be added to lessen or increase the intensity of the colors.

4. Use warm colors for foreground objects, applying paint in the same fashion. Stand back from your work from time to time. This will help you make sure the colors selected are blending as you expect them to.

5. When the paint is dry, display your work. View all the works, first from a distance, then close up.

EXAMINING YOUR WORK

- **Describe** Identify the landscape objects you used.
- **Analyze** Point out the variety of hues you used in your work. Show the different values and intensities of paint. Tell whether you used warm colors for the foreground and cool ones for the background. State whether your use of warm and cool colors helps create a sense of space in your work.
- **Interpret** Point out the features that help viewers understand the scene is of a warm, sunny day.
- **Judge** Explain in what ways your painting shares the look and feel of the Impressionist work in Figure 14–11. Tell whether any part of your work is more successful than the rest. Explain.

▲ Figure 14–11 Student work. Impressionist landscape.

COMPUTER OPTION

■ Choose the Airbrush tool and change the color settings to more transparent. Experiment with the Airbrush settings to produce a grainy effect for your landscape. Use Airbrush to build up layers of color to create a background that expresses the time of day, season, and place you have chosen. You will produce a very soft, hazy picture. Select finer and smaller Airbrush settings to draw simple objects on top of the background colors… buildings, plants, trees, or bridges. Redraw lines to darken edges or press heavily with drawing pen to emphasize the objects. Title, save, and print your work.

Joseph Wright of Derby. *The Iron Forge.* 1772. Broadlands Trust, Hants.
Mountbatten Collection. Bridgeman Art Library, London, England. BAL 1561

What Discoveries Occurred During the 1800s?

Dramatic changes in science and industry occurred in the early 1800s, just as changes in the art world were also developing.

One of the most revolutionary inventions was James Watt's improved steam engine. It was the power source for ships, trains, and wondrous machines. Other key inventions were the spinning jenny, the power loom, and the cotton gin. Whole new industries sprang up because of such inventions. With the discovery of more metals, iron and steel production advanced. As the artist shows here, inventions like the mechanical hammer made the ironworker's job easier.

In medicine, anesthetics like ether and chloroform were discovered. The beating of the human heart could now be heard with a stethoscope. Perhaps the most important medical discovery of the time was Edward Jenner's smallpox vaccine. Everyone was affected by the many inventions and discoveries of the time. All of these had a terrific impact on daily life. With the invention of the electric telegraph, the world was connected in a whole new way.

MAKING THE CONNECTION

- ✔ In Wright's painting, notice how the white-hot iron is held as a mechanical hammer is about to strike and shape the iron. How do you suppose such a machine made work easier for the ironworker?
- ✔ How did the increase in industry and mechanical inventions change people's lives?
- ✔ Find out about some other advances in iron and steel production in England and America during the 1800s.

INTERNET ACTIVITY

Visit Glencoe's Fine Arts Web Site for students at:

http://www.glencoe.com/sec/art/students

CHAPTER 14
REVIEW

◆ BUILDING VOCABULARY

Number a sheet of paper from 1 to 6. After each number, write the term from the list that best matches each description below.

art movement	Neoclassic
Impressionism	Romanticism
landscape	Salon

1. An art style that borrowed from the early classical period of ancient Greece and Rome.
2. A style of art that found its subjects in the world of the dramatic and exotic.
3. A drawing or painting focusing on mountains, trees, or other natural scenery.
4. An annual exhibition of art.
5. A trend formed when a group of artists band together to create works of a single style.
6. A style that attempted to capture the rapidly changing effects of light on objects.

◆ REVIEWING ART FACTS

Number a sheet of paper from 7 to 14. Answer each question in a complete sentence.

7. How did the French Revolution help give rise to a new art style? What was the name of this style?
8. Name an important Neoclassic painter.
9. What events helped bring about the Romantic movement?
10. What sorts of themes are found in the paintings of Eugène Delacroix?
11. Why did Joseph M. W. Turner use glowing colors and blurred images in his works?
12. Name two artists whose works were turned down by the Salon. Tell what movement they went on to develop.
13. To what school of art did Berthe Morisot belong?
14. What is Auguste Rodin's special contribution to art?

? THINKING ABOUT ART

On a sheet of paper, answer each question in a sentence or two.

1. **Analyze.** Imagine you lived in France during the 1800s. Which of the three art styles you learned about in this chapter would best fit your view of life? Explain your answer using information from the chapter.
2. **Compare and contrast.** Look at the landscape paintings by Joseph M. W. Turner (Figure 14–3) and Claude Monet (Figure 14–5). In what ways are the two works alike in subject matter, composition, and content? In what ways are they different in these three areas?
3. **Summarize.** What prompted the Impressionists to decide to hold their own art show in 1874?
4. **Extend.** Berthe Morisot's paintings were ignored by critics during her lifetime. Why do you think this was so?

┌─ MAKING ART CONNECTIONS ►

1. **Social Studies.** You are looking at the painting by Eugène Delacroix (Figure 14–2) with two friends. One notes that some of the figures seem to be in awkward poses. The other remarks that the artist "probably had problems drawing these figures." How would you reply?

2. **Language Arts.** Explore Monet's garden at Giverny in a book by Bjork Anderson, *Linnea in Monet's Garden.* As you enjoy photographs of Monet's paintings, you will follow Linnea's journey through the garden and her discovery of his paintings in a Paris gallery. Write an account of what she learned about being an Impressionist.

▲ **What type of balance is demonstrated in this painting? What is used to balance the dancers placed to the far right? Does this kind of balance make the picture look casual and unplanned?**

Edgar Degas. *Ballet Dancers in the Wings*. 1900. Pastel on paper. 71.1 x 66 cm. (28 x 26"). Saint Louis Art Museum. St. Louis, Missouri. Quixis Collection.

Art of the Late Nineteenth Century

Toward the end of the 1800s, some artists felt that Impressionism was the perfect means of self-expression. To others, the new style raised as many questions as it answered. These artists, who had been working as Impressionists, felt that something was missing from their pictures. Their own works struck them, for one reason or another, as "unfinished."

In time, this dissatisfaction led to still newer forms of expression. One is showcased in the work at the left. In this chapter you will learn about such efforts and the pioneers behind them.

PORTFOLIO IDEAS

Select two art works from this chapter. Write the names of the two artists and two paintings. Evaluate one of the paintings. What is the subject? What mood does it create? How does it use the elements and principles of art? Then evaluate the other painting and compare the two. Place a star by those items that both paintings have in common. Keep your list in your portfolio and compare the characteristics to art works created during a different time period.

OBJECTIVES

After completing this chapter, you will be able to:
- Identify the artists who became known as the Post-Impressionists.
- Describe different ways the Post-Impressionists tried to solve the problems of Impressionism.
- Name artists who affected the development of American art of the 1800s.
- Create art works in the style of the Post-Impressionists.

WORDS YOU WILL LEARN

arbitrary colors
optical colors
Pointillism
Post-Impressionism
Realism

Art of the Post-Impressionists

Have you ever created something that pleased you at first but didn't seem right later? This was the case with several artists working toward the close of the 1800s. These artists worked as Impressionists but came to feel that there were problems with this style. The more they studied their art, the more dissatisfied they became. Art, they believed, should do more than just show the changing effects of light on objects. **Post-Impressionism** is *the name given to an art movement that appeared after the Impressionist movement*. The word *post* means "after."

▲ **Figure 15–1** The artist repeated colors throughout this work to give it a sense of harmony. Can you find places where colors have been repeated?

Paul Cézanne. *Mont Sainte-Victoire.* 1902–04. Oil on canvas. 69.8 x 89.5 cm (27½ x 35¼"). Philadelphia Museum of Art, Philadelphia, Pennsylvania. George W. Elkins Collection.

In this lesson you will learn about the key artists of the Post-Impressionist movement. You will also look at the important contributions they made to the history of art.

POST-IMPRESSIONIST ART

While the Post-Impressionists agreed that there were problems with Impressionism, their solutions to these problems differed. Some argued that art should be more carefully designed — that composition should not be forgotten. Others claimed feelings and emotions should be emphasized — that content deserved its rightful place. Still others championed design and mood — both composition *and* content — as important features.

Composition

One of the Post-Impressionists was also, interestingly, an original member of the Impressionist movement. This artist's name was Paul Cézanne (say-**zan**). Cézanne objected to the loss of composition arising from the Impressionist blurring of shapes. His solution was to use patches of color. These he joined together like pieces of a puzzle to create solid-looking forms.

The painting in Figure 15–1 illustrates Cézanne's technique. This mountain near the artist's home in southern France was one of his favorite subjects. He painted it more than 60 times and from nearly every angle.

◄ Figure 15–2 Besides their bright colors, van Gogh's paintings are known for their rich textures. He often squeezed his colors from the tubes right onto the canvas. He would then use his brush, fingers, or anything else at hand to spread the paint with swirling strokes.

Vincent van Gogh. *Hospital at Saint-Remy.* 1889. The Armand Hammer Collection, Los Angeles, California.

▲ **Figure 15–3** How has the artist directed the viewer's attention to the figure on the left? How does the use of color help show the difference between the figure in the foreground and the one in the background?

Paul Gauguin. *Ancestors of Tehamana.* 1893. Oil on canvas. 76.3 x 54.3 cm (30 x 21"). Art Institute of Chicago, Chicago, Illinois. Gift of Mr. and Mrs. Charles Deering McCormick.

Cézanne's main interest, however, was not showing the mountain as it really looked. It was to demonstrate how color patches could be turned in different directions to create a solid form. Notice how the artist uses the same color patches to form buildings, trees, and other objects. All are combined to create a richly colored pattern of geometric forms.

Content

The most famous of the Post-Impressionists was Vincent van Gogh (**goh**). Van Gogh's goal was not, like the Impressionists', to reproduce what the eye saw. It was to capture his own deepest feelings about a subject. He expresses these feelings with twisted lines and forms, intense colors, and rich textures.

Near the end of his short life, van Gogh suffered from mental illness. Hoping for a cure, he entered a private hospital. It was there that van Gogh painted the work in Figure 15–2 on page **227**. Take a moment to examine this picture. The artist treats the viewer to his private view of the world of the hospital. We see yellow walls and several small figures. But the twisting trees against a blue sky are the true focus of the painting. Through them, the artist communicates his mental agony and his sensitivity to the forces of nature. What principle of art is used to organize the curving lines of the trees?

Composition and Content

Paul Gauguin (goh-**ganh**) used color and shapes in new and exciting ways. He also created art works that could be enjoyed for their decorative appearance.

The painting in Figure 15–3 shows a scene in the South Seas, where Gauguin spent part of his life. The artist has portrayed his wife against a decorated background. The painting has two parts, a portrait and a scene from the past. The composition hints at the relationship between past and present. Notice how the fan points to the small figure painted on the wall. Like most of Gauguin's other works, this one is filled with meaningful colors. **Arbitrary (ahr**-buh-trehr-ee)

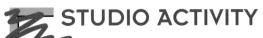

STUDIO ACTIVITY

Making a Simple Line Drawing

To Paul Cézanne, it didn't matter whether he was painting a mountain or a bottle. His goal each time was to use patches of color to create solid-looking forms.

Make a simple line drawing of a bottle. Draw the bottle big enough to fill a sheet of paper. Using a flat brush, apply patches of tempera paint to the bottle. Turn the patches in different directions— out, around, in—to show the solid, round form of the bottle.

PORTFOLIO

Write a short paragraph to tell if this technique enabled you to create a solid, round form. If not, what would you do differently to improve its success? Keep your written paragraph with the painting in your portfolio.

colors are *colors chosen to communicate different feelings.* **Optical colors** on the other hand, are *colors viewers actually see.* What feelings do you associate with each of the different colors in Gauguin's painting?

✔ CHECK YOUR UNDERSTANDING

1. Define *Post-Impressionism.* Name two leading Post-Impressionists.
2. What were three different solutions Post-Impressionists found to the problems of Impressionism?
3. What was Cézanne's goal? What was van Gogh's goal?
4. What is arbitrary color? Which two Post-Impressionists used arbitrary color in their works?
5. What is optical color?

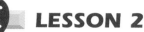
Painting in the Style of Post-Impressionists

The painting in Figure 15–4 shows yet another Post-Impressionist solution to the problems posed by Impressionism. The work is by an artist named Georges Seurat (**zhorzh** suh-**rah**). Like Cézanne, Seurat felt the Impressionists' attempt to show the blurring effect of sunlight on forms was misguided. Seurat's solution was to use *a technique in which small, carefully placed dots of color are used to create forms*. This technique, called **Pointillism** (**poynt**-uh-liz-uhm), reached its height in Seurat's painting of a sunny summer day in a park. When seen from close up, the picture looks like a grouping of tiny dots. When the viewer stands back, however, the picture totally changes. The dots seem to blend together to create new colors and clear shapes.

WHAT YOU WILL LEARN

You will create a painting in the style of Seurat or one of the other Post-Impressionists. Use color, line, shape, or texture in the manner of the artist you choose. (See Figure 15–5).

WHAT YOU WILL NEED

- Pencil
- Sheet of white paper, 9 x 12 inches (23 x 30 cm)
- Tempera paint, several brushes, and mixing tray

SAFETY TIP

When an assignment calls for paints, use watercolors, liquid tempera, or school acrylics.

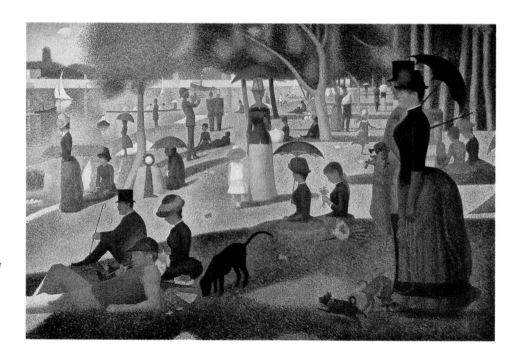

▶ **Figure 15–4** **This large painting is the artist's best known work. Thousands of colored dots are arranged with great precision to create the simple forms you see. Why do you suppose the artist made the work as large as he did? What kind of mood does it communicate to you?**

Georges Seurat. *Sunday Afternoon on the Island of La Grande Jatte.* 1884–86. Oil on canvas. 207.6 x 308 cm (81½ x 121¼"). Art Institute of Chicago, Chicago, Illinois. Helen Birch Bartlett Memorial Collection.

WHAT YOU WILL DO

1. Look once again at the paintings in Figures 15–2, 15–3, and 15–4. With classmates, discuss the main features of each artist's style.
2. Look through the pages of a magazine or newspaper. Look for a black-and-white illustration that has an interesting design or communicates a mood.
3. Using pencil, lightly redo the illustration on the sheet of white paper. Make your drawing large enough to fill the whole sheet. Keep the shapes in your drawing simple. Do not include details.
4. Finish and paint your work using one of the following styles: (a) With a fine-tipped brush, cover your drawing with closely spaced tiny dots of paint. Use colors opposite each other on the color wheel to create new hues and intensities. In this way, your work will resemble the Pointillist style of Seurat. (b) With a medium brush, apply paint in a swirling motion, creating twisted lines and shapes. Use bright, arbitrary colors to express a certain mood or feeling. In this way, your work will look like that of van Gogh. (c) Paint your drawing as a pattern of flat, colorful shapes. Paint dark outlines around these shapes. This will give your painting the same decorative look as Gauguin's.
5. When the paint is dry, display your work alongside those of classmates. See whether you can identify the Post-Impressionist style in the works of your fellow students.

EXAMINING YOUR WORK

- **Describe** Hold your painting next to the illustration on which it is based. Tell whether you can identify the objects in the illustration.
- **Analyze** Explain how you used color, line, shape, and texture. Tell which Post-Impressionist artist you used as a guide in using these elements. Point to places in your work where your use of elements was similar to that of your chosen artist.
- **Interpret** State what mood or feeling, if any, you were attempting to express. Note whether others are able to pinpoint this mood or feeling.
- **Judge** Compare your work with that of the artist who served as your guide. Tell whether your painting is similar in style to that work. Show in what ways, if any, your work is different.

▲ **Figure 15–5** Student work. Post-Impressionist painting.

COMPUTER OPTION 🖥

■ Determine the mood you will create and what you will draw. Choose a color and medium Brush tool. Click but do not drag the Brush. Draw a simple object and background by making a series of dots with the Brush tool. Do not mix or blend colors, but place dots of colors next to each other so a new color is made when viewed from a distance. Create a small, miniature picture. Cover most of the white spaces. Title, save, and print your work.

American Painting in the Late 1800s

The 1800s was a period of great change and growth in the United States. The country grew in size as pioneers and the railroad pushed westward. It grew in wealth as trade and industry boomed. By the end of the century, America had taken its place as a world power. It had also emerged as a force to be reckoned with in the world of art.

In this lesson you will read about the artists who helped put America on the map.

AMERICAN REALIST ART

During the 1800s many American artists journeyed to the art centers of Europe to study. Some were greatly influenced by the art styles they encountered. Others were mainly unaffected by European art movements. They came home to develop styles that were unmistakably American. One of these was an artist named Thomas Eakins (**ay**-kuhnz).

▲ **Figure 15–6** Everything in this picture is made to look real. The artist even included himself in the picture. He is the person in the center holding the oars.

Thomas Eakins. *Max Schmitt in a Single Scull (The Champion Single Sculls).* 1871. Oil on canvas. 81.9 x 117.5 cm (32¼ x 46¼"). The Metropolitan Museum of Art, New York, New York. Alfred N. Punnett Endowment Fund and George D. Pratt Gift.

▲ **Figure 15–7** Paintings like this capture the look and mood of the sea. With a little imagination, you can hear the roaring surf crashing against a rocky shore.

Winslow Homer. *Northeaster.* 1895. Oil on canvas. 87.4 x 127.6 cm (34⅜ x 50¼"). The Metropolitan Museum of Art, New York, New York. Gift of George A. Hearn.

Eakins, who painted only what he saw, is held to be one of America's first Realists. Realism was a movement that had its start in France in the mid-1800s. **Realism** is *a style of art in which everyday scenes and events are painted as they actually look.* Eakins, for example, stubbornly refused to show his subjects in a flattering light. As a result, he was scorned throughout his lifetime. His painting of a man in a racing boat in Figure 15–6 reveals Eakins's devotion to realism. The picture tells no story; it holds no suspense. What it does is offer a carefully studied and designed record of a simple scene that the artist witnessed. Note the care the artist took in painting even the reflections in the water.

Another artist who, like Eakins, painted exactly what he saw, was Winslow Homer.

Unlike Eakins, Homer painted pictures that often told stories, usually of people in the midst of some outdoor activity, such as hunting, fishing, or sailing.

Late in the 1880s Homer set up a studio on a rocky stretch of the Maine coast. There he painted scenes of the sea. At first his pictures were of action-filled struggles between nature and seafaring people. As time went on, the people in his works shrank in importance. His paintings began to focus instead on the power of the sea in its many moods. The work pictured in Figure 15–7 is from this later period. How would you describe the mood of the sea in this painting? What elements and principles of art help communicate this mood?

◀ **Figure 15–8 Light is important in the artist's paintings. He often showed the source of light in the form of the sun or, as here, the moon.**

Albert Pinkham Ryder. *Moonlight Marine (Toilers of the Sea)*. c. 1885. Oil on wood panel. 28.9 x 30.5 cm (11⅜ x 12"). The Metropolitan Museum of Art, New York, New York.

▶ **Figure 15–9 Notice the looseness of the brush strokes. Does this take away from the impression of detail?**

Mary Cassatt. *Sewing Woman*. c. 1880–1882. Oil on canvas. 92 x 63 cm (36 x 25"). Musee d' Orsay, Paris.

Portraying Realism

Two other artists who affected the development of American art in the 1800s were a colorful figure by the name of Albert Pinkham Ryder and Mary Cassatt.

A loner who paid little attention to the work of others, Ryder painted dreamlike images, often borrowed from literature. His style made use of large areas of color and thick layers of paint. The painting by him in Figure 15–8 shows the simple silhouette of a ship beneath a ghostly moon. The vessel seems to glide silently across the water, carrying its crew into a night filled with mystery and wonder.

Mary Cassatt, an American who studied at the Pennsylvania Academy of Fine Arts, went on to Paris for further training. There she met Degas and was influenced by his Impressionist paintings. She often chose women and children as her subjects, using the Impressionist play of light to enhance the gentle mood she created. Her work in Figure 15–9 shows why she is considered to be one of America's finest women painters.

✔ CHECK YOUR UNDERSTANDING

1. What is Realism?
2. Why were the works of Thomas Eakins shunned during his lifetime?
3. What were favorite subjects of Winslow Homer?
4. Name four artists who affected the development of American art in the 1800s.
5. What kinds of works did Albert Pinkham Ryder create? Where did he get the ideas for his works?

STUDIO ACTIVITY

Creating Texture

One element that helps viewers sense the mood of the work in Figure 15–8 is texture. Look again at the painting. Notice how the sky and sea both appear alive, although in different ways.

Working lightly in pencil, sketch a nighttime landscape. Include trees, a lake, and the moon. Make your drawing large enough to fill a large sheet of paper. Switching to crayon, trace over all the pencil lines, pressing hard. Place a sheet of burlap beneath your paper. Using the side of an unwrapped crayon, rub over the sky in your drawing. Replace the burlap with bits of dried grass and leaves. Rub the crayon over the lake in your work. Examine the results. Use other materials with rough surfaces as a base for rubbing the remaining forms in your work. (For further information on rubbings, see Technique Tip **25**, *Handbook* page **286**.)

PORTFOLIO

Describe the results of each textural experiment. Write each technique and the words that describe its effects in chart form. Keep this chart and your sketch with texture samples in your portfolio for reference. Add new techniques and textures to your chart as you discover them.

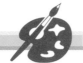

Making an Expressive Watercolor Painting

Henry Tanner was a former student of Thomas Eakins and one of America's most talented black artists. Because his paintings did not sell in America, Tanner decided to move to Europe. Settling in Paris, he painted scenes from the Bible, which were well received. After one of his paintings was accepted in the Paris Salon, a highly respected French artist insisted that it be hung in a place of honor.

Although better known for his religious pictures, some of Tanner's best works were portraits and outdoor scenes. One of his scenes can be viewed in Figure 15–10. Notice the low-intensity hues, contrasting light and dark values, and fuzzy shapes in this painting. What kind of mood does Tanner create with these hues, values, and shapes?

WHAT YOU WILL LEARN

You will use watercolor paint to create your own expressive scene. Your scene will exhibit the same low-intensity hues, contrasting dark and light values, and fuzzy shapes found in Tanner's painting. Your painting will also express the same quiet stillness. (See Figure 15–11.)

▶ **Figure 15–10 The artist's interest in art was born when, as a child, he watched an artist at work in a park.**

Henry O. Tanner. *The Seine.* 1902. Canvas. 23 x 32.9 cm (9 x 13″). National Gallery of Art, Washington, D.C. Gift of the Avalon Foundation.

WHAT YOU WILL NEED

- Container of water
- Sheet of white paper, 9 x 12 inches (23 x 30 cm)
- Watercolor paint and several brushes
- Tempera paint in different hues
- Pen and India ink

WHAT YOU WILL DO

1. With water, completely wet the sheet of white paper.
2. Load a medium-pointed brush with a light color paint, and apply this carefully to the damp paper. The area painted might represent a lake or river. Add other areas of light colors to suggest sky and clouds.
3. Use the same technique to add dark shapes to your paper. These could suggest the shoreline, distant rooftops, boats, a bridge, or other objects. Do not worry about details. Concern yourself with creating areas of color with different dark values.
4. While your picture is drying, study it carefully. Use your imagination to identify the general outlines of the different objects.
5. When your painting is dry, use a pen and India ink to outline the objects. Add details.
6. Use white paint to create highlights and additional details.

EXAMINING YOUR WORK

- **Describe** Identify the different objects in your scene. Name the hues you used.
- **Analyze** Point out the low-intensity hues, contrasting light and dark values, and fuzzy shapes.
- **Interpret** Explain how your work expresses a quiet, still mood.
- **Judge** Compare your work with that of Tanner. Tell how your picture is similar in content and composition. Point out the differences.

▲ **Figure 15–11** **Student work. Expressive watercolor painting.**

 Try This!

COMPUTER OPTION

Choose light, transparent colors and a wide Brush tool to fill in areas representing sky and water. Select darker hues and roughly add shapes of objects such as buildings, bridges, shoreline, or trees. Use Water effect with mouse or drawing pen to smudge or soften the strokes and to create a watercolor effect. You may wish to use the Airbrush tool and transparent colors to build up layers of tints and shades. Use small Brush and a dark color to outline important objects in the picture. Title, print, and save your work.

Albert Bierstadt. *Emigrants Crossing the Plains.* 1867. Oil. National Cowboy Hall of Fame and Western Heritage Center, Oklahoma City, Oklahoma.

What Adventures Awaited Frontier Settlers?

Life on the American frontier is portrayed in popular books and movies as an exciting, romantic adventure. Yet, the true picture was not very glamorous. If you could travel back in time, what would you discover?

During the 1800s, millions of emigrants ventured west. Some went in search of gold, others in search of cheap farm or ranch land. All dreamed of a better life, but the journey itself was treacherous. Accidents, disease, and exhaustion took their toll. Crossing wide, swollen rivers and steep mountains was life threatening. Along the trail, water was scarce. The sun and heat could be unbearable. There was no escaping the dust, wind, and rain. For many, this journey would be the last. Yet the brash hope and idealism of these individuals helped most survive.

The Homestead Act of 1862 granted free land to those who would farm it. Thousands more stampeded to the frontier. Many settlers were unprepared for the harsh life that awaited them. In Bierstadt's painting, we sense the rugged spirit of these emigrants paired with the awesome beauty of the landscape. How much of this image is real? How much is myth?

MAKING THE CONNECTION

- How has Albert Bierstadt used the elements and principles of art to direct the viewer's eye?
- The artist symbolized the hopes and dreams of the westward adventurers. What motivated these travelers to brave the hardships and continue onward?
- Locate examples of painting and photographs of the early West. Which ones are realistic, which ones seem idealistic? Why would an artist create a work with a certain point of view?

INTERNET ACTIVITY

Visit Glencoe's Fine Arts Web Site for students at:

http://www.glencoe.com/sec/art/students

REVIEW

◆ BUILDING VOCABULARY

Number a sheet of paper from 1 to 5. After each number, write the term from the list that best matches each description below.

arbitrary colors Post Impressionism
optical colors Realism
Pointillism

1. An art movement that appeared after the Impressionists.
2. Colors viewers actually see.
3. Colors chosen to communicate different feelings.
4. A technique in which small, carefully placed dots of color are used to create forms.
5. A style of art in which everyday scenes and events are painted as they actually look.

◆ REVIEWING ART FACTS

Number a sheet of paper from 6 to 15. Answer each question in a complete sentence.

6. Name two problems and solutions some artists of the later 1800s found in the Impressionist style.
7. Which Post-Impressionist artist was a former Impressionist?
8. Which artist besides Cézanne was interested in making the forms in his paintings clearer and more solid-looking?
9. Which Post-Impressionist besides Gauguin used arbitrary colors in his works?
10. What painter filled his works with tiny dots of color? Why did he do this?
11. What was there about his works that made Eakins unpopular during his lifetime?
12. How did Homer's paintings change from his early to his later years in Maine?
13. Which two American artists of the late 1800s often painted pictures of the sea?
14. Name the artists who affected the development of American art in the 1800s.
15. Describe Ryder's painting techniques.

❓ THINKING ABOUT ART

On a sheet of paper, answer each question in a sentence or two.

1. **Analyze.** Paul Cézanne claimed that all forms in nature are based on three forms: the sphere, the cone, and the cylinder. Examine his painting in Figure 15–1. Tell how his work supports this idea.
2. **Compare and contrast.** Acting as a critic, interpret the works by Albert Pinkham Ryder (Figure 15–8) and Thomas Eakins (Figure 15–6). Tell how the two interpretations differ. Tell how they are alike.

MAKING ART CONNECTIONS

1. **Language Arts.** Read *Meet Edgar Degas* by Anne Newlands. In the book, Degas tells you about his paintings and what it was like to be an artist during the time he worked in Paris. Write a letter to Degas and tell him about being an artist in your town today. Compare what you read in Newlands' book with what you think he might experience if he lived in present-day United States.

2. **History.** Imagine that you lived in America during the 1800s. Using history and literature books for reference, write a short report on what life would have been like for a teen growing up in this time. Identify the area of the country where you might live, the lifestyle you would experience there, and the specific years you are writing about. List some events that would shape your life.

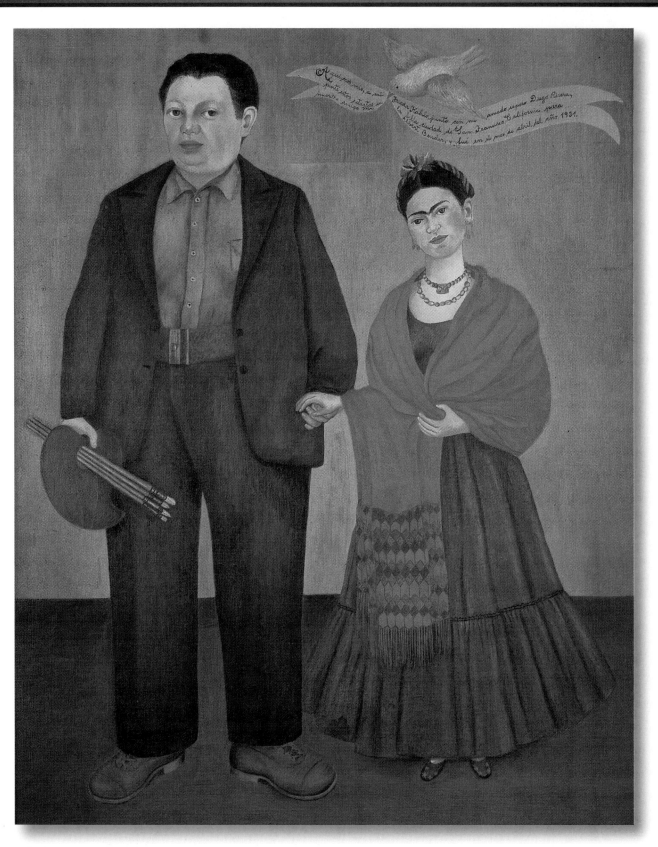

▲ Notice that the wedding couple do not look at one another. How do you know that the groom in the work is a painter? How has the artist used color to draw attention to the bride?

Frida Kahlo. *Frida and Diego Rivera*. 1931. Oil on canvas. 100 x 78.7 cm (39⅜ x 31″). San Francisco Museum of Modern Art, San Francisco, California. Albert M. Bender Collection. Gift of Albert M. Bender.

Art of the Early Twentieth Century

Art has the power to delight. Art has the power to teach. Art also has the power, as history has shown time and again, to express emotion.

While some styles that developed early in the twentieth century shocked and surprized viewers, some styles were more easily recognized as expression of the artist's struggle. The painting at the left represents the life experience of the artist who created it. In the pages that follow you will learn about some of the many varied art styles of this period.

PORTFOLIO IDEAS

Select two examples from your portfolio that were done in the same media and that demonstrate your growth in the use of that media. Evaluate the works. Describe what you learned about using the media. What improvements did you make in using the media? What changes would you improve in using the media? Store your examples and evaluation in your portfolio.

OBJECTIVES

After completing this chapter, you will be able to:

- Identify the major art movements of the early twentieth century.
- Name the leaders of those movements.
- Describe art trends in the United States and Mexico in the early twentieth century.
- Use the elements and principles of art in the style of the Cubists.
- Create an art work showing rhythm and movement.

WORDS YOU WILL LEARN

Ashcan School
Cubism
The Eight
Expressionism
Fauvism
muralist
non-objective art
Regionalism

Art of the Early Twentieth Century in Europe

Every age, it has been said, learns from and builds on the one before it. The truth of these words is clear from developments in art in the early 1900s. Several new styles came along, each borrowing in a different way from Post-Impressionism. These styles, which stunned the art world, continue to affect art through the present day. In this lesson you will learn about the pioneers behind these innovative ways of making art.

FAUVISM

In 1905 a showing by a group of French artists started the art community buzzing. The most striking feature of the works in the show was their raw, sizzling colors. No effort had been made to paint realistic pictures. The artists' goal was to express their feelings through sharply contrasting colors and heavy outlines. One angry critic wrote that the paintings looked as though they had

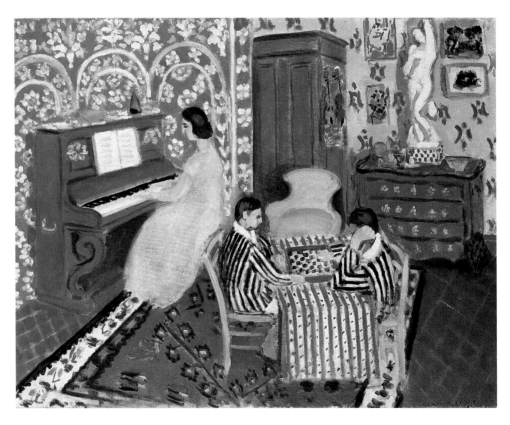

► **Figure 16–1** This painting shows the artist's favorite model and her two brothers. Matisse's own presence is suggested by the empty armchair in the center where he would often sit, his violins hanging from the cabinet, and his art works tacked to the wall.

Henri Matisse. *Pianist and Checker Players*. 1924. Oil on canvas. 73.7 x 92.4 cm (29 x 36⅜"). National Gallery of Art, Washington, D.C. Collection of Mr. and Mrs. Paul Mellon.

been done by *fauves* (**fohvs**). This term, which is French for "wild beasts," gave the movement its name: Fauvism (**fohv**-iz-uhm). **Fauvism** is *an art movement in which artists used wild, intense color combinations in their paintings.*

The leader of the Fauves was a law student who chose to become an artist. His name was Henri Matisse (ahnh-**ree** mah-**tees**). For his paintings, Matisse chose colors that communicated a joyous or happy mood. He then combined them, as in the picture in Figure 16–1, to create rich, decorative patterns. To understand the importance of color in Matisse's works, try to imagine Figure 16–1 in black and white. In what way would the painting be different? How would its mood change?

EXPRESSIONISM

Matisse and the Fauves wanted to show feelings in their art. In Germany the same goal was shared by another group of artists, who developed a movement known as Expressionism (ek-**spresh**-uh-niz-uhm). Artists using **Expressionism** worked in *a style that emphasized the expression of innermost feelings.* They ignored the contemporary rules of art. They had the strength to experiment with, to exaggerate, and in other ways to change, the proportions of figures and objects.

Painting

An early leader of the Expressionist movement was an artist named Ernst Ludwig Kirchner (**ehrnst lood**-vig **keerk**-nuhr). Figure 16–2 shows Kirchner's inner view of a street scene. Note his use of brilliant, clashing colors and sharp, twisted shapes. The people in Kirchner's world are crammed together in a small space. Yet they manage not to notice one another. How might you sum up the artist's feelings toward these people and their world?

Printmaking

The power of Expressionism can also be seen in the prints and drawings of Käthe

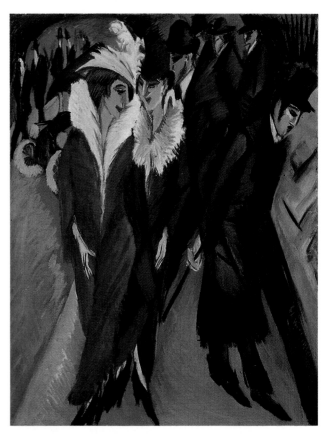

▲ **Figure 16–2 The artist has used twisted shapes to express his emotions. An earlier artist you read about did the same thing. Do you recall that artist's name?**

Ernst Ludwig Kirchner. *Street, Berlin.* 1913. Oil on canvas. 120.6 x 91.1 cm (47½ x 35⅞"). Collection. The Museum of Modern Art, New York, New York. Purchase.

Kollwitz (**kay**-tuh **kohl**-vits). At a time when most artists were exploring color, Kollwitz created works mainly in black and white. Many, like the print in Figure 16–3, reveal her concern for the poor and her outrage at the horrors of war. In this moving work, she captures the sorrow and the despair of lower-class German mothers left alone to care for their children after World War I.

CUBISM

Paul Cézanne, you will remember, was interested in showing objects as solid-looking forms. A guiding idea behind one new style was Cézanne's notion that all forms in nature are made up of three shapes. Those three are the sphere, cone, and cylinder. This idea contributed to the development of **Cubism**, *an art style in which objects and the space around them are broken up into different shapes and then put back together in new relationships.*

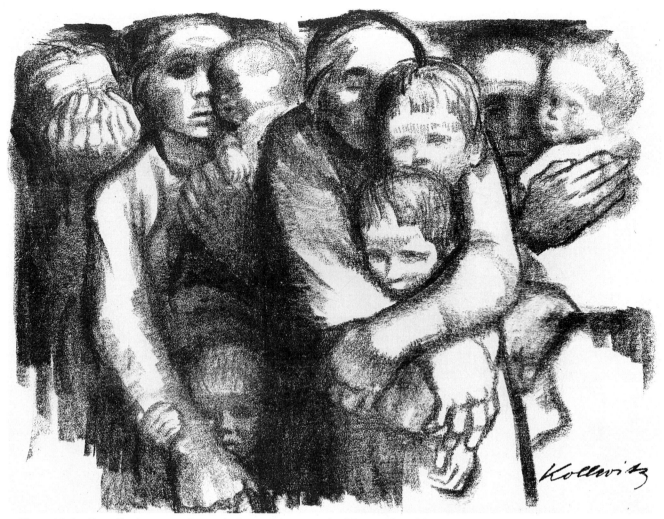

▲ Figure 16–3 Describe the expression on the faces of these people. What word would you use to describe the way these mothers act toward their children? How does this picture make you feel?

Käthe Kollwitz. *The Mothers.* 1919. Lithograph. 43.8 x 58.4 cm (17¾ x 23"). Philadelphia Museum of Art, Philadelphia, Pennsylvania. Anonymous donor.

Painting

The founder of Cubism was an artist you have met before in this book. Even if you had not met him here, his name is one you would instantly recognize. It is Pablo Picasso.

Picasso's early Cubist paintings were different arrangements of bits and pieces of his subject viewed from different angles. The subjects of these works are at times difficult to pick out. Later he began using brighter colors and larger shapes in his works. He also added texture and pattern, often by gluing found objects to his paintings. The picture in Figure 3–7 on page **42** is one of Picasso's later Cubist works. Are you able to identify the objects in this picture?

Sculpture

The Cubist style also found its way into sculpture of the early twentieth century. Jacques Lipchitz (**zhahk lip**-shuts), a Lithuanian-born sculptor who studied in Paris, used Cubism in his bronze castings. One of these works is pictured in Figure 16–4. Notice how the many fragments of a figure add up to a carefully designed three-dimensional whole. How has the artist used texture to give the work a sense of harmony?

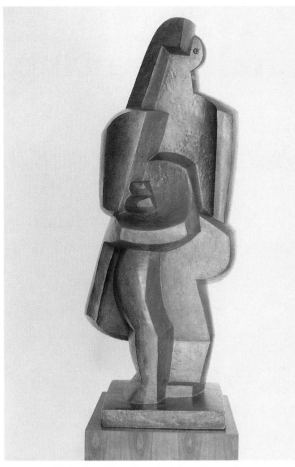

▲ **Figure 16–4** **What has the artist done to create value?**

Jacques Lipchitz. *Bather.* 1923–25. Bronze. 198.5 x 79.1 x 70.5 cm (78⅛ x 31⅛ x 27¾"). Dallas Museum of Art, Dallas, Texas. Gift of Mr. & Mrs. Algur H. Meadows and the Meadows Foundation, Inc. © 1998 Estate of Jacques Lipchitz/Licensed by VAGA, New York, NY/Courtesy Marlborough Gallery, New York.

NON-OBJECTIVE ART

One evening in 1910 after painting outdoors all day, a weary artist returned to his studio. There he was greeted by a surprise that changed the course of art history. Perched on his easel was a painting unlike anything he had ever seen. Its brightly colored shapes and lines seemed to glow and shimmer in the dim light. Rushing to the canvas, the artist had his second surprise of the night. The work was his own; he had carelessly placed it upside down on the easel! The artist's name was Wassily Kandinsky (**vahs**-uh-lee kuhn-**din**-skee). His discovery led to the birth of a new style called **non-objective art**. These are *works in which no objects or subjects can be readily identified*.

STUDIO ACTIVITY

Making a Collage

Look through the pages of a magazine for street scenes. Cut any pictures you find into angled shapes of different sizes. Arrange these shapes into a collage. Your work should capture the look and feel of a twentieth-century American street scene. Glue the shapes to a sheet of white paper. Compare your street scene with the one in Figure 16–2. Is your collage as successful in expressing a mood or feeling? Why or why not?

PORTFOLIO

For your portfolio, you may wish to mount or mat your collage. Include your written comparison telling whether your collage expresses the mood or feeling you were trying to capture.

In the experiments that followed, Kandinsky found he could express feelings using only colors, shapes, and lines. These elements could be arranged, just as the notes of a song are, to create a mood.

✔ CHECK YOUR UNDERSTANDING

1. What is Fauvism? Who was the leader of the Fauves?
2. What is Expressionism? In what way did the Expressionists ignore the rules of art?
3. To what movement did the artist Käthe Kollwitz belong? What media did she favor?
4. Define *Cubism.* Name the Post-Impressionist artist whose ideas influenced the Cubist movement.
5. Tell in what area of art Jacques Lipchitz worked. By what art movement was he influenced?
6. Tell how non-objective art got its start. Name the originator of the movement.

Making a Cubist Chalk Drawing

A co-founder of the Cubist movement was an artist named Georges Braque (**zhorzh brahk**). A favorite form of expression for Braque was the still life. Instead of fruits or flowers, he usually chose household objects as subjects. Figure 16–5 shows one of his still lifes. Notice how the table, other objects, and background are combined to make a flat, decorative design. All parts of the work are equally interesting to look at. The different colors, shapes, lines, and textures are organized into an interesting whole.

In this lesson you will use the elements and principles of art in the same way.

WHAT YOU WILL LEARN

You will create a still life with chalk in the later style of the Cubists. You will repeat colors, shapes, lines, and textures to make a flat, decorative pattern. Your pattern will fill the paper. A warm or cool color scheme will be used to add harmony and express a mood. (See Figure 16–6.)

WHAT YOU WILL NEED

- Pencil and sheets of sketch paper
- Sheet of white paper, 18 x 24 inches (46 x 61 cm)
- Colored chalk and spray fixative
- Sheets of facial tissue

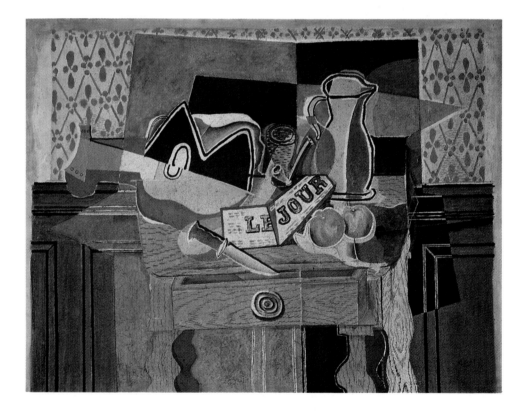

▶ **Figure 16–5** How many different objects can you identify? What other objects could be used to make an interesting still life? Describe the different textures. How has the artist added unity to this design?

Georges Braque. *Still Life:Le Jour.* 1929. Canvas. 115 x 146.7 cm (45¼ x 57¾"). National Gallery of Art, Washington, D.C. Chester Dale Collection.

WHAT YOU WILL DO

1. Bring to class an object with an interesting shape. Some possibilities are an old violin or guitar, an oddly shaped bottle, or a house plant. Working with three other students, arrange the objects on a tabletop. Each student should have a clear view of the objects.

2. Make several rough pencil sketches for a still life. You may exaggerate or in other ways change shapes and lines for added interest. Shapes should be shown as simple, flat planes. Repeat the lines of the objects in the background areas.

3. Working lightly in chalk, transfer your best sketch to the sheet of white paper. Fill the whole sheet with your design.

4. Choose four or five sticks of chalk to create either a warm or cool color scheme. As you choose, keep in mind the mood you want your work to communicate.

5. Color your still life. Color some shapes by blending two or more hues with facial tissue. Repeat colors throughout the picture to add harmony. Make some shapes stand out clearly by adding heavy contour lines. Use the chalk to create different textures in some shapes.

6. Spray your still life with fixative. Compare it with the one in Figure 16–5 and those by other students.

── **SAFETY TIP** ──

Remember to use chalk in a place with plenty of ventilation. If you begin to have breathing problems, finish the lesson using crayon. Use spray fixative outdoors or in a space with plenty of ventilation.

EXAMINING YOUR WORK

- **Describe** Point to and name the different objects in your picture. Explain how and why you changed the shapes and lines of those objects.
- **Analyze** Point out places where you have repeated colors, shapes, and lines. Explain how these elements have been used to create a flat, decorative pattern. Tell whether your design fills the whole sheet of paper.
- **Interpret** Tell how the warm or cool color scheme adds a mood to your work. Identify this mood.
- **Judge** Tell whether you feel your work succeeds. Explain your answer.

▲ Figure 16–6 Student work. Cubist chalk drawing.

Try This! COMPUTER OPTION

■ Use the Pencil tool to sketch a still life with varied, simple lines and shapes to make the objects appear flat. Use the Straight Line tool to draw horizontal and vertical lines across the still life. Fill in each space with a solid or patterned color. Repeat colors to create harmony. Emphasize some shapes by using a thick Brush to outline. Title, save, and print your work.

LESSON 3

Art of the Early Twentieth Century in America

In the early twentieth century the pace of life quickened in the United States. The airplane, assembly line, and telephone were all part of a new fascination with speed. A search for new formulas in American art mirrored the restlessness of the age. In this lesson you will learn about the most important of the new art movements. You will also learn about developments in the art of Mexico.

THE ASHCAN SCHOOL

As the 1800s gave way to the 1900s, the important names in American art remained unchanged. Homer, Eakins, and Ryder continued on as the unchallenged leaders. In New York a group of lesser-known painters felt a change was overdue. Since there were eight members in all, they called themselves, simply, **The Eight**. This was a *group of artists who created art work that reflected the spirit of the times in which they lived, the early 1900s.*

The members of The Eight were all one-time newspaper cartoonists or magazine illustrators. These experiences influenced their choice of subjects for their paintings. Their works drew on images from everyday life in the big city. These pictures of crowded city streets, dark alleys, and gray slums were recorded in a no-nonsense, realistic style. When The Eight held their first public showing in 1908, viewers politely examined their works. Then they laughed. A more fitting name for these chroniclers of working-class American life, some decided, was the **Ashcan School**. This became *the popular name given to the group of artists who made realistic paintings of working-class America.*

Painting

One of the most talented members of the Ashcan School was John Sloan. His pictures capture the color, movement, and humor of big-city life. Look at the painting by Sloan in Figure 16–7. The hairdresser in the picture goes about her business with hardly a care. Below, meanwhile, passersby stop and stare as if witnessing an important event. Locate the girls at the bottom of the picture. One, you will notice, seems to be talking excitedly. What do you suppose she is saying?

▲ Figure 16–7 **What has the artist done to emphasize the figures in the second-story window? How has movement been introduced?**

John Sloan. *Hairdresser's Window.* 1907. Oil on canvas. 81 x 66 cm (31⅞ x 26"). Wadsworth Atheneum, Hartford, Connecticut. Ella Gallup Sumner and Mary Catlin Sumner Collection.

◀ **Figure 16–8** What do you think the artist wanted to show in this painting: the poverty and hopelessness of city dwellers, or the vitality and pleasures of life in the inner-city? What sounds do you associate with this scene? What aesthetic views would you use when judging this work?

George Bellows. *Cliff Dwellers.* 1913. Oil on canvas. 102.0 x 106.8 cm (40³⁄₁₆ x 42¹⁄₁₆"). Los Angeles County Museum of Art, Los Angeles, California. Los Angeles County Fund.

An artist who was closely tied to the Ash-can School, though not one of The Eight, was George Bellows. His painting in Figure 16–8 makes use of the same urban subject matter. Groups of young men, women, and frolicking children hold center stage in the sunlit foreground. In the background are shadowed tenements with balconies crowded with figures peering down at the constant bustle that is a part of life in the heart of a great city.

Photography

The Ashcan painters were not alone in using city scenes as subjects for art. The same look and feel was achieved in the works of artist Alfred Stieglitz (**steeg**-luhts). Stieglitz played an important part in the early development of photography as a new art form. Examine his photograph in Figure 16–9. What details in the work reveal it to be of a bitterly cold winter day? What mood does the picture communicate?

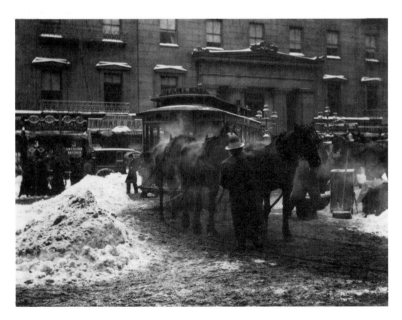

◀ **Figure 16–9** Find the curving and diagonal lines that help pull the viewer in. How does the variety of light and dark values add interest to the work?

Alfred Stieglitz. *The Terminal.* c. 1892. Photogravure. 25.4 x 33.7 cm (10 x 13¼"). The Art Institute of Chicago, Chicago, Illinois. The Alfred Stieglitz Collection.

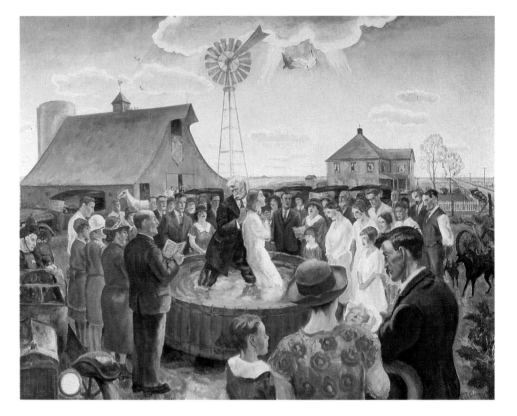

▶ **Figure 16–10** Point to the lines that lead to the figures of the preacher and the girl. Where is the circle shape formed by the windmill blades repeated? How is deep space suggested?

John Steuart Curry. *Baptism in Kansas*. 1928. Oil on canvas. 101.6 x 127 cm (40 x 50"). Whitney Museum of American Art, New York, New York. Gift of Gertrude Vanderbilt Whitney.

REGIONALISM

After World War I a different brand of realistic art enjoyed brief popularity in the United States. Several artists used a style that became known as **Regionalism** (**ree**-juh-nuh-**liz**-uhm) to record *local scenes and events from the artist's own region, or area, of the country.*

An example of the Regionalist style may be found in Figure 16–10. The artist of the work, John Steuart Curry (**stoo**-urt **ker**-ee), was a native of Kansas. In this painting he shows a preacher about to baptize, or spiritually cleanse, a young girl. The setting is a Kansas farm. Relatives and friends have gathered to witness this ritual of passage. They all look at the preacher and the girl, automatically directing the viewer's eyes there. The legs of a windmill point to the scene as well as to the glowing clouds in the sky.

ART IN MEXICO

The early twentieth century was a time of unrest and revolution in Mexico. Hard-working peasants, treated like slaves by rich landlords, struggled to free themselves. Several artists witnessed the struggle. They used their art to lend their support to the people.

One who did so was Mexico's foremost muralist (**myoor**-uh-list) Diego Rivera. A **muralist** is *an artist who paints large art works directly onto walls or ceilings.* In the mural in Figure 16–11, the artist tells of the only true escape for the poor: death. Several soldiers of the common people kneel around one of their own who has fallen in battle. In the distance flames rise from the landlord's house; the peasant's death has already been avenged.

Two years before he painted *Liberation of the Peon*, Rivera married the painter Frida Kahlo, judged by many to be Mexico's most famous woman artist. Seriously injured in a bus accident when she was a teenager, Kahlo never fully recovered, and lived in almost constant pain until her death some 30 years later. She took up painting while recovering from her accident even though her injuries were so severe she had to learn to paint lying down. The Chapter Opener on page **240** shows the wedding portrait Kahlo painted shortly after her marriage. Neither seems happy, although this should be a joyous moment in both their lives. Perhaps Kahlo realized that her marriage would be a stormy one, marred by many disputes.

✔ CHECK YOUR UNDERSTANDING

1. Who were The Eight? What were their backgrounds as artists? What kinds of paintings did they create?
2. When did The Eight stage their first showing? How did the public react? What nickname were The Eight given?
3. What art form was the specialty of Alfred Stieglitz?
4. What style of art became popular after World War I? Name an artist who created works in this style.
5. What is a muralist? Who was Mexico's foremost muralist?
6. What theme appears in the work of Diego Rivera?

STUDIO ACTIVITY

Creating Abstract Effects

Look again at Figure 16–11. The work, you will notice, is both abstract and expressive. Choose one of the following words: *war, hunger, anger.* Look through magazines, tearing out pages showing objects that capture the idea of this word. Using pencil and tracing paper, carefully transfer the images you have found to a sheet of paper. Overlap the drawings to create an abstract effect. Use India ink to create contrasts of light and dark shapes.

P O R T F O L I O

You might want to practice for portfolio presentation by presenting this art work to classmates. Display the work, and describe how you used the elements and principles of art to create a theme. Evaluate your success by asking classmates to tell the theme suggested by your work.

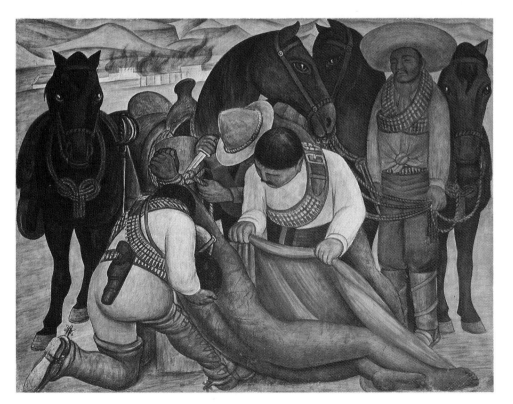

◀ **Figure 16–11 Describe the way in which these soldiers care for the dead. What feelings do you think this painting stirred up in Mexican viewers of the artist's day?**

Diego Rivera. *Liberation of the Peon.* 1931. Fresco on plaster. 187.9 x 241.3 cm (74 x 95″). Philadelphia Museum of Art, Philadelphia, Pennsylvania. Gift of Mr. & Mrs. Herbert Cameron Morris.

LESSON 4

Making a Print of a Figure in Action

Figure 16–12 shows another action scene by George Bellows. This is one of six paintings the artist made on the subject of prizefights. He also made many prints and countless drawings. Here, as elsewhere, he uses slashing diagonal lines to show movement. In this lesson you will do the same.

WHAT YOU WILL LEARN

You will overlap a series of prints showing a figure in action. You will use diagonal lines to complete the figure. These lines will add to a feeling of rhythm or movement. (See Figure 16–13.)

WHAT YOU WILL NEED

- Pencil and sheets of sketch paper
- Ballpoint pen and paper towels
- Styrofoam meat tray
- Brayer
- Water-based printing ink and shallow tray
- Scissors
- Sheet of drawing paper, 10 x 12 inches (25 x 30 cm)

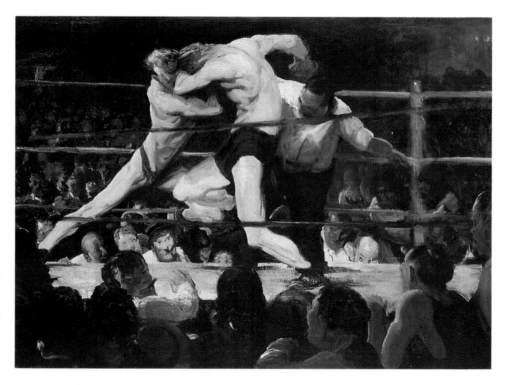

▶ **Figure 16–12** What has been done to emphasize the two figures? What kinds of lines have been used?

George Wesley Bellows. *Stag at Sharkey's.* 1909. Oil on canvas. 93 x 122.5 cm (36¼ x 48¼"). The Cleveland Museum of Art, Cleveland, Ohio. Hinman B. Hurlbut Collection.

WHAT YOU WILL DO

1. Take turns with your classmates in acting as models. Each model will strike an action pose, such as running, reaching, or pushing.

2. Make a series of gesture drawings of students in different poses. Quickly drawn diagonal lines will help you catch a sense of action. Avoid details. Focus on showing movement. (For more on gesture drawing, see Technique Tip 1, *Handbook* page **277**.)

3. Select your best drawing. Place it on top of the styrofoam meat tray and transfer the figure to the tray by tracing over it firmly with a ballpoint pen. Cut your figure out of the tray with scissors. This is to be your printing plate.

4. Squeeze a small amount of water-based printing ink into the tray. Roll the brayer back and forth through the ink until the whole brayer is covered with ink.

5. Put the figure on a paper towel. Roll the brayer over the figure. Pick up the figure by the edges and place it ink-side down on your sheet of drawing paper. Press the back of the figure firmly all over to transfer ink.

6. Ink the plate again and make another print. This time overlap images on your paper until you are satisfied with your design. Arrange your images in a horizontal or vertical line to add a feeling of rhythm.

7. Title your work, sign it, and place it on display.

EXAMINING YOUR WORK

- **Describe** Identify the figure in your print. Point out different features of the figure.
- **Analyze** Explain how the diagonal lines in your print carry a sense of rhythm.
- **Interpret** Find out whether viewers can identify the action in your print. Reveal the action you were trying to show.
- **Judge** Tell whether you feel your work succeeds. Tell what you would do to improve your work on a second effort.

▲ Figure 16–13 Student work. Figure in action.

COMPUTER OPTION

■ Using Pencil or Brush tool, create a gesture drawing of a figure in action. Use the Lasso Selection tool to Copy and Paste multiple copies on the page, arranging and overlapping the figures to show action and rhythm. Title and save. Then choose colors that go from light to dark and Flood-fill each shape to create the illusion of depth and movement. Try several color schemes. Choose the best, then retitle, save and print one drawing.

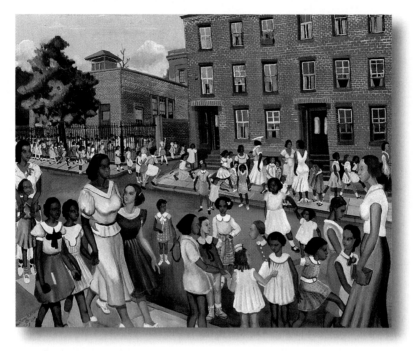

Allan Rohan Crite. *School's Out*. 1936. Oil on canvas. 76.8 x 91.8 cm (30¼ x 36⅛").
National Museum of American Art, Smithsonian Institution, Washington, D.C.

How Did the WPA Help Artists?

The stock market crash of 1929 created an economic disaster called the Great Depression. Panic and despair gripped the nation as thousands of businesses failed and workers were laid off. Banks had invested their depositors' money in the stock market. When the market crashed, there was no money to return to depositors. Millions of people lost their jobs and their life savings. By 1932, twenty-five percent of the work force was unemployed. Among the unemployed were many, many artists.

The government set up relief programs to provide jobs for the unemployed. As part of his "New Deal" for worker relief, President Franklin D. Roosevelt created a national program called the Works Progress Administration (WPA).

Artists urged the president to set up a job program for artists, so Roosevelt authorized the federal Public Works of Art Project and the Federal Art Project. These programs employed artists to paint murals on public buildings, to create public sculptures and pottery, and to teach arts and crafts. Among the artists who participated was Alan Rohan Crite, who painted neighborhood scenes like the one pictured here.

MAKING THE CONNECTION

- How would you describe the artist's style in this painting, *School's Out?*
- Crite painted this work in the midst of the Depression. He wanted to show people "enjoying the usual pleasures of life with its mixture of both sorrow and joys." Do you think he was successful? Explain.
- Find out more about artists who worked during the Depression. Identify two artists and compare their art works and their lives.

INTERNET ACTIVITY

Visit Glencoe's Fine Arts Web Site for students at:

http://www.glencoe.com/sec/art/students

REVIEW

BUILDING VOCABULARY

Number a sheet of paper from 1 to 8. After each number, write the term from the list that best matches each description below.

Ashcan School Fauvism
Cubism muralist
The Eight non-objective art
Expressionism Regionalism

1. An art movement in which artists used wild, intense color combinations in their paintings.
2. A style that emphasized the expression of innermost feelings.
3. A style in which objects and the space around them are broken up into different shapes and then put back together in new relationships.
4. A style in which no objects or subjects can be readily identified.
5. A group of New York artists who created art work that reflected the spirit of the times in the early 1900s.
6. The popular name given to the group of artists who made realistic paintings of working-class America.
7. A style that records local scenes and events from an artist's own region, or area, of the country.
8. An artist who paints large art works directly onto walls or ceilings.

REVIEWING ART FACTS

Number a sheet of paper from 9 to 14. Answer each question in a complete sentence.

9. What feature did Expressionism and Fauvism have in common?
10. Identify the artist whose idea led to the forming of the Cubist movement.
11. What artist is credited with developing the non-objective style?
12. In what way were the photographs of Alfred Stieglitz linked to the work of the Ashcan painters?
13. When did the Regionalist movement begin? Name a member of the movement.
14. Which artist that you read about in this chapter was a muralist?

THINKING ABOUT ART

On a sheet of paper, answer each question in a sentence or two.

1. **Extend.** Imagine that Käthe Kollwitz had chosen to do her print *The Mothers* (Figure 16–3) in color. Do you think such a decision would have added to the power of the work? Explain your answer.
2. **Analyze.** The work by John Steuart Curry (Figure 16–10) shows the use of emphasis. Find another work in this chapter that uses emphasis. Explain how the artist leads the viewer's eye to the most important feature.

MAKING ART CONNECTIONS

1. **Language Arts.** Divide a sheet of paper into three columns. Label one column *Subject*, one *Composition*, and one *Content*. Then, going through the art works in this chapter one by one, decide in which column or columns each artist's name belongs. Compare your completed list with those of other students in your class.

2. **Language Arts.** Examine the historical and artistic influences that shaped the art of Pablo Picasso in a book by Juliet Heslewood, *Introducing Picasso: Painter, Sculptor.* What do you think most influenced his particular style?

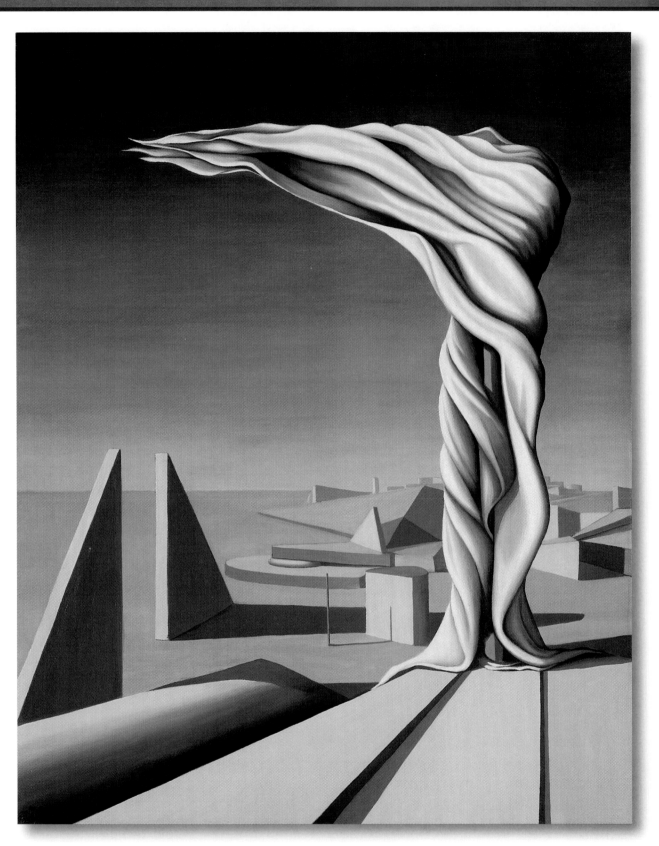

▲ Can you find any signs of life in this painting? What do you think these structures represent? What purpose do they serve? How does this painting make you feel?

Kay Sage. *I Saw Three Cities*. 1944. Oil on canvas. 91.5 x 71.0 cm (36 x 27⅞″). The Art Museum, Princeton University, Princeton, New Jersey. Gift of the Estate of Kay Sage Tanguy.

Art of Today

The long story of art is a story marked by change. With each passing age, the search for original forms of expression is renewed. A style that startled viewers of one generation becomes a part of the mainstream as another shocking style makes its appearance.

At no time in history has the search for new directions been more visible than now. The last 100 years have seen more changes in art styles, media, and techniques than all the thousand years before. One style appears in the work at the left. Can you see any similarities with art works created earlier? In this chapter you will learn how this and other recent art styles originated.

PORTFOLIO IDEAS

Select five examples of art work that demonstrate how you have grown as an artist in your ability to communicate feelings, moods, or thoughts in your art work. For each piece, state what you have learned and explain why this piece is a good example of your skills. Include your personal reflection for each piece in your portfolio.

OBJECTIVES

After completing this chapter, you will be able to:

- Identify major art movements of the last 100 years.
- Identify the characteristics and leaders of those art movements.
- Create a painting in the Surrealist style.
- Create a work using contemporary styles and techniques.

WORDS YOU WILL LEARN

Abstract
 Expressionism
Dada
Hard-Edge painting
kinetic art
mobile
multi-media art
New Realism
Op-Art
social protest painting
Surrealism

European Art Today

The Impressionists went outdoors to find ideas. The Expressionists looked to their own hearts. The second decade of the twentieth century found artists exploring still another source for art ideas. That was the inner workings of the mind.

FANTASY ART

Imagine yourself a visitor at a showing of new art. Suddenly your eye falls upon a work that is at once familiar and shocking. It is familiar because it is a photograph of the *Mona Lisa*. It is shocking because someone has drawn a mustache on Leonardo da Vinci's world-famous portrait.

It was this very experience that outraged members of Europe's art community in 1916. The artist behind the work was a one-time Cubist named Marcel Duchamp (mar-**sel** doo-**shahnh**). The movement he belonged to, **Dada** (**dahd**-ah) was *founded on the belief that Western culture had lost its meaning*. For Dadaists (**dahd**-uah-ists), the beauty of art was in the *mind*, not the eye, of the beholder. Art, in other words, did not have to be beautiful or express important ideas. Usually the point was driven home, as in Duchamp's photograph, by poking fun at art of the past.

SURREALISM

Although Dada lasted only six years, it paved the way for other art explorations of the mind. The most important of these was **Surrealism** (suh-**ree**-uh-liz-uhm). This movement *probed the subconscious world of dreams* for ideas, and was touched off by the works of a Greek-born Italian artist named Giorgio de Chirico (**jor**-joh duh **kir**-ih-koh). Like the artists who followed him, de Chirico created mysterious, nightmarish landscapes

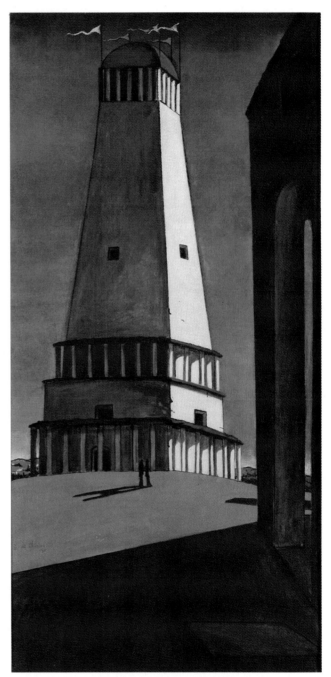

▲ Figure 17–1 What gives this picture its dreamlike appearance? What kinds of feelings does it arouse in you?

Giorgio de Chirico. *The Nostalgia of the Infinite.* (1913–14; dated on painting 1911). Oil on canvas. 135.2 x 64.8 cm (53¼ x 25½"). Collection, The Museum of Modern Art, New York. Purchase.

where time had no meaning. One of these is shown in Figure 17–1. Notice the two small figures seen as silhouettes at the center of the work. Their importance seems to shrink before the huge tower looming behind them. What is the meaning of the tower and the flags? Like a dream, the painting raises many unanswerable questions. Attempts to answer these questions only adds to the feeling that viewers are experiencing a nightmare from which they cannot awaken.

By the end of the 1920s the Surrealist movement had spread to many countries. One artist who seemed comfortable with the movement was the Spanish painter Joan Miró (**zhoo**-ahn mee-**roh**). Miró created fantasy worlds that were free not only of rhyme and reason but also of realism. In the work in Figure 17–2 he brings the viewer face-to-face with a scene depicting strange, imaginary creatures.

Several women artists were also active in the Surrealist movement. One American painter, Kay Sage, created pictures like the one in the Chapter Opener, showing a silent deserted world bathed in a cool, mysterious light. Strange architectural forms are scattered about, but there are no clues to tell us how large these forms are, what purpose they serve, or who built them. One wonders how long they have been here—and then comes the question that arouses anxiety, even fear: Where is *here?*

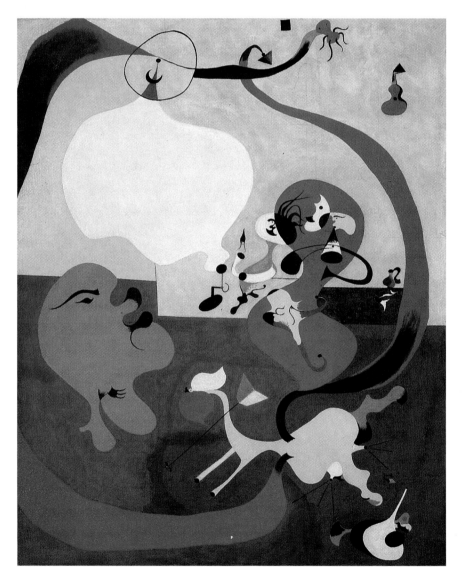

◄ **Figure 17–2 How do the foreground shapes differ from the background? Can you find any shapes that look like people, animals, or musical instruments? What aesthetic views would you use when judging this painting?**

Joan Miró. *Dutch Interior II.* 1928. Oil on canvas. 92 x 73 cm (36¼ x 28¾"). Solomon R. Guggenheim Museum, New York. Photograph by David Heald, © The Solomon R. Guggenheim Foundation.

Fantasy and humor are key ingredients also in the art of Swiss-born Paul Klee (**klay**). Though not a Surrealist, Klee based his work on images glimpsed through his mind's eye. Most, like his picture of a tightrope walker (Figure 17–3), are like simple, childlike creations. Notice how the walker makes his way boldly across a wire supported by a flimsy network of thin lines. These lines look as though they will collapse at any second. What statement might the artist be making about people who foolishly enter situations without weighing the consequences?

▲ **Figure 17–3** **What has the artist done to add a sense of harmony? Can you point to places where variety is used? What property of this work is most important — its realism, its design, or its meaning?**

Paul Klee. *Tightrope Walker.* 1923. Color lithograph. 43.1 x 26.7 cm (17 x 10½"). McNay Art Museum, San Antonio, Texas.

SCULPTURE

Over the last 40 years sculptors have also explored new areas of self-expression. Some have continued to create recognizable images. Others have taken the path toward non-objective art.

The works of Marino Marini (muh-**reen**-oh muh-**reen**-ee), an Italian sculptor, draw on a single haunting image. That image — peasants fleeing their villages on horseback during bombing raids — was one the artist witnessed during World War II. Sculptures like the one in Figure 17–4 are attempts to capture the suffering of civilians during wartime.

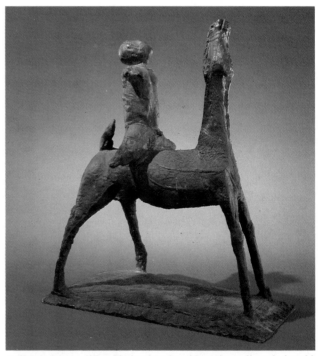

▲ **Figure 17–4** **What kinds of real and imaginary lines help add a feeling of tension? Is this a successful work of art?**

Marino Marini. *Horse and Rider.* 1951. Bronze. 55.7 x 31.1 x 43.5 cm (21⅞ x 12¼ x 17⅛"). Hirshhorn Museum and Sculpture Garden, Smithsonian Institution, Washington, D.C. Gift of the Lily Harmon Foundation. © 1998 Estate of Marino Marini/Licensed by VAGA, New York, NY

An artist best known for her non-objective creations was English sculptor Barbara Hepworth. A trademark of her work is the use of holes. As in the work in Figure 17–5, these create centers of interest within gently curving forms.

▲ **Figure 17–5** Notice the smooth texture of the alabaster. Would you be tempted to run your hands over the surface of the work?

Barbara Hepworth. *Merryn.* 1962. Alabaster. 33 x 29 x 20 cm (13 x 11½ x 8¼"). National Museum of Women in the Arts. Washington, D.C. Gift of Wallace and Wilhelmina Holladay.

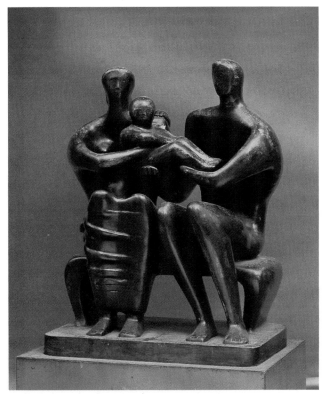

▲ **Figure 17–6** Notice how the sculptor gave the family members a feeling of unity. How did he provide variety?

Henry Moore. *Family Group.* 1948–49. Cast 1950. Bronze. 150.5 x 118.1, base 114.3 x 75.9 cm (59¼ x 46½, base 45 x 29⅞"). Museum of Modern Art, New York, New York. A Conger Goodyear Fund.

STUDIO ACTIVITY

Capturing a Surrealist Scene

Using your imagination, picture a scene you might expect to find in a dream or nightmare. In your sketchbook, list objects you imagine. Do not include people. Using pencil, draw the scene as a Surrealist might. Try to capture the feeling of confusion the image stirs up in you. Reproduce your sketch onto another sheet of paper and use crayon or chalk to color your picture. Make sure you choose hues that help emphasize the fear or other emotion you are trying to express.

P O R T F O L I O

Exchange paintings with a classmate for peer evaluation. Use the steps of art criticism for peer assessment. Include the peer evaluation, any responses you have for your self-reflection, and your art work in your portfolio.

Another sculptor, Henry Moore, created both non-objective works and works that were sometimes nearer to realism. The close relationship of family members is expressed in Figure 17–6. Moore stylized the figures and yet clearly defined them as mother, father, and child. The figures of the parents are linked by the child, the touching knees, and the husband's hand on his wife's shoulder, providing a unified whole.

✔ CHECK YOUR UNDERSTANDING

1. What did the Dadaists believe? How did they usually give expression to this belief?
2. What is Surrealism? What artist's works initiated the movement? Name another Surrealist.
3. For what kinds of works is Paul Klee best known?
4. What image turns up again and again in the works of Marino Marini?
5. What is the trademark of sculptor Barbara Hepworth?

Painting in the Surrealist Style

Another artist who painted in the Surrealist style was Belgian painter René Magritte (ren-**ay** muh-**greet**). Magritte was a painter of riddles. In his pictures, familiar objects turn up together in unusual relationships or strange settings. Look at the work in Figure 17–7. At first glance this appears to be little more than a realistic painting of an ordinary looking room with a fireplace suggesting stillness and peace. The clock on the mantle notes the slow, regular passing of time. But bursting out of the wall is a steaming locomotive! This is an image of speed, energy and noise that disturbs the peacefulness of the room. What does it mean? Perhaps the only purpose here is to create surprise. We are shocked to see ordinary objects put together in ways that make no sense at all.

WHAT YOU WILL LEARN

You will draw and paint a work in the Surrealist style. You will combine familiar objects in strange, surprising ways. Objects will be painted realistically with a variety of hues, values, and intensities. (See Figure 17–8.)

WHAT YOU WILL NEED

- Pencil and sheets of sketch paper
- Sheet of white drawing paper, 10 x 12 inches (25 x 30 cm)
- Tempera paint
- Assorted brushes
- Mixing tray

▲ **Figure 17–7** How does Magritte's dream world differ from de Chirico's (see Figure 17–1)? Does the realistic painting style add to or take away from the idea the work communicates?

René Magritte. *Time Transfixed.* 1938. Oil on canvas. 147 x 98.7 cm (58 x 39"). The Art Institute of Chicago, Chicago, Illinois. Joseph Winterbotham Collection.

WHAT YOU WILL DO

1. Pick a common object to be featured in your picture. Using your imagination, sketch this object in a setting that makes little or no sense. You might, for instance, feature a thumbtack as tall as a house. You might choose to draw a bed on which eggs are frying. Make your image as offbeat and surprising as you can.
2. Carefully transfer your best sketch to the sheet of drawing paper. Make your finished drawing as realistic as possible. Using tempera, paint your work. Add details. Mix and blend hues, values, and intensities of color to make your objects lifelike.
4. Give your work a title unrelated to the objects in it. Write this title on the back of the picture.
5. Exchange paintings with a classmate. Write a brief explanation of the painting you receive. Your explanation, like the painting itself, can be offbeat.
6. Display your work along with its explanation. Compare it with those done by other students. Which were most surprising? What qualities in them caused you to react this way?

EXAMINING YOUR WORK

- **Describe** Identify the objects in your picture. Explain what steps you took to make these objects appear lifelike.
- **Analyze** Point to the variety of hues, values, and intensities in your work. Identify any other elements and principles you used to make objects more real-looking.
- **Interpret** Explain what steps you took to surprise and shock viewers.
- **Judge** Tell whether you feel your work succeeds. State what aesthetic view you feel would be best for judging your work.

▲ **Figure 17–8 Student work. Surrealist painting.**

Try This! COMPUTER OPTION 🖥

■ Scan into your computer program pictures of two dissimilar objects. Use the Resizing tool or menu to change the objects to create an unexpected size relationship. Use other tools available to add shadows, background, and details to make the images look real. Title, save, and print your work. Images can be scanned into the computer using a digital, analog, or *Quick-cam* camera, or a hand-held or flatbed scanner.

American Art Today

In the late 1800s the United States was recognized as a global power. It began slowly but surely to emerge as a world leader in art. By 1950 the change was complete. New York replaced Paris as the center of painting and sculpture.

Art since that time has been rocked by one new style after another. Countless new materials and techniques have been tried as artists attempt to solve an age-old problem. That problem is how best to speak to viewers through the language of art. In this lesson you will look at some solutions.

ABSTRACT EXPRESSIONISM

The first new form of expression was a bold style that was influenced by several past styles. Its name is **Abstract Expressionism**. In this art style, *paint was dribbled, spilled, or splashed onto huge canvases to express painting as an action*. Abstract Expressionist artists rejected the use of subject matter in their work. They dripped, spilled, and splashed rich colors on canvas to create their paintings. The *act* of painting was so tied to their work that the Abstract Expressionists became labeled "action painters."

One of the first members of the Abstract Expressionist movement was an Armenian-born artist named Arshile Gorky (**ar**-shuhl **gor**-kee). Gorky's early works show strong traces of Surrealism. By the mid-1940s, however, he was showing real objects as doodle-like lines and shapes in his paintings. Figure 17–9 shows a painting completed a year before his death. To appreciate such works demands that viewers open themselves to the artist's one-of-a-kind blending of colors, shapes, and lines.

▲ **Figure 17–9** Does a viewer need to see things in a painting to enjoy it? Can a painting be enjoyed for the beauty of the visual elements?

Arshile Gorky. *Golden Brown.* c. 1943–44. Oil on canvas. 110.8 x 141.3 cm (43⅝ x 55⅝"). Washington University Gallery of Art, St. Louis, Missouri. University Purchase, Bixby Fund, 1953.

▲ **Figure 17–10** What is the positive shape in this work? What is the negative shape?

Ellsworth Kelly. *Red/White.* 1964. Oil on canvas. 95.3 x 91.4 cm (37½ x 36"). Courtesy Blum Helman Gallery, New York, New York.

Equally dazzling in their use of color are the paintings of Helen Frankenthaler (**frank-uhn-tahl-uhr**), another Abstract Expressionist. Frankenthaler's action paintings often begin on the floor of her studio. Standing above a blank canvas, the artist pours on layer after layer of thinned color. With each new addition, the work grows. Study the painting by Frankenthaler in Figure 2–5 on page **20**. Like most works by the artist, edges of shapes are sometimes sharp, sometimes blurred. Find the flamelike shape at the center. Notice how it appears to be spreading outward to other parts of the canvas.

OTHER DIRECTIONS IN PAINTING

It was not long after Abstract Expressionism appeared on the scene that other artists began challenging it. The style, they argued, was too personal—too much in the mind of the artist. Among the solutions that arose were:

- **Hard-Edge painting**. This was *a style that emphasized clear, crisp-edged shapes*. The work shown in Figure 17–10 is by Hard-Edge painter Ellsworth Kelly. Notice how the square shape of the canvas shows off the simple positive and negative shapes. What would you see first if the colors were reversed?

- **Social protest painting**. Emerging in the 1930s, this was *an art style that attacked the ills of big-city life*. It remained alive through the 1960s in the works of Jacob Lawrence, a black artist. Study the painting by Lawrence in Figure 17–11. Like the artist's other works, this one tells a story. What words would you use to describe the story?

- **New Realism**. Not all artists of the past few decades have been content to use non-objective styles. Some formed a movement called **New Realism**, *an art movement that rediscovered the importance of realistic detail*. Figure 17–12 shows a work by Andrew Wyeth, who has been a realist throughout his long career. The painting, you will notice, offers more than just a photographic record of its subject. It gives a glimpse of the kind of person the man is. Notice that he is turned away from the viewer. In this way he cannot see the pity in our eyes. Alone in his empty room he stubbornly guards the possessions left to him—his pride and dignity.

◀ **Figure 17–11** This is an example of social protest painting. What symbols did the artist use to convey his ideas?

Jacob Lawrence. *Toussaint L'Overture Series*. 1938. Tempera on paper. 46.4 x 61.6 cm (18¼ x 24¼"). Fisk University.

▲ **Figure 17–12 Notice how the man in the picture is turned away from the viewer. What reason might the artist have had for positioning him this way?**

Andrew Wyeth. *That Gentleman.* 1960. Tempera on panel. 59.7 x 45.1 cm (23½ x 17¾"). Dallas Museum of Art, Dallas, Texas.

SCULPTURE

Painters have not been alone in the search for new methods of self-expression. Sculptors, too, have experimented with new styles. One of them, Alexander Calder, was able to number among his contributions the invention of a new term. That term, **mobile** (**moh**-beel), was used to describe a *sculpture made of carefully balanced shapes hung on wires.* Most of Calder's mobiles, like the one in Figure 17–13, are non-objective. Imagine this moving sculpture as it might appear as you stand near it. Try to picture the ever-changing patterns created by the bobbing and twisting of the shapes. What images do you think might come to mind?

A different approach to non-objective sculpture is found in the three-dimensional collages of Louise Nevelson (**nev**-uhl-suhn). Her works, one of which appears in Figure 17–14, were assembled from found objects and wood scraps. Viewers often experience these sculptures as at once familiar and foreign. The wood scraps in Figure 17–14 are easily identified. They are combined in such a way, however, that they create something

entirely new and different. Are they gates or doors? If so, what kind of fascinating world lies beyond?

Just as some painters of recent times have made realism their goal, so have some sculptors. One is artist Duane Hanson. Hanson's sculptures are so lifelike they are often mistaken for real people. Imagine yourself

▲ **Figure 17–13 What shape is emphasized in this mobile? How is this emphasis achieved? Is pattern an important principle? How is pattern shown?**

Alexander Calder. *Zarabanda* (Un Disco Blanco). 1955. Painted sheet metal, metal rods and wire. 106.6 x 166.1 cm (42 x 65⅜"). Hirshhorn Museum and Sculpture Garden, Smithsonian Institution, Washington, D.C. Gift of Joseph H. Hirshhorn.

▲ Figure 17–14 What would happen if this sculpture were painted in several different colors? Would it be as successful? Why or why not?

Louise Nevelson. *Mrs. N's Palace.* 1971. Painted wood, mirror. 355.6 x 607 x 457.2 cm (140 x 239 x 180"). The Metropolitan Museum of Art, New York, New York. Gift of the artist.

▲ Figure 17–15 The people in this work are types you might pass on the street or at a shopping mall. Why do you think the artist has chosen to freeze these types in time? What are we able to learn about them? What can we learn about ourselves?

Duane Hanson. *Tourists.* 1970. Polyester and fiberglass. Lifesize. OK Harris Works of Art, New York, New York.

STUDIO ACTIVITY

Creating an Action Painting

Experiment with your own action painting using watercolor paints and cotton swabs. Moisten a cotton swab with water and a single hue of color. Rub the swab across a large sheet of paper to make varied paint strokes. Use a fresh cotton swab and choose another hue. Put feeling and expression into your work by including drips and dabs of color.

Use this technique to complete several works, each expressing a different feeling. Display your finished works along with those of classmates.

P O R T F O L I O

For your portfolio, write a detailed description of the techniques you used in your experiments. Tell which results you thought were most successful and why. Include your written summary with your finished works in your portfolio.

standing before Hanson's sculpture of tourists in Figure 17–15. Typical of his work, these people are average-looking and wear everyday clothing. What reaction do you suppose the artist wants viewers to have? What message about life in present-day America might he be sending?

✔ CHECK YOUR UNDERSTANDING

1. What is Abstract Expressionism? Name two members of the movement.
2. Besides Abstract Expressionism, name three directions painting has taken in the last 40 years. Define each school.
3. What term did Alexander Calder invent? Describe the kinds of sculptures he created.
4. Which of the artists you learned about in this lesson created three-dimensional collages?

Making a Hard-Edge Op Art Work

The painting in Figure 17–16, by artist Gene Davis, is typical of another movement of the second half of the twentieth century. The movement's name is **Op Art**. Artists working in this style *made use of precise lines and shapes to create optical illusion.* Stare at Davis' painting for a moment. Notice how the vertical lines in the picture appear to vibrate with color.

Compare this work with the Hard-Edge painting on page **264**. Imagine the artists of the two had decided to combine their styles in a single painting. What would it look like?

WHAT YOU WILL LEARN

Using India ink, you will create a pattern of black and white values. You will create this design over another made up of simple positive and negative shapes. The finished work—a blend of Op Art and Hard-Edge styles—will give a feeling of dizzying movement. (See Figure 17–17.)

WHAT YOU WILL NEED

- Pencil, sheets of sketch paper, and ruler
- Piece of illustration board, 12 x 12 inches (30 x 30 cm)
- India ink
- Pen holder and assorted points, or nibs

▶ **Figure 17–16 How does the artist add variety to this composition? Where are the most intense colors found? When you stare at it, does this picture seem to vibrate?**

Gene Davis. *Cool Buzz Saw.* 1964. Acrylic on canvas. 189.9 x 291.1 cm (113¾ x 115″). San Francisco Museum of Modern Art, San Francisco, California. Gift of the Women's Board.

WHAT YOU WILL DO

1. Look once again at the Hard-Edge painting by Kelly on page **264**. Draw several pencil sketches of a single Hard-Edge shape. The negative and positive shapes on your paper should be equally interesting.
2. Pick your best sketch. Using pencil and ruler, draw it on the piece of illustration board.
3. Study the Op Art painting by Gene Davis in Figure 17–16. Again working with ruler and pencil, cover the illustration board with closely spaced vertical lines. The spaces between the lines need not be exact. No two lines, however, should be more than a half inch apart.
4. With a pen and India ink, fill in the shape at the top left corner of your design. Be careful to stay within the lines. Working downward, leave the next shape white. Ink in every other shape until you reach the bottom of the illustration board. Repeat the process for the next vertical strip, this time leaving the topmost shape white. Continue in this fashion until all the strips have been completed.
5. Display your work alongside those of classmates. Which have the most interesting Hard-Edge designs? Which give the same kind of vibrating effect found in Figure 17–16?

EXAMINING YOUR WORK

- **Describe** Point out the positive and negative shapes in your work.
- **Analyze** Explain how the pattern of dark and light values causes the picture to seem to vibrate.
- **Interpret** Tell whether your work gives a dizzying feeling.
- **Judge** Tell whether you feel your work succeeds. State which aesthetic view you would use in explaining your judgment.

▲ **Figure 17–17 Student work. Hard-Edge Op Art.**

Try This! COMPUTER OPTION

▨ Flood-fill page with a light color. Choose a darker, complementary color and a wide Brush or Straight Line tool. Draw parallel horizontal, diagonal, or vertical lines to create stripes from side to side on the page. Use a variety of Selection tool shapes to select round or rectangular areas. Flip, Turn, or Rotate selections so lines within the shape move in a different direction from the background stripes. Title, save, and print your work. Try another option: Begin with a variety of parallel line colors and follow the steps. Compare. Is the effect as dramatic as using two contrasting colors?

Art of the Next Frontier

Artists have never been content to stay in one place for long. They are a restless breed, forever moving on, thirsting after new challenges. As we enter the twenty-first century, questions arise: What challenges will open themselves to the artists of tomorrow? What will art be like in the new century?

Answering these questions would take a crystal ball. Still, possible glimpses of the art of tomorrow are afforded by innovative developments in the art of today. In this lesson you will look at some of these developments.

ART AND TECHNOLOGY

If there is one word most closely identified with art of today, it is *technology*. Technology is the use of science to make life better. Art of the past few years has drawn on such technological advances as the computer and laser. It has also redefined the boundaries between one branch of art and the next.

Staged Photography

In the late 1800s the new art of photography changed the way painters looked at their subjects. In more recent times another new art—filmmaking—has had the same effect on photographers. Some have begun staging pictures in much the way movie directors set up a scene.

Figure 17–18 shows a staged photograph by artist Sandy Skoglund (**skoh**-gluhnd). For this work the artist sculpted each of the goldfish individually from clay. She also painted the room and directed the location of the two people. What twentieth-century style of painting does this work call to mind? What message might the photographer be sending to viewers?

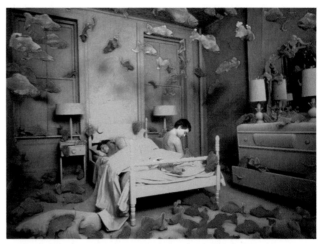

▲ **Figure 17–18** How would you describe the artist's use of color? Would this work have a different appearance if it had been shot in black and white?

Sandy Skoglund. *Revenge of the Goldfish.* 1981. Staged Photograph. Lorence Monk Gallery. New York, New York.

Multi-Media Art

The ancient Hindus, you may recall, believed temples to be as much sculpture as architecture. This idea has been carried forward in recent years by artists of multi-media works. **Multi-media art** is *a work that makes use of tools and techniques from two or more areas of art.*

A careful merging of architecture and sculpture is found in the expressions of sculptor Judy Pfaff (**faf**). Study the multi-media work by her in Figure 17–19. Parts of the work are the floor of the room, walls, and ceiling themselves. The viewer is able to move not only around this sculpture but also *within* it.

Kinetic Art

Examine the "sculpture" in Figure 17–20 by Nam June Paik. This work loosely belongs to a movement begun in the 1960s called **kinetic** (kuh-**net**-ik) **art**. This is *a style in which parts of works are set into motion.* The motion can be triggered by a form of energy or by

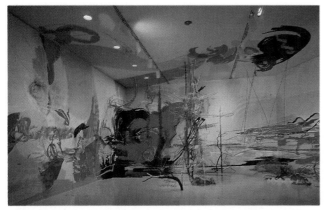

▲ **Figure 17–19** In what ways has the artist created a "real" landscape? What other branches of art besides sculpture and architecture are brought into play in this multi-media work?

Judy Pfaff. *Kabuki (Formula Atlantic)*. 1981. Mixed media. Hirshhorn Museum and Sculpture Garden, Smithsonian Institution, Washington, D.C.

the viewer moving past the work. Some art gives the impression of movement without actually moving. The work in Figure 17–20 is made up in part of 300 television screens. The viewer experiences a number of different images and sounds all at the same time. What do you imagine this experience would be like? What statement might the artist be making about the age of television?

STUDIO ACTIVITY

A Futuristic Dwelling

Art, it has been said, mirrors the time in which it is created. This holds especially true for the branch of art called architecture.

On a sheet of paper, make a pencil drawing of a dream dwelling of the future. Provide solutions to such growing problems as pollution and thinning of the ozone layer. Share your finished work with classmates. Which design is the most interesting? Why?

PORTFOLIO

Provide information for art historians of the future. Include this information with your drawing in your portfolio.

✔ CHECK YOUR UNDERSTANDING

1. What is technology? What part has technology played in art of the present?
2. What is a staged photograph?
3. Define *multi-media art*.
4. To what two art movements does the painting in 17–16 belong?

▲ **Figure 17–20** A computer is used to "flip" and enlarge images on the different screens in this work. How many different images can you count? In what way is being bombarded by all these images at once similar to a typical day in our lives?

Nam June Paik. *Fin de Siècle II*. 1989. Video installation: Approximately 300 television sets. Originally shown at the Whitney Museum of American Art, New York, New York.

Patrick Boyd. *Hato no Naka no Neko (Cat Among the Pigeons)*. 20.3 x 25.4 cm (8 x 10"). Photo-montage stereogram on glass, with life-size display stand. Holos Gallery, San Francisco, California.

What Do You See in a Hologram?

A hologram is a three-dimensional record of an image made with laser light. Holograms look so real that the viewer has the sensation of being able to reach out and touch the image.

Holography is similar to photography. Precision optical instruments are used to expose special photo-sensitive materials to laser light. Although a hologram is a "flat" picture, when a beam of light strikes it at the proper angle, a three-dimensional image will appear. The hologram displays an image that can be viewed from many different angles and depths, just like solid objects in the real world.

Holograms have many uses in science and engineering, especially when combined with computer graphics. Medical scientists can record three-dimensional views of living cells. Pilots can use holographic instruments to land planes in bad weather. Holograms even appear on credit cards to prevent forgery.

Artists can create new art forms using holographic imaging. In *Cat Among the Pigeons*, Patrick Boyd has produced a kind of hologram, called a stereogram, on a glass plate. The technique makes you feel as though you could reach right into the picture.

MAKING THE CONNECTION

- In the hologram shown here, what makes the images appear to be floating in mid-air? What makes them look like sculptures?
- How are holograms used in science and in everyday life? Where have you seen holograms used?
- Laser light is different from ordinary light. Find out more about laser technology and its benefits.

INTERNET ACTIVITY

Visit Glencoe's Fine Arts Web Site for students at:

http://www.glencoe.com/sec/art/students

CHAPTER 17
REVIEW

BUILDING VOCABULARY

Number a sheet of paper from 1 to 10. After each number, write the term from the list that best matches each description below.

Abstract Expressionism
Dada
Hard-Edge painting
kinetic art
mobile
multi-media art
New Realism
Op Art
social protest painting
Surrealism

1. An art movement founded on the belief that Western culture had lost its meaning.
2. An art movement that probed the subconscious world of dreams.
3. An art style in which paint was dribbled, spilled, or splashed onto huge canvases to express painting as an action.
4. An art style that emphasized clear, crisp-edged shapes.
5. An art style that attacked the ills of big-city life.
6. An art movement that rediscovered the importance of realistic detail.
7. A style made of carefully balanced shapes hung on wires.
8. An art style that made use of precise lines and shapes to create optical illusion.
9. A work that makes use of tools and techniques from two or more areas of art.
10. An art style in which parts of works are set into motion by a form of energy.

REVIEWING ART FACTS

Number a sheet of paper from 11 to 18. Answer each question in a complete sentence.

11. Name an artist of the Dada movement.
12. Describe the works of Paul Klee.
13. What sculptor did works of Italian peasants fleeing a bombing raid?
14. For which type of sculpture was Barbara Hepworth best known?
15. In what art movement was Arshile Gorky a pioneer?
16. What sculptor you learned about created three-dimensional collages?
17. Name an artist who works in the area of staged photography.
18. For what kinds of works is Judy Pfaff known?

THINKING ABOUT ART

On a sheet of paper, answer each question in a sentence or two.

1. **Analyze.** React to the opinion that art must be serious to be good. Find works from the chapter that support your position.
2. **Compare and contrast.** Compare the works in Figure 17–2 and Figure 17–13. Aside from the fact that one is a painting and the other a sculpture, how do they differ? What do they have in common? Would you use the same aesthetic view in judging the two? Explain.

MAKING ART CONNECTIONS

1. **Language Arts.** Choose one of the non-objective works you learned about in this chapter. Make a list of points about this work you would bring up in a debate with someone who claimed a two-year-old could create the same "art."
2. **History.** In this chapter you learned of some art movements that appeared in the late twentieth century. The following are several others: Pop Art, Earth Art, and Conceptual Art. Using an encyclopedia or other library resource, find out the names of artists who worked in the movement, and identify their goals. Report your findings to the class.

▲ Working on group murals is an excellent way to practice
artistic skills, gain recognition, and at the same time, have fun.

HANDBOOK CONTENTS

PART 3: Career Spotlights

PART 4: Additional Studios

DRAWING TIPS

1. Making Gesture Drawings

Gesture drawing is a way of showing movement in a sketch. Gesture drawings have no outlines or details. You are not expected to draw the figure. Instead, you are expected to draw the movement, or what the figure is doing. Follow these guidelines:

- Use the side of the drawing tool. Do not hold the medium as you would if you were writing.
- Find the lines of movement that show the direction in which the figure is bending. Draw the main line showing this movement.
- Use quickly drawn lines to build up the shape of the person.

2. Making Contour Drawings

Contour drawing is a way of capturing the feel of a subject. When doing a contour drawing, remember the following pointers:

- If you accidentally pick up your pen or pencil, don't stop working. Place your pen or pencil back where you stopped. Begin again from that point.
- If you have trouble keeping your eyes off the paper, ask a friend to hold a piece of paper between your eyes and your drawing paper. Another trick is to place your drawing paper inside a large paper bag as you work.
- Tape your paper to the table so it will not slide around. With a finger of your free hand, trace the outline of the object. Record the movement with your drawing hand.

- Contour lines show ridges and wrinkles in addition to outlines. Adding these lines gives roundness to the object.

3. Drawing with Oil Pastels

Oil pastels are sticks of pigment held together with an oily binder. The colors are brighter than wax crayon colors. If you press heavily you will make a brilliant-colored line. If you press lightly you will create a fuzzy line. You can fill in shapes with the brilliant colors. You can blend a variety of color combinations. For example, you can fill a shape with a soft layer of a hue and then color over the hue with a heavy layer of white to create a unique tint of that hue.

If you use oil pastels on colored paper, you can put a layer of white under the layer of hue to block the color of the paper.

4. Drawing Thin Lines with a Brush

Drawing thin lines with a brush can be learned with a little practice. Just follow these steps:

1. Dip your brush in the ink or paint. Wipe the brush slowly against the side, twirling it between your fingers until the bristles form a point.
2. Hold the brush at the beginning of the metal band near the tip. Hold the brush straight up and down.
3. Imagine that the brush is a pencil with a very sharp point. Pretend that pressing too hard will break the point. Now touch the paper lightly with the tip of the brush and draw a line. The line should be quite thin.

To make a thinner line still, lift up on the brush as you draw. After a while, you will be able to make lines in a variety of thicknesses.

5. Making a Grid for Enlarging

Sometimes the need arises to make a bigger version of a small drawing. An example is when you create a mural based on a small sketch. Follow these steps:

1. Using a ruler, draw evenly spaced lines across and up and down your original drawing (Figure T–1). Count

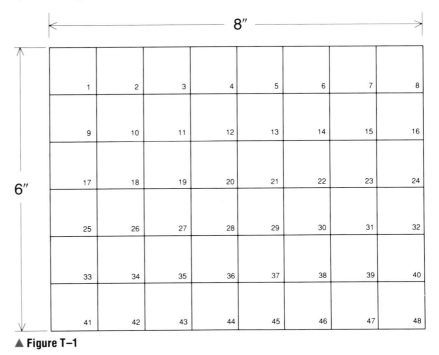

▲ **Figure T–1**

the number of squares you made from side to side. Count the number of squares running up and down.

2. Measure the width of the surface to which the drawing is to be transferred. Divide that figure by the number of side-to-side squares. The resulting number will be the horizontal measure of each square. You may work in inches or centimeters. Using a ruler or yardstick, mark off the squares. Draw in light rules.

3. Measure the height of the surface to which the drawing is to be transferred. Divide that figure by the number of up-and-down squares. The resulting number will be the vertical measure of each square. Mark off the squares. Draw in pencil lines.

4. Starting at the upper left, number each square on the original drawing. Give the

same number to each square on the large grid. Working a square at a time, transfer your image. (See Figure T–2.)

6. Using Shading Techniques

When using shading techniques, keep in mind the following:

- Lines or dots placed close together create dark values.
- Lines or dots placed far apart, on the other hand, create light values. To show a change from light to dark, start with lines or dots far apart and little by little bring them close together.
- Use care also to follow the shape of the object when adding lines. Straight lines are used to shade an object with a flat surface. Rounded lines are used to shade an object with a curved surface.

7. Using Sighting Techniques

Sighting is a technique that will help you draw objects in proportion.

1. Face the object you plan to draw. Hold a pencil straight up and down at arm's length. Your thumb should rest against the side of the pencil and be even with the tip.

2. Close one eye. With your other eye, focus on the object.

3. Slide your thumb down the pencil until the exposed part of the pencil matches the object's height. (See Figure T–3.)

▲ Figure T–3

4. Now, without moving your thumb or bending your arm, turn the pencil sideways.

5. Focus on the width of the object. If the height is greater, figure out how many "widths" will fit in one "height." If the width is greater, figure out how many "heights" will fit in one "width."

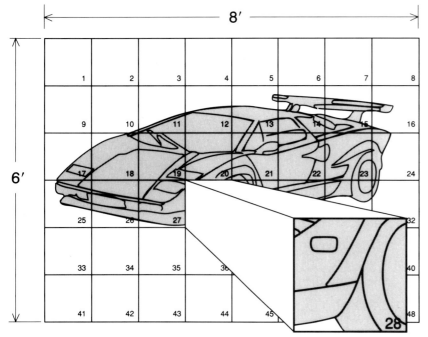

▲ Figure T–2

8. Using a Viewing Frame

Much in the way a camera is used to focus on one area of a scene, you can better zero in on an object you plan to draw by using a viewing frame (Figure T–4). To make a viewing frame do the following:

1. Cut a rectangular hole in a piece of paper about 2 inches (3 to 5 cm) in from the paper's edges.
2. Hold the paper at arm's length and look through the hole at your subject. Imagine that the hole represents your drawing paper.
3. Decide how much of the subject you want to have in your drawing.
4. By moving the frame up, down, sideways, nearer, or farther, you can change the focus of your drawing.

9. Using a Ruler

There are times when you need to draw a crisp, straight line. By using the following techniques, you will be able to do so.

1. Hold the ruler with one hand and the pencil with the other.
2. Place the ruler where you wish to draw a straight line.
3. Hold the ruler with your thumb and first two fingers. Be careful that your fingers do not stick out beyond the edge of the ruler.
4. Press heavily on the ruler so it will not slide while you're drawing.
5. Hold the pencil lightly against the ruler.
6. Pull the pencil quickly and lightly along the edge of the ruler. The object is to keep the ruler from moving while the pencil moves along its edge.

▲ Figure T–4

PAINTING TIPS

10. Cleaning a Paint Brush

Cleaning a paint brush properly helps it last a long time. *Always*:

1. Rinse the thick paint out of the brush under running water. Do not use hot water.
2. Gently paint the brush over a cake of mild soap, or dip it in a mild liquid detergent (Figure T–5).

▲ Figure T–5

TECHNIQUE TIPS

3. Gently scrub the brush against the palm of your hand to work the soap into the brush. This removes paint you may not have realized was still in the brush.

4. Rinse the brush under running water while you continue to scrub your palm against it (Figure T–6).

▲ **Figure T–6**

5. Repeat steps 2, 3, and 4 as needed.

When it is thoroughly rinsed and excess water has been squeezed from the brush, shape your brush into a point with your fingers (Figure T–7). Place the brush in a container with the bristles up so that it will keep its shape as it dries.

▲ **Figure T–7**

11. Making Natural Earth Pigments

Anywhere there is dirt, clay, or sand, there is natural pigment. To create your own pigments, gather as many different kinds of earth colors as you can. Grind these as finely as possible. (If you can, borrow a mortar and pestle.) (See Figure T–8.) Do not worry if the pigment is slightly gritty.

pestle

mortar

▲ **Figure T–8**

To make the binder, mix equal parts of white glue and water. Place a few spoonfuls of your powdered pigment into a small jar. Add a little of the binder. Experiment with different amounts of each.

When you work with natural pigments, remember always to wash the brushes before the paint in them has a chance to dry. The glue from the binder can ruin a brush. As you work, stir the paint every now and then. This will keep the grains of pigment from settling to the bottom of the jar.

Make a fresh batch each time you paint.

12. Mixing Paint to Change the Value of Color

You can better control the colors in your work when you mix your own paint. In mixing paints, treat opaque paints (for example, tempera) differently from transparent paints (for example, watercolors).

- *For light values of opaque paints.* Mix only a small amount of the hue to white. The color can always be made stronger by adding more of the hue.
- *For dark values of opaque paints.* Add a small amount of black to the hue. Never add the hue to black.
- *For light values of transparent paints.* Thin a shaded area with water (Figure T–9). This allows more of the white of the paper to show through.
- *For dark values of transparent paints.* Carefully add a small amount of black to the hue.

▲ **Figure T–9**

280 *Technique Tips*

13. Working with Poster Paints (School Tempera)

When using poster paints (school tempera) remember the following:

- Poster paints run when wet. To keep this from happening, make sure one shape is dry before painting a wet color next to it.

14. Working with Watercolors

- If you apply wet paint to damp paper, you create lines and shapes with soft edges.
- If you apply wet paint to dry paper, you create lines and shapes with sharp, clear edges.
- If you dip a dry brush into damp paint and then brush across dry paper, you achieve a fuzzy effect.
- School watercolors come in semi-moist cakes. Before you use them, place a drop of water on each cake to let the paint soften. Watercolor paints are transparent. You can see the white paper through the paint. If you want a light value of a hue, dilute the paint with a large amount of water. If you want a bright hue, you must dissolve more pigment by swirling your brush around in the cake of paint until you have dissolved a great deal of paint. The paint you apply to the paper can be as bright as the paint in the cake.

15. Making a Stamp Printing

A stamp print is an easy way to make repetitive designs. The following are a few suggestions for making a stamp and printing with it. You may develop some other ideas after reading these hints. Remember, printing reverses your design, so if you use letters, be certain to cut or carve them backwards.

- Cut a simple design into the flat surface of an eraser with a knife that has a fine, precision blade.
- Cut a potato, carrot, or turnip in half. Use a paring knife to carve a design into the flat surface of the vegetable.
- Glue yarn to a bottle cap or a jar lid.
- Glue found objects to a piece of corrugated cardboard. Make a design with paper-clips, washers, nuts, leaves, feathers, or anything else you can find. Whatever object you use should have a fairly flat surface. Make a handle for the block with masking tape.
- Cut shapes out of a piece of inner tube material. Glue the shapes to a piece of heavy cardboard.

There are several ways to apply ink or paint to a stamp:

- Roll water-based printing ink on the stamp with a soft brayer.
- Roll water-based printing ink on a plate and press the stamp into the ink.
- Apply tempera paint or school acrylic to the stamp with a bristle brush.

16. Working with Clay

To make your work with clay go smoothly, always do the following:

1. Dip one or two fingers in water.
2. Spread the moisture from your fingers over your palms.

Never dip your hands in water. Too much moisture turns clay into mud.

17. Joining Clay

If you are creating a piece of sculpture that requires joining pieces, do the following:

1. Gather the materials you will need. These include clay, slip, (a creamy mixture of clay and water), a paint brush, a scoring tool, (perhaps a kitchen fork) and clay tools.
2. Rough up or scratch the two surfaces to be joined (Figure T–10).

▲ **Figure T–10**

3. Apply slip to one of the two surfaces using a paint brush or your fingers (Figure T–11).

▲ **Figure T–11**

4. Gently press the two surfaces together so the slip oozes out of the joining seam (Figure T–12).

▲ **Figure T–12**

5. Using clay tools and/or your fingers, smooth away the slip that has oozed out of the seam (Figure T–13). You may wish to smooth out the seam as well, or you may wish to leave it for decorative purposes.

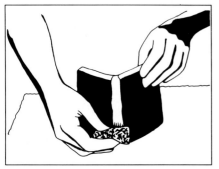

▲ **Figure T–13**

18. Making a Clay Mold for a Plaster Relief

One of the easiest ways to make a plaster relief is with a clay mold. When making a clay mold, remember the following:

- Plaster poured into the mold will come out with the opposite image. Design details cut into the mold will appear raised on the relief. Details built up within the mold will appear indented in the relief.
- Do not make impressions in your mold that have *undercuts* (Figure T–14). Undercuts trap plaster, which will break off when the relief is removed. When cutting impressions, keep the deepest parts the narrowest.
- In carving a raised area in the mold, take care not to create a reverse undercut (Figure T–15).

If you want to change the mold simply smooth the area with your fingers.

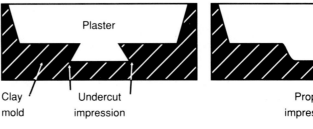

▲ **Figure T–14**

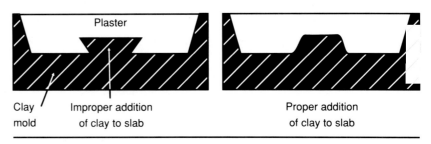

▲ **Figure T–15**

19. Mixing Plaster

Mixing plaster requires some technique and a certain amount of caution. It can also be a very simple matter when you are prepared. Always do the following:

- Use caution when working with dry plaster. Wear a dust mask or work in a well-ventilated room.
- Cover your work space to keep the dust from spreading.
- Always use a plastic bowl and a stick for mixing. Never use silverware you will later eat from.
- Always use plaster that is fine, like sifted flour. Plaster should never be grainy when dry.
- Always add the water to the bowl first. Sift in the plaster. Stir slowly.
- Never pour unused plaster down a drain. Allow it to dry in the bowl. To remove the dried plaster, twist the bowl. Crack the loose plaster into a lined trash can.

20. Working with Papier-Mâché

Papier-mâché (**pay**-puhr muh-**shay**) is a French term meaning "chewed paper." It is also the name of several sculpting methods using newspaper and liquid paste. These methods can be used to model tiny pieces of jewelry. They can also be used to create life-size creatures.

In creating papier-mâché sculptures, the paper-and-paste mixture is molded over a support. You will learn more about supports shortly. The molded newspaper dries to a hard finish. The following are three methods for working with papier-mâché:

- **Pulp Method.** Shred newspaper, paper towels, or tissue paper into tiny pieces. (Do not use glossy magazine paper; it will not soften.) Soak your paper in water overnight. Press the paper in a kitchen strainer to remove as much moisture as possible. Mix the mashed paper with commercially prepared papier-mâché paste or white glue. The mixture should have the consistency of soft clay. Add a few drops of oil of cloves to keep the mixture from spoiling. A spoonful of linseed oil makes the mixture smoother. (If needed, the mixture can be stored at this point in a plastic bag in the refrigerator.) Use the mixture to model small shapes. When your creations dry, they can be sanded. You will also be able to drill holes in them.
- **Strip Method.** Tear newspaper into strips. Either dip the strips in papier-mâché paste or rub paste on them. Apply the strips to your support (Figure T–16). If you do not want the strips to stick to your

▲ **Figure T–16**

support, first cover it with plastic wrap. Use wide strips for large shapes. Use thin strips for smaller shapes. If you plan to remove your finished creation from the support, apply five or six layers. (Change directions with each layer so you can keep track of the number.) Otherwise, two or three layers should be enough. After applying the strips to your support, rub your fingers over the surface.

As a last layer, use torn paper towels. The brown paper towels that are found in schools produce an uncomplicated surface on which to paint. Make sure no rough edges are sticking up. Store any unused paste mixture in the refrigerator to keep it from spoiling.

- **Draping Method.** Spread papier-mâché paste on newspaper. Lay a second sheet on top of the first. Smooth the layers. Add another layer of paste and another sheet of paper. Repeat until you have four or five layers of paper. Use this method for making drapery on a figure. (See Figure T–17.) If you allow the lay-

▲ **Figure T–17**

ers to dry for a day or two, they will become leathery. They can then be cut and molded as you like. Newspaper strips dipped in paste can be used to seal cracks.

Like papier-mâché, supports for papier-mâché creations can be made in several different ways. Dry newspaper may be wadded up and wrapped with string or tape (Figure T–18). Wire coat hangers may be padded with rags. For large figures, a wooden frame covered with chicken wire makes a good support.

▲ **Figure T–18**

▲ **Figure T–19**

To create a base for your papier-mâché creations, tape together arrangements of found materials. Some materials you might combine are boxes, tubes, and bowls. (See Figure T–19.) Clay can also be modeled as a base. If clay is used, be sure there are no undercuts that would keep the papier-mâché from lifting off easily when dry. (For an explanation of undercuts, see Technique Tip **18**, *Handbook* page **276**.)

Always allow time for your papier-mâché creations to dry. The material needs extra drying time when thick layers are used or when the weather is damp. An electric fan blowing air on the material can shorten the drying time.

21. Making a Paper Sculpture

Another name for paper sculpture is origami. The process originated in Japan and means "folding paper." Paper sculpture begins with a flat piece of paper. The paper is then curved or bent to produce more than a flat

surface. Here are some ways to experiment with paper.

- **Scoring.** Place a square sheet of heavy construction paper, 12 x 12 inch (30 x 30 cm), on a flat surface. Position the ruler on the paper so that it is close to the center and parallel to the sides. Holding the ruler in place, run the point of a knife or a pair of scissors along one of the ruler's edges. Press down firmly but take care not to cut through the paper. Gently crease the paper along the line you made. Hold your paper with the crease facing upward.

- **Pleating.** Take a piece of paper and fold it one inch from the edge. Then fold the paper in the other direction. Continue folding back and forth.

- **Curling.** Hold one end of a long strip of paper with the thumb and forefinger of one hand. At a point right below where you are holding the strip, grip it lightly between the side of a pencil and the thumb of your other hand. In a quick motion, run the pencil along the strip. This will cause the strip to curl back on itself. Don't apply too much pressure, or the strip will tear. (See Figure T–20.)

▲ **Figure T–20**

22. Measuring Rectangles

Do you find it hard to create perfectly formed rectangles? Here is a way of getting the job done:

1. Make a light pencil dot near the long edge of a sheet of paper. With a ruler, measure the exact distance between the dot and the edge. Make three more dots the same distance in from the edge. (See Figure T–21.)

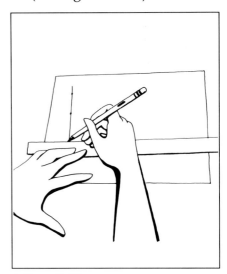

▲ **Figure T–21**

2. Line a ruler up along the dots. Make a light pencil line running the length of the paper.
3. Turn the paper so that a short side is facing you. Make four pencil dots equally distant from the short edge. Connect these with a light pencil rule. Stop when you reach the first line you drew. (See Figure T–22.)
4. Do the same for the remaining two sides. Erase any lines that may extend beyond the box you have made.
5. Trace over the lines with your ruler and pencil.

The box you have created will be a perfectly formed rectangle.

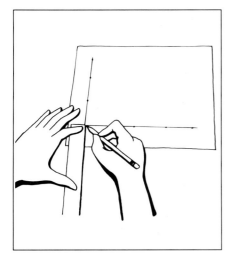

▲ Figure T–22

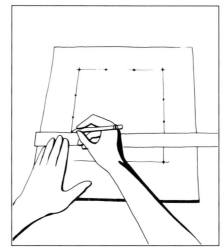

▲ Figure T–23

23. Making a Mat

You can add appeal to an art work by making a mat, using the following steps.

1. Gather the materials you will need. These include a metal rule, a pencil, mat board, cardboard backing, a sheet of heavy cardboard to protect your work surface, a mat knife with a sharp blade, and wide masking tape.
2. Wash your hands. Mat board should be kept very clean.
3. Measure the height and width of the work to be matted. Decide how large a border you want for your work. (A border of approximately 2½ inches on three sides with 3 inches on the bottom is aesthetically pleasing.) Your work will be behind the window you will cut.
4. Plan for the opening, or window, to be ¼ inch smaller on all sides than the size of your work. For example, if your work measures 9 by 12 inches, the mat window should measure 8½ inches (9 inches minus ¼ inch times two) by 11½ inches (12 inches minus ¼ inch times two). Using your metal rule and pencil, lightly draw your

window rectangle on the back of the board 2½ inches from the top and left edge of the mat. (See Figure T–23.) Add a 2½ inch border to the right of the window and a 3 inch border to the bottom, lightly drawing cutting guidelines.

Note: If you are working with metric measurements, the window should overlap your work by 0.5 cm (centimeters) on all sides. Therefore, if your work measures 24 by 30 cm, the mat window measures 23 cm (24 − [2 x 0.5]) by 29 cm (30 − [2 x 0.5]).

▲ Figure T–24

5. Place the sheet of heavy, protective cardboard on your work surface. Place the mat board, pencil marks up, over the cardboard. Holding the metal rule firmly in place, score the first line with your knife. Always place the metal rule so that your blade is away from the frame. (See Figure T–24.) In case you make an error you will cut into the window hole or the extra mat that is not used for the frame. Do not try to cut through the board with one stroke. By the third or fourth stroke, you should be able to cut through the board easily.
6. Working in the same fashion, score and cut through the board along all the window lines. Be careful not to go beyond the lines. Remove the window.
7. Cut a cardboard backing for your art work that is slightly smaller than the overall size of your mat. Using a piece of broad masking tape, hinge the back of the mat to the backing. (See Figure T–25.)

▲ Figure T–25

TECHNIQUE TIPS

Position your art work between the backing and the mat and attach it with tape. Anchor the frame to the cardboard with a few pieces of rolled tape.

24. Mounting a Two-Dimensional Work

Mounting pictures that you make gives them a professional look. To mount a work, do the following:

1. Gather the materials you will need. These include a yardstick, a pencil, poster board, a sheet of heavy cardboard, a knife with a very sharp blade, a sheet of newspaper, and rubber cement.

2. Measure the height and width of the work to be mounted. Decide how large a border you want around the work. Plan your mount size using the work's measurements. To end up with a 3-inch (8 cm) border, for example, make your mount 6 inches (15 cm) wider and higher than your work. Record the measurements for your mount.

3. Using your yardstick and pencil, lightly draw your mount rectangle on the back of the poster board. Measure from the edges of the poster board. If you have a large paper cutter available, you may use it to cut your mount.

4. Place the sheet of heavy cardboard on your work surface. Place the poster board, pencil marks up, over the cardboard. Holding the yardstick firmly in place along one line, score the line with your knife. Do not try to cut through the board with one stroke. By the third try, you should be able to cut through the board.

▲ Figure T–26

5. Place the art work on the mount. Using the yardstick, center the work. Mark each corner with a dot. (See Figure T–26.)

6. Place the art work, face down, on a sheet of newspaper. Coat the back of the work with rubber cement. (*Safety Note:* Always use rubber cement in a room with plenty of ventilation.) *If your mount is to be permanent, skip to Step 8.*

7. Line up the corners of your work with the dots on the mounting board. Smooth the work into place. *Skip to Step 9.*

8. After coating the back of your art work, coat the poster board with rubber cement. Be careful not to add cement to the border area. Have a partner hold your art work in the air by the two top corners. Once the two glued surfaces meet, you will not be able to change the position of the work. Grasp the lower two corners. Carefully lower the work to the mounting board. Line up the two corners with the bottom dots. Little by little, lower the work into place (Figure T–27). Press it smooth.

▲ Figure T–27

9. To remove any excess cement, create a small ball of nearly dry rubber cement. Use the ball of rubber cement to pick up excess cement.

25. Making Rubbings

Rubbings make interesting textures and designs. They may also be used with other media to create mixed-media art. To make a rubbing, place a sheet of thin paper on top of the surface to be rubbed. Hold the paper in place with one hand. With the other hand, rub the paper with the flat side of an unwrapped crayon. Always rub away from the hand holding the paper. Never rub back and forth, since this may cause the paper to slip.

26. Scoring Paper

The secret to creating neat, sharp folds in cardboard or paper is a technique called scoring. Here is how it is done:

1. Line up a ruler along the line you want to fold.

2. Lightly run a sharp knife or scissors along the fold line. Press down firmly enough to leave a light crease. Take care not to cut all the way through the paper (Figure T–28).

▲ **Figure T–28**

3. Gently crease the paper along the line you made. To score curved lines, use the same technique. Make sure your curves are wide enough to ensure a clean fold. Too tight a curve will cause the paper to wrinkle (Figure T–29).

▲ **Figure T–29**

27. Making a Tissue Paper Collage

For your first experience with tissue, make a free design with the tissue colors. Start with the lightest colors of tissue first and save the darkest for last. It is difficult to change the color of dark tissue by overlapping it with other colors. If one area becomes too dark, you might cut out a piece of white paper, glue it over the dark area carefully, and apply new colors over the white area.

1. Apply a coat of adhesive to the area where you wish to place the tissue.
2. Place the tissue down carefully over the wet area (Figure T–30). Don't let your fingers get wet.
3. Then add another coat of adhesive over the tissue. If your brush picks up any color from the wet tissue, rinse your brush in water and let it dry before using it again.
4. Experiment by overlapping colors. Allow the tissue to wrinkle to create textures as you apply it. Be sure that all the loose edges of tissue are glued down.

28. Working with Glue

When applying glue, always start at the center of the surface you are coating and work outward.

- When gluing papers together don't use a lot of glue, just a dot will do. Use dots in the corners and along the edges. Press the two surfaces together. Keep dots at least ½ inch (1.3 cm) in from the edge of your paper.
- Handle a glued surface carefully with only your fingertips. Make sure your hands are clean before pressing the glued surface into place.
- *Note:* The glue should be as thin as possible. Thick or beaded glue will create ridges on your work.

▲ **Figure T–30**

▲ Artists, down through the ages, have helped us visualize what we learn about history. Art historians are responsible for much of what we know about the artists who have lived in the past.

Paul Cézanne
1839–1906
French Painter

The Card Player
page 19

Mont Sainte-Victoire
page 226

In 1839 the art of photography was born in France. Another French birth the same year — that of Paul Cézanne — would lead to equally important developments in the future of pictures.

Cézanne was born in the town of Aix (**ex**) in southern France. At the age of 22 he journeyed to Paris to study with the Romantics. He soon learned of other styles of painting that held even greater appeal for him.

By the end of the 1870s Cézanne began experimenting with an art style all his own. He returned to the south of France to perfect it. His goal, as he described it, was "to make of Impressionism something solid and permanent, like the art of the museums."

A loner, Cézanne struck the people of his little town as a strange figure. Who, they wondered, was this man who spent his days alone in the fields, making paintings no one bought? It was while out in the fields one rainy day during his sixty-seventh year that Cézanne developed a bad cough. A few days later he died of pneumonia.

Cézanne's one-of-a-kind use of color patches to create solid forms is showcased in *Mont Sainte-Victoire* (page **226**). This is one of over 60 views of a favorite subject the artist painted.

The widespread availability in the early 1300s of a product called paper ushered in a new era in writing. A new era in painting came about during this same period. The person responsible for this second development was a gifted Italian artist named Giotto di Bondone (**jah**-toh dee-bahn-**dohn**-ee).

Giotto's lifelong calling as an artist was clear from the time he was 10. The son of a shepherd, he liked to pass the time drawing on flat stones in the fields. According to a popular story, one day a famous artist named Cimabue (chee-muh-**boo**-ay) came across young Giotto at work. Amazed at the boy's skill, Cimabue took him into his studio. Soon Giotto's skill as a painter was recognized throughout Italy.

In the early 1300s Giotto was asked to paint a series of frescoes on the walls of a church in Padua, Italy. One of these, *The Flight into Egypt*, is shown on page **154**. Like other religious paintings of the day, Giotto's works focused on familiar stories from the Bible. Unlike anything ever done before, however, Giotto's paintings were peopled with flesh-and-blood figures. These figures moved about in what appeared to be real space. They also exhibited feelings and emotions with their facial expressions and gestures. Painting had taken a giant step forward.

So great was Giotto's contribution that when he died, a statue was created in his honor. On its base were the words "I am Giotto, that is all. The name alone is a victory poem."

Giotto (di Bondone)
1266–1337
Italian Painter

The Flight into Egypt
page 154

Francisco Goya
1746–1828
Spanish Painter

Cornered (From the Disasters of War)
 page 187

The early 1800s found the world on the move. The invention of the steamboat was followed quickly by the building of the first railroad. The art world, too, was on the move — into a realm of self-expression where it has stayed to this day. The artist most identified with this move is a free spirit named Francisco Goya (fran-**sis**-koh **goy**-uh).

Goya was born in Saragossa (sar-uh-**goh**-suh), Spain. As a young man he traveled to Italy. He was not impressed by the Renaissance masterpieces and returned home. There he went to work as a portrait painter. His works flattered the members of the Spanish ruling class, who were his subjects. In 1786 he was named personal painter to King Charles IV.

An illness four years later left the artist deaf. Far from plunging him into despair, his handicap seemed to fuel his imagination. When war broke out in 1808, the artist created a series of prints unlike anything done before. Goya's view of war has no heroes or acts of glory. Like *Cornered* (page **187**), the prints in this series speak, rather, of senseless waste and brutality.

As Goya grew older, his view of the world grew grimmer still. His later works drew more and more on his own inner dreams and visions.

By the mid-1890s the United States had entered the age of communication. The newly invented telephone and wireless telegraph made it possible for people to communicate with one another over great distances. Not all people benefited from these inventions, however. To Native Americans tucked away in the New Mexico wilderness, time had stood still. It was in that quiet place at this not-so-quiet time that an artist named Lucy Lewis was born.

Lucy Lewis was raised in a pueblo in the town of Acoma (uh-**coh**-muh). She learned early of the importance of pottery to her people. As a child, Lewis watched her aunt make wide-mouthed pots called *ollas* (**oy**-uhs). She was taught where to dig for the best clay and how to mix the clay with water. As she grew, she began to experiment with different natural pigments. The pots she designed and crafted were unusually lightweight and handsome.

In time, people in the pueblo became aware that Lucy Lewis had a special gift. They encouraged her to enter craft fairs and shows. She followed their advice — and came away with many awards.

Today Lewis still lives in the Acoma area with her family. There she and her daughters teach others the fine craft of pottery.

Lucy Lewis
1897–
Native American Craftsperson

Polychrome Pots
 page 201

Judith Leyster

1609–1660
Dutch Painter

Self-Portrait
page 181

The late 1800s were a time of great discovery. In Germany a scientist named Roentgen (**rent**-guhn) discovered X-rays. In France a husband and wife named Curie (**kyu**-ree) discovered the element radium. Another discovery in France at the time had important consequences for the art world. It was the discovery of a signature on a painting long thought to be by the great Dutch artist Franz Hals. The surprising signature read "Judith Leyster" (**ly**-stuhr), not Franz Hals.

This "mystery" artist had been born some 250 years earlier in the Dutch city of Haarlem (**har**-luhm). At a time when women seeking art careers were often helped by artist fathers, Leyster — a brewer's daughter — had to rely on talent alone. Another difference between her and other female painters was her choice of subject matter. Instead of delicate still lifes, Leyster did robust genre paintings and portraits. One of these, her now-famous *Self-Portrait*, appears on page **181**. By 17 she had gained a reputation as an artist of great promise.

Leyster learned — and learned well — from other major painters of her day. Most notable among these are Hals, for his brush technique, and Caravaggio (see page **179**), for his use of light. Still, her works have a look that on careful inspection is unmistakably hers. Her portraits, especially, seem to invite the viewer in as if subject and viewer were close friends.

The voyages in the late 1400s of Christopher Columbus and Vasco da Gama broadened the world's horizons. So did the birth during that period of possibly the greatest artist the world has ever known. His name was Michelangelo Buonarroti (my-kuh-**lan**-juh-loh bwohn-uh-**rah**-tee).

Michelangelo was born in Florence to a poor family. At the age of six he was sent to live with the family of a stonecutter. There he came to love the feel of a sculptor's chisel and hammer in his hands. Art had found its way into his life.

Over the next 10 years Michelangelo's genius was given shape and direction through study with Florence's foremost artists. By the time he was 24, he had completed his first masterpiece, the *Pietà* (page **165**).

Despite his great talents, Michelangelo was hampered by some very human shortcomings. One was a hot temper, which made him hard to work with. Another was a need to see every project he took on in larger-than-life terms. Because of this second weakness, many of his works were never finished. One that was completed — and one of his most famous achievements — was his magnificent painting of the ceiling of the Sistine Chapel in Rome. The heroic job took four years to complete. During that time Michelangelo worked flat on his back on a platform he had built 68 feet (20 m) above the chapel floor!

Michelangelo (Buonarroti)

1475–1564
Italian Sculptor, Painter

Pietà
page 165

Joan Miró
1893–1983
Spanish Painter

Femme (Woman)
page 27

Dutch Interior
page 259

The year was 1925. The world had scarcely recovered from "the war to end all wars" when it was shaken again. This time the explosion took place within the art world of Paris. It was caused by paintings like _Dutch Interior_ (page **259**), created by a shy little Spanish artist named Joan Miró (zhoo-**ahn** meer-**roh**).

Miró was born in a town outside of Barcelona (bahr-suh-**loh**-nuh), Spain. As an art student, he was made to draw objects by "feeling" them rather than looking at them. For someone more fascinated by the world within than the one outside, the exercise was perfect training.

In 1919 Miró traveled to Paris, the capital of the art world. There he fell upon hard times. He was forced to get by on one meal a week. In between he ate dried figs to keep up his strength. It may have been the visions brought about by hunger that led to his first important Surrealist pictures.

After his first showing, Miró was hailed as a major new talent. He went to live on the island of Majorca (muh-**yor**-kuh), off the coast of Spain. There he painted in a room so small he had trouble moving around in it.

Later in his long career Miró broadened his interests to include sculpture. He also created huge weavings that, like _Femme_ (page **27**), mirror the colorful designs of his paintings.

After the Brooklyn Bridge opened in the late 1800s, bridge building would never be the same. After a showing of paintings in Paris during this same period, art would never be the same. The showing was by a group of artists who had been turned down by the Salon. Their style, which became known as Impressionism, took its name from a work by one of the group's founders. The artist's name was Claude Monet (**klohd** moh-**nay**).

Monet was born in Paris in 1840. His father, a grocer, moved the family to the port city of Le Havre (luh **hahv**-ruh) soon after his son's birth. Even as a child, Monet saw something magical in sunlight's effects on water. He studied with a noted landscape artist, who taught him the basics of Realist painting.

It was while a student that Monet met two other young artists, Pierre Auguste Renoir (oh-**guste** ren-**wahr**) and Alfred Sisley. The three soon became friends. They also began experimenting together, making paintings outdoors in natural sunlight. At first their works were laughed at by critics. Today the works of these three artists are among the most admired in the history of art.

During a stay along the river front Monet painted _Bridge at Argenteuil_ (page **220**). Like his other mature works, this work contains no solid lines or forms. Rather, these elements are hinted at through dabs and dots of color.

Claude Monet
1840–1926
French Painter

Banks of the Seine, Vetheuil
page 216

Bridge at Argenteuil
page 220

Berthe Morisot

1841–1895
French Painter

Jeune Fille au Chien
(Young Girl with her Dog)
page 218

The last decade of the 1800s was a time of change. In 1896 Thomas Edison burst on the scene with the invention of the motion picture. A year earlier the art world mourned the passing of a maker of pictures of a different sort. The artist's name was Berthe Morisot (**behrt maw-re-zoh**).

Berthe Morisot was born into an art family. Her parents were art lovers and Jean-Honoré Fragonard (**zhahnh** oh-nor-**ay** frah-goh-**nahrh**), an important painter of the 1700s, may have been her great-grandfather. From the time she was a young girl, she knew she would become a painter. At 15 she met and became good friends with Edouard Manet (ay-doo-**ahrh** mah-**nay**), a leading artist of the day. Several years later she married Manet's brother.

Like Manet, Morisot focused on indoor scenes and portraits. Her portrait titled *Jeune Fille au Chien* (page **218**) is one of her best-known art works.

Although other artists praised her work, during her lifetime Morisot was ignored by critics. Many did so merely because she was a woman. It was not until her death that her work began receiving the respect it had always deserved.

In 1905 Albert Einstein published his theory of relativity. In so doing, he challenged age-old beliefs about the meaning of time and space. In that same year a young girl moved with her family from Russia to America. She would grow up to create art that would challenge age-old beliefs about the meaning of sculpture. Her name was Louise Nevelson (**nev-uhl-suhn**).

As a child in Maine, Nevelson spent long hours playing in her father's lumberyard. She loved to carve and build using the scraps of wood she found.

At the age of 20 Louise married and two years later gave birth to a child. In time, she came to resent the responsibilities of marriage and motherhood that took time away from her art. In 1931 she left her son with her parents and headed to Europe to study art.

Nevelson's first showing came in 1941. The reviews, which were favorable, spurred her on. In the decades that followed, she began more and more to experiment with "found" media. It was not uncommon to find her studio littered with wood scraps very much like the ones she had played with in her father's lumberyard. Most of Nevelson's works from the 1960s on are, like *Mrs. N's Palace* (page **267**), three-dimensional collages. Most invite viewers to use their imaginations as well as their eyes.

Louise Nevelson

1900–1988
American Sculptor

Mrs. N's Palace
page 267

Albert Pinkham Ryder

1847–1917
American Painter

Moonlight Marine (Toilers of the Sea)
 page 234

The first two decades of the twentieth century were a politically stormy time. The winds of revolution swept through Russia and China. In 1914 the world went to war. To take their minds off gloomy events of the day, some people turned inward. One who did—and came back to the world with a rare gift of art—was Albert Pinkham Ryder.

Ryder was born in New Bedford, Massachusetts. When he was a young man, his family moved to New York City. There an older brother helped pay his way through art school. Showing little interest in the works of other artists, Ryder forged his own one-of-a-kind style. Among the features of his style were paint layers so thick that his pictures sometimes looked three-dimensional.

Always given to strange personal habits, Ryder developed still odder ways during his middle years. He gave up his Greenwich Village apartment and moved into a run-down rooming house. Burdened by poor eyesight, he spent his days indoors, his nights roaming the streets alone. After 1900 he became a hermit altogether.

It may have been during his silent night walks that Ryder dreamed up ideas for his pictures. Most, like *Moonlight Marine* (page **234**), are glimpses of a dream world, which capture the viewer's imagination.

In 1921 a bitterly fought revolution in Mexico ended. Honest, hard-working people, long treated as slaves by rich landlords, were free at last. In that same year a talented Mexican artist returned from abroad. He began the first of many larger-than-life chronicles of the struggle for freedom. His name was Diego Rivera (dee-**ay**-goh rih-**vehr**-uh).

Rivera was born in the city of Guanajuato (gwahn-uh-**waht**-oh). As a young man, he journeyed to Paris, where he met Picasso and Matisse. While in Europe he also studied the art of the great Italian fresco painters. The size of the frescoes—some covered entire walls—appealed to him. Such an art form, he felt, would be a fitting tribute to those who had fought so bravely in the Mexican Revolution. It would also be a reminder to Mexico's rich of the power of the people.

Murals like *The Liberation of the Peon* (page **251**) reveal Rivera's skill as a storyteller. They also reveal the influences of both Giotto and Rivera's pre-Columbian ancestors.

After making a name for himself, Rivera was asked to paint murals in the United States. He created works that, like those in Mexico, were filled with people and action. These illustrated the American fascination with speed and the machine. Unfortunately, many of these magnificent murals were destroyed.

Diego Rivera

1886–1957
Mexican Painter

The Liberation of the Peon
 page 251

Alfred Stieglitz

1864–1946
American Photographer

The Terminal
page 249

Around 1900 the United States opened its doors to Americans-to-be from all nations. To young Abstract painters hoping to enter the art world of the day, the door was firmly shut. Abstract painting was misunderstood and unappreciated by the public and most art critics. One free thinker who provided an outlet for these brave new talents was himself an artist. He was photographer Alfred Stieglitz (**steeg-luhts**).

Stieglitz was born in Hoboken, New Jersey. His interest in photography began when he was young. Early in his career he began seeing photography's potential as an art medium. He spent long hours — sometimes in swirling snow — waiting for just the right shot.

In 1902 he formed Photo-Secession, an organization devoted to the art of photography. Three years later he opened a gallery at 291 Fifth Avenue in New York City. Known as 291, the gallery became a haven for struggling young artists from all areas of art. One artist whose work was displayed at 291 was a native of Wisconsin named Georgia O'Keeffe. Stieglitz and O'Keeffe developed a friendship that grew over time. Despite an age difference of 23 years, the two were married in 1924.

Stieglitz spent his life championing the world of other photographers. Still, his own photographs are among the most sensitive ever taken. Through instant human studies, like *The Terminal* (page **249**), he carried photography to new heights.

In 1875 Congress passed an act giving African Americans the right to serve on juries. Eight years later the Supreme Court declared the act unconstitutional. It was not long after that decision that artist Henry Tanner made a decision of his own. Tanner, an African American artist having little success selling paintings in America, decided to set sail for Europe.

Tanner had been born 32 years earlier in Philadelphia, Pennsylvania. His father was a minister, who later became a bishop. Tanner's interest in art began when he was only 12. Walking through a park with his father, he saw a landscape painter at work. Tanner watched in fascination. As his fascination grew, so did his desire to become a painter.

Tanner entered the Pennsylvania Academy of Fine Arts, where his teacher was Thomas Eakins. Eakins advised his student to turn from landscapes to genre scenes — which Tanner did. But Tanner found there was little market for paintings of any kind by an African American. Wanting, in any case, to focus on Biblical subjects, he headed for Paris. Within five years one of his Biblical pictures was hanging in a place of honor at the Paris Salon.

While Tanner painted mostly religious works, he still found time now and then to exhibit his skills at painting landscapes. *The Seine* (page **236**) is one of these works.

Henry O. Tanner

1859–1937
American Painter

The Seine
page 236

▲ There are many career opportunities in art and art-related fields.

Art Director

You may know that movies are the work of hundreds of people. You may also know there is one person in charge of all others, called the director. But did you know that advertisements, books, and magazines also have directors?

Art directors are experienced artists whose job is to lead or supervise other artists. Like film directors, art directors are responsible for seeing that all other jobs in a project are done.

Art directors are hired by advertising agencies, book publishers, and television or radio stations. The specific tasks of the job may differ slightly from place to place. In general, the art director hires and oversees the work of illustrators, photographers, and graphic designers. Together, the art director and the people who report to him or her are called a team. The art director has the responsibility for signing off, or approving, all work done by team members.

Art Teacher

Many people with an interest in art and a desire to share their knowledge become art teachers.

A career in art teaching requires a college education. Part of that education is devoted to methods of teaching. Part is devoted to developing a broad background in the history of art and the use of art materials and techniques.

Good art teachers open their students to a wide variety of art experiences. They give students the chance to create their own art and to react to the art of others. They also make sure their students learn about such important areas as aesthetics, art criticism, and art history.

While most art teachers work in schools, some find employment opportunities in other areas. Some art teachers work in museums or hospitals. Some teachers work in retirement centers. Still others work in nursery schools and day-care centers.

Computer Graphics Specialist

What do computers have to do with art? To the person known as a computer graphics specialist, the answer is "everything!"

Computer graphics specialists are skilled professionals who use state-of-the-art electronic equipment to create designs. The work they do has brought the world of commercial art into the space age. A career in this field combines a strong background in design with a knowledge of computers.

The computer graphics specialist works with tools such as electric light pens on electronic tablets. With these tools, any image may be drawn and colored in. Such computer drawings may be stored permanently in the computer's memory. They can then be called up and reworked by the designer as needed.

Some computer graphics specialists work with systems that allow them to see their finished work in different sizes and colors. Computer-made designs can also be sent along telephone lines around the world.

Editorial Cartoonist

Newspaper editorials are written accounts that invite readers to form an opinion about important news topics. Editorial cartoons do the same work in pictures.

Editorial cartoonists, the people who create such pictures, work for newspapers and magazines. Their creations usually appear as single drawings without titles or captions. Sometimes editorial cartoons go hand-in-hand with the main editorial, which is printed nearby. At other times they comment on other issues figuring in current events.

Many editorial cartoonists use a style of art called *caricature* (**kar**-ih-kuh-chur). This is the exaggerating of facial features or expressions to poke fun at well-known figures. Some editorial cartoonists use symbols to communicate their meanings. What familiar figures are used to symbolize the two political parties in the United States?

Exhibit and Display Designer

The next time you pass a display of clothing or other goods in a department store, look carefully. Somewhere within that display will be a hidden message: artist at work.

Exhibit and display designers work in a number of retail and non-profit settings. Some of these settings are trade shows, department stores, showrooms, art galleries, and museums. Such designers plan presentations of collections, exhibits, and traveling shows of all kinds. They are responsible for such matters as deciding what items should be grouped together. They also take into account how displays should be arranged and lighted.

The display designer is an important part of the sales team. Displays attract customers. They can affect a customer's decision to buy. The way the display designer does his or her job can make all the difference between whether or not a sale is made.

Graphic Designer

There are artists all around us. They are there behind every billboard, street sign, and soup can label. These artists are called graphic designers. They use pictures and words to inform or decorate.

Graphic designers work in a great many areas. Each area has its own special tasks and title. Technical illustrator is one of these titles. Sign maker is another.

The field of graphic design has its roots in the 1500s. It was in that century that the printing press was invented. People were needed to arrange words and pictures on the printed page. To this day that task, known as layout, is a job of graphic designers. Graphic designers also pick type faces, or styles of lettering, for printed material. They must also decide how drawings or photographs will be used as illustrations.

Industrial Designer

What do toys, vacuum cleaners, and cars have in common? All are designed to work easily and have a pleasing look. These and countless other items you see and use each day are the work of industrial designers.

Industrial designers work for makers of products. These artists work closely with engineers who develop the products. Sometimes industrial designers are asked to work on things as simple as tamper-proof caps for medicines. At other times they are asked to work on projects as complicated as space vehicles. Before they begin work, industrial designers need to know how the product is to be used.

Because different brands of the same product are sold, industrial design sometimes crosses over into advertising. The appearance of a design becomes especially important in the case of very competitive products such as cars and entertainment systems, for example.

Interior Designer

Architects give us attractive, functional spaces in which to live, work, and play. Interior designers fill those spaces with attractive and useful furnishings and accessories.

The job of the interior designer is to plan the interior space. This includes choosing furniture, fabrics, floor coverings, lighting fixtures, and decorations. To do this job well, the designer must take into account the wants and needs of the users of the space. In planning a home, for example, the interior designer will learn as much as possible about the lifestyle of the family that lives there.

Interior designers help their clients envision their ideas through the use of floor plans, elevations, and sketches—sometimes using special computer software programs. Once a client has agreed to a plan, the designer makes arrangements for buying materials. He or she also oversees the work for builders, carpenters, painters, and other craftspeople.

Magazine Designer

Magazine designers are graphic designers who work for publications called *periodicals*. These are booklets or pamphlets that come out on a regular basis in issues.

There are two parts to a magazine design — the fixed design and the variable design. The fixed design includes the features of the magazine that seldom change. These include the different type faces and decorative elements such as page borders. The magazine designer works mostly on the variable design. This includes making sure all the pages in an issue are a standard length. Another part of variable design is figuring out where illustrations should go and how large they should be.

At times a magazine designer is called upon to create special features for a periodical. These are used to highlight a theme running throughout the issue.

Medical Illustrator

Among Leonardo da Vinci's many achievements were his drawings of *anatomy* or human body parts. Ever since his time there has been a call for medical illustrators.

Medical illustrators work for medical schools, teaching hospitals, and publishers of medical journals and textbooks. All have a basic knowledge of medicine and an ability to work with many different art media. Among these are transparencies (trans-**pare**-uhn-sees), or illustrations that are placed on overhead projectors.

The work of medical illustrators falls into two main areas. One is the drawing of diagrams showing various details, such as the heart and limbs. The second is doing step-by-step illustrations of surgical and other medical procedures.

At times medical illustrators are called upon to work with such medical equipment as X-ray machines, microscopes, and scanners.

Museum Curator

Like universities and libraries, museums have the job of preserving and passing on culture. The person in charge of seeing that the museum does its job is called the museum curator (**kyoor**-ayt-uhr).

Curators are part custodian, part scholar, and part historian. The tasks of the curator are many. They include securing, caring for, displaying, and studying works of art. The curator makes sure works are arranged so they teach, inform, and delight.

As holders of advanced college degrees, curators carry on research in their own areas of interest. They report their findings in books, lectures, and journals.

Photojournalist

Photography, as you have learned, was unheard of until the mid-1800s. No sooner had photography emerged on the scene, however, than the field of photojournalism was born. Photojournalism is the taking of pictures for newspapers and magazines.

One of the earliest photojournalists was a photographer named Mathew Brady. Brady lived in America during the Civil War. His early black-and-white snapshots offer dramatic glimpses of life on and off the battlefield.

Since Brady's time the field of photojournalism has grown and with it, the responsibilities of the photographer. Photojournalists are expected to seek out and record newsworthy scenes. They must also be able to take action pictures quickly and process them with equal speed.

Some photojournalists in recent decades have chosen specialties for themselves. Two of these areas are politics and sports.

Special Effects Designer

Are you the sort of person whose imagination works overtime? Then maybe the field of special effects design is for you.

Unlike people in other art careers, special effects designers may not attend special schools. The field is very new. The people who have created film and television magic to date have come up through the ranks. They may have started by building sets for plays or designing film backgrounds.

Special effects artists are one part painter, one part sculptor, and one part engineer. They have the ability to imagine, and then create, fantasy scenes or creatures. They are masters of make-believe.

There is no limit to the tools used by special effects designers. Depending on the needs of a project, they might use papier-mâché, plaster, plastic molds, or paint. Makeup, trick photography, and computers are just a few of the other media they use.

Urban Planner

Have you ever wondered how big cities come to look the way they do? The two-word answer to this question is urban (or city) planners.

City planners are people whose job is to supervise the care and improvement of a city. Every large American city has a planner.

A main task of city planners is to enforce zoning laws. These are laws controlling what part of a city may be used for what purposes. Thanks to city planners, garbage dumps are not located in residential communities.

A second task of the city planner is to look after the growth and development of the urban areas. The planner works with the mayor and other city officials to create parks, harbors, and shopping malls.

City planners are trained as architects. Their knowledge of design helps them to plan a pleasing cityscape.

Creating a Computer Quilt Design

Artists use the computer as a design tool to make patterns for application to other media such as silk screen or tapestry. Christopher Pallotta created these two quilt patterns on the computer. The designs can be displayed and enjoyed as art works or they can be used to make quilts from fabric.

You can create quilt patterns by designing a motif for a quilt square and adding solid colors, patterns, and textures. To make the quilt pattern, repeat the motif, using the same combination of colors or include contrasting colors. You can then emphasize the design with the addition of intricate details.

WHAT YOU WILL LEARN

You will use the principle of rhythm by repeating a geometric motif to make a decorative quilt pattern. First you will explore the Shape and Line tools to design a geometric motif. Next, you will use the Bucket tool to add color. Then you will learn how to Copy, Paste, and arrange copies of the square motifs to create a quilt design. Discover how rotating or inverting copies of the motif creates varying quilt designs. Make several examples showing different arrangements of the original motif.

WHAT YOU WILL NEED

- Computer with an art application
- Mouse or graphics tablet with a stylus or drawing pen
- Floppy disk to save work
- Color printer (for black-and-white printer, add color with pen, pencils, or markers)

WHAT YOU WILL DO

1. Look at Pallotta's quilt designs or recall other quilts you have seen. On the computer, make two or three geometric motifs. Hold down the Shift or Option key and draw an open square with the Rectangular Shape tool. (Choose the No Fill setting for an open square.) Choose from the Shape tools to add more open shapes. Use a variety of shapes and sizes, including circles, triangles, or hexagons.

▶ **Figure S–1**

Christopher Pallotta. *Collideoscope Quilt, Kaleidoscope Quilt*

2. Select the Straight Line tool to divide the area into smaller spaces or shapes. Add smaller lines and shapes to create details. Title and Save this geometric motif.

3. Create a different motif, beginning again with an open square. Title and Save.

4. Choose the motif you like the best. Select several hues—solid, gradients, or mixed with a pattern. Fill in spaces of the motif with color using the Bucket Flood-fill tool. (You may begin with the original line motif and fill with another color choice.) Title and Save your work.

5. Use the Lasso or Rectangular Selection tool to Select the geometric motif. From the Edit menu, click, drag, and choose Copy to copy the motif in the Clipboard.

6. From the Edit menu, click, drag, and choose Paste to place a copy on the screen. Note the keyboard shortcut key in the menu command box. You may wish to use this key later.

7. Notice the moving dotted lines around the selection. These indicate the motif is Selected and now can be moved or changed. Put the cursor on top of the motif and drag it into position. While the motif is still Selected, choose Flip, Rotate, or another command from the menu that allows you to transform selected graphics. To Paste selection into position, click the cursor on another area of the screen outside the selection.

8. Continue to Paste additional copies and arrange them to complete a repeating rhythm. Decorate with a frame or border, if needed. Retitle, save, and print.

EXAMINING YOUR WORK

- **Describe** Name the colors in your motif. Identify the geometric shapes used.
- **Analyze** Explain how you arranged the individual motif to make the quilt; identify the tools and menus. Tell why you chose the color scheme. Identify any combinations of color and patterns you used.
- **Interpret** Compare and explain the varying appearance of the quilt designs caused by flipping, rotating, and arranging the original motif differently. What is the mood or feeling created by the shapes, colors, and textures? Title your work.
- **Judge** Tell if you have used the principle of rhythm by repeating a geometric motif to make a decorative quilt. What part do you like best? Would you make any changes? How?

▲ Figure S–2 Student work. Computer quilt.

 Try This!

STUDIO OPTION

■ Make a storytelling quilt. Choose a theme for your quilt to record an event, a celebration, or a favorite folk tale. Begin by using the Pencil or Brush tools to draw a picture. Choose hues and patterns to emphasize the mood of the quilt. Apply color directly using Brush tools or fill in line drawings with the Bucket tool. Title and Save. Follow Studio Lesson directions to create a repeating geometric border design. Retitle, save, and print the storytelling quilt pattern.

LESSON 2

Coil Pot

Look at the object in Figure S–3. This is an example of an early Native American coil clay pot. Scientific dating of artifacts like this helps experts estimate the earliest time ancient people may have arrived on this continent. Works like this also provide a window on the way of life of those people.

WHAT YOU WILL LEARN

You will create a clay pot in the style of prehistoric Native Americans. You will give the work a sense of rhythm by increasing and then decreasing the size of coils. Your finished pot should be both useful and decorative.

WHAT YOU WILL NEED

- 2 pounds of clay, and slip
- Canvas-covered clay board
- Large plastic bag and bowl of water
- Scrap piece of heavy cardboard

WHAT YOU WILL DO

1. Review Technique Tip **16**, *Handbook* page **281**. It will give you some general background information on working with clay.
2. Gently throw your clay against the clay board. Doing this will remove any air pockets that might cause your work to explode when fired.

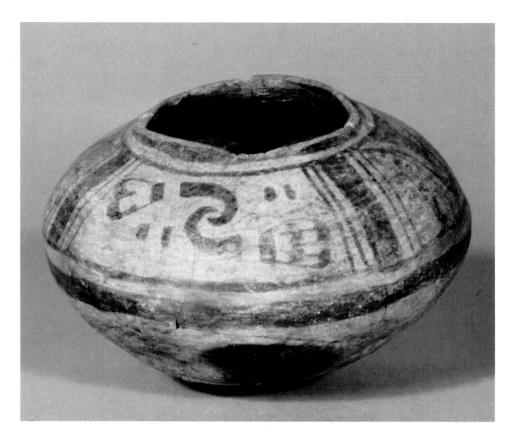

▶ **Figure S–3 What do you suppose were some of the functional uses of a pot like this in the Pueblo culture?**

Pueblo. Ceramic Jar. Prehistoric. White slip with black painted decoration. 10.8 x 15.8 cm (4¼ x 6¼"). Indian Arts Research Center, Santa Fe, New Mexico.

3. Pinch off a lump of clay about the size of a lemon. With the heel of your hand, flatten the lump into a circle about ½ inch (13 mm) thick. Set it aside. (See Figure S–4.)

4. Pinch off a second smaller lump, and roll it into a rope. The rope should be about ½ inch (13 mm) thick and 12 inches (30 cm) long. Form the rope into a ring, joining the two ends with slip. Seal the ring to the circle you made. This is to be the base of your pot.

5. Create four more ropes. All should be the same thickness as the first rope. Each, however, should be slightly longer than the one before it. Form the shortest rope into a ring, as you did earlier. Using slip, attach it to your base. Form the next longest rope into a ring. Attach it to the outer edges of the last coil. Continue to work in this fashion until your work is five coils high.

6. Roll out five more ropes, this time making each slightly shorter than the one before it. Form the longest into a ring. Attach it to the inner edges of the last coil on your pot. Continue working in this manner until you have used all your ropes. (*Hint:* If it takes longer than one class period to finish your pot, store it in the plastic bag. This will keep it moist until you are ready to work with it again.)

7. Allow your pot to dry to the greenware stage. Use the scrap of cardboard as a scraper to smooth out any bumps. Fire the pot in a kiln. Display your finished pot alongside those of classmates. Which pots succeed in showing a sense of rhythm?

EXAMINING YOUR WORK

- **Describe** Tell whether all the coils in your pot have the same thickness. Describe the form of your pot. Explain what you did to obtain this form.
- **Analyze** Tell which principles were used to organize the elements in your work. State whether your pot has a sense of rhythm. Explain how this sense of rhythm is realized.
- **Interpret** Point out in what ways your pot is similar to a prehistoric Native American coil pot.
- **Judge** Tell whether you have succeeded in creating a work that is both useful and decorative. Tell what changes you would make if you were going to redo your pot.

▲ Figure S–4 Student work. Coil pot.

STUDIO OPTIONS

Try This!

■ Make a second pot similar to the first one. This time, use your fingernails or a pencil point to dent each coil every inch (2.5 cm) or so. This will add an interesting texture. Compare your pot with the coiled pot in Figure 13–2 on page **194**.

■ Make a second pot similar to the first one. This time, use your cardboard scraper to smooth out the coils. Using a sharp clay tool, carve a geometric design in the surface of your pot. This design should be made so that it fits comfortably within the shape of your pot.

Making Silk Screen Prints

Screen printing is the easiest technique to use when making a print using many colors. Study the screen print in Figure S–5. This was done by American artist Andy Warhol. How many different colors of ink do you think the artist used? How do the colors affect the mood of the work?

WHAT YOU WILL LEARN

You will make a screen plate out of cardboard, masking tape, and net fabric. You will block out a design with a wax crayon. The design will use the principle of rhythm to organize the element of shape. Give your print a title that describes the mood or feeling you want to capture. You will print an edition of three prints.

WHAT YOU WILL NEED

- Pencil and ruler
- Shoe box lid
- Utility knife and scissors
- Sheets of sketch paper
- Masking tape and nylon net fabric
- Wax crayon
- Colored water-based printing ink or school acrylic paint
- Squeegee or a piece of heavy-duty cardboard the size of the screen opening
- Sheets of white paper

▲ **Figure S–5**

Andy Warhol. *Double Self Portrait*. Screen print in paint on canvas. 1.8 x 1.8 m (6 x 6'). The Detroit Institute of Arts, Detroit, Michigan. Founders Society Purchase, Friends of Modern Art.

WHAT YOU WILL DO

1. With pencil and ruler, measure a 3 x 5 inch (8 x 13 cm) square on the shoe box lid. Using the utility knife, carefully cut out the rectangle. Protect the table with a thick piece of cardboard.

2. Trace the size of the opening in the shoe box lid on sheets of sketch paper. Experiment drawing rhythmic designs that lead the eye around the space. One way to do this is by repeating shapes. Change the size, however, to add interest to these shapes. Choose the best of your designs. Shade the space between the shapes with a pencil. Set your sketch aside.

3. Cut a rectangle of net fabric slightly larger than the opening. With masking tape, fasten the fabric securely to the inside of the lid. Cut a piece of cardboard that will fit inside the lid but cover the opening. The cardboard will act as a squeegee later.

4. Place the screen over your design. Hold it firmly in place. Pressing heavily with the crayon, plug the holes in the net over the shaded areas.

5. Place the screen over a sheet of white paper. Choose a color of ink. Squeeze a small amount of ink at the top of the screen. With your cardboard squeegee, pull ink from the top of the screen to the bottom. As you do, press down heavily.

- **Describe** Tell how this print technique is different from the other types of printmaking. Tell how the finished work is different. Show how you repeated the same shape in different sizes to add interest.
- **Analyze** Explain how you used the principle of rhythm to organize the shapes. Tell whether the element of texture plays an unplanned role in the finished work. Discuss what this reveals about printmaking.
- **Interpret** Tell how the title describes the mood you wanted to express in your art work.
- **Judge** Tell whether you feel your work succeeds. Explain your answer.

6. Lift the screen carefully off the paper so as not to smear the ink. Make a second and third print.

7. Display one of your finished prints. Discuss any interesting textures you created.

Try This! STUDIO OPTION

■ Make a screen print using crayon to draw a line design on the screen.

■ Borrow a classmate's printing plate. Using a second color of ink, add a second color to one of your dried prints. Line up the outlines of your print and the plate opening. Describe the results.

LESSON 4

Computer Cartooning

Cartoons represent objects with simple lines, shapes, and colors. Cartoon characters can be human, animal, or objects. They often appear as exaggerated caricatures portrayed with human characteristics: shy, bold, clumsy, athletic, villainous, or heroic. Cartoonists usually combine characters, action, setting, and message in one pictorial frame or a series of frames, called a comic strip, to tell a story. Newspapers have popularized cartoon characters since the early twentieth century. The computer saves artists many hours of hand labor by quickly replicating cartoon characters and settings. Artists like Mike Pantuso create cartoons for young children. His pictures are cartoons created by using simple shapes and primary and secondary colors.

WHAT YOU WILL LEARN

You will create an original cartoon character on the computer, using simple lines and shapes. You will either scan a sketch of your character into the computer or use the mouse or drawing pen to draw the character directly into an art application. Once the image is on the screen, you will manipulate it, change the size, or make variations to improve your character. Your final cartoon may be one picture or several frames put together to create a strip.

WHAT YOU WILL NEED

- Pencil and sketchbook
- Computer with art application
- Mouse or graphics tablet with a stylus or drawing pen
- Scanning device, hand-held or flatbed scanner (optional)
- Floppy disk to save work
- Color printer (for black-and-white printer, add color with pen, pencils, or markers) *Optional:* If scanning devices are not available, draw image directly into computer application. If a computer is not available, use pencil, pens, and paints.

WHAT YOU WILL DO

1. Choose a favorite animal or figure for your sketch. Think of the characteristics you want to express: bold, cunning, shy, or heroic, for instance. Make several sketches on paper. Use simple lines and shapes to draw the figure. Emphasize each characteristic by exaggerating proportion, shape, and size.

▶**Figure S–6**

Mike Pantuso. *Banana Man.* Computer art, appears in the following publication: *Adobe Photoshop, Creative Techniques.* Salles, Denise, Gary Poyssick, and Ellenn Behoriam. 1995. Macmillan Computer Publishing and Shepard Poorman Communications Corporation, Indianapolis, Indiana.

2. Draw your cartoon character directly into the computer using a mouse or stylus pen and the Pencil or a small Brush tool. Scan your original sketch into the computer as Line Art with a hand-held or flatbed scanner, if available. You may also lay your sketch on a graphics tablet and trace around lines of the cartoon character with the stylus or drawing pen. When the image is in the computer, Title and Save your work to a file or disk.

3. Explore variations of the character by manipulating and altering the position and size. Choose a Selection tool such as the Lasso to select the image and pick options from the Transformation or Special Effects menu to change size, flip, rotate, or distort the image. Retitle and save variations you like.

4. Think of a message you want to express or a problem that needs to be solved. Include humor if possible. Decide whether you can accomplish your idea in one frame or if you need several frames to convey the action and the message. Add objects, figures, and details to help convey the message. Retitle and save your work.

5. Select three or four primary and secondary colors and use the Bucket tool to flood-fill shapes and spaces with hues. If the color leaks into other spaces, use the Undo command from the Edit menu, or the keyboard shortcut. Then choose the Fatbits or Zoom-in tool or command to find the missing pixels in the outline. Fill these in with Pencil or small Brush tool to close the outline. Imitate the comic strip look by clicking the Brush tool to add dots of color.

6. Retitle, save, print, and display your cartoon.

EXAMINING YOUR WORK

- **Describe** Identify your cartoon character. Name the colors you used. Describe the setting.
- **Analyze** Tell what elements you used to emphasize the character's personality. Show how you exaggerated the character's features.
- **Interpret** What is the mood? How do the colors and composition help to convey this mood? What title did you choose to name your work?
- **Judge** Did you create an expressive cartoon using exaggeration and simple lines, shapes, and colors? How did you make use of computer tools in your work? What would you change to improve it?

▲ **Figure S–7 Student art. Computer cartoon character.**

STUDIO OPTION

Try This!

■ If you have a slide show option you can animate your cartoon by creating a strip and displaying it frame by frame. Select one frame of a cartoon you like. Redraw the frame making it larger using the Pencil or small Brush tool. Use simple lines and shapes. Redraw several times, making changes in each successive frame. Add details but do not include any words. Title and save. Add color using the Bucket or Brush tools. Try using dots of color to imitate the dot patterns used in comic strips. Retitle, save, and print your strip.

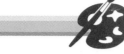
Computer-Designed Advertisement

Graphic artists use the computer to create product package designs, brochures, advertisements, and company logos. Look at the work shown in Figure S–8 by Philip Nicholson. The entire piece was created using a computer.

Today, art applications are easier to use. Artists may work directly on the computer or begin with pencil and paper sketches. The computer makes some tasks easier because it can retrieve, reproduce, recombine, and alter images with ease. Some software programs simulate textures and appearance of traditional art media, such as watercolors and oil paints. Artists combine photographs and scanned images with textures and collage effects. Commercial illustrators use a combination of media including computer graphics applications, clip art, and traditional art materials to create exciting images for product marketing.

WHAT YOU WILL LEARN

You will design a product package or advertisement on the computer using a variety of fonts, styles, and sizes. Choose a theme and select hues to emphasize the mood. Decide whether you will draw objects or import and combine clip art images. You will then create harmony by using repeating colors, textures, shapes, and letters. Add variety by changing the size or rotating the shapes. After you design your package, you may wish to include a frame or border to create unity.

▲ **Figure S–8**

Philip Nicholson. *Poster Series*

WHAT YOU WILL NEED

- Pencil and sketchbook
- Computer with art application
- Mouse or graphics tablet with a stylus or drawing pen
- Floppy disk to save work
- Color printer (for black-and-white printer, add color with pen, pencils, or markers)

WHAT YOU WILL DO

1. Choose the kind of product or promotion you wish to represent. Design a package cover or an advertisement representing a product or products, such as the one shown in Figure S–8.
2. Make pencil sketches of the layout. Include fictitious product names, images, or symbols that represent your product and illustrate the message of the advertisement. Choose simple shapes and colors.
3. On the computer, begin with the letters of the product name. Select the Text tool and choose a Font, Style, and Size. Use a Selection tool to manipulate the letters by stretching, rotating, or distorting them. Add shadows to give perspective or emphasis to the letters. Title and save your work at intervals, so you can return to different points of the design process. Try other tools, menus, and designs.
4. Draw symbols or objects with the Pencil or Brush tools. Combine with Clip Art, if available. Add color directly with the Pencil or Brush tool or use the Bucket tool to Flood-fill spaces with color and texture. Title and save your work again.
5. Examine the words and images you have created. Select, Copy, and Paste words, letters, shapes, or objects to repeat

EXAMINING YOUR WORK

- **Describe** Identify the products in the package or advertisement. Point to your color choices and the use of images in your design.
- **Analyze** Discuss the layout. Explain how the advertisement is organized and the sequence you followed. Tell what you drew first, what you added next, and how you organized the design.
- **Interpret** Describe how the choice of font, style, size, and color help to emphasize the message in your design. Explain which elements and principles you used to organize the layout.
- **Judge** Did you use the principles of unity, harmony, and variety in your design? Did you manipulate fonts, shapes, and colors to make a successful product design?

images and create harmony through repetition. While objects are selected, add variety with changes in color, size, or position. Try overlapping images. Fill the page.

6. You may wish to make a frame or border around the design to create unity. Make a frame using lines, shapes, letters, or objects. Draw an object with a Pencil and then Select, Copy, and Paste image at regular intervals around the perimeter.
7. Retitle, save, and print your work. Try printing on different types of paper for different effects.

STUDIO OPTION

■ Design a travel brochure to promote a city or a vacation or recreation spot. Decide what popular and attractive points would promote the location, such as climate or activities. Include information in your brochure that would attract potential customers. Create a name or logo. Draw objects or include clip art. Choose colors to augment the mood of the resort. Title, save, and print your brochure.

ARCTIC OCEAN

GREENLAND
(Denmark)

Baffin Bay

ICELAND

CANADA

NORTH

AMERICA

Alaska (U.S.)

Bering Sea

ALEUTIAN ISLANDS

NORTH

PACIFIC

UNITED STATES

Hudson Bay

Labrador Sea

NORTH

ATLANTIC

IRE

PORT

Azores (Portugal)

OCEAN

HAWAIIAN ISLANDS

TROPIC OF CANCER

Hawaii (U.S.)

OCEAN

MEXICO

Gulf of Mexico

BAHAMAS

CUBA

Bermuda (U.K.)

OCEAN

Madiera Islands (Portugal)

Canary Islands (Spain)

MORC

WESTERN SAHARA (Morocco)

MAURITAN

BELIZE JAMAICA
GUATEMALA HONDURAS
EL SALVADOR NICARAGUA

HAITI DOMINICAN REPUBLIC

PUERTO RICO

Caribbean Sea

LESSER ANTILLES

CAPE VERDE

SENEGAL

GAMBIA
GUINEA-BISSAU GUINEA

COSTA RICA PANAMA

VENEZUELA

GUYANA

FRENCH GUIANA (France)

SIERRA LEONE

LIBERIA

Galápagos Islands (Ecuador)

COLOMBIA

SURINAME

ECUADOR

SOUTH

EQUATOR

PHOENIX ISLANDS

LINE ISLANDS

KIRIBATI

MARQUESAS ISLANDS

Tokelau (New Zealand)

WESTERN SAMOA

American Samoa (U.S.)

TUAMOTU

Cook Islands (New Zealand)

TONGA

French Polynesia (France)

TUBAI ISLANDS

PERU

BRAZIL

AMERICA

BOLIVIA

CHILE

PARAGUAY

Easter Island (Chile)

ARGENTINA

URUGUAY

SOUTH

SOU

ATLA

OCE

Kermadec Islands (New Zealand)

TROPIC OF CAPRICORN

0 100 200 300 400 500 600
MILES
0 100 200 300 400 500 600
KILOMETERS

PACIFIC

OCEAN

Falkland Islands (Islas Malvinas) (U.K.)

Ross Sea

Weddell Sea

170° 160° 150° 140° 130° 120° 110° 100° 90° 80° 70° 60° 50° 40° 30° 20°

Longitude West of Gre

ARCTIC OCEAN

80°
70°
60°
50°

A S I A

RUSSIA

EUROPE

DEN
FINLAND
ESTONIA
LATVIA
LITHUANIA
BELARUS
POLAND
SLOVAKIA
HUNGARY MOLDOVA
IA ROMANIA
NIA HERZEGOVINA
YUGOSLAVIA BULGARIA
MACEDONIA
ALBANIA
UKRAINE

KAZAKHSTAN

MONGOLIA

NORTH
KOREA
SOUTH
KOREA

Sea of
Japan

JAPAN

NORTH

PACIFIC

GEORGIA
ARMENIA
AZERBAIJAN TURKMENISTAN
TURKEY
GREECE
CYPRUS SYRIA
LEBANON
ISRAEL
JORDAN
IRAQ
IRAN

UZBEKISTAN KYRGYZSTAN
TAJIKISTAN
AFGHANISTAN

CHINA

OCEAN

30°

Mediterranean Sea

KUWAIT
BAHRAIN
QATAR
U.A.E.
SAUDI
ARABIA
OMAN

PAKISTAN

NEPAL
BHUTAN

Taiwan

TROPIC OF CANCER

20°

LIBYA

EGYPT

Arabian
Sea

BANGLADESH

INDIA

MYANMAR
(BURMA)
LAOS

South
China
Sea

Philippine
Sea

Northern
Marianas
Islands
(U.S.)

CHAD

SUDAN

ERITREA
YEMEN

Bay
of
Bengal

THAILAND

VIETNAM

Guam
(U.S.)

MARSHALL ISLANDS

10°

RICA

CENTRAL
AFRICAN
REPUBLIC

DJIBOUTI

ETHIOPIA

SOMALIA

SRI
LANKA

CAMBODIA

PHILIPPINES

BRUNEI

Palau
(U.S.)

FEDERATED STATES OF MICRONESIA
CAROLINE ISLANDS

MALDIVES

MALAYSIA

EQUATOR

GO

UGANDA
RWANDA
BURUNDI

KENYA

SUMATRA

BORNEO

SULAWESI

NEW GUINEA
PAPUA
NEW
GUINEA

NAURU
KIRIBATI

ZAIRE

TANZANIA

SEYCHELLES

JAVA

INDONESIA

SOLOMON
ISLANDS

TUVALU

10°

ANGOLA

MALAWI

COMOROS

ZAMBIA

ZIMBABWE
MOZAMBIQUE

MADAGASCAR

INDIAN

OCEAN

Coral Sea
Islands Territory
(Australia)

VANUATU

FIJI

AMIBIA

BOTSWANA

MAURITIUS

New
Caledonia
(France)

TROPIC OF CAPRICORN

20°

SWAZILAND

AUSTRALIA

SOUTH
PACIFIC

SOUTH
AFRICA

LESOTHO

Tasman
Sea

OCEAN

30°

Tasmania
(Australia)

NEW
ZEALAND

40°

50°

60°

ARCTICA

70°

Ross
Sea

80°

© Eureka Cartography, Berkeley, CA.

Greenwich
30° 40° 50° 60° 70° 80° 90° 100° 110° 120° 130° 140° 150° 160° 170°

Performing Arts Handbook

The following pages of content were excerpted from *Artsource®: The Music Center Study Guide to the Performing Arts*, developed by the Music Center Education Division, an award-winning arts education program of the Music Center of Los Angeles County.

The following artists and groups are featured in the Performing Arts Handbook.

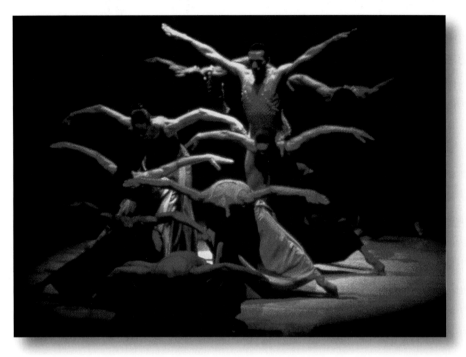

The Alvin Ailey American Dance Theater. Alvin Ailey, founder and choreographer. "Revelations." Photo: Bill Hilton.

The Alvin Ailey Company performs classical ballet and modern works by well-known choreographers, but the group is best known for dances drawn from Alvin Ailey's African-American background. These masterpieces capture the essence of his black experience in America and feature musical themes based on African-American cultural heritage such as blues, spirituals, and jazz. "Revelations," the dance shown on this page, has become the signature piece for the company because it clearly captures the spirit and aesthetics of the company and its creator. The choreography includes different dances, all of which celebrate the human spirit and its ability to overcome adversity.

■ DISCUSSION QUESTIONS

1. The word *revelation* means something that was unknown and is now revealed. Discuss a revelation a person might have while struggling through a difficult situation.
2. Look at the photo on this page. What images come to mind as you study the positions of the dancers? Discuss how unity and variety are demonstrated.
3. Imagine you are going to create a signature piece to represent yourself. Identify three to five traits that describe different parts of yourself. Demonstrate these traits with a gesture or expressive movement. Which ones seem appropriate for your signature piece? Why?

■ CREATIVE EXPRESSION ACTIVITIES

Language Arts Think about Discussion Question 1. Write about a time when you or someone you know had a revelation.

Dance/Theatre After discussing Question 3, find gestural movement that can express each of the personal traits you listed. Choose one you like and abstract it in several different ways by exaggerating the size, doing it in slow motion, giving it a rhythmic pattern, adding a turn or change of level, or performing it as you walk. Share ideas with a partner and discuss what worked best.

Theatre

In the Heart of the Beast Puppet and Mask Theatre

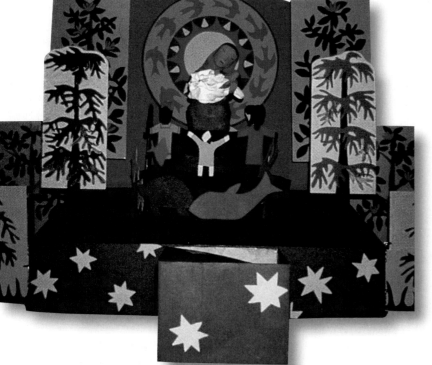

In the Heart of the Beast Puppet and Mask Theatre. Sandy Spieler, artistic director. *On the Day You Were Born,* by Debra Frasier.

The idea for the production of *On the Day You Were Born* began when author/illustrator Debra Frasier approached Sandy Spieler and In the Heart of the Beast Puppet and Mask Theatre to make a mask or puppet to celebrate the publication of her book. The theatre wanted to do a play about the natural wonders of the world and Frasier's book was perfect in both theme and visual style. The story is based on the natural events that unfold on the day a child enters the world. The play combines puppetry, painting, poetry, dance, and music. It celebrates the natural miracles of the earth and extends an enthusiastic welcome to each member of our human family.

■ DISCUSSION QUESTIONS

1. What other rites of passage, in addition to birth, are causes for celebration in our lives?
2. Look at the photo on this page. Identify and describe as many different forms of media as you can.
3. What ideas would you include in a song, book, or poem that welcomes a new child into the world? Think of ways to include some natural forces such as wind or sun in your welcome.

■ CREATIVE EXPRESSION ACTIVITIES

History Research how different cultures celebrate birth. Make a list of the various rituals or customs.

Language Arts Visit the library to locate and read a newspaper published on the day you were born. Select ten items from that issue to describe in a journal or story.

Art Topics in the glossary of Frasier's book include: migration, rotation, gravity, the moon's phases, rising and falling tides, sunlight, and photosynthesis. Using mixed media, design a collage that captures one of these themes from nature.

Duke Ellington with singer Vikki Carr. Photo: Courtesy of The Music Center Operating Company Archives. Otto Rothchild Collection.

Duke Ellington is an American Jazz legend who composed his first piece, "Soda Fountain Rag," while still a teenager. Born in 1899, he showed promise in art as well as music. He decided to pursue a career in music, eventually organizing his own band that he led for 50 years. He and his band revolutionized the concept of jazz, elevating it to a new level. One of his compositions, "The Prowling Cat," is a short, playful, swinging tune for solo trumpet. The piece begins with trumpet sounds like a cat howling in the night. At the end, the trumpet plays its highest notes and then the full band joins in for the finale.

■ DISCUSSION QUESTIONS

1. What qualities of the trumpet could be used to capture the sounds of a prowling cat? What other instruments could also be used?
2. Think of the characteristics of a cat. What words or phrases describe the quality, actions, and tempo of a prowling cat?
3. The basic elements of jazz include: *syncopation, improvisation, blue notes, break,* and *riff*. Find a definition and give an example of each. Listen to jazz music and see if you can identify any of these elements.

■ CREATIVE EXPRESSION ACTIVITIES

Music Listen to some examples of Duke Ellington's work. Identify the basic elements of syncopation, improvisation, blue notes, break, and riff. Explain how they impact the music.

Music Listen to music about cats written by other composers, such as: "The Waltzing Cat" by Leroy Anderson; "Gellico Cats" from the musical *Cats* by Andrew Lloyd Webber; "Royal March of the Lions" from *Carnival of the Animals* by Saint-Saens. Notice how each composer used voices and/or instruments to suggest the sounds and movements of cats. Select two, then compare and contrast your findings.

ART SOURCE
ARTSOURCE

PERFORMING ARTS

Bali and Beyond, Creative World Cultures. Cliff DeArment and Maria Bodmann. "Sumer Time." Photo: Cliff DeArment.

The musical group called Bali and Beyond embraces music from the East Indies and combines it with American music. This unique style creates extraordinary sounds that go beyond the familiar aspects of Western music. Fusing the ancient tradition of Hindu-Buddhist Asia with a contemporary spirit, Bali and Beyond creates new and exciting pieces from early cultural sources. One of their pieces, "Sumer Time," is a version of George Gershwin's classic "Summertime" from the musical *Porgy and Bess.* The group incorporates many different combinations of ancient instruments. For example, the sound of the Gamelan Gender Kantilan (a metal bar instrument like the xylophone) is combined with the modern sound of the saxophone.

■ **DISCUSSION QUESTIONS**

1. Name and describe some familiar bar instruments such as the xylophone, similar to the Indonesian ones described.
2. The traditional Gamelan Indonesian ensemble is made up of bar instruments, bamboo flutes, gongs, zithers, Indonesian violins, cymbals, balls, reed horns, log drums and a variety of other percussion instruments. What instruments might an American jazz ensemble use?
3. Study the photo on this page. Describe the instruments pictured. Put each instrument into one of the following four categories: metal and wood; drums; flutes, saxophone, and bassoon; violin and cello.

■ **CREATIVE EXPRESSION ACTIVITIES**

Language Arts Shadow puppetry has been a part of the Balinese culture for over one thousand years. Read about this ancient art form and learn about the significance of the Gamelan in relationship to this art form.

Art Just as visual artists work with a palette of colors in creating their works of art, musicians also have a variety of sounds with which to work. Find sound sources in your environment by experimenting with ordinary objects and hitting, blowing, plucking, or shaking them to hear their tone color. Try using wooden pencils tapped on tables or running fingers up and down venetian blinds.

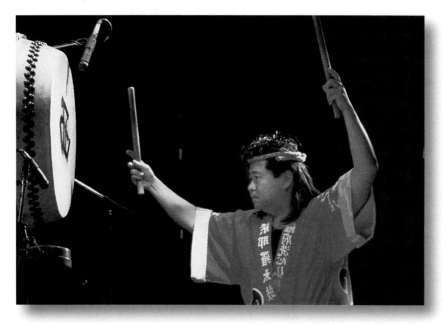

Japanese Festival Sounds. John Y. Mori, artistic director.
Photo: Craig Schwartz © 1989.

John Y. Mori was fascinated by the Taiko drummer who accompanied the folk dancers at the annual Obon Buddhist Festival in Los Angeles. This inspired him to learn to play the drums. Today he blends traditional Taiko drumming with a modern Japanese-American style. Taiko drumming originated in ancient India as part of religious ceremonies and celebrations. This form eventually found its way to Korea, China, and Japan. Traditionally, Taiko drums were included in ensembles with other instruments. In some cultures the drums were also used to perform functional roles, such as announcing the time of day or calling people to special gatherings. Today, Taiko is featured in performances with some ensembles composed solely of various sized drums.

■ DISCUSSION QUESTIONS

1. Where did Taiko drumming originate? To what other countries did it spread?
2. Taiko performers demonstrate great skill and control in movement and drum technique. Their performance skills are a result of many hours of concentrated, vigorous work involving the mind, body, and spirit. Discuss how Taiko drummers are like athletes and dancers.
3. What other cultures place an emphasis on drumming? For what purposes are the drums used?

■ CREATIVE EXPRESSION ACTIVITIES

Language Arts The technique of learning drum patterns by vocalizing the sounds began in India and was transferred to many Asian cultures. Five basic syllables used in Taiko are: KA; KARA; DON; DOGO; and SU (which means *rest*). Combine the syllables in different patterns, saying them as you clap or beat out the rhythms. Repeat each pattern several times.

Geography Using a map or globe, trace the geographical and historical route of the Taiko drums from India through Asia to the United States.

Music Learn about and try the three basic techniques for playing percussion instruments: striking, shaking, or scraping.

Dance

Ballet Folklorico de Mexico

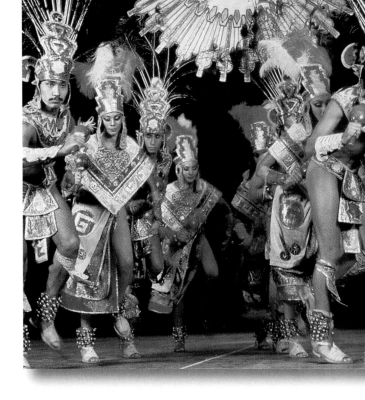

For over 25 years, the Ballet Folklorico de Mexico has presented authentic folk dances from different ethnic groups within Mexico. Amalia Hernández, the featured director of the dance group shown on this page, creates exciting dances based on ancient traditions. From the time of the Olmec Indians to the birth of modern Mexico, more than thirty distinct cultures have influenced Mexican culture. The dance shown in this photo is called "Los Mitos" and features the pageantry and ritual of these cultures before the arrival of the Spaniards.

Ballet Folklorico de Mexico. "Los Mitos."
Amalia Hernández, artistic director.

■ DISCUSSION QUESTIONS

1. Compare the headdress of the dancers to the headdress of the Zapotecan goddess on page 80 in your book. What similarities do you see in the patterns and symbols?
2. What symbolism do you see in the photo on this page that inspired ancient cultures of Mexico? What characteristics of the symbol can you name?
3. After viewing the video, describe how the dancers used geometric spatial designs.

■ CREATIVE EXPRESSION ACTIVITIES

Dance Stand in an open area with 6–8 students and organize yourselves into three different geometric shapes, selecting from a circle, square, triangle, or the letter X. After your designs are organized, choose two that you like and walk or skip from one figure into another using 8 counts to travel.

Language Arts Write a personal reflection of your impressions and feelings about either the images you see in the illustration on this page or of the dance in the video.

PERFORMING ARTS

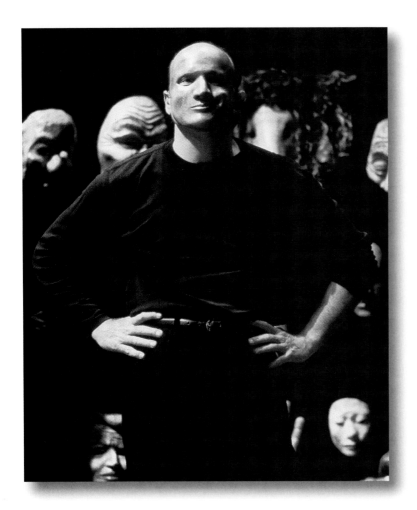

Faustwork Mask Theater was founded in 1983 by Robert Faust, artistic director, actor, athlete, dancer, choreographer, and mask-maker. *The Mask Man* is a solo performance about masks that simultaneously entertains and educates. The set is a wall of masks, all original creations by Robert Faust. First comes a brief introduction about the many uses of masks throughout the world. Then the performer demonstrates their power by removing the masks from the wall one by one, and assuming the character expressed in each face. A variety of characters spring to life. Through the parade of almost twenty characters, the audience glimpses human nature at its silliest and most touching.

Faustwork Mask Theater. *The Mask Man.*
Robert Faust, artistic director.
Photo: Craig Schwartz, © 1993.

■ DISCUSSION QUESTIONS

1. The photo on this page shows Robert Faust with masks from *The Mask Man.* Study the expression of the masks. What kinds of personalities are being shown? What can you tell about the character's age, culture, and personality traits from the mask alone?
2. How might a mask be used in the theatre?
3. The first Greek masks were used in plays to impersonate gods. What Greek gods and goddesses can you name? What were their attributes or symbols?
4. Masks are often part of festivals, celebrations, and rituals. Describe activities you have participated in that used masks.

■ CREATIVE EXPRESSION ACTIVITIES

Language Arts Read Greek myths or Greek stories such as "Theseus and the Minotaur" or "The Golden Fleece." How might masks be used in these works?

Physical Education The ancient Greeks invented the first Olympic Games over 2,500 years ago. Plan a classroom Olympics with events from the original Greek games such as running, long-jump, and javelin.

Art Create a two-sided mask showing contrasting feelings on each side. You might choose happy and sad, or good and evil. Think of movements to go with your mask to express each emotion.

Dance/Music

Ranganiketan Manipuri Cultural Arts Troupe

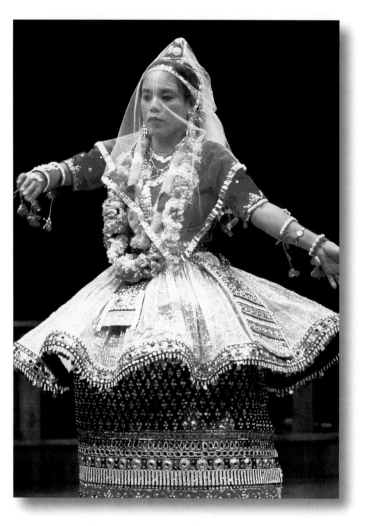

The tiny community of Manipur, called the "Jewel of India," is a secluded state. It is tucked into an oval-shaped valley in the Himalayan mountains of India. The ancient culture here has been preserved intact for thousands of years. Traditions are carefully passed on from one generation to the next by master artists and teachers. "Rasa Lila" is a classical dance believed to have been created by the Hindu god Krishna. The specific form of the dance was communicated to King Jai Singh through a dream with specific descriptions of movements, style, and costumes. Performed in the spring at the Festival of Colors, the dance begins in the early evening and continues for eighteen hours.

Ranganiketan Manipuri Cultural Arts Troupe. Dr. T.D. Singh, founder and director. "Vansanta Rasa Lila." Photo: Craig Schwartz, © 1992.

■ DISCUSSION QUESTIONS

1. Study the photo of the costumed dancer performing "Vansanta Rasa Lila." Describe the details of her dress.
2. The people of Manipur believe that everything is divinely inspired, including all of their artistic expressions. What do you think this means?
3. From an early age, young children commit to an honored and respected relationship with a specific master teacher. If you were a master teacher to a young child, what important ideas would you want to teach him or her?

■ CREATIVE EXPRESSION ACTIVITIES

Dance The dances of India incorporate gestures that symbolize an idea or image. Create gestures to show the concept of the following words: tree, mountain, stream, rain, boat, friend, fish. Make up three more words and gestures. Share and combine them with gestures from classmates.

Language Arts Select a simple story or poem about something in nature. Make up gestures and movement that are performed as the story is told. Add music if you wish.

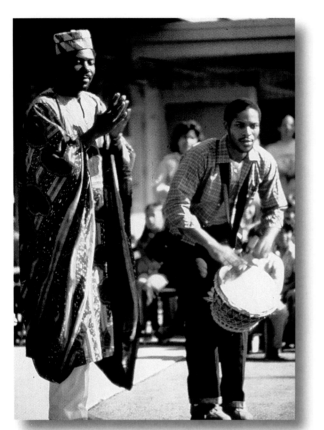

During the infamous Middle Passage of the 1700s, black people from Africa were transported to many different lands. They carried the traditions and customs of several different racial and ethnic groups with them. All of the dance styles from countries such as Brazil, the Caribbean, and black Africa, as well as those from black America, were impacted by this movement of peoples. Every year Chuck Davis journeys to Africa and "sits at the feet of the elders." He researches the history of specific ethnic groups and their dances, music, and songs. His work is an African-American interpretation of authentic material from Africa. The result is a blending of styles and movement in the dances he creates.

The African American Dance Ensemble. Chuck Davis, artistic director and choreographer. "African Diaspora." Photo: Lee Hanson.

■ DISCUSSION QUESTIONS

1. The dance called "African Diaspora," which means "scatter widely," expresses a connection to Africa wherever black people traveled. Name the countries where you think African culture has had a major impact.
2. Study the photo of Mr. Davis. Describe what he is wearing and discuss how it is similar to or different from American outfits. What ideas or words would you use to describe his facial expressions and arm gestures?
3. What dance styles do you think have their roots in traditional African cultures?

■ CREATIVE EXPRESSION ACTIVITIES

Language Arts In many African ethnic groups, it is believed that wise people speak in proverbs and that everything has a place in life and a reason for being. Read the following proverbs, and then think of English equivalents: "Rain beats a leopard's skin, but it does not wash out the spots."(Ashanti); "When spider webs unite, they can tie up a lion." (Ethiopia); "Cross the river in a crowd and the crocodile won't eat you." (Kenya).

Social Studies Most African groups have ceremonies that celebrate life passages. Create a Naming Ceremony for you and your classmates. Select a name for yourself that tells something of your character, appearance, accomplishments, or history. Include a special song and movements.

When Paul Salamunovich joined the Boys Choir of St. James Catholic Church he was first exposed to Gregorian Chant. His early experience with music of the Middle Ages became a lifelong devotion. Salamunovich met famed choral director Roger Wagner when he served at St. James Church as guest conductor. Thus began a close lifetime association. Salamunovich joined Wagner's Los Angeles Youth Choir, a choral group that formed the nucleus for the Roger Wagner Chorale. The Chorale eventually became the Los Angeles Master Chorale with Salamunovich as its director. With mutual respect for Gregorian Chant, both Wagner and Salamunovich have infused the sounds of the Chorale with the beauty and basic traditions of Gregorian Chant.

The Los Angeles Master Chorale. Paul Salamunovich, director. Gregorian Chant. Photo: Robert Millard, Courtesy of the Los Angeles Master Chorale.

■ DISCUSSION QUESTIONS

1. Gregorian Chant is known for its pure, unaccompanied, non-rhythmic melodic lines. This is in direct contrast to most contemporary music. Why do you suppose Gregorian Chant has recently become popular again?
2. Early Gregorian Chants were performed solo or by groups of voices singing in unison. Name some chants, usually performed in unison, that you might hear today.
3. One style of Gregorian Chant—called Melismatic—is when the singer(s) sing several notes on one syllable of a word. Identify some modern music styles that also use this style.

■ CREATIVE EXPRESSION ACTIVITIES

History It is believed that Gregorian Chant was named for Pope Gregory I, who organized existing chant into a unified body. Identify another historical figure who has influenced an event that was then named for that person.

Music Trained singers are able to ornament, or add extra notes, to a simple Gregorian Chant, adding interest to the performance. Compare this practice with performances by contemporary popular singers.

Art Discuss the contributions of music and art to the Church during the Middle Ages.

The Guthrie Theatre Ensemble and Cityscape. Jennifer Tipton, director. *The Tempest*, by William Shakespeare, 1991 Production. Photo: Michal Daniel

The story in *The Tempest*, a play by William Shakespeare, unfolds on an enchanted island where Prospero, the rightful Duke of Milan, has found refuge with his daughter Miranda. With his art and magic, and the help of the spirit Ariel, Prospero brings his enemies to the isle. There he brings them to justice and spiritual redemption. In this world of fantasy, Shakespeare brings to life a story of love, revenge, despair, hope, and wisdom. These elements are combined in a delicate web of poetry, imagination, and charms. Director Jennifer Tipton assembled a team of internationally acclaimed artists for this production. She created an island world reflecting the elements of nature and art, inspired by their interpretation of Shakespeare's play.

■ DISCUSSION QUESTIONS

1. The photo on this page depicts a scene from *The Tempest*. Study the characters and their postures and relationships to each other. Discuss what you think might be happening between them.
2. At the end of *The Tempest* Prospero gives up his magical powers and returns to the world of men. Discuss reasons why someone would want to give up magic and return to the real world.
3. Themes highlighted by the director of the play includes mirrors, shadows, and dreaming. The island in *The Tempest*, like a stage, is a place for dreams. Think about this statement and discuss whether or not you agree.

■ CREATIVE EXPRESSION ACTIVITIES

Language Arts Work with a group to select a Shakespearean sonnet and perform it as choral reading. Highlight the poetry and rhythm of the verse. You may have all voices reading in unison, solos, or combinations.

Dance The Guthrie Theatre production of *The Tempest* incorporates the movement technique of mirroring in the staging of the play. With a partner, practice creating mirror images and movements.

Language Arts Explore some of Shakespeare's most well-known quotations and discuss their meanings. For example, consider Jaques' statement in a scene from *As You Like It*, "All the world's a stage, and all the men and women merely players." (Act 2, Scene 7)

ART SOU RC ARTSOURCE

PERFORMING ARTS

Diana Zaslove, Lyric Soprano. 16th- and 17th-Century Music. Photo: Courtesy of Diana Zaslove.

Singer Diana Zaslove performs popular songs of the sixteenth and seventeenth centuries. The mood of this dynamic time following the Renaissance was one of optimism and discovery. During this period composers began to emphasize the expressiveness of the human voice as a solo instrument. Poetry and music were combined to express a variety of emotions, especially aspects of love. Before the Renaissance, most music was written for the church to express religious, or sacred, themes. Now, for the first time, music was written to express the human spirit and worldly, or secular, themes. The lute, similar to the guitar, was the most popular instrument of this period and was often used to accompany singers.

■ DISCUSSION QUESTIONS

1. Notice the relaxed quality of the singer's dress. Discuss how the type of music she sings is reflected in her dress and manner.

2. Composers of this period wrote music for more than one solo voice, sometimes for up to four or five voices in harmony. Before this time, the instruments usually played the same part that was being sung. Now the vocalist would sing the melody while the lute player carried the parts of all the other voices. This allowed the beauty of *all* the harmony parts to be heard. Discuss how Renaissance ideas allowed for the development of harmony.

■ CREATIVE EXPRESSION ACTIVITIES

Language Arts Write a rhythmical poem that expresses an aspect of love, such as friendship, loss, devotion, or romance. If you wish, set it to music.

Music/Dance Instrumental music and dance of this period were intimately connected. Many of the patrons who supported musicians were people of wealth and power. They commissioned works for special occasions that often included dancing. Research some dance forms such as the galliard, pavane, ronde, or bergerette. Make a comparison between these and other popular folk dance forms such as the jig and reels that use partners, lines, and circles.

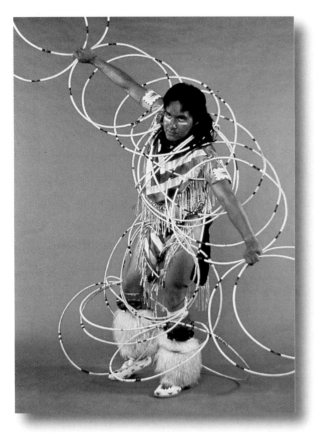

Hanay Geiogamah was born in Anadarko, Oklahoma. He was raised with the traditions of the Kiowa Tribe. As he grew up, his interest in his traditional culture increased. At first he sought ways to express himself and communicate about his culture through drama. In 1987, Geiogamah and Barbara Schwei formed the American Indian Dance Theatre. The dance shown in the photo on this page is the "Hoop Dance." It is based on a legend of a dying man who wished to leave something on earth. The Creator gave him a hoop of wood and told him that for each natural form he could recreate, one more hoop would be added. As he danced, he grew stronger, for each additional hoop allowed him to create other designs.

American Indian Dance Theatre, Hanay Geiogamah, artistic director. Eddie Swimmer performing "Hoop Dance." Photo: Don Perdue.

■ DISCUSSION QUESTIONS

1. Study the photo of the hoop dancer. Describe what natural form he appears to be showing. What other natural forms might be included in the hoop dancer's repertoire?
2. The "Hoop Dance" was originally designed to teach stories of creation. As many as 40 reed hoops are manipulated to show how all natural things are connected, yet everything grows and changes. Discuss how a dancer might move with the hoops to create different ideas without ever losing the beat of the music.
3. Mr. Geiogamah has developed a system for categorizing American Indian dance. These categories are: *seasonal/functional; spiritual/ceremonial;* and *celebrational/ bravura.* Discuss what you think each of these categories means and the type of dance that would be included.

■ CREATIVE EXPRESSION ACTIVITIES

Art Make a drawing of a hoop dance. Start with the pose of the hoop dancer shown in the photo. Then draw a series of ten or more drawings showing the dancer in slightly different positions. Combine the drawings to create an animated progression of positions.

Language Arts Read this statement by the hoop dancer and expand on it, "When I started dancing, I discovered that my hoops had stories in them and the shapes I made could…"

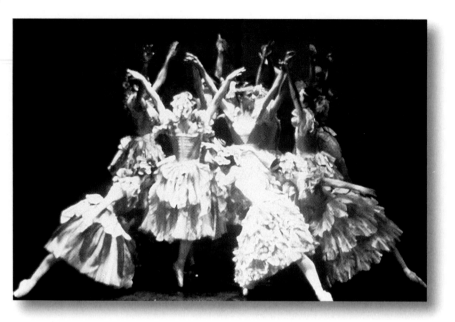

The Joffrey Ballet. Gerald Arpino, artistic director. *The Nutcracker,* "Waltz of the Flowers." Photo: Herbert Migdoll.

The Nutcracker is a traditional holiday ballet, treasured all over the world. The dance was inspired by the musical score of Tchaikovsky and based on a delightful story by E.T.A. Hoffman, *The Nutcracker* and *The King of the Mice.* Hoffman's story was written in 1851 and then rewritten and simplified in 1890 by the Russian choreographer Marius Petipa. Petipa then presented the script to Tchaikovsky for the score. This production of the ballet was conceived and directed by Robert Joffrey with special choreography by Gerald Arpino. The Joffrey Ballet gives an American interpretation of the story. Their special production emphasizes its international cultural heritage by combining the classic tale with modern dance concepts.

■ **DISCUSSION QUESTIONS**

1. Have you seen a version of *The Nutcracker*? If so, describe what you remember of the story and the dance interpretation.
2. Study the photo of the dancers performing "The Waltz of the Flowers." Describe the costumes and discuss how a costume designer might create outfits so that performers can move and dance easily.

■ **CREATIVE EXPRESSION ACTIVITIES**

Art In a small group, listen to a specific section of the music or take a specific section of the story. Brainstorm ideas on how to create the sets, props, costumes and lighting. Each person should take one of the roles and all group members then work in collaboration to draw sketches and discuss their vision of the scene.

Mime Create a mime or movement study based on toys and how they might move if animated. These might include: yo-yos, kites, balls, plastic clay, different types of dolls, jack-in-the-box; or action figures.

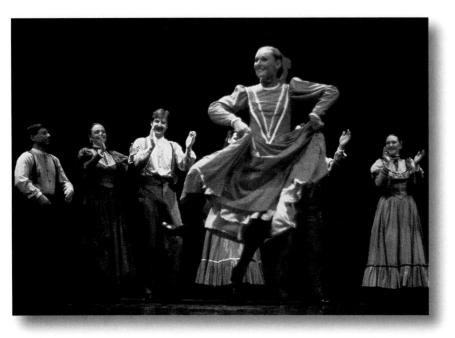

AMAN International Folk Ensemble. Jerry Duke, choreographer. "Suite of Appalachian Music and Dance." Photo: Craig Schwartz.

AMAN International Folk Ensemble was founded in 1964. Its purpose is to research, preserve, and present traditional dance, music, and folklore of the many diverse ethnic groups in America. The "Suite of Appalachian Music and Dance" shown in the photo gives a perspective on different dance forms found in the Appalachians, a far-reaching geographical area east of the Mississippi. The style and costuming is set around the turn of the nineteenth century. Dance styles range from stiff and formal postures of the north to stronger upper body movements of southern dances. The later dances have a West African influence.

■ DISCUSSION QUESTIONS

1. Study the photo of dancers on this page. What do the costumes tell you about the historical time period of the dance?
2. Find a book of Appalachian folksongs and study the lyrics. Discuss the lyrics and how they often tell a story.
3. Discuss how dance and music help a community establish common traditions that form a culture.

■ CREATIVE EXPRESSION ACTIVITIES

Dance Circle dances were often used in Appalachian dances. Create a circle dance that uses some of the following ideas: around, moving in and out, bridges, spirals, circles inside of circles. Choose 8 counts or 16 counts for each movement.

Art A wooden, jointed dancing puppet is used as the rhythmic accompaniment to the dance. Use wood and paint to create your own simple dancing puppet. Loosely attach arms and legs to the body with nails or screws. Use a dowel to wedge through a hole in the center of the puppet and a flexible piece of wood or plastic to place under it. Use a rhythmic flicking motion to animate the puppet as you move it up and down.

This ballet is based on the notorious outlaw Billy the Kid. It is the first time that American themes, music, and movements were used in a classical ballet. Choreographer Eugene Loring began the process of choreographing by organizing the events of Billy's life. He placed events sequentially into scenes and then determined their dramatic impact and length. He then sent these plans to Aaron Copland in Paris. Copland used them to create his musical score which is based on themes from cowboy songs. The work was premiered by a small group who danced all the parts, changing both their costumes and the lighting each time the scene changed. The score was played on two pianos. The ballet was so successful that Mr. Loring was featured on the cover of *Life Magazine* in 1938.

The Joffrey Ballet. Eugene Loring, choreographer. Tom Mossbrucker dancing *Billy the Kid*, composed by Aaron Copland. Photo: Herbert Migdoll.

■ **DISCUSSION QUESTIONS**

1. The ballet begins with the "Opening March" showing pioneers traveling westward, and is composed of various actions, or motifs, inspired by the activities in their daily life. Discuss what activities would be shown. Describe some of the basic movements involved with each activity.

2. Discuss how a composer might translate a cowboy song into the classical music style for an orchestra. What changes would need to be made to the song?

3. Study the photograph on this page and describe the costume. Discuss how it has been stylized to represent a cowboy of the old West. What ideas does it capture?

■ **CREATIVE EXPRESSION ACTIVITIES**

Theatre Choose characters from the Old West and show three different poses for each. Move from one position to the next, making four-count transitions. Combine characters to form group portraits.

Mime List activities of pioneer life, such as chopping, sawing, baking, sewing, and pulling a cart. Mime each of these ideas separately. Then develop a sequence of movements that includes four or five of these activities.

History Sometimes dances have to be reconstructed. *Billy the Kid* is a ballet that has been preserved as a historical piece. Each time a company wants to perform it, they must get permission and then have a reconstructionist come. Research how dances are reconstructed and find out how technology helps this process.

Simply Maria, or The American Dream. Josefina López, playwright. Actors left to right: Margarita Cota, Daniel Mora, Claire Engel, Andres Monren, Albert Loredo, Leila Knox, Connie Collier, Don Loper. Photo: Courtesy of the Playwrights Project.

Simply Maria, or The American Dream is a one-act play about a young Hispanic girl's struggle to find her own sense of self. She finds freedom by challenging the traditional part of her heritage. The main character, Maria, finds herself living in dual cultures—the Mexican traditions of her former homeland and the newfound liberty of the United States. Ms. López weaves her tale between dream sequences and realistic experiences. The play includes a range of characters from the familiar to the symbolic. *Simply Maria* gives a unique perspective on the universal journey of adolescence with a powerful and inspirational message.

■ DISCUSSION QUESTIONS

1. Have you ever felt that you needed to free yourself from a gender or cultural stereotype? Describe the situation and discuss the limitations involved.

2. Do you feel women are expected to fulfill traditional or cultural roles? Has this changed throughout history or in different cultures?

3. Study the photograph and create a simple scenario of what you think is happening. Keep your idea connected to the basic premise of the play, as described above.

■ CREATIVE EXPRESSION ACTIVITIES

Language Arts Make a list of all the roles a person plays in life. Choose one role and write a brief paragraph describing a problem you might face in that role.

History Select a social studies unit to dramatize. Choose characters of historical interest to portray. For example, if the American Revolution were selected, historical characters could be John and Abigail Adams, Ben Franklin, or Thomas Jefferson. Scenes might include the Boston Tea Party or signing of the Declaration of Independence.

Art Use illustrations or paintings of different settings to make up stories that could only happen in those settings.

Artists and Their Works

Artists and Their Works

Glossary

A

Abstract Expressionism An art style in which paint was dribbled, spilled, or splashed onto huge canvases to express a feeling. (Ch. 17–3)

Abstract work A work in which the artist uses a recognizable subject but portrays it in an unrealistic manner. (Ch. 9–1)

Adobe (uh-**doh**-bee) Sun-dried clay. (Ch. 6–3)

Aesthetic view (ess-**thet**-ik) An idea, or school of thought, on what is important in a work of art. (Ch. 3–1)

Amphora (**am**-fuh-ruh) A twin-handled vase. (Ch. 7–1)

Aqueduct (**ak**-wuh-duhkt) A network of channels meant to carry water to a town or city. (Ch. 7–3)

Arabesques (ar-uh-**besks**) Swirling geometric patterns of plant life used as decoration. (Ch. 8–3)

Arbitrary colors (**Ahr**-buh-trehr-ee) Colors chosen to communicate different feelings. (Ch. 15–1)

Architecture The planning and creating of buildings. (Ch. 2–3)

Art criticism Studying, understanding, and judging works of art. (Ch. 3–1)

Art history The study of art from past to present. (Ch. 3–3)

Artifacts Simple handmade tools or objects. (Ch. 6–1)

Art movement A trend formed when a group of artists band together to create works of a single style. (Ch. 14–3)

Ashcan School The popular name given to the group of artists who made realistic paintings of working-class America. (Ch. 16–3)

B

Balance A principle of art concerned with arranging the elements so that no one part of a work overpowers, or seems heavier than, any other part. (Ch. 1–3)

Baroque (buh-**rohk**) An art style emphasizing movement, contrast, and variety. (Ch. 12–1)

Binder A liquid that holds together the grains of pigment in paint. (Ch. 2–1)

Buttress A brace or support placed on the outside of a building. (Ch. 10–3)

C

Calligraphy (kuh-**ligg**-ruh-fee) A method of beautiful handwriting sometimes using a brush. (Ch. 8–3)

Castles Fortlike dwellings with high walls and towers. (Ch. 10–1)

Cathedral A large, complex church created as a seat of office for a bishop. (Ch. 10–3)

Coiled pot A pot formed by coiling long ropes of clay in a spiral. (Ch. 13–1)

Collage (kuh-**lahzh**) An art work made up of bits and pieces of two-dimensional materials pasted to a surface. (Ch. 8–4)

Color An element of art that refers to what the eyes see when light is reflected off an object. (Ch. 1–1)

Composition The way the art principles are used to organize the art elements of color, line, shape, form, space, and texture. (Ch. 3–1)

Concrete A finely ground mixture of small stones and powdered minerals used in building. (Ch. 7–3)

Content The idea, feeling, mood, or message expressed by an art work. (Ch. 3–1)

Contour drawing (**kahn**-toor) Drawing an object as though your drawing tool is touching the edges of the form. (Ch. 11–2)

Cradle board A harness worn on the shoulders and used to carry a small child. (Ch. 13–1)

Crafts The different areas of applied art in which craftspeople work. (Ch. 2–3)

Cubism An art style in which objects and the space around them are broken up into different shapes and then put back together in new relationships. (Ch. 10–1)

Culture The ideas, beliefs, and living customs of a people. (Ch. 4–1)

D

Dada (**dahd**-ah) An art movement founded on the belief that Western culture had lost its meaning. (Ch. 17–1)

E

Edition A series of identical prints made from a single plate. (Ch. 2–1)

Effigy (**eff**-uh-jee) An image that stands for ideas or beliefs. (Ch. 6–1)

The Eight A group of New York artists who created art work that reflected the spirit of the times in which they lived, the early 1900s. (Ch. 16–3)

Emphasis A principle of art concerned with making an element or object in a work stand out. (Ch. 1–3)

Etching An intaglio print made by scratching an image onto a specially treated copper plate. (Ch. 12–3)

Expressionism (ek-**spresh**-uh-niz-uhm) A style that emphasized the expression of innermost feelings. (Ch. 16–1)

F

Facade (fuh-**sahd**) The outside front of a building. (Ch. 12–1)

Face mask A mask worn to hide the identity of the wearer. (Ch. 9–3)

Fauvism (**fohv**-iz-uhm) An art movement in which artists use wild, intense color combinations in their paintings. (Ch. 16–1)

Form An element of art that refers to an object with three dimensions. (Ch. 1–1)

Freestanding sculpture Sculpture surrounded on all sides by space. (Ch. 2–3)

Fresco (**fres**-koh) A painting created when pigment is applied to a section of wall spread with fresh plaster. (Ch. 10–3)

Frieze (**freez**) A decorative band running across the upper part of a wall. (Ch. 7–1)

Funerary urns (**fyoo**-nuh-rehr-ee) Decorative vases or vessels found at burial sites. (Ch. 6–2)

G

Gargoyle A projecting ornament on a building carved in the shape of a fantastic animal or grotesque creature. (Ch 10–4)

Genre pieces (**Zhahn**-ruh) Art works that focus on a subject or scene from everyday life. (Ch. 6–1)

Glaze Glass-like finish on pottery. (Ch. 5–1)

H

Hard-Edge painting An art style that emphasized clear, crisp-edged shapes. (Ch. 17–3)

Harmony A principle of art concerned with blending elements to create a more calm, restful appearance. (Ch. 1–3)

Headpieces Masks carved of wood and worn on the head like a cap. (Ch. 9–3)

Hieroglyphic (**hy-ruh**-glif-**ik**) An early form of picture writing. (Ch. 4–3)

I

Illuminations Hand-painted book illustrations. (Ch. 10–1)

Impressionism An art style that attempted to capture the rapidly changing effects of light on objects. (Ch. 9–2)

K

Kachina A hand-carved statuette that represents spirits in Pueblo rituals. (Ch 13–1)

Kinetic art (kuh-**net**-ik) An art style in which parts of works are set into motion by a form of energy. (Ch. 17–5)

L

Landscape A drawing or painting focusing on mountains, trees, or other natural scenery. (Ch. 14–1)

Line An element of art that refers to the path of a moving point through space. (Ch 1–1)

Linear perspective (puhr-**spek**-tiv) The use of slanted lines to make objects appear to extend back into space. (Ch. 11–1)

Loom A frame holding a set of crisscrossing threads. (Ch. 13–2)

M

Madonna A work showing the Virgin Mary with the Christ Child. (Ch 11–1)

Media The plural of *medium*. (Ch 2–1)

Medium of art A material used to create a work of art. (Ch. 2–1)

Glossary

Megaliths Large stone monuments, such as Stonehenge in England. (Ch. 4–1)

Menus Drop-down boxes on the computer screen that list selections available in software programs. (Ch. 2–4)

Mihrab (**meer**-ahb) A highly decorated nook found in a mosque. (Ch. 8–3)

Minaret (min-uh-**ret**) A slender tower from which Muslims are called to prayer. (Ch. 8–3)

Mixed media The use of more than one medium in a work of art. (Ch. 3–1)

Mobile (**moh**-beel) A sculpture made of carefully balanced shapes hung on wires. (Ch. 17–3)

Monolith (**mahn**-uh-lith) A structure created from a single stone slab. (Ch. 6–3)

Mosque A Muslim house of worship. (Ch. 8–3)

Motif (moh-**teef**) Part of a design that is repeated over and over in a pattern or visual rhythm. (Ch. 6–2)

Movement A principle of art used to create the look and feeling of action and to guide a viewer's eye throughout the work. (Ch. 1–3)

Multi-media art A work that makes use of tools and techniques from two or more areas of art. (Ch. 17–5)

Muralist An artist who paints large art works directly onto walls or ceilings. (Ch. 16–3)

N

Neoclassic (nee-oh-**klas**-ik) An art style that borrowed from the early classical period of ancient Greece and Rome. (Ch. 14–1)

New Realism An art movement that rediscovered the importance of realistic detail. (Ch. 17–3)

Non-objective Having no recognizable subject matter. (Ch. 2–1)

Non-objective art (nahn-uhb-**jek**-tiv) Art works in which no objects or subjects can be readily identified. (Ch. 1–2), (Ch. 16–1)

O

Oil paint A mixture of pigment, linseed oil, and turpentine. (Ch. 11–3)

Op art An art style that made use of precise lines and shapes to create optical illusion. (Ch. 17–4)

Optical colors Colors viewers actually see. (Ch. 15–1)

P

Pagoda (puh-**gohd**-uh) A tower several stories high with roof curving slightly upward at the edges. (Ch. 5–3)

Papier-mâché (pap-yah-muh-**shay**) A sculpting technique using newspaper and liquid paste. (Ch. 9–4)

Perceive To become aware of through the senses of the special nature of objects. (Ch 5–1)

Perceiving To become aware of through the senses.

Petroglyphs (**peh**-truh-glifs) Rock carvings and paintings. (Ch. 13–1)

Pietà (pee-ay-**tah**) A work showing Mary mourning over the body of Christ. (Ch. 11–1)

Pigment A finely ground powder that gives every paint its colors. (Ch. 2–1)

Pixels Individual squares on the computer screen. (Ch. 2–1)

Pointed arch A curved arrangement of stones reaching up to a central point. (Ch. 10–3)

Pointillism (**poynt**-uh-liz-uhm) A technique in which small, carefully placed dots of color are used to create forms. (Ch. 15–2)

Polychrome (**pahl**-ee-krohm) Having many colors. (Ch. 13–3)

Porcelain (**pore**-suh-luhn) A fine-grained, high-quality form of pottery. (Ch. 5–1)

Portfolio A pad of drawing paper on which artists sketch, write notes, and refine ideas for their work. (Ch 1–1)

Portrait A painting of a person. (Ch. 12–1)

Post and lintel system (**lint**-uhl) An approach to building in which a crossbeam is placed above two uprights. (Ch. 4–3)

Post-Impressionism An art movement that appeared after the Impressionists. (Ch. 15–1)

Printing plate A surface onto or into which the image is placed. (Ch. 2–1)

Printmaking A technique in which an inked image from a prepared surface is transferred onto another surface. (Ch. 2–1)

Proportion A principle of art concerned with the relationship of one part to another and to the whole. (Ch. 1–3)

Pueblos Stacked, many-family dwellings made of adobe. (Ch. 13–1)

R

Realism A style of art in which everyday scenes and events are painted as they actually look. (Ch. 15–3)

Regionalism (**reej**-uhn-uhl-iz-uhm) An art style that records local scenes and events from an artist's own region, or area, of the country. (Ch. 16–3)

Relief sculpture Sculpture partly enclosed by space. (Ch. 2–3)

Renaissance (ren-uh-**sahns**) A period of great awakening. (Ch. 11–1)

Rhythm A principle of art concerned with repeating an element to make a work seem active or to suggest vibration. (Ch. 1–3)

Rococo (ruh-**koh**-koh) An art style stressing free, graceful movement; a playful use of line; and bright colors. (Ch. 12–3)

Romanticism (roh-**mant**-uh-siz-uhm) A style of art that found its subjects in the world of the dramatic and exotic. (Ch. 14–1)

Round arch A curved arrangement of stones over an open space. (Ch. 7–3)

S

Salon (suh-**lahn**) An annual exhibition of art. (Ch. 14–3)

Sand painting The pouring of different colors of powdered rock on a flat section of earth to create an image or design. (Ch 13–3)

Screen A partition used as a wall to divide a room. (Ch. 5–3)

Scroll A long roll of illustrated parchment or silk. (Ch. 5–1)

Shape An element of art that refers to an area clearly set off by one or more of the other elements of art. (Ch. 1–1)

Shoulder masks Large, carved masks made to rest on the shoulders of the wearer. (Ch. 9–3)

Sketchbook A carefully selected collection of art work kept by students and professional artists. (Ch. 2–1)

Social protest painting An art style that attacked the ills of big-city life. (Ch. 17–3)

Solvent A material used to thin a paint's binder. (Ch. 2–1)

Space An element of art that refers to the distance between, around, above, below, and within things. (Ch. 1–1)

Stained glass Colored glass pieces held in place with lead strips. (Ch. 10–3)

Stele (**stee**-lee) An upright monument, usually a carved stone slab. (Ch. 4–3)

Stupas (**stoop**-uhs) Beehive-shaped domed places of worship. (Ch. 8–1)

Style An artist's personal way of using the elements and principles of art and expressing feelings and ideas in art. (Ch. 3–3)

Stylized Simplified or exaggerated to fit the rules of a specific type of design. (Ch. 6–3)

Subject The image viewers can easily identify in an art work. (Ch. 3–1)

Surrealism (suh-**ree**-uh-liz-uhm) An art movement that probed the subconscious world of dreams. (Ch. 17–1)

Symbolism The use of an image to stand for a quality or an idea. (Ch. 11–3)

T

Tempera (**tem**-puh-ruh) A painting medium in which pigment mixed with egg yolk and water is applied with tiny brush strokes. (Ch. 10–1)

Tepee (**tee**-pee) A portable house. (Ch. 13–1)

Texture An element of art that refers to the way a thing feels, or looks as though it might feel, if touched. (Ch. 1–1)

Totem pole An upright log carving picturing stories of different families or clans. (Ch. 13–1)

Triumphal arch (try-**uhm**-fuhl) A monument built to celebrate great army victories.

U

Ukiyo-e (oo-**kee**-yoh-ay) An art style meaning "pictures of the floating world." (Ch. 5–3)

Unity The arrangement of elements and principles with media to create a feeling of completeness or wholeness. (Ch. 1–3)

Urban planning Arranging the construction and services of a city to best meet its people's needs. (Ch. 4–4)

Glossary

Variety A principle of art concerned with combining one or more elements to create interest by adding slight changes. (Ch. 1–3)

Warp Threads running vertically and attached to the loom's frame (Ch. 13–2)

Weaving A craft in which fiber strands are interlocked to make cloth or objects. (Ch. 13–1)

Weft Threads passed horizontally over and under the warp. (Ch. 13–2)

Woodblock printing Making prints by carving images in blocks of wood. (Ch. 5–3)

Yamato-e (yah-**mah**-toh-ay) An art style meaning "pictures in the Japanese manner." (Ch. 5–3)

Z

Ziggurat (**zig**-uh-raht) A stepped mountain made of brick-covered earth. (Ch. 4–4)

A

Abstract Expressionism/Expresionismo abstracto
Un estilo artístico en el que se salpicaba, derramaba y chorreaba pintura sobre lienzos inmensos para expresar una emoción. (Capítulo 17–3)

Abstract work/Obra abstracta Una obra en la cual el artista presenta un sujeto fácil de identificar de una manera que no es realista. (Capítulo 9–1)

Adobe/Adobe Arcilla que se ha secado al sol. (Capítulo 6–3)

Aesthetic view/Opinión estética Lo que una persona o escuela considera importante en una obra de arte. (Capítulo 3–1)

Amphora/Ánfora Jarra de dos asas. (Capítulo 7–1)

Aqueduct/Acueducto Un sistema de canales por donde se transporta el agua hasta una ciudad o pueblo. (Capítulo 7–3)

Arabesques/Arabescos Adornos geométricos de plantas que se repiten en espirales o remolinos. (Capítulo 8–3)

Arbitrary colors/Colores arbitrarios Colores que han sido seleccionados para comunicar distintas emociones. (Capítulo 15–1)

Architecture/Arquitectura El planear y crear edificios. (Capítulo 2–3)

Art criticism/Crítica del arte Estudiar, comprender y evaluar obras de arte. (Capítulo 3–1)

Art history/Historia del arte El estudio del arte desde el pasado al presente. (Capítulo 3–3)

Artifacts/Artefactos Objetos o instrumentos sencillos, hechos a mano. (Capítulo 6–1)

Art movement/Movimiento artístico Una tendencia que se produce cuando un grupo de artistas se reúne para crear obras en un estilo en particular. (Capítulo 14–3)

Ashcan School/Escuela del basurero El nombre popular que se le dio a un grupo de artistas que pintaron cuadros realistas de gente de clase obrera. (Capítulo 16–3)

B

Balance/Equilibrio El principio artístico que trata de la disposición de los elementos artísticos de tal manera que ninguna parte de una obra domine a otra. (Capítulo 1–3)

Baroque/Barroco Un estilo artístico que enfatiza el movimiento, el contraste y la variedad. (Capítulo 12–1)

Binder/Aglutinante El líquido en que se disuelven los granos de pigmento. (Capítulo 2–1)

Buttress/Contrafuerte Un pilar que se pone en la parte de afuera de un edificio para apuntalaro o reforzarlo. (Capítulo 10–3)

C

Calligraphy/Caligrafía Un método de escribir con letra bella, a veces con pincel. (Capítulo 8–3)

Castles/Castillos Fortalezas que servían de viviendas, con murallas altas y torres. (Capítulo 10–1)

Cathedral/Catedral Una iglesia grande y complicada que es la sede de un obispo. (Capítulo 10–3)

Coiled pot/Vasija enrollada Una vasija que se forma colocando rollos de arcilla en forma de espiral. (Capítulo 13–1)

Collage/Collage Una obra de arte hecha de pedazos de materiales de dos dimensiones pegados a una superficie. (Capítulo 8–4)

Color/Color Uno de los elementos del arte que se refiere a lo que ven los ojos cuando un objeto refleja la luz. (Capítulo 1–1)

Composition/Composición La manera en que se usan los principios del arte para organizar los elementos de color, línea, contorno, forma, espacio y textura. (Capítulo 3–1)

Concrete/Concreto Una mezcla de piedras pequeñas y minerales en polvo que se muele finamente y se utiliza en la construcción de edificios. (Capítulo 7–3)

Content/Contenido La idea, sentimiento, atmósfera o mensaje que expresa una obra de arte. (Capítulo 3–1)

Contour drawing/Dibujo de contorno Dibujar un objeto como si el instrumento de dibujar estuviera tocando los bordes de la figura. (Capítulo 11–2)

Cradle board/Tabla de acunar Un armazón de cuero que se lleva en las espaldas para cargar a un niño chiquito. (Capítulo 13–1)

Crafts/Artesanía Las artes aplicadas en que trabajan los artesanos. (Capítulo 2–3)

Cubism/Cubismo Un estilo artístico en el que se quiebra la forma de los objetos y del espacio que los rodea, y se vuelven a reunir los pedazos de manera que formen un conjunto nuevo. (Capítulo 16–1)

Glossary/Glosario

Culture/Cultura Las ideas, creencias y costumbres vivas de un pueblo. (Capítulo 4–1)

Dada/Dadaísmo Un movimiento artístico que se basó en la creencia de que la cultura Occidental ya no tenía sentido. (Capítulo 17–1)

E

Edition/Edición Una serie de grabados idénticos que están hechos de una misma placa. (Capítulo 2–1)

Effigy/Efigie Una imagen que representa ciertas ideas o creencias. (Capítulo 6–1)

The Eight/Los Ocho Un grupo de artistas neoyorquinos que creaban obras que reflejaban el espíritu de la época en que vivían, el comienzo de los años 1900. (Capítulo 16–3)

Emphasis/Énfasis El principio artístico que trata de la manera en que se puede hacer resaltar un elemento u objeto en una obra. (Capítulo 1–3)

Etching/Aguafuerte Un tipo de grabado entallado en el que se hacen cortes en una placa de cobre que ha sido tratada con substancias químicas para producir la imagen. (Capítulo 12–3)

Expressionism/Expresionismo Un estilo que enfatiza la expresión de los sentimientos más profundos. (Capítulo 16–1)

F

Facade/Fachada El frente de un edificio. (Capítulo 12–1)

Face mask/Máscara facial Una careta que usa una persona para esconder su identidad. (Capítulo 9–3)

Fauvism/Fauvismo Un movimiento artístico en el cual los artistas usan combinaciones extrañas de colores intensos en sus pinturas. (Capítulo 16–1)

Form/Forma El elemento del arte que se refiere a un objeto de tres dimensiones. (Capítulo 1–1)

Freestanding sculpture/Escultura de pie Escultura que está completamente rodeada por espacio vacío. (Capítulo 2–3)

Fresco/Fresco Una pintura en la que el pigmento se aplica a una sección de pared que está recién cubierta de yeso. (Capítulo 10–3)

Frieze/Friso Una franja decorativa a lo largo de la parte superior de una pared. (Capítulo 7–1)

Funerary urns/Urnas fúnebres Vasijas decoradas que se encuentran en lugares de sepultura. (Capítulo 6–2)

G

Gargoyle/Gárgola Un ornamento que sobresale de un edificio en la forma de un animal fantástico o criatura grotesca. (Capítulo 10–4)

Genre pieces/Obras de género Obras que enfocan en un sujeto o escena de la vida diaria. (Capítulo 6–1)

Glaze/Vidriado Un barniz que parece cristal que se le pone a los objetos de cerámica. (Capítulo 5–1)

H

Hard-Edge painting/Pintura con bordes definidos Un estilo artístico en el que los contornos están muy nítidos. (Capítulo 17–3)

Harmony/Armonía El principio artístico que trata de la combinación de elementos para crear una apariencia más tranquila y relajante. (Capítulo 1–3)

Headpieces/Cascos con máscaras Caretas talladas en madera que se llevaban en la cabeza como una gorra. (Capítulo 9–3)

Hieroglyphic/Jeroglíficos Un tipo de escritura antigua que usaba dibujos para expresar ideas. (Capítulo 4–3)

Illuminations/Iluminaciones Ilustraciones pintadas a mano que se usaban en los libros. (Capítulo 10–1)

Impressionism/Impresionismo Un estilo artístico en el que se trataba de capturar los efectos de la luz sobre los objetos, efectos que cambian rápidamente. (Capítulo 14–2)

Intaglio/Entallar Un método de imprimir en el cual la imagen que se va a grabar se corta en una superficie.

Kachina doll/Muñeca Kachina Una pequeña estatua tallada a mano que se usa para enseñarle a los niños acerca de las ceremonias de los indios pueblo. (Capítulo 13–1)

Kinetic art/Arte cinético Un estilo artístico en el que partes de las obras se mueven por medio de algún tipo de energía. (Capítulo 17–5)

L

Landscape/Paisaje Un dibujo o pintura principalmente de montañas, árboles u otras escenas de la naturaleza. (Capítulo 14–1)

Line/Línea El elemento del arte que se refiere a la trayectoria de un punto que se mueve a través de un espacio. (Capítulo 1–1)

Linear perspective/Perspectiva lineal El uso de líneas inclinadas para hacer parecer que los objetos están más atrás en el espacio. (Capítulo 11–1)

Loom/Telar Un bastidor que sujeta una serie de hilos entrecruzados. (Capítulo 13–2)

M

Madonna/Madona Una obra que representa a la Virgen María y al Niño Jesús. (Capítulo 11–1)

Media/Medios En inglés, el plural de "medium" que significa medio o recurso. (Capítulo 2–1)

Medium of art/Medio de expresión El material usado para crear una obra de arte. (Capítulo 2–1)

Megalith/Megalito Monumento inmenso de piedra, como Stonehenge en Inglaterra. (Capítulo 4–1)

Menus/Menús Casillas que enumeran las selecciones que ofrece un programa de software. (Capítulo 2–4)

Mihrab/Mihrab Un nicho muy decorado en una mezquita. (Capítulo 8–3)

Minaret/Minarete Una torre delgada desde donde los musulmanes son llamados a rezar. (Capítulo 8–3)

Mixed media/Técnica mixta El uso de más de un medio de expresión en una obra de arte. (Capítulo 3–1)

Mobile/Móvil Una escultura hecha de piezas bidimensionales colgadas de alambres y equilibradas con mucho cuidado. (Capítulo 17–3)

Monolith/Monolito Una estructura hecha de un solo pedazo de piedra. (Capítulo 6–3)

Mosque/Mezquita Un edificio religioso islámico. (Capítulo 8–3)

Motif/Motivo Parte de un diseño que se repite de acuerdo a un patrón o ritmo visual. (Capítulo 6–2)

Movement/Movimiento El principio artístico que trata de cómo crear una sensación de acción y que guía la mirada del observador a través de la obra. (Capítulo 1–3)

Multi-media art/Arte multimedia Una obra que utiliza los instrumentos y las técnicas de dos o más tipos de arte. (Capítulo 17–5)

Muralist/Muralista Un artista que pinta obras grandes directamente en paredes o techos. (Capítulo 16–3)

N

Neoclassic/Neoclásico Un estilo artístico basado en las artes clásicas de Grecia y Roma antiguas. (Capítulo 14–1)

New Realism/Nuevo realismo Un movimiento artístico que volvió a descubrir la importancia de los detalles realistas. (Capítulo 17–3)

Non-objective/Sin objeto Que no tiene ningún sujeto que se pueda reconocer. (Capítulo 2–1)

Non-objective art/Arte sin objeto Obras que no tienen objetos o sujetos que se puedan identificar con facilidad. (Capítulo 1–2), (Capítulo 16–1)

O

Oil paint/Pintura al óleo Una mezcla de pigmento, aceite de linaza y trementina. (Capítulo 11–3)

Op art/Op-art Un estilo artístico que utiliza líneas y contornos muy precisos para crear ilusiones ópticas. (Capítulo 17–4)

Optical colors/Colores ópticos Los colores que los observadores ven en realidad. (Capítulo 15–1)

P

Pagoda/Pagoda Una torre que tiene varios pisos de altura y techos cuyos bordes hacen una pequeña curva hacia arriba. (Capítulo 5–3)

Papier-mâché/Papel maché Una técnica de esculpir que utiliza periódicos y pegamento líquido. (Capítulo 9–4)

Perceive/Percibir Darse cuenta de la naturaleza particular de los objetos por medio de los sentidos. (Capítulo 5–1)

Perceiving/Percibir Observar detenidamente y profundizar sobre lo que uno ve.

Petroglyphs/Petroglifos Piedras grabadas y pintadas. (Capítulo 13–1)

Pietà/Piedad Una obra que representa a María llorando la muerte de Cristo que está en sus brazos. (Capítulo 11–1)

Pigment/Pigmento El polvo fino que le da color a la pintura. (Capítulo 2–1)

Pixels/Pixeles Cuadrados individuales en la pantalla de un computador. (Capítulo 2–1)

Pointed arch/Arco ojival Una construcción de piedra en forma de curva con un pico central. (Capítulo 10–3)

Pointillism/Puntillismo Una técnica en la que se pintan pequeños puntos de color para crear figuras. (Capítulo 15–2)

Polychrome/Policromo Que tiene muchos colores. (Capítulo 13–3)

Porcelain/Porcelana Un tipo de cerámica de grano fino de alta calidad. (Capítulo 5–1)

Portrait/Retrato Una pintura que representa a una persona. (Capítulo 12–1)

Portfolio/Carpeta de trabajos Una colección de obras de arte que un estudiante o artista profesional selecciona con cuidado y conserva.

Post and lintel system/Sistema de puntal y dintel Una manera de construir en la que un madero horizontal se coloca encima de dos postes. (Capítulo 4–3)

Post-Impressionism/Postimpresionismo Un movimiento artístico que surgió después del impresionismo. (Capítulo 15–1)

Printing plate/Placa de imprimir Una superficie en la cual se coloca o talla la imagen. (Capítulo 2–1)

Printmaking/Grabar Una técnica en la que se entinta una imagen en una superficie preparada y se traslada a otra superficie. (Capítulo 2–1)

Proportion/Proporción El principio artístico que trata de la relación de una parte con otra y con el todo. (Capítulo 1–3)

Pueblos/Pueblos Los poblados de los indios pueblo que comprendían viviendas de adobe para muchas familias, apiladas una sobre otra. (Capítulo 13–1)

R

Realism/Realismo Un estilo artístico en el que las escenas y eventos de la vida diaria se pintan tal y como son. (Capítulo 15–3)

Regionalism/Regionalismo Un estilo artístico que documenta escenas y eventos locales del área o región donde vive el artista. (Capítulo 16–3)

Relief Sculpture/Escultura en relieve Una escultura que está sólo parcialmente rodeada por espacio vacío. (Capítulo 2–3)

Renaissance/Renacimiento Un período de gran actividad intelectual y artística. (Capítulo 11–1)

Rhythm/Ritmo El principio artístico que trata de la repetición de un elemento para hacer parecer que hay actividad o vibración en una obra. (Capítulo 1–3)

Rococo/Rococó Un estilo artístico que enfatiza el movimiento libre y lleno de gracia, los colores vivos y el contenido alegre. (Capítulo 12–3)

Romanticism/Romanticismo Un estilo artístico que utiliza lo dramático y exótico como sujetos. (Capítulo 14–1)

Round arch/Arco de medio punto Una construcción de piedra en forma de curva sobre un espacio vacío. (Capítulo 7–3)

S

Salon/Salón Una exposición de arte anual. (Capítulo 14–3)

Sand painting/Pintar en la arena El verter polvo de piedras de distintos colores sobre una sección plana de tierra para crear una imagen o diseño. (Capítulo 13–3)

Screen/Mampara Un separador movible que se usa como pared para dividir una habitación. (Capítulo 5–3)

Scroll/Rollo Un carrete largo de pergamino o seda ilustrado. (Capítulo 5–1)

Shape/Contorno El elemento del arte que se refiere a una imagen de dos dimensiones, destacada por uno o más de los otros elementos visuales del arte. (Capítulo 1–1)

Shoulder masks/Máscaras de hombros Grandes caretas talladas que descansan en los hombros de los que las llevan puestas. (Capítulo 9–3)

Sketchbook/Cuaderno de bocetos Un bloc en el que un artista dibuja, toma notas y perfecciona sus ideas para una obra. (Capítulo 2–1)

Social protest painting/Pintura de protesta social
Un estilo artístico que ataca los males de la vida en las grandes ciudades. (Capítulo 17–3)

Solvent/Solvente Un material que se usa para diluir el aglutinante de una pintura. (Capítulo 2–1)

Space/Espacio El elemento del arte que se refiere al área entre, alrededor, arriba, debajo y dentro de las cosas. (Capítulo 1–1)

Stained glass/Vidrio de colores Pedazos de cristal de colores que se sostienen en su sitio con tiras de plomo. (Capítulo 10–3)

Stele/Estela Un monumento hecho por lo general de un pedazo de piedra tallada. (Capítulo 4–3)

Stupas/Stupas Templos con cúpulas en forma de colmena. (Capítulo 8–1)

Style/Estilo La manera particular que tiene un artista de utilizar los principios y elementos artísticos y de expresar sus sentimientos e ideas. (Capítulo 3–3)

Stylized/Estilizado Simplificado o exagerado para hacer que se conforme con las reglas de un tipo de diseño. (Capítulo 6–3)

Subject/Sujeto La imagen que un observador puede identificar con facilidad en una obra. (Capítulo 3–1)

Surrealism/Surrealismo El movimiento artístico que exploró el inconsciente y el mundo de los sueños. (Capítulo 17–1)

Symbolism/Simbolismo El uso de imágenes para representar una cualidad o idea. (Capítulo 11–3)

Tempera/Al temple Un medio de pintar en el que se mezcla el pigmento con yemas de huevo y agua, y se pinta con pinceladas muy pequeñas. (Capítulo 10–1)

Tepee/Tipi Una casa portátil. (Capítulo 13–1)

Texture/Textura El elemento del arte que se refiere a la manera en que las cosas se sienten o parece que deben sentirse al tocarlas. (Capítulo 1–1)

Totem pole/Tótem Un tronco tallado con las historias de una familia o clan. (Capítulo 13–1)

Triumphal arch/Arco de triunfo Un monumento construido para celebrar grandes victorias militares. (Capítulo 7–3)

Ukiyo-e/Grabado en madera El nombre japonés de un estilo artístico que significa "ilustraciones de un mundo flotante." (Capítulo 5–3)

Unity/Unidad La manera en que los elementos se arreglan en el medio de expresión, de acuerdo con los principios artísticos, para crear la noción de que la obra está terminada o entera. (Capítulo 1–3)

Urban planning/Planificación urbana Organizar la construcción y servicios de una ciudad para mejor proporcionar lo que el pueblo necesita. (Capítulo 4–4)

Variety/Variedad El principio artístico que trata de la combinación de elementos para crear interés a través de pequeños cambios. (Capítulo 1–3)

Warp/Urdimbre Los hilos verticales que sujeta el telar. (Capítulo 13–2)

Weaving/Tejer Una artesanía en la que se entrelazan hilos para hacer tela u objetos. (Capítulo 13–1)

Weft/Trama Los hilos horizontales que se pasan por arriba y por debajo de los de la urdimbre. (Capítulo 13–2)

Woodblock printing/Grabado en madera Tallar imágenes en bloques de madera para hacer grabados. (Capítulo 5–3)

Y

Yamato-e/Estilo japonés El nombre japonés de un estilo artístico que significa "a la japonesa." (Capítulo 5–3)

Z

Ziggurat/Zigurat Una montaña escalonada hecha de tierra cubierta de ladrillos. (Capítulo 4–4)

Bibliography and Resource List

The following resources provide information in various areas of art and education. The entries are organized by subject and each title is followed by a brief description to help you choose the subjects you wish to read about.

Art History

Anderson, Bjork. *Linnea in Monet's Garden*. New York: R and S Books, 1985. When Linnea visits Claude Monet's garden in Giverny, she gets to stand on the bridge over his lily pond and walk through his house. Later, when she sees his paintings in Paris, she understands what it means for a painter to be called an Impressionist. This delightful book contains photographs of Monet's paintings as well as old family snapshots.

Avi-Yonah, Michael. *Piece by Piece! Mosaics of the Ancient World*. Minneapolis, Minn.: Lerner, 1993. This book describes ancient and modern techniques as well as early Greek, Roman, and Byzantine mosaics.

Barnicoat, John. *Posters: A Concise History*. New York: Thames and Hudson, 1985. The importance of the poster, including its role in various artistic movements.

Capek, Michael. *Artistic Trickery: The Tradition of Trompe L'Oeil Art*. Minneapolis, Minn.: Lerner, 1995. From the ancient Greeks to contemporary designers, artists have long been inspired to play visual jokes. This book lets the reader in on some of the gags.

Davidson, Rosemary. *Take a Look: An Introduction to the Experience of Art*. New York: Penguin, 1993. This book introduces the history, techniques, and functions of art through discussion and reproductions of paintings, photographs, drawings, and design elements. It also includes valuable diagrams and information about seeing and looking at art.

"Introduction to the Renaissance," *Calliope: World History for Young People*. Peterborough, N.H.: Cobblestone Publishing, May/June 1994. This issue of *Calliope* deals with many aspects of the arts and sciences during the Italian Renaissance. It features articles on artists such as Michelangelo and Leonardo da Vinci, rulers such as Isabella d'Este, and composers such as Monteverdi.

Biography

Gilow, Louise. *Meet Jim Henson*. New York: Random House, 1993. The creator of the Muppets, puppet stars of television and the movies, is the subject of this biography.

Greene, Katherine, and Richard Greene. *The Man Behind the Magic: The Story of Walt Disney*. New York: Viking, 1991. This biography of Walt Disney discusses his boyhood on a Missouri farm, his struggles as a young animator, and his building of a motion picture and amusement park empire.

Heslewood, Juliet. *Introducing Picasso: Painter, Sculptor*. Boston: Little, Brown, 1993. By examining the life of the well-known modern painter and the historical and artistic influences on his work, this book gives young readers a sense of who Picasso was and how his art developed. Photographs illustrate his work and his life.

Kastner, Joseph. *John James Audubon*. New York: Harry N. Abrams, 1992. This biography chronicles the life of Audubon from his childhood in France to his adventures in the New World, and shows how he captured these adventures in his artwork.

Neimark, Ann E. *Diego Rivera: Artist of the People*. New York: HarperCollins, 1992. Diego Rivera is brought to life in this comprehensive biography. It is illustrated with reproductions of Rivera's artwork.

Newlands, Anne. *Meet Edgar Degas*. New York: Lippincott, 1988. Degas talks to the reader about 13 of his paintings, describing what it's like to be a young artist in Paris.

Careers

Gordon, Barbara. *Careers in Art: Graphic Design*. VGM Career Horizons, 1992. Provides descriptions of careers in the graphic design field including art directors, book and magazine publishers, industrial designers and production artists. Information on courses and training requirements, job opportunities, and portfolio preparation.

Kaplan, Andrew. *Careers for Artistic Types*. Brookfield, Conn.: Millbrook, 1991. The author interviews 14 people who work in careers that are of interest to young people who like art.

Media and Techniques

James, Jane H. *Perspective Drawing: A Point of View.* 2d ed. Englewood Cliffs, N.J.: Prentice Hall, 1988. For students who want to learn more about perspective.

Kehoe, Michael. *A Book Takes Root: The Making of a Picture Book.* Minneapolis, Minn.: Carolrhoda, 1993. This book traces the process of making a picture book from idea to manuscript to final production. Color photographs accompany the text and make this a fun-to-read and informative book.

Lauer, David A. *Design Basics.* 2d ed. New York: Holt, Rinehart and Winston, 1985. A resource for design students.

Mayer, Ralph. *The Artist's Handbook of Materials and Techniques.* 5th ed., rev. and updated. New York: Viking-Penguin, 1991. An up-to-date reference on art materials and techniques.

Meilach, Dona Z., Jay Hinz, and Bill Hinz. *How to Create Your Own Designs: An Introduction to Color, Form and Composition.* New York: Doubleday and Co., 1975. An excellent introduction to the elements of design.

Patterson, Freeman. *Photography and the Art of Seeing.* Rev. ed. San Francisco: Sierra Club Books, 1990. This book offers good advice on creative photography and is of particular interest to the beginning photographer.

Porter, Albert W. *Expressive Watercolor Techniques.* Worcester, Mass.: Davis Publications, 1982. A useful resource with valuable information on techniques and processes.

Sheaks, Barclay. *Drawing Figures and Faces.* Worcester, Mass.: Davis Publications, 1987. A helpful resource for students who wish to expand their drawing techniques.

Weldon, Jude. *Drawing: A Young Artist's Guide.* London: Dorling Kindersley, 1994. This well-designed and beautifully illustrated book guides the young artist through a wide variety of artistic experiences. Each idea is illustrated with master drawings and paintings. Topics include light and shade, color, imagination, and storytelling.

Multimedia Resources
Laserdiscs

American Art from the National Gallery A collection of 2,600 paintings and sculpture by American artists spanning three centuries.

Louvre Compendium Includes more than 5,000 works of art and 35,000 detailed images in a three-volume series.

Videodisc Volume I: Painting and Drawings

Videodisc Volume II: Sculpture and Objets d'Art

Videodisc Volume III: Antiquities

The National Gallery of Art A guided tour of the National Gallery featuring more than 1,600 masterpieces. A printed catalog and on-screen captions identifying each work are included.

The National Gallery of Art Laserstack Use this laserstack to create your own notes or slide lists for presentations. Works may be arranged by artist, nationality, period, style, date, medium, or subject.

Regard for the Planet A resource for 50,000 photographs documenting world cultures, places, and events of the last 40 years.

CD-ROMs

Art and Music Series Focuses on art and music from medieval times to Surrealism, with text linked to 24-volume student encyclopedia and glossary. Events, challenges, and achievements of each time period are highlighted. (lab packs available) WIN & MAC

National Museum of Women in the Arts Access to 200 artworks from the collection. Available on CD-ROM or videodisc.

With Open Eyes Access to images through time line, geographical location, and close-ups. View 200 multimedia and multicultural artworks from the collection of the Art Institute of Chicago. View any object in a virtual-reality gallery to get a sense of scale. Includes games, music, poetry, and sound effects. WIN & MAC

Index

Index

Student Art Contributors

The following students contributed exemplary works for Studio Activities and Studio Lessons.

Figure 1-12 **Julie Brown**, El Modena High School, Orange, CA; Figure 2-15 **Leanne Bellar**, Medina Elementary, Bothell, WA; Figure 4-8 **Brenna Sullivan**, St. Athanasius School, Evanston, IL; Figure 5-4 **Cathleen Cramer**, St. Athanasius School, Evanston, IL; Figure 5-13 **Allison Hengemuhle**, Junction Middle School, Palo Cedro, CA; Figure 5-13 **Rachel Simon**, Junction Middle School, Palo Cedro, CA; Figure 5-13 **Jenny Spencer**, Junction Middle School, Palo Cedro, CA; Figure 6-9 **Kayci Mackey**, Junction Middle School, Palo Cedro, CA; Figure 6-19 **Eric Sargeant**, El Modena High School, Orange, CA Figure 6-19 **Shelly Eaddy**, South Florence High School, Florence, SC; Figure 8-16 **Annie Medina**, El Modena High School, Orange, CA; Figure 8-7 **Emilia Hofmeister**, St. Athanasius School, Evanston, IL; Figure 8-7 **Catherine Harr**, St. Athanasius School, Evanston, IL; Figure 8-7 **Iwona Klapa**, Akron Central School, Akron, NY; Figure 8-7 **Andrea Hallbach**, Akron Central School, Akron, NY; Figure 8-7 **Jamie Jacobs**, Akron Central School, Akron, NY; Figure 9-11 **Chris DeNardo**, St. Athanasius School, Evanston, IL; Figure 9-13 **Crystal Crain**, Junction Middle School, Palo Cedro, CA; Figure 10-9 **Anthony Kaster**, Junction Middle School, Palo Cedro, CA; Figure 10-15 **Jason Markus**, Valleywood School, Kentwood, MI; Figure 11-9 **Michael Morel**, St. Athanasius School, Evanston, IL; Figure 12-7 **Pedro Arcos**, El Modena High School, Orange, CA ; Figure 14-9 **Jack Nondorf**, St. Athanasius School, Evanston, IL; Figure 14-11 **Tim Zazynski**, Akron Central School, Akron, NY; Figure 15-5 **Paul Sargeant**, El Modena High School, Orange, CA; Figure 15-11 **Andrea Sagerman**, Akron Central School, Akron, NY; Figure 16-6 **Annie Medina**, El Modena High School, Orange, CA; Figure 16-13 **Patrick Kennelly**, St. Athanasius School, Evanston, IL; Figure 17-17 **Susan Ramsden**, El Modena High School, Orange, CA; Figure S-2 **Ben Scannell**, Skyview Junior High, Bothell, WA; Figure S-4 **Cassie Armstrong**, El Modena High School, Orange, CA; Figure S-7 **Sean Kebely**, Medina Elementary, Bothell, WA;

Artists Rights Society (ARS)

Georges Braque, *Still Life: Le Jour*, 1929, 246, Fig. 16-5 ©1997 Artists Rights Society (ARS), New York/ADAGP, Paris; **Alexander Calder**, *Zarabanda (Un Disco Blanco)*, 266, Fig. 17-3 ©1997 Artists Rights Society (ARS), New York/ADAGP, Paris; **Marc Chagall**, *Green Violinist*, 1923-24, 4, Fig. 1-3 ©1997 Artists Rights Society (ARS), New York/ADAGP, Paris; **Willem de Kooning**, *Merritt Parkway*, 34, Fig. 3-1 ©1997 Willem de Kooning Revocable Trust/Artists Rights Society (ARS), New York; **Arshile Gorky**, *Golden Brown*, 264, Fig. 17-9 ©1997 Estate of Arshile Gorky/Artists Rights Society (ARS), New York; **Luis Jiménez**, *Vaquero*, 16, Chapter 2 Opener ©1997 Luis Jimenez/Artists Rights Society (ARS), New York; **Käthe Kollwitz**, *The Mothers*, 244, Fig. 16-3 ©1997 Artists Rights Society (ARS), New York/VG Bild-Kunst, Bonn; **Richard Lindner**, *Rock-Rock*, 8, Fig. 1-7 ©1997 Artists Rights Society (ARS), New York/ADAGP, Paris; **René Magritte**, *Time Transfixed*, 262, Fig. 17-7 ©1997 C. Herscovici, Brussels/Artists Rights Society (ARS), New York; **Henri Matisse**, *Pianist and Checker Players*, 242, Fig. 16-1 ©1997 Succession H. Matisse, Paris/Artists Rights Society (ARS), New York; **Joan Miró**, *Dutch Interior*, 259, Fig. 17-2 ©1997 Artists Rights Society (ARS), New York/ADAGP, Paris; **Joan Miró**, *Femme*, 27, Fig. 2-13 ©1997 Artists Rights Society (ARS), New York/ADAGP, Paris; **Pablo Picasso**, *Mandolin and Guitar*, 42, Fig. 3-7 ©1997 Estate of Pablo Picasso/Artists Rights Society (ARS), New York

Photography: R. A. Acharya/Dinodia 114; **Art Resource**, New York 25T, 96, 152, 178; **Bill Ballenberg** 89L; **Gary Braash** 73(3); **Jack Breed** 201R; **Digital Art**/Westlight 304; **Laima Druskis** 299L; **Robert Frerck**/Odyssey, Chicago 55B, 83T, 84T, 90, 105(2), 115B, 122(3), 146, 147T, 148, 150R; **Ann Garvin** 297(2), 298(2), 299(2), 301(2), 302(2), 303L; **Giraudon**/Art Resource, New York 49T, 149, 187, 190; **Jack Stein Grove**/Photo Edit 91T; Erich Lessing/Art Resource, New York 64, 163, 176, 182; Erich Lessing/Photo Edit 106L; **Ray Lutz** 196L; **Bruno Maso/Bill Roberts**/Photo Edit 185T; **Douglas Mazonowica** 52; **Stephen McBrady**/Photo Edit 300R; **National Museum of American Art**, DC/Art Resource 254; **Henry Nelson** 20T; **Nimatallah**/Art Resource 100R, 174; **Dennis O'Clair**/Tony Stone Images 296; **Odyssey** 115B; **RIL**/Westlight 299; **M. Richards** 303R; **Bill Roberts**/Photo Edit 150L, 153B; **Scala**/Art Resource, New York 61, 85T, 100L, 101, 107T, 154B, 165T, 172, 179L, 185; **Tektronix** 300L; **Susan Van Etten**/Photo Edit 73R; **Westlight**/Comnet 50B; **Nick Wheeler**/Black Star 60; **R. White** 49B; **Lee White**, selected student works.

Maps: Eureka Cartography, Berkeley, California